World of Art

David Curtis is a leading authorit
include *London's Arts Labs and t*
and *A History of Artists' Film and*
responsible for artists' films at th
from 1977 to 2000, and curated '
Britain' at Tate Britain, London, in

CW01464460

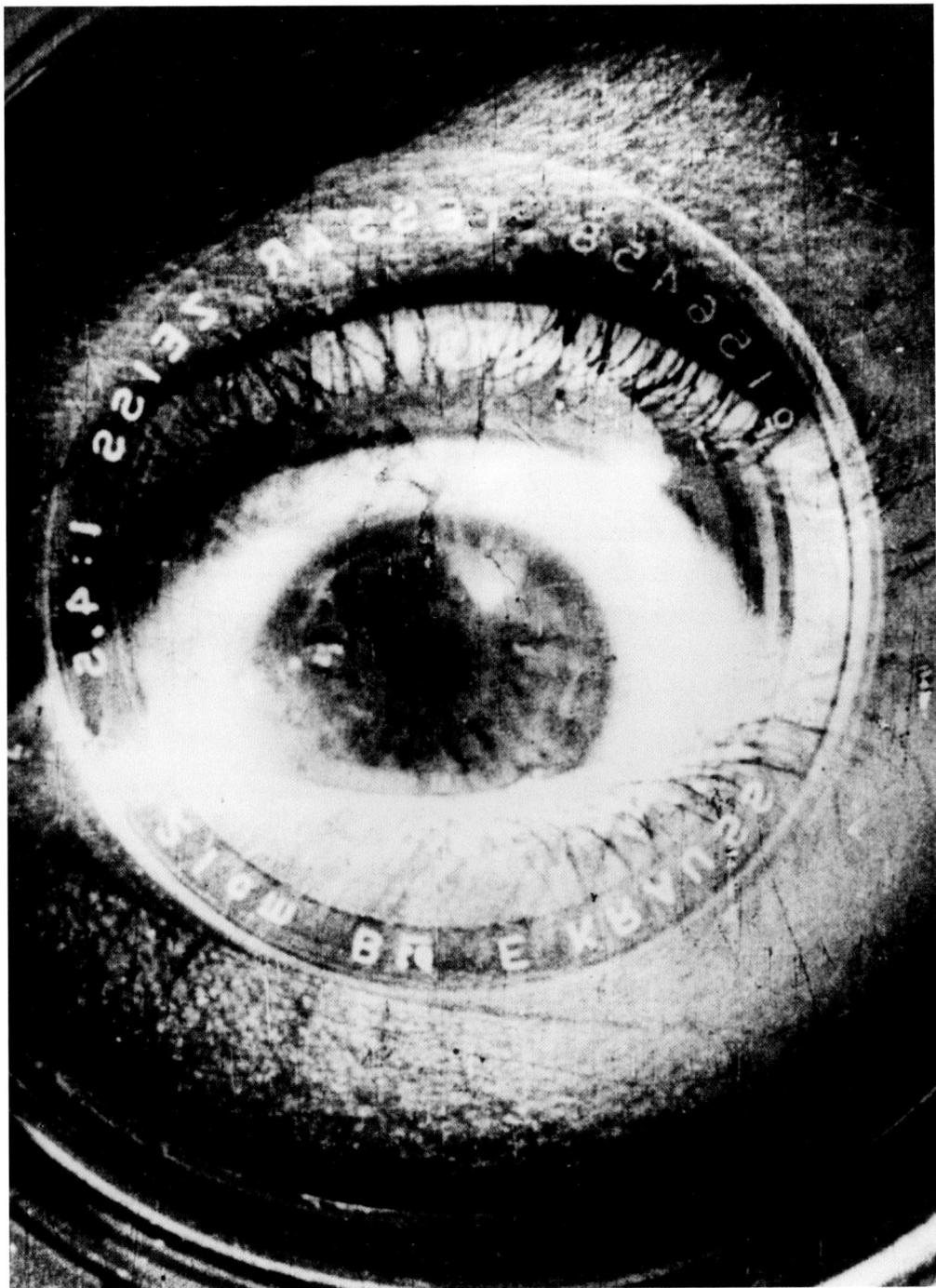

1 Dziga Vertov, *Tchelovek s kinoapparatom* (*Man with a Movie Camera*), 1929 (detail)

World of Art

Artists' Film
David Curtis

Foreword by Steve McQueen

T&H

Acknowledgments

Many hands have helped give shape to this text. Ryszard Kluszczynski gave early encouragement; Tim Cawkwell, Phillip Drummond and my partner Biddy Peppin all contributed thoughtful editing at early stages; Heather Stewart, William Fowler and Camilla Erskine at the British Film Institute usefully commented on the text while it was still homeless; Roger Thorp at Thames & Hudson saw the book's potential and boldly commissioned it; Nicky Hamlyn and Roselee Goldberg offered invaluable, detailed suggestions at a vital late stage. At Thames & Hudson, Kate Edwards, Mohara Gill, Jo Walton, Adam Hay and Celia Falconer have steered the book towards the printers with quiet professionalism. Many artist friends have shared ideas with me over the years, so helping to deepen and expand my understanding of this medium; indeed, enjoying and often being challenged by their work is what sustains me. Not least among these artists is Steve McQueen, who has generously contributed a foreword to this book.

First published in the United Kingdom in 2021 by
Thames & Hudson Ltd, 181A High Holborn, London
WC1V 7QX

www.thamesandhudson.com

First published in 2021 in the United States
of America by Thames & Hudson Inc.,
500 Fifth Avenue, New York, New York 10110

www.thamesandhudsonusa.com

Artists' Film © 2021 Thames & Hudson Ltd, London
Text © 2021 David Curtis

Art direction and series design by Kummer & Herrman
Layout by Adam Hay Studio

All Rights Reserved. No part of this publication may
be reproduced or transmitted in any form or by any
means, electronic or mechanical, including photocopy,
recording or any other information storage and retrieval
system, without prior permission in writing from the
publisher.

British Library Cataloguing-in-Publication Data
A catalogue record for this book is available from
the British Library

Library of Congress Control Number 2021934218

ISBN 978-0-500-20473-3

Printed and bound in China through Asia Pacific
Offset Ltd

MIX
Paper from
responsible sources
FSC® C136333

Contents

Foreword
Steve McQueen

In the summer of 1993, David Curtis came to Goldsmiths College to assess the final year Fine Arts undergraduate students, of which I was one. At that time I had been accepted as a graduate of film at NYU and my mind was elsewhere.

My first encounter with David was in a dark room with a rattling 16mm projector cutting light through the dark, illuminating my own and another's naked bodies. The film was called *Bear* (1993). David stayed for two viewings of this ten-minute, silent black-and-white film, then left, saying nothing. Shortly after I bumped into him in the corridor, where he spoke with a soft voice – barely audibly – and asked questions about my film. I got the impression he was enthusiastic, but I wasn't sure if he liked it. He gave me a card and invited me to his office at the Arts Council, where he worked.

I arrived one typically overcast London day and was shown in by his trusted deputy Gary Thomas. David began to say how much he admired *Bear* and asked what I was doing next. I told him I was off to New York and wanted to focus on feature films. He looked surprised, but said if I ever returned I should contact him if I needed assistance in making another project. I smiled and said thank you. A year later, with my tail between my legs, I sheepishly got in contact with David asking for assistance to make a new project. He (or his committee) kindly gave me £5,000 and I took it to make my second artwork, *5 Easy Pieces*, which I showed at the ICA in 1995 in the exhibition 'Mirage'. From that day I never looked back.

David is the only person I know who has an encyclopaedic knowledge of – and a passion for – film in all its possibilities. Long before it became popular in the 1990s to work in film or video, David was committed to the medium; I had no idea

that someone like him existed in the UK until I met him. His dedication to and knowledge of film and video is incomparable.

This book is an important document that describes the development of artists' film in all its forms, and should be treasured. Thankfully it will enable David's vast experience and knowledge to reach future generations of artists, filmmakers, researchers and academics, whose lives may be changed by it as mine was....

Introduction

Artist: person who practises or is skilled in an art, now esp. a
fine art; a person who has the qualities of imagination and taste
required in art; a painter or draughtsman; a performer esp. in
music; a person good at, or given to, a particular activity...a learned
man...someone who professes magic, astrology, alchemy etc.

<div align="right">The Chambers Dictionary</div>

This dictionary definition from the 1990s, still gender-biased, struggles as we all do to concisely define the role of the artist in society. In this book, 'artist' is employed as it is most commonly understood: to describe individuals who 'practise and are skilled at a particular activity', in this case, working with the moving image.

It should hardly need stating that the giants of mainstream cinema's past – Renoir, Antonioni, Varda, Ray, Tarkovsky et al. – have as much right to be called an artist as any of the around 400 moving-image makers included in these chapters. They too managed to establish a distinctive vision, despite working in the context of an often hostile entertainment industry. But their work is of a different scale and intention to that described here, contributing instead to a long-established history of the narrative arts – the novel, the play or the history painting. The relationship of cinema director to film-making artist has been compared by some to that of prose writer to poet. The artists described here tend to work alone (as do painters and poets), often wholly outside – or at best on the fringes of – mainstream cinema and the commercial art market. And many, at least early in their careers, exhibit a willingness to shock – to 'rock the boat'. Often, they have struggled to make their voices heard, yet they have still had an impact on the evolution of the art form. This book is dedicated to these individuals (moving image 'alchemists', in the eyes of some).

When describing this field, historians have sometimes focused on the lineage of one particular branch of moving-image art – for example, the experimental film, video art, expanded cinema or multimedia art. These medium-specific histories are important, but taken alone they can obscure the bigger picture of the artist's contribution to film over the last 100 years. This introductory book brings these histories back together, discussing works thematically, whether film, video or installation, while respecting chronology and acknowledging an artist's particular engagement with a chosen technology where important. The primary purpose here is to give a sense of the richness and diversity of this field, and the pleasures to be discovered within. These thematic groupings allow connections to be made across decades, continents and media. The social and political environments in which these artists worked is also outlined here, albeit sometimes briefly. Artists may work in isolation from their times or revisit ideas first explored decades earlier; what they bring new to their work is what matters.

This, then, is a single history: the story of creative individuals scattered across the world who have been attracted by the flickering screen and felt compelled to contribute their own images to it, 'film' their shared language. This inclusive approach also recognizes that today, in the age of digital distribution, there are multiple ways in which artists' films will be encountered – in cinemas, on gallery walls and, probably most frequently, on the internet. Many of these forms are now far removed from the artists' original expectations, a phenomenon discussed in Chapter 9. Hopefully this book will encourage readers to seek out and enjoy these encounters.

Chapter 1
The Attraction of Film

I go to the cinema for any number of different reasons.... At random, here are a few of them: I go to be distracted (or 'taken out of myself'); I go when I don't think; I go when I do want to think and need stimulus; I go to see pretty people; I go when I want to see life ginned-up, charged with an unlikely energy; I go to laugh; I go to be harrowed; I go when a day has been such a mess of detail that I am glad to see even the most arbitrary, the most preposterous patterns emerge; I go because I like bright light, abrupt shadow, speed; I go to see America, France, Russia; I go because I like wisecracks and slick behaviour; I go because the screen is an oblong opening into the world of fantasy for me; I go because I like story, with its suspense; I go because I like sitting in a packed crowd in the dark, among hundreds riveted on the same thing; I go to have my most general feeling played on.[1]

Elizabeth Bowen

In this evocative text, written nearly eighty years ago, the novelist Elizabeth Bowen identifies just a few of the reasons why many of us – including artists – are still frequent cinema-goers. Engaging stories, far-flung places and glamorous people remain the main focus of commercial feature film production. But almost from the start of film history there have been voices protesting that this isn't enough; the moving image is capable of more. In 1924, the painter Fernand Léger put it bluntly:

The story of the artists' film is very simple. It is a direct reaction against *the films that have scenarios and stars. [Artists' films] offer* imagination *and* play *in opposition to the commercial nature of the other kinds of films. That's not all; they are the painters' and poets' revenge.*

Revenge for the commercial abuse of the medium, no doubt. Revealing more of his reasoning, Léger added:

The idea of putting a novel on the screen is a fundamental mistake, connected to the fact that the majority of directors have had a literary background and education.... They sacrifice that wonderful thing, the 'moving image', in order to inflict on us a story that would be better suited to a book. We end up with yet another nefarious 'adaptation' – convenient enough, but which impedes the creation of anything new.[2]

This book is about how artists fell in love with the moving image and fought on its behalf, and in the process made it their own.

What did those artists alive at the beginning of the twentieth century *see* in the moving image that so attracted them to it? Sadly, there are very few first-hand accounts of these initial impressions – whether these occurred in childhood or in adulthood – yet some distant memory of that primal scene must surely have influenced their subsequent choice of film as the medium to work with. Here at least are two. The first is offered by a student at the Bauhaus, Ludwig Hirschfeld-Mack:

I remember the overpowering impression of the first film I saw in Munich in 1912: the content of the film was tasteless and left me totally unmoved – only the power of the alternating, abrupt and long-drawn-out movements of light-masses in a darkened room, light varying from the most brilliant white to the deepest black – what a wealth of expressive possibilities.[3]

An earlier, rightly celebrated account is by the novelist Maxim Gorky, written in 1896, the very first year of cinema, when he was twenty-eight:

Last night I was in the Kingdom of Shadows...I was at Aumont's and saw Lumière's cinematograph – moving photography. The extraordinary impression it creates is so unique and complex that I doubt my ability to describe it with all its nuances.... When the lights go out...there suddenly appears on the screen a large grey picture, 'a street in Paris'; shadows of a bad engraving. As you gaze at it, you see carriages, buildings and people in various poses, all frozen into immobility.... But suddenly a strange flicker passes through the screen and the picture stirs to life. Carriages – coming from nowhere in the perspective of the picture – move straight at you, into the darkness in which you sit; somewhere from afar people appear and loom larger as they come closer to you; in the

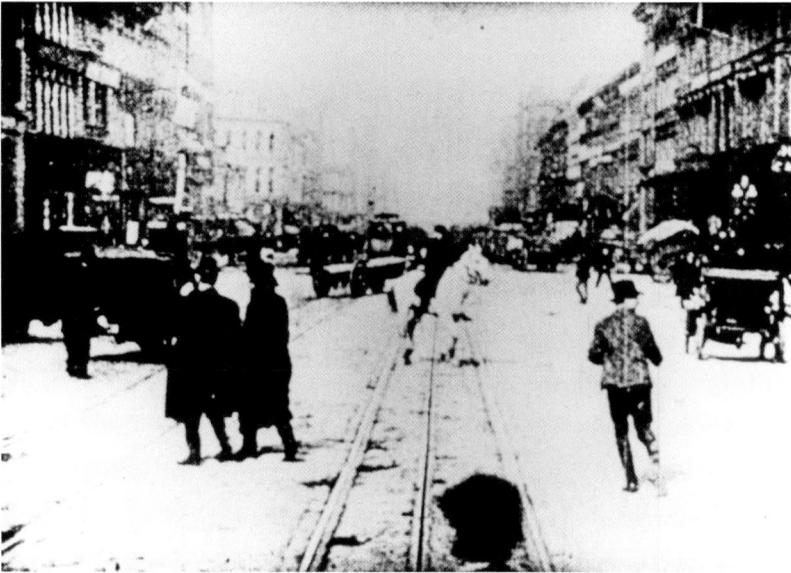

foreground children play with a dog, bicyclists tear along and pedestrians crossing the street pick their way among the carriages. All this moves, teems with life, and, upon approaching the edge of the screen, vanishes somewhere beyond it…. It is terrifying to see, but it's the movement of shadows, only of shadows.[4]

The American artist Ernie Gehr's film *Eureka* (1974) could be viewed as an attempt to recover this kind of innocent, overwhelming viewing of the projected image. Gehr had discovered a filmed street scene that was nearly contemporary with that witnessed by Gorky – a continuous shot taken from the front of a street-car travelling the length of Market Street, San Francisco, in 1905. He slowed it down variously six or eight times, allowing its astonishingly complex choreography of horse-carts, early motorcars and pedestrians to be savoured in exquisite detail, as if these moving images were being seen for the very first time. Today, most people enjoy this primal experience of the moving image as infants, rather than in adulthood, in front of a domestic television or iPad, and almost certainly in colour. But for some the memory of these primal 'shadows' may still be life-changing.

Gorky's experience was evidently heightened by a trick played by the Lumière Company projectionist, for it seems that he dramatized the moment of stillness-in-the-image when the projector lamp was lit, but *before* the hand-cranked

2 OPPOSITE Ernie Gehr, *Eureka*, 1974
3 ABOVE René Clair, *Paris qui dort*, or *The Crazy Ray*, 1926

mechanism had fully stirred into life. It's a transition from still-to-movie much loved by artist filmmakers then and now, a moment in which film declares one of its unique qualities – its roots in the still image and the freezing of fragments of time. It's a piece of cheap magic that contributes to the success of René Clair's *Paris qui dort*, or *The Crazy Ray* (1926), where much of the film consists of variations on the theme of 'time altered' – arrested, slowed-down, accelerated. (In the story, this is city life responding to the influence of a mad scientist's time-controlling 'crazy ray' beaming down from the Eiffel Tower; in reality, it was just Clair having fun with film-speed.) Its opposite – the effect of a moving image encountered in a context of stillness – is what makes Chris Marker's *La Jetée* (1962) so effective. In a film composed entirely of still images, there occurs one brief instant of near-movement when, in close-up, a woman appears to blink.

For some early spectators, Lumière's cinema also offered the extraordinary phenomenon of seeing one's own image in movement, and as others see us, not reversed as in reflection; or of seeing the immediately familiar surroundings of the local high street, as photographed perhaps earlier the same day, doubtless by the very person now operating the projector. This shock of recognition – of an unfamiliar aspect of the familiar – is still available to us today in our first encounter with a video camera or camera-phone. Film's power to reveal different aspects of the individual experience has given force to the work of recent generations of artists with different voices and from different cultures who are concerned with 'self' and identity.

Within twenty years of its birth, the moving image had become predominantly associated with 'fiction', and it remained so until cinema's centenary. As popular cinema established itself, a 'language' of narrative film developed in which rules dictated how one shot should follow another if the storyline was to be clear. The camera operator should maintain eye-line match (so people appear to look at each other), direction-match (of movement within the image, so that one knows 'where things are going'), and should respect the different roles of close-up, wide-shot and long-shot. Similarly, the editor should further the progress of the storyline as smoothly and unobtrusively as possible; editing should be invisible, not draw attention to itself. But artists have little time for such conventions. They often *welcome* editing's visible punctuation of the material presented, embracing its rupture of the flow as a reminder to the viewer to 'keep awake', to 'watch for what happens next'. Jean Cocteau, hardly the most formally

3

radical of artist–filmmakers, nonetheless spoke for many when he declared:

my primary concern in a film is to prevent the images from flowing, *[and instead] to oppose them to each other; to anchor them and to join them without destroying their impact.... It is precisely that deplorable* flow *that is called 'cinema' by the critics, who mistake it for style.*[5]

So determined have some artists been 'to prevent the images from flowing' that they have formulated strict rules to govern the pattern of editing, to give a dominant rhythm to their films. Jean Epstein recalled:

In the days of silent films, when speech had not yet subjugated the rhythm of montage to its own rhythm, we could really edit-in the rhythm that seemed cinematographically necessary to the film. Rhythm had its importance, and I made it a rule...to put together only shots that have a simple relationship between them, as in music.[6]

In reality, the needs of speech and action within the frame tended to dominate in Epstein's later films, which limited his ability to construct mathematically rigid relationships. This would also be the case in the work of Abel Gance, Walter Ruttmann, Sergei Eisenstein and Vertov, all of whom toyed with mathematical editing systems within a narrative context. But formal editing patterns do indeed dominate the work of some artists, to the extent of forming the backbone of a film. The abstract 'film music' of the 1920s and the metrical/structural films of the 1960s and 1970s are two examples of film types that are heavily dependent on exploiting strict film-rhythm.

Artists including Marie Menken, Rudy Burckhardt and Margaret Tait evolved their own unconventional filming and editing styles, without reference to conventional film-language. Tait, for example, edited by simply 'following the image', her eye responding to the rhythms she perceived in the viewfinder while shooting, then allowed these same rhythms in the recorded image to dictate the length and often the order of her shots. The results may seem unpolished to an unaccustomed eye, but the viewer is soon seduced by the directness and immediacy of what she is showing. A very different artist, Robert Beavers, has theorized his own comparable approach, contrasting it with that of film industry practice:

The act of filming should be a source of thought and discovery. I am opposed to the film director's conception of theatrical mise-en-scène *in front of the camera and to the cameraman being asked to create a style for the image. By dividing the act of filmmaking between director and cameraman, the image is reduced to illustrating a preconception; whereas, in the hands of a filmmaker, the camera functions to create an image that is newly seen.*[7]

In their battle with mainstream cinema, artists have sometimes struggled against the spectator's apparently inbuilt need to read a narrative into any edited sequence of images when viewed onscreen. Wim Wenders was shocked to make this discovery while editing his first film, *Silver City* (1969), which was conceived as a landscape study consisting of just eight static cityscape shots of three minutes each: 'I didn't move the camera; nothing happened. The shots were like the paintings and watercolours I'd done previously'. Yet he found that the unplanned intrusion of a running figure in one shot immediately set up narrative expectations. People anticipated 'action' in all subsequent shots, and looked for narrative links between them. 'That wasn't what I wanted.... I have always been more interested in pictures; the fact that – as soon as you assemble them – they seem to want to tell a story – is still a problem for me today.'[8] When artists edit, they sometimes deliberately frustrate the 'easy' connections; or when they accept them, they exploit this expectation in order to make narrative links that surprise and disturb.

The possible total *absence* of editing has also appealed to some artists. For them, the vitality of the uninterrupted film or video record mirrors the absorbing stare or unprejudiced gaze of daily life. The amateur technology of early video in fact made editing impossible – if you stopped and restarted a recording, the video-image would 'tear' and lose stability – and so artists discovered the delights of monologues delivered straight to camera, and long uninterrupted takes recording otherwise ephemeral performances. But rather more radically, as early as the 1930s, Léger – who *did* have a very real interest in editing, manifest in his one realized film *Ballet mécanique* (1924) – apparently speculated about the potential of the unedited view, and proposed *24 Hours*, a film 'in which ordinary people with ordinary jobs are investigated with a sharp but concealed eye for all those hours'. It would record 'work, silence; banal everyday intimacy and love. Project such a film – unadorned and without any control – and you will realize how dreadful

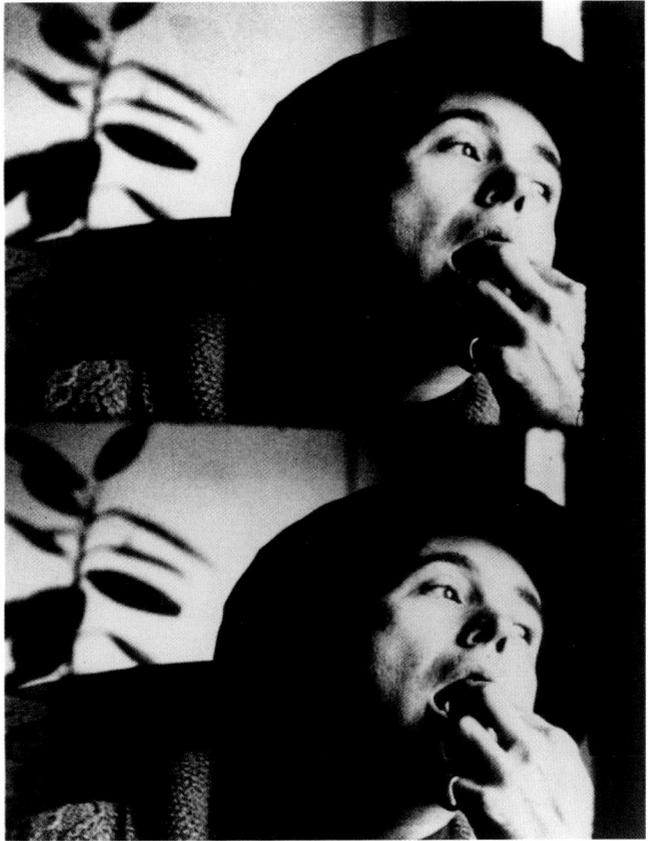

4 Andy Warhol,
Eat, 1964

and disquieting is the unembroidered truth'.[9] Though he
never pursued this 'dreadful' vision himself, his proposal
surely anticipated the films of Andy Warhol, who loved long,
uninterrupted takes full of 'silence; banal everyday intimacy',
as in *Eat* (1964), his portrait of the artist Robert Indiana eating
a mushroom, observed in silence for forty-five minutes (the
'dreadful and disquieting', voyeuristic 'reality' television shows
such as *Big Brother*, which began in 1997, also come to mind in
this context). Of this period of his filmmaking, putting a more
positive spin on such voyeurism, Warhol remarked:

> I made my earliest films using, for several hours, just one actor on
> the screen doing the same thing: eating or sleeping or smoking; I
> did this because people usually just go to the movies to see only the
> star, to eat him up, so here at last is a chance to look only at the
> star for as long as you like, no matter what he does, and to

4

eat him up all you want to. [He adds, winningly,] *it was also easier to make.*[10]

James Benning is among the many other artists who love the long take, as his fellow filmmaker Nicky Hamlyn has noted: 'most of his landscape films consist of long single takes – which have got longer since he switched to digital recording, e.g., *Ruhr* (2009), which has a single shot of seventy minutes.'[11]

For and Against 'Experiment'

One characteristic that has become associated with artist filmmakers is their alertness to the non-obvious uses of any moving image technology. Pioneer George Méliès, writing in 1907 about his own introduction to the magic of cinema, describes how he accidentally discovered the technique that revealed the film camera's invaluable ability to tell lies:

One day, when I was filming as usual at the Place de l'Opéra, the camera I used...jammed and produced an unexpected result. It took a minute to disengage the film and to make the camera work again [and] during this minute, the passers-by, a horse-trolley and the vehicles, had, of course, changed positions. When projecting the film re-joined at the point of the break, I suddenly saw a Madeleine-Bastille trolley-bus change into a hearse, and men into women.[12]

The whole field of animation and fantasy cinema derive from this discovery.

'Experiment', like 'innovation', is a feature of both artist's cinema and the narrative mainstream – through it is arguably more plentiful among artists. Some artists, such as the animator Len Lye, saw every new film they made as a challenge to try out some new technique, and the history of artists' film is littered with inspired one-off experiments that sometimes lead nowhere, but occasionally produce artworks that are satisfying in themselves. An example of the latter is Michael Snow's camera-mount designed to allow 360-degree continuous movement, used in *La Région Centrale* (1971), discussed on p. 111. Such inventions are eccentric, essentially timeless and unrelated to other contemporary developments. Other technical innovations do indeed represent 'progress' – such as the invention of sound technology, widely adopted from 1929, and colour film, which was widely available from the early 1930s. Artists were often among the first to explore their potential, sometimes leading and often exceeding the

60

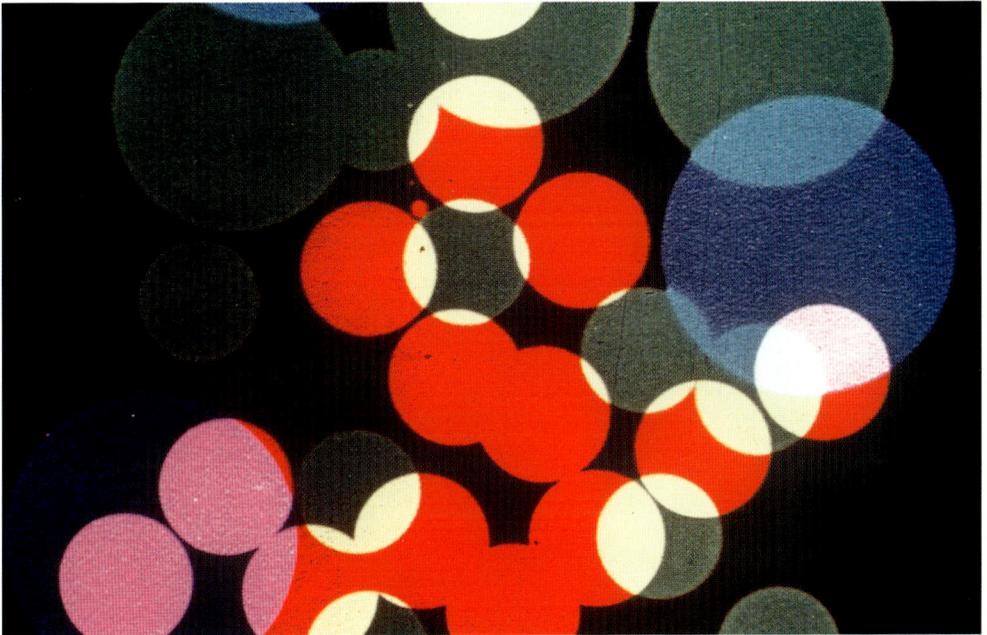

5 Oskar Fischinger, *Kreise* (*Circles*), 1934

commercial industry's achievements. (Was there ever a more
ecstatic use of colour than Oskar Fischinger's abstract film
Kreise (*Circles*, 1934) probably the first full colour film seen
in Germany, an experiment supported by the Gasparcolor
factory?) But among artists, ideas are more often recycled
and reappraised endlessly.

The very idea that experiment is an essential part of artists'
film was – and still is – widely debated. Cocteau, writing before
he had made any films himself, saw experimentation with
technique as being something that would uniquely distinguish
artists' film: 'I want disinterested artists to exploit perspective,
slow motion, fast motion, reverse motion, [to reveal] the
unknown world onto which chance often opens the door'.[13] His
own *Le Sang d'un poète* (*The Blood of a Poet*, 1930, discussed on
p. 139) benefited from many such camera tricks, and his fellow
artists have obliged him in every decade. Extensive use of
time-lapse shooting gives the early landscape films of William
Raban and Chris Welsby, such as *River Yar* (1972), their unique
atmosphere, as its opposite, extreme slow motion, dominates
in the video installations of Bill Viola.

On the other hand, Cocteau's near-contemporary, the
writer, actor and occasional filmmaker Jacques Brunius, was

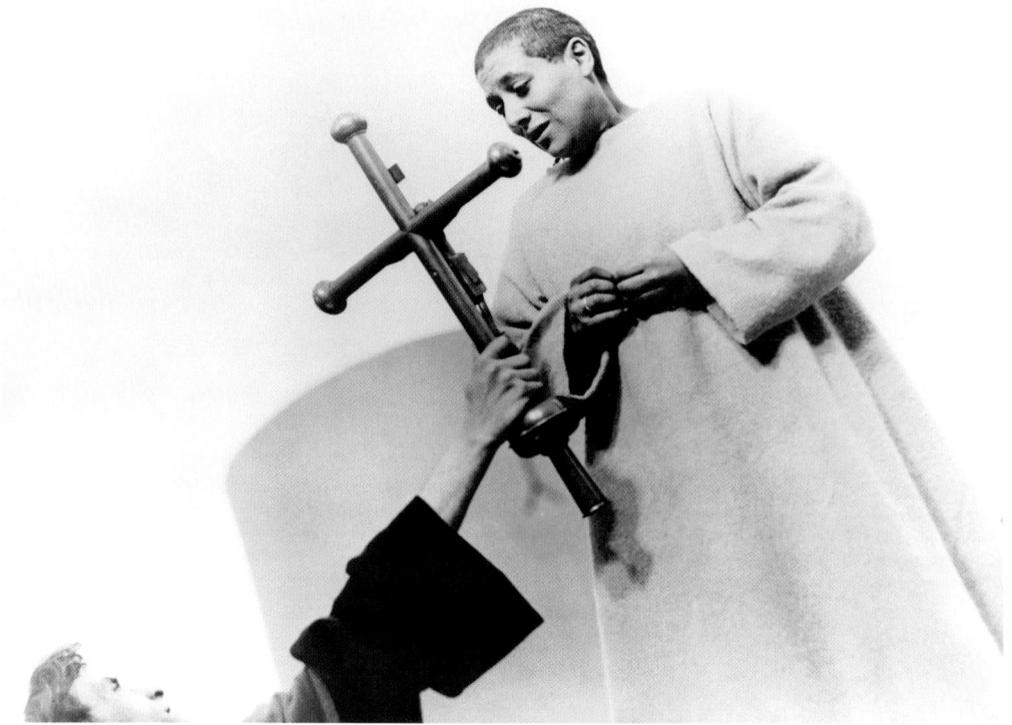

6 Carl-Theodore Dreyer, *The Passion of Joan of Arc*, 1928

contemptuous of such camera tricks and issued a stern rebuke to his French peers:

Fast editing?...*by trying to make it signify whatever they liked, they abused it, speeded it up to the point of rendering it painful.* Superimpositions? *Squandered as well. In* Le Diable dans la ville *(1926) Germaine Dulac doubles up the images under the pretext of describing a character's violent emotion....* The cricking *[tilting] of the camera is another of this school's inventions which has since known a regrettable vogue. Thus in Carl-Theodore Dreyer's* The Passion of Joan of Arc *(1928) this mania...results in rendering the topography of the scene and the positions of the characters absolutely indecipherable....* Deformations *[camera-lens distortions] were equally in favour.... Germaine Dulac, who had a weakness for this technique and who used it to abuse it, utilized it once with relative success in a scene in* Gosette *(1924) about the effects of drunkenness.... As for the use of* soft focus and gauze,

the least said the better. Everyone tries without rhyme or reason to rival Turner or Claude Monet.[14]

Brunius's message is clear – camera tricks alone don't make an artists' film!

Earlier, Epstein, one of those accused by Brunius, had boldly suggested how a single strategy might form the defining characteristic of a film. In 1921, he wrote a deliciously over-the-top response to the 'American' close-up, implying that – taken on its own – it could be subject enough for a film:

A head suddenly appears on screen...I'm hypnotized. The drama is now anatomical. The 'décor'...is this corner of a cheek, torn by a smile.... Muscular preambles ripple beneath the skin. Shadows shift, tremble, hesitate. Something is being decided. A breeze of emotion underlines the mouth with clouds. The orography of the face vacillates. Seismic shocks begin. Capillary wrinkles try to split the fault. A wave carries them away. Crescendo. A muscle brindles. The lip is laced with tics like a theatre curtain. Everything is movement, imbalance, crisis. Crack. The mouth gives way, like a ripe fruit splitting open. As if slit by a scalpel, a keyboard-like smile cuts laterally into the corner of the lip.[15]

So he continues. Here, Epstein anticipates the slow-motion filming of his own *La Chute de la Maison Usher* (1928) and the near continuous close-ups of Dreyer's *The Passion of Joan of Arc* (another accused by Brunius), but even more so the slowed-down, fixed-camera close-up portraits of Andy Warhol's *Screen Test* series (1964–66) and perhaps most exactly Yoko Ono's 333 frames-per-second close-up portrait of John Lennon, *Film no. 5 (Smile)* (1968), in which – during its fifty-two minutes of scrutiny – the mouth does indeed 'give way, like a ripe fruit'.

Antonin Artaud, responsible for the Surreal scenario of Dulac's *La coquille et le clergyman* (*The Seashell and the Clergyman*) (1927), extolled the role of spontaneity and the unconscious in his approach to film-making: 'We know that the most characteristic and the most striking virtues of the cinema were always, or almost always, the result of chance, that is, a kind of mystery whose occurrence we never manage to explain'.[16] And while Brunius's contempt for double exposures and superimpositions may have been shared by many mainstream film directors, Sergei Eisenstein and innumerable artists since have relished their power. Here, for example, Eisenstein describes the effect of a double-exposure in *Strike* (1924), where he 'wanted to create the effect of sound and music through purely plastic [visual] means', this still being the era of silent film. In a double-exposure, he

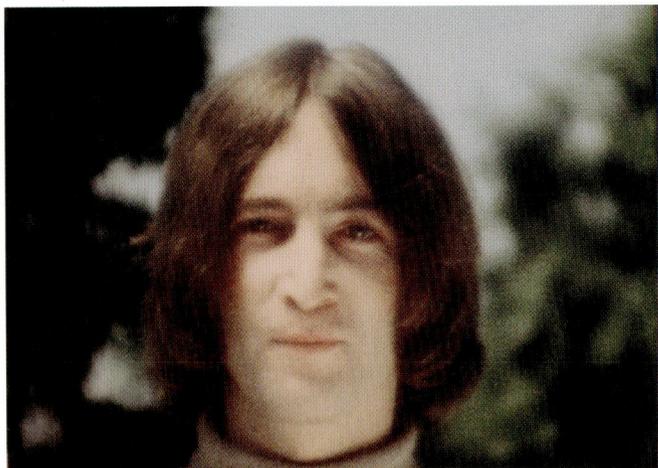

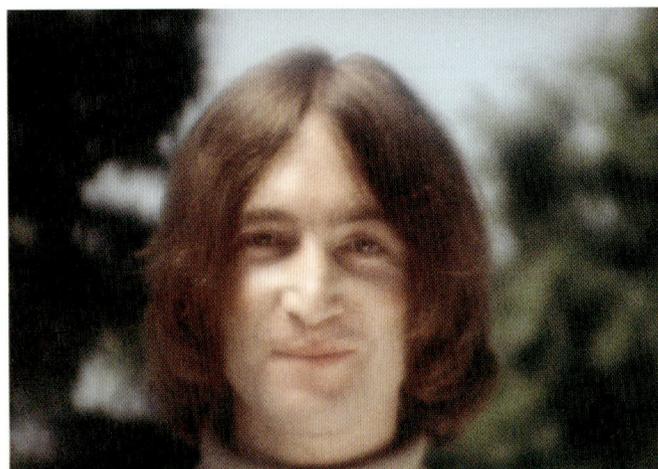

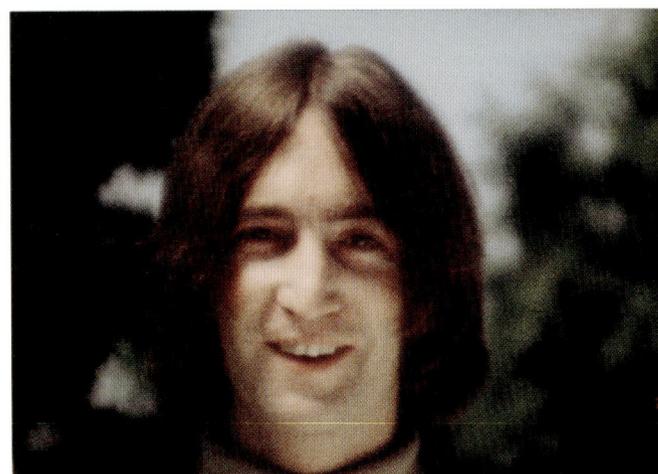

7 Yoko Ono, *Film No. 5
(Smile)*, 1968

shows striking workers attempting to disguise their illegal meeting as an innocent gathering to listen to music:

In the first exposure a pond could be seen at the bottom of the hill, up which were moving towards the camera a throng of strollers with their accordion. The second exposure was of the huge accordion in close-up, filling the entire screen with its moving bellows and highlighted keys. This movement, seen from different angles, over the other continuous exposure, created the full sensation of a melodic movement, which drew together the whole sequence.[17]

Eisenstein's use of superimposition is typically deterministic, planned and calculated in effect, with little left to chance. Later artists have been much more relaxed in their usage, combining images simply to indicate various elements currently in play, or to construct broad metaphors. Stan Brakhage's superimpositions in *Song I* (1964), his silent 8mm portrait of his first wife, Jane, is an example. In this, he used double-exposure extensively, to suggest his awareness of Jane's interior life. He passed the entire film through the camera three times, welcoming chance combinations but also calculating the placement of key images:

Song I *is 'Portrait of Jane'…just as she sits around the house and reads. As I see her sitting and reading. I knew I had to get something of the sense of what her world was like to her, so I kept track of the footage numbers as I ran the film through the camera for the first time; then I went back and laid-in two levels of superimposition. I tried to do it very subtly, to give some sense of the passage of the world through her mind's eye, as it was imagined in* my *mind's eye, of what she was thinking and doing. It was a mystery to me what this woman that I loved was doing when she was so much in her own world – reading, sitting by herself. Not to presume more in what she was actually thinking about, but only to put myself in it enough to say, well, here are rocks that pass through her mind and that I know she loves so much, and here is her parent's shadow moving, and so on.*[18]

The film is, of course, as much a portrait of him as of her.

The unpredictable nature of the act of double-exposure was at the core of Tacita Dean's vast, vertical-format projection work *FILM* (2011), created for Tate Modern's Turbine Hall. *FILM* was her celebration of the medium as it appeared to face extinction. Chance is a quality that she finds missing in the new world of the digital moving image:

8

*What I love most about film is the spontaneity and the
blindness. When I made* FILM*...everything was filmed inside the
camera – different shapes, objects and architecture were effectively
stencilled with light onto the emulsion, which was put through the
camera multiple times. I couldn't see what I was doing so when
I saw the results it was full of both miracle and disappointment.
Some things far exceeded what I could have done deliberately, and
that is the point – digital is too deliberate a medium for me, too
intended. It's like working with the lights on the whole time and
I am someone who craves the darkness too, and by that I mean I
solicit the chance and the accidental.*[19]

Curiosity has made many artists challenge and interrogate the
technology associated with filming and projection – again,
looking for *other* ways of using it. They have literally taken
apart cameras, projectors, video monitors and display screens,
laid bare their workings or rebuilt them according to their
own design. This may be seen as a do-it-yourself riposte to
the commercial cinema's relentless search for technical
improvement in its pursuit of greater realism, but more usually
the artist's purpose has been simply to see the potential that
commercial cinema has neglected to uncover. Sometimes it has
been a case of looking backwards to revisit the first cinematic
principles, even 'redundant' technologies, as if looking to
reconnect with what is essential to the moving image.

Modernist décor

Though a defining characteristic of artists' film throughout
its history has been its dissatisfaction with the conventions
of cinema's storytelling mainstream, in the early years some
artists were content simply to transform the look of the
story–film; to make it appear new by applying a Modernist
veneer in the form of painterly décor and costumes. Only
later, through experiments with editing, and in the wake of
examples offered by Modernist novelists such as Joyce and
Woolf, would artists find ways of making narrative more
appropriate to the film medium. As a result, while these early
films are visually striking, the conventions of melodrama and
the acting styles remained typical of the silent-period film. An
example is Anton Giulio Bragaglia's *Thais* (1917). Often cited as
a Futurist film, it was based on a novel by Anatole France about
an artistic courtesan, Thais Galitzy, her friend Bianca and her
many well-heeled lovers. Bragaglia employed the painter and

8 Tacita Dean, *FILM*, 2011

photographer Enrico Prampolini to design the set for Thais's studio, but the film is otherwise utterly conventional in acting style and editing. Prampolini's blurred time-lapse photos, *Fotodinamismo Futuristica* (1911–12), were wonderfully suggestive of movement and unquestionably Futurist, but in *Thais* he was confined to creating a series of jazzy patterns on Thais's studio walls, contributing little but a visual exoticism to the romantic melodrama. Did Bragaglia really hope that this set alone would allow his film to live up to the Futurist vision? Perhaps the Futurist composer Luigi Russolo's original score, now lost, added a properly discordant element? When Prampolini attended the momentous meeting of avant-garde filmmakers at La Sarraz in 1929, he would have seen the more formally experimental narratives of Dulac, Eisenstein and others, and must surely have felt seriously out of his depth. By then, he was involved in Aeropainting: modern subject matter but, again, hardly Modernist language.

9 Marcel L'Herbier's *L'Inhumaine* (1923) is another conventional melodrama embellished by Modernist sets – this time by not one but four distinguished artists and designers. Fernand Léger created the fabulous laboratory of 'the scientist'; the architect Robert Mallet-Stevens designed the grand facades of the protagonists' homes; Alberto Cavalcanti and Claude Autant-Lara (soon to be directing their own films) designed the stylish interiors; the costumes were by Paul Poiret. Léger's set designs were so abstract that they apparently perplexed the set builders, and he had to supervise construction himself; but their static quality and the film's overall lack of dynamism may have helped prompt the decision to make his own film, *Ballet mécanique*, where – at last – wheels turned purposefully, human action could be made to look as mechanical as that of machines, and the spectator could be made to do some work making sense of it all. As he produced his designs for L'Herbier, Léger wrote of his admiration of the editing of sections of Abel Gance's *La Roue* (1920–24), which depended, as he saw it, on seeing things as a collage of fragments: 'choose your image well, define it, put it under the microscope, do everything to make it yield up its maximum potential; you'll have no need for text, description, perspective, sentimentality or actors'.[20] The sets for *L'Inhumaine* were indeed remarkable, though perhaps best appreciated when shown in the form of designs and photographs at 'L'exposition de l'art dans le cinema Français' at the Musée Galleria in 1924, rather than in a cinema. Here they were presented alongside images from *La Roue* (with projected film clips, according to some accounts), and they reached an

9 Marcel L'Herbier, *L'Inhumaine* (*The Inhuman Woman*), 1923

10 Robert Weine, *Das Kabinett des Dr Caligari* (*The Cabinet of Dr Caligari*), 1919

even wider audience when reproduced in Mallet-Stevens's sumptuous book *Le Décor au Cinéma*, published in 1928.

A less clear-cut case of success or failure as a landmark Modernist film narrative is Robert Weine's *Das Kabinett des Dr Caligari* (1919), noted for its extraordinary Expressionist sets, costumes and make-up. The film's storyline concerns a doctor-cum-hypnotist-cum-showman and his somnambulist exhibit Cesare, who seemingly 'predicts' a death, but may also be a murderer – or is the doctor the murderer? It's a story with enough twists and confusions to make it an engaging narrative puzzle. One can see in *Caligari* an early attempt to depict an individual's subjective experience – an aspiration that would come to dominate the more recent history of artists' film. But as in *L'Inhumaine*, the shooting style and acting are essentially conventional, and it is largely the décor that offers opportunities for divergent readings. Writing at the time, Blaise Cendrars recognized this weakness, and published a rich denunciation:

I do not like this film. Why?
Because it's a film based on a misunderstanding.
Because it's a film which does disservice to all modern art.
Because it's a hybrid film, hysterical and pernicious.
Because it's not cinematic.

He lists its cinematic shortcomings:

The pictorial distortions are only gimmicks (a new modern
convention); Real characters placed in an unreal set
(meaningless);.... There is movement but not rhythm....
all the effects are obtained with the help of means belonging
to painting, music, literature, etc.; nowhere does one see [the
unique contribution of] the camera.

His final objection (here admitting to a modicum of sour
grapes): *It does excellent business.*[21]

Innovative or clichéd, rhythmic or not, *Caligari* did indeed
do excellent business, to the extent that its Expressionist sets
were slavishly copied by avant-gardists at home – notably
in Karl Heinz Martin's *Von morgens bis mitternachts* (*From
Morn to Midnight*, 1920), a film about the mental torments
of an embezzling bank clerk, and abroad, in Robert Florey's
ambitious amateur production *The Loves of Zero* (1928), one of
the first films of the American avant-garde. Similarly, there
are many celebrated feature films from the silent period
that benefit from ambitious architectural sets. Hans Poelzig,
architect of the astonishing Grosses Schauspielhaus in Berlin,
designed the gothic–medieval (almost Middle-Earth-style)
sets for *Der Golem* (1920) while Aleksandra Ekster designed
extraordinary constructivist sets and costumes for Yakov
Protazanov's *Aelita* (*Queen of Mars*, 1924), her vision of the
Martian queen's exotic realm.

This desire to marry the moving image with an avant-garde
visual style established in painting perhaps has its happiest
expression in the realm of animation, a medium that even
in the digital age is defined by the artist's ability to draw,
and through drawing to establish a coherent visual style
from which everything else flows. The Expressionist human
figures in Bertholde Bartosch's *L'Idée* (1932) are based on the
book of woodcuts of the same name by Frans Masereel (1920),
and, being hand-drawn (or hand-cut from card), are liberated
from acting conventions; figure and background are as one.
This tradition of graphic film Expressionism has continued
throughout the decades and includes works such as Alexandre
Alexeieff and Claire Parker's *Une nuit sur le mont chauve* (*A*

11 Kara Walker, *Testimony: Narrative of a Negress Burdened by Good Intentions*, 2004

Night on the Bald Mountain, 1933), Vlado Kristl's *Don Kihot* (*Don Quixote*, 1961), Walerian Borowczyk's *Le Théâtre de Monsieur & Madame Kabal* (1967), Peter Foldès early computer-assisted line animation *Hunger* (*La Faim* 1974) and works by the Quay brothers, Susan Pitt, Jay Bolotin and many more. In all these examples, it is the individuality and force of the artist's graphic line that gives the films their power.

Such animation has often reflected political struggles. Bartosch's *L'Idée* was itself a call for respect for freedom of thought, made at a time of rising fascism; more recently, Kara Walker (in the USA) and William Kentridge (in South Africa) have each developed variants of Bartosch's shadow-play, used in their gallery-presented works to dissect the corruption of society by slavery and the oppression of Black people. Their use of articulated puppets (and sometimes live figures) set against intricate cut-out backgrounds could be seen as an ironic revisiting of the silhouette technique pioneered by Bartosch's

mentor Lotte Reiniger in Germany in the 1920s – as seen in the exoticized imagery of her dazzling Arabian Nights fantasy *Die Abenteuer des Prinzen Achmed* (*The Adventures of Prince Achmed*, 1926). Where Reiniger set out simply to divert, Walker and Kentridge are also determined to disturb; to insist that as viewers are being entertained, they should also think about what they are seeing.

Novelty films

Another avant-garde storytelling model widely adopted by artists in the silent period was what might be called 'the novelty narrative' – works in which a conventional-enough story is seen from an oblique or deliberately limited viewpoint, or according to an arbitrary set of rules. One of the earliest of these is Marcel Fabre's *Amor Pedestre* (*Love Afoot*, 1914). In close-up, we see the feet of three people as they act out an adulterous affair, the fun being our necessary imagining of what is happening 'up above'. The film is often cited as the only filmed record of a Futurist 'reductionist performance'.[22] Closely related to this was Filippo Tommaso Marinetti's 1915 theatre performance *Le Basi* (*Feet*), where the curtain rose successively to waist-height to reveal a series of utterly disconnected one-event scenes mocking bourgeois life, again only visible from a radically reduced perspective. Marinetti's version surely represented the greater provocation, but Fabre's seems to have been the more widely noticed, and certainly spawned endless imitations.

Two films made in Germany in 1928, both called *Hände* (*Hands*), similarly tell stories or illustrate themes by focusing on one body part to the exclusion of the rest. *Hände: das Leben und die Liebe einess Zärtlichen Geschlechts* (*Hands: The Life and Loves of the Gentler Sex*) made by American photographer Stella Simon with Miklós Bándy, is the more ambitious of the two, and is perhaps the first artists' film to focus exclusively on dance. A cast of many hands and arms performs a ballet in several movements – *Prelude, Variations* and *Finale* – with the hand-protagonists dancing through Expressionist-influenced miniature sets, accompanied by a Modernist score for four-hand mechanical piano by composer Marc Blitzstein. The other *Hände*, made by the anti-fascist documentary maker Albrecht Victor Blum, is more prosaic; almost a catalogue of hands and their activities, starting with a baby's hands, then its mother's; hands sowing seeds, playing cards, arranging flowers, cutting grass and so on. A similar film, *Ruce v úterý* (*Hands on Tuesday*, 1935), by the Czech team of Čeněk

12 Peter Fischli and David Weiss, *Der Lauf der Dinge* (*The Way Things Go*), 1987

13 Walerian Borowczyk, *Renaissance*, 1963

Zahradníček and Lubomir Smejkal, recounts a day in the
life of an office worker, his fantasies, love life and all, shown
exclusively through his hands. The commercial film industry
has perpetuated this reduced approach to narrative in feature
film title sequences, where the mix of written text and live-
action footage represents a rare moment of license to present
stylish, self-contained visual mini-narratives, sometimes
taking themes from the film's plot and re-presenting them in a
condensed form (a pop-culture relative of the opera overture).

More recent artists have adapted the 'novelty narrative'
form to create works that feature a single theme or procedure.
Such novelties occupy a place somewhere between the avant-
garde and the mainstream, making them the most likely
artists' films to be seen widely. Examples include Walerian
Borowczyk's *Renaissance* (1963), which uses reverse motion to
depict various household objects that have been destroyed (a
table, a prayer book, a stuffed owl and a doll) reassembling
themselves into a stuffy bourgeois living room, only to be
destroyed again when the last object (a hand grenade) is
completed – a rare example of a novelty film with darker
overtones. A simpler piece is the witty *Der Lauf der Dinge* (*The
Way Things Go*, 1987) by assemblage artists Peter Fischli and

David Weiss, in which the camera tracks through the artists' studio and witnesses a chain-reaction of 'accidental' events. Each perfectly plausible but utterly improbable action triggers the next – fire burning through string, water filling a pot, sand pouring from a punctured bag and so on – the fascination being the animation of normally inanimate objects without apparent human intervention. Fischli and Weiss effortlessly sustain this game for more than half an hour, keeping the viewer guessing as to what might happen next. Television commercials have slavishly imitated this film (of course without acknowledgement).

A modern master of the single-technique film is Zbigniew Rybczynski, whose *Tango* (1980) is an exhaustive catalogue of the various repetitive activities that might take place in a nondescript domestic room. As activities repeat, they progressively accumulate and seamlessly co-exist in both time and space, having been collaged optically at the film-printing stage so that they all miraculously 'fit' around each other and into the cramped space – a comment, no doubt, on life in the congested apartment blocks of Poland at that time. In *Nowa Ksiazka* (*A New Book*, 1975), another variant of Rybczynski's habitual deconstruction of time and space, we watch nine separate images arranged in three rows, in which seemingly unrelated activities take place in domestic and urban spaces – a flat, the street, a bus, a café. The camera is sometimes static, sometimes moving. There is no initially obvious temporal or spatial connection between the nine images, until we notice a lone figure in a red hat and coat weaving his way from the top left image to the bottom right, then back again – exiting one image and immediately entering the adjacent one – his passage proving the apparent temporal unity of the whole: a man making his laborious way to take delivery of his new book.

Christian Marclay's *Telephones* (1995) is an example of the closely related single-theme film – in this case, a collage of readily recognizable clips from classic Hollywood movies in which leading characters interact with (old-style) phones, their encounters ordered by task: they reach for the phone, it rings, they respond (surprised, alarmed, expectant); they answer it again with a variety of responses, they ring off...what happens next? It doesn't matter. The theme's the thing, identifying the movie and its star the added fun. Marclay's greatest success has been *The Clock* (2010), another montage of archival clips from feature films, documentaries, amateur footage and even some fellow artists' films. The novelty this time is the film's twenty-four-hour length and the fact that somewhere in every image is a timepiece showing the 'actual' time of day (or night) of one's

14

14 Christian Marclay, *The Clock*, 2010

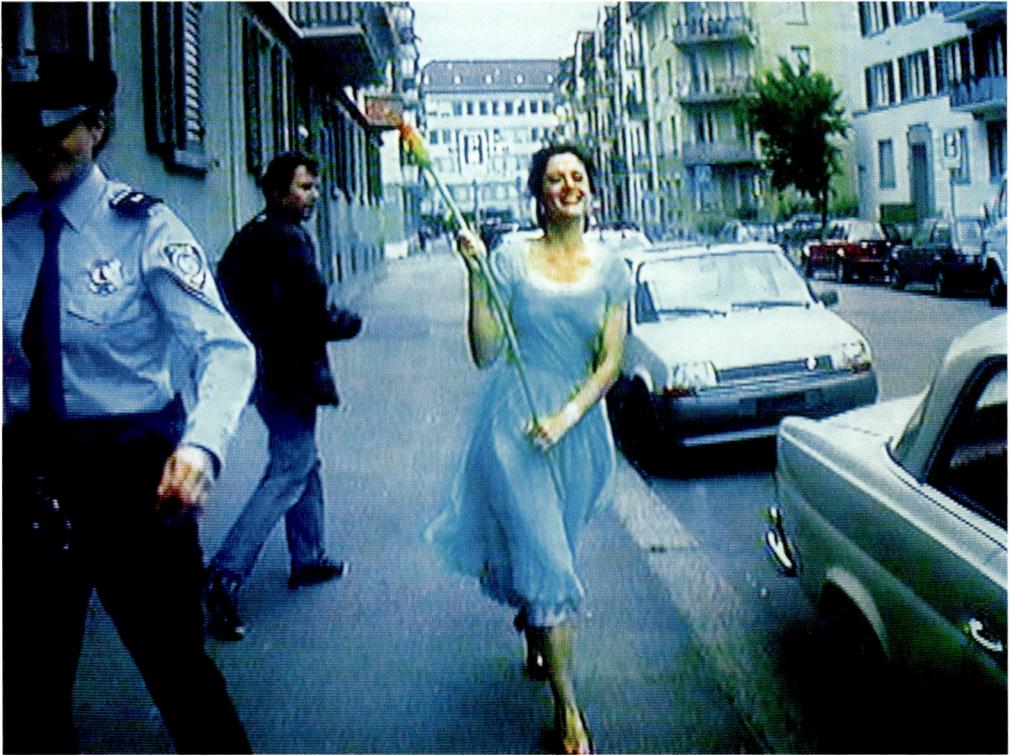

15 Pipilotti Rist, *Ever is Over All*, 1997

viewing. Endlessly engaging, it should be installed in every
airport waiting lounge as a public service.

More daringly, and in a return to first cinematic principles,
artists have proved that a single shot can provide a wholly
satisfying form for a film. Such works take their strength from
the fact that one inspired thought or heightened observation
is embedded in a single uninterrupted take; something is seen
and seized. An example from the 1960s, *All my Life* by Bruce
Baillie (1966), consists of nothing more than a continuous
camera movement across a rose-covered fence and up a rose-
entwined post, set to Ella Fitzgerald singing the song that
gives the film its title. Humour, a sense of play, a pure *jeu
d'esprit*, is at the root of many of these works, as exemplified
by Pipilotti Rist's *Ever is Over All* (1997), in which the camera
follows the artist (and an attendant, smiling policewoman) in
slow motion as she strides down a street, gleefully swinging a
sledgehammer-flower and smashing the windows of a line of
parked cars; a joyously anarchic state of mind given physical

15

expression. Others are remarkable as examples of virtuoso camera-choreography. The artist Tony Hill has made a career of designing handcrafted rigs that allow his camera to perform astonishing feats – such as rolling head over heels through the landscape in *Downside Up* (1984). The pleasure in these works is that of being taken by surprise by the unconventional viewpoint, with the reward of successfully working out what is going on. This is filmmaking at its simplest; all of its strength lies in its conception.

The 'self-mocking loop film' is another variety of novelty film, particularly suited to gallery installation. In Rodney Graham's short *Vexation Island* (1997), a Robinson Crusoe-like character (Graham himself) wakes up on a tiny desert island, realizes that a coconut in the solitary tree above him is his only hope of sustenance and shakes the tree to dislodge it. The coconut falls on his head and knocks him out; he wakes up again and the film loops like a recurring nightmare. Similarly, his *City Self/Country Self* (2000) has a dandy collide with a labourer (both played by the artist) in the streets of eighteenth-century Paris (actually the perfectly preserved centre of the town of Senlis). The fop kicks the worker's backside, the two repeating their encounter *ad infinitum.* The futility of hope? The inevitability of social inequality and class hatred? One is offered literally countless opportunities for speculation as to its meaning. Such novelties obviously appealed to early film-club audiences, and they continue to appeal to the art world today; they are an easily digestible form of the artists' film.

The pre-Second World War filmmaking described in the next three chapters shows artists involved in a series of dialogues: with painting, music, the documentary movement and cinema's mainstream. Cumulatively, it laid the groundwork for the diverse field that is artists' filmmaking today.

Chapter 2
The Music of Light

The power of…light-masses in a darkened room, light varying from the most brilliant white to the deepest black – what a wealth of expressive possibilities[1]

<div align="right">Ludwig Hirschfeld-Mack</div>

From Painting to Film

In the early years of the twentieth century, many painters saw potential links between the abstract compositions they were making on canvas and paper, and the new, still relatively untried medium of film. Movement, so often implicit in their painted abstract shapes – the way the eye is led from one motif to another, the way one coloured form seems to advance or recede in relation to another – could surely be more fully explored through film. Music seemed to suggest one model; Chinese scroll-painting another. In some early experiments, artists used animation cameras to laboriously photograph a series of drawings on paper, one frame at a time, each image incorporating tiny changes from the previous one, as if watching a painting evolve in extreme slow-motion, while others more boldly and experimentally painted designs directly onto the clear celluloid film-strip.

Among the first artists to attempt to make moving designs were the Italian Futurists Bruno Corra and his brother Arnaldo Ginna. In 1910, after some abortive experiments filming programmed lights, they made their first hand-painted 'study of effects' derived from the sequencing of complementary colours – *Studio di effetti tra quattro colori*. This is their description of its opening:

[It is] the simplest one could imagine. It has two colours only, the complementaries, red and green. To begin with the whole screen is green, then in the centre a small six-pointed star appears. This rotates on itself, the points vibrating like tentacles and enlarging until it fills the whole screen. The entire screen is red, and then unexpectedly a nervous rash of green spots breaks out all over it. These grow until they absorb all the red and the entire canvas is green. This lasts a minute.[2]

They apparently painted several such reels; they mention a colour composition, *Accordo di colore*, based on a painting by Giovanni Segantini, and also interpretations in colour of Mendelssohn's *Canto di Primavera* (*Spring Song*) and Stéphane Mallarmé's poem *Les Fleurs*. These films no longer survive – the hand-painted originals were possibly projected until they fell apart, there being no mechanical way to make faithful colour copies at the time. But their titles already suggest the kind of analogies with music and dance that would come to characterize many later abstract films, developed through the work of Viking Eggeling, Walter Ruttmann, Oskar Fischinger and Norman McLaren, and the 'musical' live-action abstract works of Germaine Dulac, Francis Bruguière and many others.

We don't know in what way Ginna and Corra mapped out the overall shape of their films, and their paint-on-film technique was not explored again until Len Lye re-invented it in the 1930s, but another painter of the pre-First World War period, Léopold Survage, has left us very complete evidence of his compositional method, though he never got as far as putting his work under the camera. Survage developed his *Rythmes colorés pour le cinema* (1912–14) as a series of nearly 200 paintings, in which it is possible to see large abstract elements grow or diminish across a number of images. Survage was clear about his purpose:

Rythmes colorés *is in no way an illustration or an interpretation of a musical work…it is an art in itself, even if it is based on the same psychological realities as music…. The fundamental element in my dynamic art is coloured visual form, which plays a part analogous to that of sound in music.*[3]

These paintings are clearly very preliminary ideas; some even adopt a vertical format, as if Survage had forgotten cinema's already firmly established horizontal frame, and there is no indication of how one sequence might lead to another. This didn't prevent his friend, the poet Blaise Cendrars, from vividly imagining their impact as if he had actually seen the film:

16

16 Léopold Survage, *Rythmes colorés pour le cinema* (*Coloured Rhythms*), 1912–14

Looking at [the imagery] one would think that one was taking part in the very creation of the world. Little by little, red invades the black screen and soon fills one's whole circle of vision. It is a sombre red, rough and wrinkled like seaweed. It is made up of a close-knit multitude of little scales. Each scale comprises a pimple which trembles softly and ends by cracking like cooling lava. All of a sudden, the red weed divides itself down the middle....[4]

Probably the earliest surviving abstract film was made by Walter Ruttmann in Germany, and dates from 1921. Like

Survage, Ruttmann had been trained as a painter, and his *Opus 1 (Lichtspiel Opera 1)* was literally a painting – executed on a glass sheet and altered frame-by-frame beneath the animation camera. The image is lit from below, with cut-out shapes sometimes superimposed, forming silhouettes, as when two sharp triangles poke in from the screen-edge towards the painted, softer, rounded forms. Ruttmann added colour later by toning (dyeing) and directly painting onto the film-strip, and the whole piece was accompanied by the live performance of a Bartók-like score by his friend Max Butting, which generally reflected the film's rhythms. *Opus II, III* and *IV* (1921–25), which followed, show Ruttmann developing a language of forms with ever greater assurance and technical sophistication. *Opus III* contains motifs created by introducing masks under the glass sheet, and included 3-D objects seen in silhouette above, while circular shapes intrude from the sides of the screen. *Opus IV* is a brilliant study of rhythm created almost entirely from horizontal and vertical stripes, formed with hard-edged cut-outs rather than painted shapes. Ruttmann funded his experiments by patenting his animation system and making a number of more conventionally animated advertising films, which also had the benefit of making him fluent in aspects of film language such as timing movement within a shot and editing together differently paced sequences. As a result, his *Opus* series has the surest sense of visual rhythm of all the abstract films made before Oskar Fischinger's *Studies*, without the latter's dependence on the familiar accompanying recorded music. Ruttmann's understanding of film-rhythm paved the way for his well-received and influential documentary *Berlin, Symphony of a Great City* (1927); he was to go on to make Nazi propaganda films.

One of the most ambitious of the early abstract films was *Diagonal Symphony (Diagonalsymfonin*, 1924), the only surviving film by the Swedish painter Viking Eggeling. Eggeling had moved to Berlin in search of like minds, and found one in the person of Hans Richter, who helped him develop much of his initial thinking about an abstract language of film. Whether or not it justifies its title's claim to be a visual 'symphony', Eggeling's silent film is musical in a number of ways. He establishes a series of visual themes, followed by sections in which these motifs – collections of straight lines, bars and half-moon shapes – are variously combined, opposed to each other, enlarged and diminished, developed and recapitulated. Beginning with a scroll of drawings, Eggeling adopted a variation of Ruttmann's method of using a lightbox on which

to animate the artwork. Instead of drawing his motifs, he cut them as stencils from tinfoil, which, when laid on the illuminated surface, allowed the cut areas to appear under the camera as sharp white shapes on black. He altered these 'drawings' a frame at a time by sliding a mask over parts of them to make the lines grow or shrink, then combined the resulting images through superimposition, which involved running the film through the camera again and again. His assistant Erna Niemeyer recalls: 'Quite often the whole working process had to be repeated because the winding-back of the film [to create a superimposition] had been unsuccessful – and to open the camera and see a whole roll of film drop out was extremely disappointing.' [5] In this way, Eggeling was able to combine different motifs in his picture track, rather as a composer today might collect different voices through multi-track recording; he was essentially constructing the film equivalent of musical chords.

Hans Richter stuck with paper animation – but his second film attempt, *Rhythmus 21*, has the boldness of an artist returning to basics, as if he were declaring 'the screen is a rectangle; I'll stick to lines and rectangles'. The film consists simply of the play of black, white and grey regular shapes – squares, rectangles and broad lines – cut from paper and pinned to the picture plane, and hence to the screen. Through frame-by-frame animation (and a lot of scissor-work), they grow, shrink and move across the screen rhythmically. Richter showed at least part of this work at the notorious Dada *La Soirée du Coeur à Barbe* in 1923 as *Film Abstrait*, but by the time he showed it in London at the Film Society in 1927 he had doubled its length by inventively splicing in a copy of the film's negative. In this extended version, one sees the same movements but in reverse, with the black now white and vice-versa, a laboratory-made dissolve smoothing the transition.[6]

The mid 1920s saw several notable one-off attempts to make similar short abstract works. At the Bauhaus, students Werner Graeff and Kurt Kranz planned short, silent films that surely related to Bauhaus design exercises, though these were not completed at the time. Graeff's *Kompositions 1/22* and *2/22* (*c.* 1922) were drawn as sequences in which squares recede, advance and overlap (as in Richter), and were eventually put under the camera by the artist in 1977. Kranz's scroll *The Heroic Arrow* (1930) is a play of arrows and lines, its imagery surely reflecting Bauhaus tutor Paul Klee's enthusiasm for directional graphic notations in his paintings.

17 ABOVE LEFT Walter Ruttmann, *Opus IV*, 1925
18 ABOVE RIGHT Viking Eggeling, *Diagonalsymfonin (Diagonal Symphony)*, 1923–24

Music-led Abstraction

The introduction of sound technology to film at the end of the 1920s tempted many artists to base their work on existing musical recordings. Germaine Dulac was among the first artists to edit live-action imagery in direct response to an existing piece of music. This is how she introduced her (still silent) film *Étude cinématographique sur une arabesque* (1928):

On hearing the second Arabesque *by Debussy...I had my own vision of the earth turning, revitalized by the sun, a vision of flowers, of sap rising, of water-jets jumping and falling, of joy, of rebirth, of physical well-being. I have chosen visual rhythms to compose a 'cinematographic ballet' made from the seventh art's material base, that is to say of movement, light, forms and their associations.*[7]

In her *Thèmes et variations* (also 1928), she sought 'a sort of correspondence of rhythms attempting to provoke a simple pleasure of the eyes, without story; the movement of machines, movements of a dancer, a cinematographic ballet'.[8] Dulac moved on to undertake other kinds of film-experiment, but once established, this form of live-action music-film has never lost its popularity. Often, the artist's chosen music was itself a response to an earlier visual stimulus, so finding appropriate film images completed a virtual circle – as in Jean Mitry's *Pacific 231* (1949), which synchronized its images of steam trains to the orchestral composition of the same title of 1923 by Arthur Honegger, itself a response to train travel.

At the end of the 1920s, the German animator Oskar Fischinger achieved a wide cinema release for his music-led abstract films, and with it an unprecedented degree of popular recognition. He described his works variously as 'motion painting' and 'visual music', terms which have since become widely adopted when describing this field. Fischinger was one of those rare filmmaking artists whose most interesting work was the result of systematic experiment – the trying-out of different techniques that allowed him to explore different ways of constructing dynamic visual sensations onscreen. These included the cataloguing of techniques in his *Wax Experiments* (1921–26) and his Surreal silhouette fantasy *Spiritual Constructions* (1927), made using pliable modelling wax on a light-table, in which the mental battles of two drunken men are visualized in the form of continually morphing expressive shapes. (This surely would have found an appreciative audience among those already enjoying the animated anarchy of *Felix the Cat* and other American cartoons, yet it was rarely publicly screened in his lifetime). Public recognition arrived with the

19 Germaine Dulac, *Thèmes et variations* (*Themes and Variations*), 1928

20 Oskar Fischinger, *Komposition in Blau (Composition in Blue)*, 1935

Studies series (1929–32) – all animated as charcoal and graphite drawings on white paper, but shown in negative as white images on black, and, in the first years of sound, synchronized with existing popular or light classical recordings.

More visually daring and experimental were Fischinger's first works in colour, *Kreise* (*Circles*, 1934), set to bars from the *Tannhäuser* overture, *Squares* (1934, silent) and *Komposition in Blau* (*Composition in Blue*, 1935), set to bars from Otto Nicolai's *The Merry Wives of Windsor*. In *Circles*, the choreography of growing and multiplying circles – which subtly change colour as they fly in and out of the picture plane in one long unbroken movement – represents an extraordinary feat of animation, as every frame of film required the complete re-drawing and re-painting of the image. With *Komposition in Blau*, Fischinger daringly added three-dimensional objects to the mix; coloured

20

rods and cubes like children's building blocks stack up and un-build themselves amid two-dimensional artwork in mutating colours. It won a prize at the 1935 Venice Film Festival, and Hollywood beckoned. The remainder of Fischinger's life was spent in America, and became a painful mix of high expectations and dashed hopes. He worked very briefly in turn for Paramount, MGM and Disney, all unhappily, and his best films, such as *Radio Dynamics* (1942) and *Motion Painting No. 1* (1947), were mostly either rescued from abandoned commercial projects or entirely self-generated. The silent *Radio Dynamics* was one of Fischinger's most inventive works in terms of its range of visual motifs, being at the same time more condensed and more compositionally unruly than any of his previous films. Similarly, the late *Motion Painting No. 1* remained experimental in its approach and its doggedly labour-intensive technique. Onscreen, we see an abstract painting growing, brushstroke by brushstroke, with lines and coloured areas slowly spreading across the picture surface in tiny accretions, later additions obliterating the earlier ones. The film might appear to record the spontaneous evolution of different visual ideas within the space of a few minutes, following both logical and impulsive twists and turns; in fact it is the record of a process that took months of slow-motion painting, performed directly under the camera, remembering what had gone before and responding to it, with no possibility of Fischinger changing his mind, since looking back could only happen when the entire length of film in the camera had been exposed. 'I worked nine months [on it]', he said, 'without seeing a piece of it'.[9] He finally abandoned filmmaking and turned to painting – creating abstract 'musical' compositions and even a series of stereoscopic paintings. Experimental to the last, he sold little, and survived largely through the support of his wife Elfriede, whose modest earnings kept them alive. But the sustained level of visual invention in his films set a benchmark for group of West Coast artists who followed him – Harry Smith, the Whitney brothers, Jordan Belson and Hy Hirsh.

If Fischinger's most direct impact was on artists in California, the popularity of the *Studies* series, which continued to be shown in Europe, meant that his influence was felt there too. Norman McLaren remembered seeing his 'first abstract movie', *Study 7* set to Brahms's *Hungarian Dance No. 5*, while at Glasgow School of Art in 1935. In London, Len Lye saw the same film, probably at its Film Society screening, and recalled, 'the dynamic dance of abstract light wouldn't go out of my mind....Since I didn't have any money for cameras and cels [animation celluloids], I started drawing directly on

film, in experiments that led to *A Colour Box*' (1935).[10] In the USA, the contemporary films of Mary Ellen Bute, including *Rhythm in Light* (1934, made with Melville Webber), *Synchromy No. 2* (1935) and *Parabola* (1937) equalled Fischinger's work in terms of their technical inventiveness, but similarly leaned heavily on existing light-classical recordings. Indeed, that dependence upon well-known pieces of music or classical pastiche is the weakness of the Fischinger tradition. Too often the music leads the image rather than enjoying an equal role, and rarely does it provide the invigorating sound-image counterpoint that Dziga Vertov and others advocated. Others have observed, more kindly, that Fischinger is the true father of today's ubiquitous music video.

The followers of Fischinger most likely to have met with Vertov's approval were John and James Whitney, brothers now widely recognized as pioneers of computer-based animation, who in the 1940s worked with pre-computer analogue mechanisms of their own devising to create a series of abstract works close in method to Eggeling's *Symphony*. In these early works, they composed both image and sound on an equal basis, with each component as abstract and as original as the other. In their series of *Five Film Exercises* (1943–44), the imagery is the result of a process extraordinarily close to Eggeling's. The compositions were made by moving stencils of simple geometric shapes under the camera and accumulating complex image-clusters through a process of multiple exposures and consequent superimposition. Cut-out shapes grow, shrink, change colour and transform following various patterns of permutation. The sound that accompanies these morphing shapes is startlingly new, a music of rising and descending notes and chords produced synthetically by 'drawing' on the part of the film-strip where the optical soundtrack usually resides, in this case by pendulums calibrated to create squiggly lines. These sound-designs were created in parallel with the image track, a true counterpoint. Later, in the 1950s and 1960s, John Whitney worked with early computers to animate mandala-like patterns set mostly to existing pieces of music, while James pursued a more personal language of hand-crafted abstract pattern-films, which resulted in works of real spiritual intensity. *Yantra* (1957) is perhaps his masterpiece. Though he additionally used an optical printer to solarize his imagery, he was still essentially relying on Eggeling's practice of accumulating complex imagery through repeated acts of superimposition.

21

Also on the West Coast, Jordan Belson furthered what might be called the Fischinger–Whitney project, with its aim to create the visual equivalent of spiritual journeys through the medium

21 Jordan Belson, *Allures*, 1961

of colour composition in time. In a method quite unlike that of his film predecessors, Belson created a tiny 'optical theatre' on his workbench, into which he projected light from different sources through distorting lenses and colour filters. He filmed the resultant, evolving 'mix' in real time, sometimes adding further imagery at the printing stage. We are almost back in the realm of pre-cinema colour organs, film providing a superior vehicle for accumulating and fixing a particular performance.

After the war, other European artists once again began to explore abstract colour movement. In Italy, Luigi Veronesi made a series of nine animated, Richter-like hard-edged abstractions between 1939 and 1952, of which *Films Nos 4 & 6* (1949), were shown at the Knokke festival in 1949 and won a prize for their use of colour. Also in Italy, the designer Bruno Munari made *I colori della luce* (*The Colours of Light*, 1963) and a rhythm-based piece, *Tempo nel Tempo* (*Time is Time*, 1964). The former was the result of experiments in the extraction of pure colour out of light refracted from crystals and polarized surfaces, and was edited in tandem with music especially composed by Luciano Berio – another rare example of an equal sound and image partnership.

In Paris in the 1950s, the American painter-turned-animator Robert Breer initially adopted Richter-like principles, animating flat, coloured paper cut-outs and lines in his series *Form*

22 Robert Breer,
Recreation, 1956–57

Phases 1–4 (1952–54). In a more experimental vein, he went on to make films that tested the spectator's ability to make sense of compositions that changed entirely between one frame and the next. As he wrote:

I exposed six feet of film one frame at a time, as is usual in animation, but with this important difference – each image was as unlike *the preceding one as possible. The result was 240 distinctly different optical sensations packed into 10 seconds of vision. By cementing together both ends of this film to form a loop, I was able to project it over and over for long periods. I was surprised to*

discover that this repetition did not become monotonous because the eye constantly discovered new images.[11]

In *Recreation* (1956–57) and *Blazes* (1961), he further explored this phenomenon, adding variations within the basic pattern of repetition. He then returned to first principles with the brief, semi-figurative, morphing line animation *A Man and his Dog Out for Air* (1957), surely his homage to the 'every line in motion' delights of *Fantasmagorie* (1908) by the animation pioneer Emile Cohl. There followed a sequence of films in which he intercut fragments of stream-of-consciousness narrative with bursts of rapid-fire abstract movement. The resulting *69* (1969), *Swiss Army Knife with Rats and Pigeons* (1981) and *Bang* (1986), are among the most visually inventive and original of artists' animations.

In Poland in the 1950s, where the work of Lye and Fischinger would certainly have been known, but their American successors would not, artists Mieczyslaw Wáskowski and Andrzej Pawlowski developed their own highly experimental ways of creating colour abstractions. Both used a mix of recorded light-projection and superimpositions. Wáskowski's *Somnambulists* (*Somnambulicy*, 1957) featured splashes, brushstrokes and flowing liquids, anticipating the live projected lightshows of a decade later. Pawlowski's *Cineforms* (*Kineformy*, 1957) additionally employed time-exposures that turned solid forms into spectral clouds that evolved and morphed, with rhythm added by rotating mechanical forms seen in layers of superimposition.

Moving towards the twenty-first century, it has become increasingly rare to find artists prepared to engage with the labour-intensive method of frame-by-frame re-drawing associated with Fischinger and the early films of the Whitneys. Almost universally, computers have taken over the hard slog of calculating the tiny incremental movements within the image that characterize the process of animation – a digital revolution spearheaded by John Whitney, Stan VanDerBeek and others. But a few have persisted with analogue methods. The Dutch artist Joost Rekveld is one, and his ongoing series of abstract coloured-light compositions are made using a variety of extraordinarily complex techniques, often resembling those of the Whitneys, but directed to very different ends. As in the early work of Fischinger, his imagery results from an experimental approach to technique, each film becoming an exploration of a different form, including filming light-points (as the Corra brothers had apparently attempted), multiple-exposures to accumulate imagery (as in Eggeling and Whitney), hand-painting (as in Lye) and moiré patterns, kaleidoscopes,

23 Joost Rekveld, #3, 1994

diffraction lenses and time-lapse (as in Belson). Even so, his work is distinctive and instantly recognizable. A remarkable early work is *#3* (1994), 'a film of pure light'[12] in which he recorded the movements of a tiny light-source with extremely long exposures, to 'draw' traces on the film-emulsion. The resulting morphing, colour-changing 'objects' perform un-rhythmic but hypnotic movements in a sea of darkness.

Painting on Film

One characteristic of the imagery made by painting on the film-strip is that brush-marks, however smoothly applied, make the painted areas appear to flicker or 'boil' when projected. This is an effect that the Corra brothers would have had to contend with, and was generally considered a defect in contemporary hand-coloured live-action films. But two artists working simultaneously in Britain in the 1930s recognized that this unstable flickering gave the image a life and energy of its own, and developed an artistic language that exploited this effect.

Len Lye and Norman McLaren both received vital support in the form of commissioned advertising films from British government agencies such as the General Post Office and Empire Marketing Board. This allowed them to experiment with film *and* to have their work publicly exhibited to an extent that few other artists enjoyed in the pre-war years. Lye's talent was encouraged by the poet Robert Graves, who recognized the largely self-taught New Zealander's close understanding of Maori and Aboriginal art, especially its basis in visual rhythm and ability to give expression to imagery from the unconscious. For Lye, movement was the portal through which an individual might access the life-force. He believed that through visual empathy his films and later kinetic sculptures would help viewers to achieve a state of 'individual happiness now'.[13] He accepted with good grace the compromise that his films should carry sales slogans by their sponsors – *A Colour Box* (1935) for the Post Office parcel service, *Kaleidoscope* (1935) for Churchman's Cigarettes and *Colour Flight* (1937) for Imperial Airways. Each of these films was hand-painted directly onto the film stock, with the additional use of spray-painting and stencils, to produce bold shapes that chase each other across the screen and perform in counterpoint to the equally vigorous and rhythmic jazz recordings he chose to work with.

Lye's inventiveness was not limited to painting on film. He was working at a time when colour film was still a novelty, and in Technicolor's complicated three-strip process he saw an opportunity for his own creative intervention. The Technicolor

camera simultaneously exposed three separate black-and-white negatives through colour filters, then required a process of lithographic printing to reassemble a full colour image. In his films *Rainbow Dance* (1936) and *Trade Tattoo* (1937), Lye composed the three records separately, allowing him to create an extraordinary collage of live-action and hand-stencilled imagery. After turning his hand to kinetic sculpture for many years, Lye returned to making marks directly on the film-strip in his last two films, *Free Radicals* (1958; revised 1979) and *Particles in Space* (1979). Working with black-and-white 16mm film, he simply scratched marks into the black film-strip using a variety of different mark-making tools. This fierce calligraphy, sometimes a jagged line, sometimes a single intense squiggle or chorus of squiggles, sometimes a field of dots, was created in counterpoint with syncopated African drums; the effect is mesmerizing and as visceral as a heart-beat. No artist has understood rhythm better.

Norman McLaren was, for many years, better known than Lye, and is often seen as the father of hand-painted film, largely owing to the effective promotion and sponsorship of his work by the National Film Board of Canada from 1941 until his death in 1987. McLaren was 'discovered' by John Grierson while making hand-painted films as a student at Glasgow School of Art, and was invited to work at the Post Office. There

24 RIGHT Len Lye, *A Colour Box*, 1935
25 BELOW Len Lye, *Rainbow Dance*, 1936
26 OPPOSITE Norman McLaren, *Hen Hop*, 1942

he made mainly live-action films, and only seriously resumed hand-painting when he emigrated to New York during the Second World War. The conjoined films *Dots* and *Loops* (both 1940) were made as calling-card pieces for Fischinger's patron Baroness Rebay, in the hope of further commissions. In them, McLaren's joyful dots and squiggles are accompanied by sounds made by mechanically reproducing the very same marks in the soundtrack area of the filmstrip, an innovation he explored again later in *Synchromy* (1971). Rebay bought two prints – presumably for a good price, for McLaren then made *Stars and Stripes, Boogie Doodle* and *Scherzo* (all *c.* 1940) hoping for more sales, but in vain. They were eventually released by the National Film Board of Canada.

In Canada, his numerous hand-drawn films, such as *Hen Hop* (1942) and *Fiddle de Dee* (1947), became dominated by a mix of whimsical figuration and abstraction, perhaps encouraged by the example of Paul Klee's inclusion of swirls, star shapes and childlike tree forms in otherwise abstract paintings. More experimentally, McLaren used stop-motion to make his rightly celebrated anti-war parable *Neighbours* (1952), in which two friends allow themselves to become mortal enemies through the escalation of a minor disagreement. McLaren coined the term 'pixilation' to describe this frame-by-frame live-action technique, which allows the combatants to hover intriguingly above the ground as they do battle (the actors had to jump into the air as each frame was shot).

26

Like the Whitneys, Harry Smith was inspired by contact with Fischinger, but his own film work remained little known until the mid-1960s, eclipsed by his work as a collector and cataloguer of American folk music and blues. His astonishing hand-painted films and collage animations, now collected together as *Early Abstractions* (1946–57), only came to light when Jonas Mekas, a fellow resident at New York's Chelsea Hotel, persuaded him to have 16mm copies made for distribution by the New York Filmmakers Cooperative. Smith had originally worked on 35mm film (as had Lye and McLaren), in which each individual frame is roughly the size of a thumbnail, just large enough to paint on when using an eyeglass. Smith developed his own method of batik stencilling – drawing motifs in wax, flooding the frame with colour that left the waxed areas blank, then washing off the wax and filling in the now-blank areas with a different colour. He often repeated this process, to build layers of design within the film frame; and of course it had to be repeated frame after frame, slightly modifying the image each time, to create movement and change within the composition.

Few artists since have equalled or even attempted to emulate Smith's astonishingly labour-intensive hand-work on the frame. A number have taken Lye and McLaren as their inspiration, adopting a freer approach to mark-making on the film-strip. Distinguished among them are Patricia Marx, Marie Menken, Cioni Carpi, Margaret Tait, Vicky Smith and Kayla Parker. José Antonio Sistiaga, a Spanish artist, knew nothing of Lye or Smith's work, but was sufficiently inspired by McLaren to attempt hand-painted animation on a heroic scale. Where McLaren's hand-painted animations are just a few minutes long, Sistiaga's wholly abstract *Ere Erera Baleibu Icik Subua Aruaren* (the title is meaningless, 1970) fills an astonishing seventy-five minutes, and comes close to equalling Smith's work in terms of visual intensity. Silent, created on 35mm film and designed for big-screen projection, the film progresses through a sequence of 'movements' in which different colours and textures predominate, following not so much a musical programme as the equivalent of an epic journey through a range of different natural environments. His equally impressive *Impresiones en la alta atmósfera* (*Impressions from the Upper Atmosphere*, 1988–89) bears a dedication to the painter Van Gogh – presumably the inspiration behind its intense colour.

Photograms and Light Sculpture

Another means of directly working on the film-strip involves making photographic images from shadows alone, without

27 Harry Smith, *Early Abstractions*, 1946–57

the intervention of any form of camera or lens, a process that creates photograms (or, when made by Man Ray, 'Rayograms'). Apart from Ray, artists associated with the technique – used most widely in still photography – include the Themersons, Lye and Moholy-Nagy, and it is still very much alive today in the hands of Vicky Smith and others. In 1926, Moholy described the process as 'light-composition':

Light is allowed to fall on to a screen (photographic plate, light-sensitive paper)...through objects...[or] can be deflected from its original path by various contrivances.... The technique of the process consists in fixing a differentiated play of light and shadow.[14]

The technique featured prominently in Stefan and Franciszka Themersons' now-lost advertising film *Apteka* (*Pharmacy*, 1930), a film of strangely luminous chemist's vessels, animated by moving shadows and superimpositions, which was reconstructed in 2001 by Bruce Checefsky following clues left in surviving still images, and also in *Zwarcie* (*Short Circuit*, 1935), also now lost, which was composed in close collaboration with the twenty-two-year-old composer Witold Lutoslawski (marking his professional debut). The first section was a frame-by-frame transposition of Lutoslawski's sound textures, while in the second the procedure was reversed, the composer having to match existing images with his sound, giving each its own musical note. These lost Themerson films are among the most tantalizing artistic casualties of the Second World War. But more than a hint of their power survives in the form of the recently rediscovered *Europa* (1930/32), their interpretation of Anatole Stern's Futurist poem, in which their imagery of a Europe hurtling towards self-destruction combines with the memorable graphic design of the original's printed text. It is also evident in the two films they made after escaping to England – *The Eye and the Ear* (1944–45), an almost didactic response to four songs by Karol Szymanowski, and *Calling Mr Smith* (1943), a passionate call to fellow citizens to condemn the ongoing Nazi atrocities while determinedly reclaiming the beauty of the German music of Bach and Beethoven.

While teaching at the Bauhaus, Laszlo Moholy-Nagy was also responsible for introducing another approach to light composition, based on the live filming of mechanically produced light patterns. In 1936, he described the origins of his kinetic sculpture, *Lichtrequisit* (*Light Space Modulator*, 1922–30):

I dreamed of a light apparatus, which might be controlled either by hand or by an automated mechanism by means of which it would

29 Stefan and Franciszka Themerson, *The Eye and the Ear*, 1944–45

be possible to produce visions of light, in the air, in large rooms, on screens of an unusual nature, on fog, vapour and clouds.[15]

This vision inspired both his polemical writing about projection in the book *Painting, Photography, Film*, and his sole abstract film, *Ein Lichtspiel: schwarz weiss grau (A Lightplay: Black White Grey*, 1930), which is based on the sculpture's performance. He filmed the *Modulator*'s rotating form, the interplay of light and polished chromium surfaces, its perforated sheets and glass balls, and further complicated and enhanced the imagery by superimposition and the inclusion of negative imagery to create a dense, spatially complex, ever-changing composition.

Did Moholy-Nagy encourage his Bauhaus students to research the work of the colour-organ pioneers Thomas Wilfred, Alexander Wallace Rimington and others, or were these artists rejected as part of a discredited Romantic past? The latter seems likely, as the light-plays designed by Kurt Schwerdtfeger and Ludwig Hirschfeld-Mack certainly share Moholy-Nagy's

28 László Moholy-Nagy, *Ein Lichtspiel: schwarz weiss grau* (*A Light Play: Black White Grey*), 1930

Modernist insistence on 'light as light', entirely free of any suggestion of synesthesia. Schwerdtfeger's deliberately prosaically titled *Reflektorische Farblichtspiele (Reflected Colour-Light-Play*, 1921–23) was originally conceived for performance at one of the Bauhaus Lantern Festivals. Only black-and-white still images survive from these performances, but these and the coloured footage from a 1960s reconstruction suggest that their imagery was probably inspired by a series of watercolours made by Paul Klee at the Bauhaus, such as *Reifendes Wachsturm n71* (*Ripening Growth*), *Stufung Rot / Grun n.102* (*Red / Green Gradation*) and *Fuge in Rot n.69* (*Fugue in Red*), all based on 'gradations' of colour (Klee's term) and executed around 1921. In these, overlapping, morphing shapes move across the picture plane in degrees of decreasing tone and subtle, additive colour combinations. Hirschfeld-Mack, discussing the very similar, if more regimented, forms in his own *Farbenlichtspiele (Coloured Lightplay 1924)*, acknowledged his debt, though somewhat dismissively: 'Look at the painting of Kandinsky or Klee: all the elements for actual movement – tensions from plane to plane to space, rhythm and musical relationships are present, [but] in outmoded painting'.[16] The mechanically changing shapes in the Bauhaus light performances were limited to smooth evolutions along predictable planes, but had the attraction of a sharpness of image, intensity of colour and the undeniable appeal of 'live' movement. A sense of how these performances might have looked can be gained from those of the machines constructed in the USA in the late 1940s and 1950s by Charles Dockum, who independently made what he called 'Mobilcolor Projectors' along very similar lines, at one time with the support of Baroness Rebay.

The association of electric light with mechanical movement is also prominent in Czech director Otakar Varva's *Světlo proniká tmou* (*Light Cuts the Darkness*, 1930), which took as its 'modulator' an illuminated abstract construction made by kinetic artist Zdeněk Pěšánek, mounted on the roof of the Edison Transformation Station in Prague – a notable example of the enthusiastic embrace of Modernism by Czech artists. Pěšánek had earlier designed a 'colour piano', and Varva's film incorporates imagery of fingers on piano keys, perhaps alluding to this, alongside a complex montage of imagery derived from the sculpture, and primitive light bulbs, pylons, sparks and unrolling wires, much seen in negative and superimposition, as in Moholy-Nagy's film. In the same year, the American photographer Francis Bruguière, working in London with the critic Oswell Blakeston, made *Light Rhythms* (1930), a remarkably pure abstract film based on the interplay of moving light and

30

30 Francis Bruguière, *Light Rhythms*, 1930

shadow on static paper 'sculptures'. A diagrammatic score determined both the choreography of light movements and the number of levels of superimposition, the latter used (as in Moholy-Nagy's *Light-play*) to add density and spatial complexity to the image. This little-known work, sadly the only one of its kind by Bruguière, has a surviving Modernist score for two pianos by Jack Ellitt, the equal of its remarkable visual track.

In the post-war period, such music–image explorations become part of the oft-intertwined early histories of computer-based art and electronic music. One can see Moholy-Nagy's influence in films made in France by the Hungarian-born Nicolas Schöffer, featuring kinetic metal sculpture and the play of coloured light and shadow. Some, such as *Fer Chaud* (*Hot Iron*, 1957) with music by Yannis Xenakis, and *Spatiodynamisme* (1958) were made initially as light-play sculptures, the films an afterthought; others, such as *Variations Lumindynamiques* (1961, and later versions in 1974) solely with film in mind. But by the early 1960s, the oscilloscope and video feedback had taken over as sources of sound-related movement – with notable examples

31 Mary Ellen Bute, *Abstronic*, 1952

31 by Mary Ellen Bute (*Abstronic*, 1952), Lutz Becker (*Horizon*, 1966)
and Willhelm Bernhard Kirchgässer. Kirchgässer's *Pentagramm*
(1959–62), 'an electronic film' made with the assistance of the
broadcaster Westdeutscher Rundfunck, was shown at the
avant-garde hothouse of the International Modern Music school
at Darmstadt, and was synchronized to the music *Zyklus for
One Percussionist* by one of the school's star pupils, Karlheinz
Stockhausen.

Chapter 3
'To Discover and To Reveal' – Artists' Documentary

To discover and to reveal – that is the way every artist sets about his business. All art is, I suppose, a kind of exploring. Whether or not it's true of art, that's the way I started filmmaking. I was an explorer first, and a filmmaker a long way after

Robert Flaherty[1]

The term 'documentary' was probably first linked with film by John Grierson, the impresario of Britain's pre-war documentary movement, when reviewing the depiction of landscape and the way of life in the South Seas in Robert Flaherty's narrative idyll *Moana: A Romance of the Golden Age* (1926).[2] Grierson could have had little conception that 'documentary' would later be associated with a branch of artists' filmmaking, though one hopes he might have taken pleasure from the continuing focus on *real* events and *real* people, and that his unspoken command that 'this is something to think about' is still firmly embedded in most artists' works.

Today, artists' documentary takes many physical forms. At its simplest, it may be a single-screen work made for cinema, the gallery and occasionally television; at its most complex, a multi-screen installation made for the gallery. Most observe Cocteau's injunction that editing should '*prevent* the images from flowing'; in other words, that the work should offer a collage of images and ideas rather than a smooth didactic narrative. Most also forego any spoken commentary, requiring the viewer to make the connections. Perhaps the characteristic that most clearly distinguishes artists' documentary is an acknowledgement of subjectivity in the work's making. Implicit, sometimes even explicit in the work is some form of the statement 'I am (just) an artist – these are my thoughts and observations'. Luke Fowler expressed this directly while introducing *All Divided Selves*

33 Jeremy Deller, *The Battle of Orgreave*, 2001

(2012), his film about the radical psychotherapist R. D. Laing and his patients at Kingsley Hall. The film is composed of found documentary footage and what looks like home movie imagery, with no added commentary. He stated: 'What distinguishes my films from documentaries is that I'm also shining a light on myself – revealing the distortions and colourations of my own decision-making'.[3]

Examples of artists' documentary today that might surprise Grierson include: a re-enactment of an infamous clash between striking coal miners and the police, as filmed by a celebrated feature film director on behalf of a Conceptual artist (Jeremy Deller's *The Battle of Orgreave*, 2001, directed by Mike Figgis); classically composed images of decommissioned vessels being broken up, or awaiting break-up, stranded on beach in Mauritania, intercut with images of migrating birds, shown over fourteen screens and presented with sounds but no commentary in an elegy for the lives of migrant Africans lost on the way to Europe (Zineb Sedira's *Currents of Time/Floating Coffins*, 2009); a collection of interviews with sex workers, pimps and police filmed in dingy rooms in the frontier town of Dubi on the German-Czech border, interspersed with extracts from the artist's video diary, displayed across thirteen screens and monitors in a gallery (Ann-Sofi Sidén's *Warte Mal! / Hey Wait!*, 1999, the title taken from sex workers' shout to passing drivers on the road from Dresden to Prague); a single-screen portrait in

34 Ann-Sofi Sidén, *Warte Mal!* (*Hey Wait!*), 1999

newsreel footage, which deftly complicates the received image of the Northern Irish Member of Parliament Bernadette Devlin (Duncan Campbell's *Bernadette*, 2008); a reflection on human conflict at the Mexico–USA border that employs nineteen monitors, a video projector and three spaces to show a divided landscape, people waiting in improvised camps, night-vision helicopter shots of tiny figures attempting to cross the border and the artist's flatly narrated, verbatim accounts of those who succeeded and those who failed (Chantal Akerman's *De l'autre côté, fragment d'une exposition*, 2003). These are but a few of the countless other forms that artists' documentary has taken.

Simplest in every way are documentaries in which the artist does little more than make a no-frills record of aspects of his or her own artistic output. This may include the equivalent of footnotes – references to sources and inspirations – as in the case of Robert Smithson's film *Spiral Jetty* (1970), in which the artist includes images and texts that illuminate the making of his remotely sited land art work of the same name. Smithson's film can also be seen an example of the essay film, now one of the most popular of forms of artists' documentary.

Closest to scientific experiments, yet still poetic in spirit, are landscape studies that are shaped by time-lapse photography, system-based shooting patterns, or direct interaction with the elements. These diverse examples all have their origin in the documentary movement of the 1920s and 1930s.

32 Robert Smithson, *Spiral Jetty* (still from the film), 1970

35 Charles Sheeler and Paul Strand, *Manhatta*, 1921

Pioneers

One of the first documentaries to intentionally show an
artist's vision was *Manhatta* (1921), a collaboration between the
American painter Charles Sheeler and the photographer Paul
Strand. Inspired by Walt Whitman's poem of almost the same
name, *Mannahatta* (1900), which takes as its title the indigenous
Lenape name for the island, it celebrates New York's then still-
novel landscape of towering buildings in a series of superbly
framed fixed-camera images, often adopting a skyscraper-top
viewpoint, distant from life on the streets below. Almost the
only movement visible in its slow-paced shots is of smoke
curling from chimneys, tiny figures on pavements far below
and boats distantly progressing up and down the Hudson River.
The film is essentially a dialogue between these stately images
and lines from Whitman's verses, presented in the silent film as
inter-titles.

Robert Flaherty was clear that in order to 'discover and
reveal', one also sometimes had to invent; his first attempts
to film the people and landscape of the Belcher islands of

Hudson's Bay left him convinced that some events would have to be staged for the camera if a coherent account was to be given. His *Nanook of the North* (1921) documents the daily struggles of an Inuit family living with spear, sled and igloo in the snows of remote North Canada, and is the first of a series of feature-length 'ethnographic' portraits that he would make of distant peoples and their cultures, often set in the past, where he could present their way of life as free from the compromises of the present. His essential theme was human courage and inventiveness in the face of nature's extremes. In *Moana* – the film reviewed by Grierson – he reversed the balance and made a slight, fictional story upon which to hang his documentary footage – a concession, no doubt, to the context of making films for the cinema rather than the film club. In *Man of Aran* (1934), he returned to his previous model, building his portrait of a family living on the remote Aran Islands off the West of Ireland around reconstructions of activities that had often been abandoned many decades before: collecting seaweed to create soil in which to grow potatoes among the rocks, gathering birds from their cliff-nests to eat, fishing for whales in tiny boats; all features of life endured in isolation. For all its artifice, his shooting method was true to the documentary spirit in its dedication to portraying real people, not actors, and real places, never the studio.

Over a century later, a keener awareness of the dangers of exoticizing and misrepresenting other cultures has steered artists away from such over-simplistic portraits. Instead, one finds works in which artists meditate on the complexities of cultural identity in the postcolonial age. The US-based artist Trinh T. Minh-ha, speaking about her film *Surname Viet Given Name Nam* (1989), commented:

I made a film on Vietnam (my so-called native land or birth culture).... You can tell immediately by this title that a national identity is not given but construed according to circumstances and contexts.... the more you look into what you think is unique to your culture, the wider it gets. What is thought to be typically Vietnamese turns out to be not so typical after all.[4]

The particularities of a national culture are still worth exploring, but more critically. Today, artists must also inevitably acknowledge the impact of global capitalism, wars and migrations, and not least the pervasive and homogenizing influence of the moving image itself.

36 OPPOSITE Robert Flaherty, *Man of Aran*, 1934

37 Trinh T Minh-ha,
*Surname Viet Given
Name Nam*, 1989

The City Symphony

Artists' documentary as a serious reflection on contemporary life, a mirror to the experience of urban cinema-goers, arrived in 1927 with Walter Ruttmann's silent *Berlin, die Sinfonie der Grosstadt* (*Berlin, Symphony of a Great City*) opening at the Tauentzien-Palast cinema in Berlin for an extended run, with a score by Edmund Meisel and a live orchestra. Its title made clear to audiences that this was a film organized as music – one could enjoy its imagery abstractly, with different movements given distinctive themes as in the programme of a symphony. To emphasize its abstract formality, it opens with a section of animated drawn curves and straight lines (an echo from Ruttmann's earlier abstract films) evoking the rhythms of the city, which, with a change of tempo, merge into wave reflections and the rhythms of train-tracks as seen from a speeding commuter train. Hereafter, every live-action shot feels carefully composed and considered, even when showing the chaos of everyday life. The film's development follows the patterns of city life from dawn, through the working day, playtime, and then into the night; all classes at work and play, all forms of labour and entertainment, contrasts of stillness and rapid movement and a mass of daily incidents.

Ruttmann's approach to the shooting of *Berlin* was initially intuitive and responsive to what he saw, with order to be imposed only later through his editing – though the day-in-the-life template must have been ever-present in his mind as he gathered his material. He commented:

It took longer than a year to capture the many facets of [Berlin's] character in thousands of takes and minuscule snippets. With no studio, no standing sets, and under imponderable circumstances, I had to lie in wait with my tiny detective camera, always ready to pounce, submerged in the life of the city, under constant cover, lest my subjects became aware of my activities and, knowing they were being filmed, started 'acting'.[5]

In fact, three cameramen are credited in the film's title sequence, none of them Ruttmann, but his claim to have provided the vision for the film is irrefutable. Superbly shot and edited, *Berlin* provided a model followed by many artists in the next decade. Ruttmann's own interest appears not to have extended to include the social challenges of the time, not least the plight of the urban poor, who must have been ever-present during his year of observing the streets of Berlin. Perhaps this is what made it possible for him to join Leni Riefenstahl just seven years later, as the editor of her film glorifying the Nazi regime

38 Walter Ruttmann, collage for poster advertising *Berlin, die Sinfonie der Grosstadt* (*Berlin, Symphony of a Great City*), 1927

and the fascist spectacle of the Nuremberg Rally of 1934, *Triumph des Willens* (*Triumph of the Will*, 1935).

Berlin was not the first filmed study of city life. Earlier examples, surely known to Ruttmann through avant-garde film circles, included *Rien que les heures* (*Nothing But Time*, 1926), made by Alberto Cavalcanti, and *Moskva* (*Moscow*, 1927) by Mikhail Kaufman and Ilya Kopalin. Cavalcanti's film deliberately focused on the marginal people and scruffy aspects of Paris, rather than the *beau-monde* and the tourist landmarks. It anticipates *Berlin* in its 'day in the life' structure, to which Cavalcanti adds human interest in the form of micro-narratives – a prostitute wandering the night streets seeking a client; a drunk old lady staggering home – and ironic contrasts between laden market vegetable stalls and dustbins, chauffeur-driven cars and donkey carts. Perhaps following the example of photographer Eugène Atget (though his photographs were little-

39 László Moholy-Nagy, *Impressionen vom alten Marseiller Hafen* (*Impressions of the Old Port of Marseilles*), 1929

known at that time), it peers at crumbling buildings and down side alleys, showing the Paris familiar to tourists only through pale reproductions of the Post-Impressionist paintings of Utrillo, Marquet, Bonnard, Delaunay and others, as if mocking these clichéd images. Kaufman's *Moskva* has fewer artistic pretensions and cannot conceal its origin as a commissioned celebration of the modern Socialist metropolis. The film is studiously upbeat, showing the daily lives of busy, cheerful people, with little focus on work except for a glimpse of efficient public services – the post office, the telephone exchange – and leafy suburbs, the building of mass housing, a museum with peasants enjoying classical nude sculptures, the zoo, a funfair, night illuminations, grandees at work and the sights of the Kremlin. His brother Dziga Vertov's *Tchelovek s kinoapparatom* (*Man with a Movie Camera*, 1929), a work of immediate and lasting impact on the artists' documentary, made two years later, may have been in part a critique of its political blandness.

The use of the concealed camera was something that Ruttmann may have learned from Laszlo Moholy-Nagy, who made his own short Berlin portrait *Berliner Stilleben* (*Berlin Still Life*) in 1926. Five years earlier, he had written a 'sketch' for a city film entitled *Dynamic of the Metropolis*; it was never made, but remains a wonderful montage of still images, dynamic

indications and typography, published in his book *Painting, Photography, Film* (1926). As in Cavalcanti's film, Moholy-Nagy's 'still life' focuses on people and places at the margins of the city, the upper classes absent. He adopts unusual viewpoints such as an upstairs window, responding to abstract patterns in the image, enjoying things mirrored in reflections. He would return to this strategy in *Impressionen vom alten Marseiller Hafen* (*Impressions of the Old Port of Marseilles*, 1929), which observed the ways in which people inhabited the crumbling streets around the harbour: the alleyways with walls crudely propped up by great timbers, water and rubbish running down them; close-up portraits of weathered faces; a child squatting to urinate against a wall. Above all of this looms the skeletal structure of the now long-vanished transporter bridge, its workings visually explained in a few shots. More evident in his films than in his contemporary still photography was Moholy's interest in recording the ways in which people survived in such conditions. His *Grosstadt – Zigeuner* (*City – Gypsies*, 1932) documents the habits of the Sinti and Roma people living in their winter caravans beyond Berlin's bourgeois suburbs, their horse-trading and racing, bartering and fighting. A year later, making this film would have been dangerous for both maker and subjects, and indeed it was banned when the Nazis came to power.

Vertov's *Man with a Movie Camera* is another city symphony of sorts, though based not in one city but a composite of three – Moscow, Kiev and Odessa. It is a film as much about the process of its own making as about any other subject. Vertov, like Ruttmann, was able to draw on the resources of the professional industry, in his case a state-endorsed company, and he presented the world with a startlingly virtuoso display of editing, through a montage utterly unlike anything in *Berlin*. This difference is in part due to Vertov's close identification with Soviet revolutionary politics; though hardly the product of the working class himself, he saw himself as a champion of the working classes, and was committed to the struggle for their emancipation. More radically, it also reflects his philosophy of 'catching life unaware' – filming events as they happened, not as artificially staged for the camera, while simultaneously letting the audience see how cinema works as a fundamental aspect of his anti-theatrical, anti-illusionist project. Vertov's political commitment has inspired much Leftist filmmaking and especially the cinéma-verité movement of the 1960s;[6] but more importantly, his visible excitement about the un-staged, 'captured' film image has echoed down the decades in a much wider range of low-budget filmmaking by artists, where 'truth' in the image is paramount.

40 *Man with a Movie Camera* follows earlier models to the extent that it presents twenty-four hours of city life, bookended by scenes of dawn and dusk: life begins to stir, a woman wakes and washes, streets and buildings are hosed down, machinery starts, factories come to life, the streets fill with rushing trams and wagons; then later, as the working day ends, the machines stop and sport and leisure take over – notably including cinema-going. The film's opening image, a superimposition in which camera-lens and human eye become one, encapsulates Vertov's influential concept of 'the camera-eye'. Another iconic image follows, in which the tiny figure of the cameraman with his tripod seemingly stands atop a giant film camera. Later, in the day-in-the-life sequences, Vertov repeatedly interjects shots of this cameraman, his brother Mikhail Kaufman, at work. We quickly recognize that this is also the man filming the surrounding shots. The following sequences contain camera tricks, superimpositions, animation (cinema seats tip themselves down to greet arriving customers) and strange viewpoints and camera movements, all proclaiming the intervention of the cameraman and the artifice of cinema. As the film progresses, the editing becomes more prominent, and the film editor Elizaveta Svilova (Vertov's wife) is shown at work, again clearly working on the film we are watching. A sequence of Svilova wielding her scissors and holding up film-strips introduces a virtuoso montage of progressively shorter shots that recapitulate the film thus far. The film is simultaneously a celebration of city life under benign Communism and a song in praise of the joys of filmmaking, from shooting to editing through to the screening of the completed film (a sequence shows happy cinema-goers seeing themselves onscreen, as we have just seen them). This is self-referential filmmaking of a type never seen before, justifiable in the Soviet context as part of the film's mission to make everything available to the viewer; the very opposite of Hollywood's 'invisible' editing and concealment of the production process.

41 With *Entuziazm: Simfoniya Donbassa* (*Enthusiasm*, *Symphony of the Don Basin*, 1931), Vertov had the new technology of sound film to play with. His aim for the film was 'to grasp the feverish reality of life in the Don Basin, to convey as true to life as possible its atmosphere of the clash of hammers, of train whistles, of the songs of workers at rest.'[7] Made during the first Five Year Plan (1928–32), it follows the plan's three key missions: its attack on the old evils of religion and alcoholism; the drive to increase industrial production following shortages, especially of coal; and once again, the collectivization of farming. Implied but unspoken in the film is the contemporary widespread

40 TOP Dziga Vertov, *Tchelovek s kinoapparatom* (*Man with a Movie Camera*), 1929
41 ABOVE Dziga Vertov, *Entuziazm: Simfoniya Donbassa* (*Enthusiasm, Symphony of the Don Basin*), 1931

Here they could find shelter and work.

42 LEFT AND OPPOSITE
Deimantas Narkevičius,
Energy Lithuania, 2000

resistance to these initiatives by workers and peasants. For
Vertov, the film also offered an opportunity to attempt the
recording of synchronized sound while on location, something
widely believed impossible. But his film, like the Five Year Plan
itself, was a victim of local failures, with footage going missing
and a hostile reception to its first version that caused him to
radically reduce its length before its wider release. But enough
of Vertov's experimentation survives to make it an extraordinary
work: the images of sound-recording and a peasant listener's joy
at hearing its playback; the deliberately playful juxtaposition of
synchronized and non-synchronized sound; and a sequence of

42

shots of a steel blast furnace and rolling-mill in which movement and sound are choreographed into an exhilarating audio-visual composition. Vertov's optimistic vision is intoxicating; but we now know that the impact of forced collectivization was disastrous, and the failure of successive Five Year Plans led to widespread starvation. Later generations of artists working in the former Soviet Union have been able to explore the downside of this great rush for modernization. In *Energy Lithuania* (2000), Deimantas Narkevičius presents the bedraggled state of a Modernist electrical power plant – once the embodiment of Soviet revolutionary optimism – as a metaphor for failed hopes.

43 Henri Stork, *Images d'Ostende* (*Images of Ostend*), 1929

The fame of Ruttmann's *Berlin* was such that home-grown city symphonies of varying degrees of originality soon appeared in avant-garde cine-clubs across Europe and beyond. Keen to boast the virtues of other capitals, most are primarily expressions of civic pride, but some, perhaps reacting against Ruttmann's lofty detachment, display a stronger sense of the artist–maker's individual viewpoint. What unites these films is that they were almost always made without industry support and on minimal budgets, and were rarely seen beyond the film-club circuit. But with fewer financial resources came greater artistic freedoms.

One of the first in this wave of Berlin-inspired activity was a five-minute miniature by the Dutch filmmaker Joris Ivens, *Études de mouvements à Paris* (*Studies of Movements in Paris*, 1927), which observes the patterns of movement of cars and pedestrians, mostly seen at ground level, with just one overhead shot that shows how these movements interlock – a close-up of a traffic policeman revealing his role in the choreography. Ivens became an important and prolific maker of political documentaries, but only after he had released a spate of

artistic works, many made with fellow cine-club member Mannus Franken: notably *De Brug* (*The Bridge*, 1929) and the rhythmic, intimate city symphony *Regen* (*Rain*, 1929). The latter was originally silent, but later set to Hans Eisler's Modernist composition *14 Ways to Describe Rain* (1941), which it inspired.

Corrado D'Errico's day in the life of Milan, *Stramilano* (1929), has been described as a Futurist work, but, apart from a couple of oddly chosen camera angles, is no more so than any other city portrait. Henri Stork's study *Images d'Ostende* (1929) comes closer to matching the technical brilliance of Ruttmann's rhythmic editing, but it is also more emphatically an artist's documentary in that its response to the depicted place is overtly subjective and personal. It is emphatically Stork's choice of viewpoints; his perception of the spirit of place. His film turns its back on the city and faces the harbour and shoreline. Like *Berlin*, it presents its subject in a number of acts, each with its own mood: 'Harbour', 'Anchors', 'Wind', 'Foam', 'Dunes', 'The North Sea'. Its carefully framed images are linked by these themes alone, with no narrative development. Above all, the film is offered as a rhythmic composition.

There are echoes from further afield. Adalberto Kemeny and Rodolfo Lustig's *São Paulo: Sinfonia da Metrópole* (1929) shows the Brazilian city from dawn to dusk: the working class safely at work, the rich at play and the city's bourgeois architecture celebrated – ornate steel-framed offices, department stores and apartment blocks. Perhaps recognizing the need for novelty in what was already becoming an over-familiar genre, the Czech artists Svatopluk Innemann and František Pilát made *Praha v záři světel* (*Prague Shining in Lights*, 1927/8), and Eugène Deslaw his *Les nuits électrique* (*Electric Nights*, 1928), both of which celebrate the novelty of urban electric lighting; the former is also 'a night in the life of the city'. The two works mark the arrival of a type of black-and-white film stock capable of filming the jazzy dance of 'neon drawings' on storefronts, cinemas and public buildings, some of them turned into abstract patterning through superimposition and mirroring.

More radically, and possibly encouraged by Stork's embrace of subjectivity, Alexander Hackenschmied's view of Prague, *Bezúčelná procházka* (*An Aimless Walk*, 1930), heralds the modern place-study in which the personal and subjective dominate. An unnamed protagonist – clearly a surrogate for the filmmaker – acts as the medium through which we view the city, as he makes his way by tram to its outskirts. Initially, the camera is alone on the tram; the protagonist is only revealed after a few shots, when he jumps aboard. Our viewpoint then becomes his as he observes the city – details in the passing

scene, reflections, people at work, then the city giving way to suburbs. While the tram is still running, he jumps off, and now in open country, looks about him, then lies on the grass to take in the scene. Eventually, he stirs himself and walks off, but in a startling twist, also leaves a version of himself still seated. He catches the tram back, but again leaves himself standing beside the track, creating a striking visual metaphor for mental escape from the city, and a reluctant return.

After the war, as artists' studies of city life began to re-emerge, they revealed a new sense of purpose in the context of a wider reassessment of the workings of society, and the need to rebuild human values. Typical are *Aubervilliers* (1945) by Buñuel's cameraman Eli Lotar, with text and lyrics by Surrealist Jacques Prévert, and *N. U. (Nettezza Urbana*, 1948), an early work by Michelangelo Antonioni about the city's Municipal Cleansing Service. Lotar's film is a study of marginal life in 'la zone', the Paris suburb containing its refuse heaps, abandoned military fortifications, canals, factories, decrepit dwellings and shanty-towns, in which people scavenge for food and materials to recycle. Antonioni's film similarly identifies with those on the city's margins, in this case those employed to sweep the streets of Rome. On the soundtrack, he comments, 'apparently we don't care who these sweepers are and how they live, these quiet and humble workers who no one deems worthy of a word, or even a stare.... And yet, no one more than they partake in the life of the city'. They are seen visiting soup kitchens, huddled against a sunny wall as they feed. They sort rubbish in the suburbs alongside pigs similarly rooting for scraps. The uncaring bourgeoisie are visible only in the guise of a couple seen arguing in the street, he dropping torn documents into the gutter – perhaps a sign that the relationship is over, but certainly adding to the sweepers' labour. The film ends with a classic Antonioni image set at the city's edge, a lone figure wandering into the distance.

Half a century later, the city symphony is still with us in many guises; most are critical or analytical rather than celebratory and invariably defined by the artist's personal identification with the subject. Patrick Keiller's feature-length *London* (1994) might be seen as the child of Hackenschmied's *Aimless Walk*, but here the protagonist, Robinson, remains unseen as he undertakes his journeys across the city. Instead, Keiller's camera follows his wandering courses – from suburb to city centre and out again – in a succession of static, stately images. We gain Robinson's insights and reflections in voiceover only, as he ruminates on history, the effects of globalization, the 1992 General Election (when

44 Patrick Keiller, *London*, 1994

Labour failed to profit from Margaret Thatcher's fall) and the immediate aftermath of an IRA bomb in the City. Closer to the model of *Berlin*, Kahlil Joseph's *m.A.A.d.* (2014), a music video of sorts, offers a portrait of Compton, an African American neighbourhood in Los Angeles, which, as well as its predominantly Black working-class citizens, is home to a striking mix of subcultures and groups – gang members, bodybuilders, boy racers, transgender people and drug addicts – shown individually in impassive, trusting, straight-to-camera portraits, in contrast to the surrounding, spectacular shots of the urban landscape. The film was commissioned by the rapper Kendrick Lamar, who was born in Compton, and its editing follows the pulse of Lamar's similarly themed album *good kid, m.A.A.d city* (2012). Like *Berlin*, the film shows the dawn-to-dusk diversity of the area – stores, empty lots, dry canal-beds, domestic interiors, people sunbathing at a lido, a drive-through mortuary, imagery from local television, surveillance footage and helicopter shots, blurred mobile phone images of shootings and street violence. Also like *Berlin*, and despite its tough subject matter, the visual track

45

45 Kahlil Joseph,
m.A.A.d., 2014

is determinedly glamorous and seductive, the camera gliding smoothly through the scene; the film's visual elegance and formality is emphasized by the use of two screens and the occasional mirroring of imagery across them. Against this visual pleasure is set the raw, almost cynical anger of Lamar's lyrics, which offer their own reflection on the neighbourhood.

Subversion and Protest

As early as 1929, the whole city symphony genre was nicely subverted by Jean Vigo's *À propos de Nice* (*On the Subject of Nice*), which mocked the city's superficial glamour and exposed its avarice, focusing on the grotesque – the bizarre masks and giant puppets of the annual *Carnaval* and the grim spectacle of the rich bourgeoisie sunning itself by the sea. Like Vigo, the Surrealists did their best to undermine the conventional documentary's association with bourgeois self-satisfaction. Luis Buñuel's *Las Hurdes: Tierra Sin Pan* (*Land Without Bread*, 1933) savagely portrays a remote mountain community living in extreme poverty near the Spanish town of La Alberca. The film is shocking both in its subject and the seeming casualness of its making. The critic of Surrealist film Ado Kyrou thoroughly approved, admiring its 'extraordinary counterpoint':

the shots themselves are terrifying: sick people, idiots, corpses, churches, sordid poverty. Their full horror is underscored by the dry, factual style of the commentary, which resembles one that might accompany a documentary on the cultivation of peas in the lower Pyrenees. The commentator remarks in his neutral voice: 'there are many cretins' while on the screen we see creatures that not even [the painter] Zurbarán would have imagined. At this point, insipid romantic music [Brahms!] reinforces the image, much as a piece of royal-blue velvet would enhance the horror of a shrunken head placed upon it.[8]

Shot silent by Lotar, Buñuel originally provided a live commentary, no doubt practising the flat delivery of the later recorded narration. Though the poverty was real, there were claims that the excesses were sometimes enhanced; an ailing donkey was covered with honey so that Buñuel could film it being 'stung to death' by bees; a mountain goat that 'accidentally' falls from a cliff was in fact shot – 'truthful' inventions exceeding those of Flaherty. Closer to home, and also Surreal in spirit, Georges Franju's poetic portrait of the slaughterhouses of La Villette in Paris, *Le Sang des Bêtes* (*Blood of the Beasts*, 1949), gloried in the casual horrors of the butcher's

46

46 ABOVE Georges Franju, *Le Sang des bêtes* (*Blood of the Beasts*), 1949
47 OPPOSITE Alberto Cavalcanti et al., *Coalface*, 1935

trade. Nothing is hidden; animals die before the camera, but the film's tone is sweetly ironic – at one point, a worker seen sweeping away a sea of blood starts whistling 'La Mer', and Franju deliberately juxtaposed his gory images with scenes from the surrounding bourgeois daily life.

As the 1930s progressed, unemployment and the rise of fascism introduced a new sense of anger to the documentary. Irony gave way to outrage, and many artists joined the move towards socially and politically charged documentary-making. Two films made in the mid-1930s in very different circumstances give voice to this anger. Shot clandestinely and on a shoestring, *Misère au Borinage* (*Poverty in the Borinage*, 1934) by Ivens and Stork is a desperate shout from the devastated industrial region of Wallonia, Belgium, as capitalism failed its mining industry. Made in the aftermath of a lengthy and bitter strike that resulted in many of the already poor workforce being thrown out of their homes, this silent film's opening titles set the tone: 'Crisis in the Capitalist World. Factories are closed down, abandoned. Millions of proletarians are hungry!' There follow sequences of images of police brutality and abject human poverty – and in the distance, the deliberately unused stocks of coal.

By contrast, *Coalface* (1935), by Cavalcanti and others, was funded by the government-backed GPO Film Unit as

47

48 Steve McQueen, *Caribs' Leap / Western Deep*, 2002

'unbiased' public information about an essential industry, and has many of the artistic pretensions of the classic avant-garde. Images of miners working in grim conditions were edited by the painter William Coldstream with sections of brisk montage, against which are set flatly delivered statistics, unusual music and an extraordinary chanted chorus, a collaboration between W.H. Auden and Benjamin Britten, both at the start of their careers. The anger reveals itself in the almost casually intoned statements 'every working day, four miners are killed and 450 injured or maimed', and annually 'one in every five [of the 750,000 employed] are injured'. These are astonishing statistics if true, and that the film was released suggests that the government was untroubled by them. (Memories of this period still reverberated in the minds of the striking English miners depicted in Deller's *The Battle of Orgreave*).

Seventy years on, while inhuman mining conditions may have moved elsewhere and the mode of address may have changed dramatically, the issue can still provide an artist with an urgent subject. Steve McQueen's *Caribs' Leap / Western Deep* (2002) juxtaposes images on two large screens, with a small third screen offering a coda. One screen shows the impassive faces of miners descending over two miles below the earth's surface in a cramped lift-cage in Western Deep No. 3 Shaft, a highly profitable gold mine near Johannesburg, South Africa, where they face accidents, indescribable air-pressure, dirt, noise, heat and darkness. In real time, the camera follows their entire descent. The other screen depicts cliffs on the Caribbean island of Grenada, seen distantly from the sea; from time to time, a solitary falling figure is caught mid-air, suspended in time. The literal link between these screens is the image of Black figures descending; the more powerful, unspoken links are the colonial aftermath, resistance, endurance and death. The mine is still in the same ownership decades after the end of apartheid; the workforce is uniformly Black; sixty miners die in South Africa's gold mines each year and the mental and physical health of others is gravely impaired. The Grenadian cliffs, 'Caribs' Leap', were the site of a mass suicide in 1651 by the native Carib Indian population of the island, when, after 150 years of proudly resisting all attempts to colonize them, they were finally overrun. The small third screen shows contemporary life in Grenada in the form of a video diary, and ends with images of coffins in a morgue, including that of McQueen's grandmother, silently acknowledging the artist's personal link with this history.

48

The Essay Film

The collage of ideas that is today's most popular form of documentary was given the title 'The Essay Film' by Hans Richter,[9] in response to two films made specifically for the New York World's Fair of 1939 – *Spare Time* by Humphrey Jennings and *Violons d'Ingres* by Jacques Brunius. Richter saw them as establishing a new form in which the filmmaker was able to put onscreen the 'invisible world of thought and ideas'; a form that aided argument rather than pretended to settle it, thus fully liberating the documentary from its role as travelogue and public message board. Montage clearly already contained this potential – his own short film *Inflation* (1928) might have been an example – but the essay film offered a more open and extended framework in which to lay out a range of ideas. Both films cited by Richter are about what working people do 'when not at work' – in the former, factory workers, steel workers and miners and their recreational pastimes; in the latter, 'outsider artists' – committed non-professionals, making work far from the official art-world. Both are, perhaps, about the individual's right to happiness.

In *Spare Time*, Jennings built upon his experience of participation in Mass Observation, a non-governmental social research organization set up by anthropologist Tom Harrisson, poet Charles Madge and Jennings himself to study British everyday life. Shot in Lancashire and South Wales around the steel and cotton mills and coal mines, it shows working men and women 'between work and sleep [in] the time we call our own...a time when we have a chance to do what we like, a chance to be ourselves'. Apart from these brief scene-setting words spoken by the writer Laurie Lee, the film is without commentary and seamlessly weaves together sequences of people in the pub, mending bicycles, tending racing pigeons, watching football and in the dancehall, with clever use of overlapping natural sound and music recorded on location. The unmediated recording of people 'doing their thing' is pure Mass Observation, but the poetic montage of images united by a theme would become the signature method of Jennings, who in later films collaborated with his editor and sometimes co-director Stewart McAllister.

As a cinematic form, the essay film appealed particularly to French feature film directors associated with the New Wave. A powerful example is Alain Resnais's *Nuit et brouillard* (*Night and Fog*, 1955), in which Resnais interweaves archival images of Auschwitz atrocities with even-paced travelling shots of the abandoned camp ruins taken a decade later, long before its tidying-up and re-presentation as a grim visitor attraction. Its quiet, questioning voiceover was written by Jean Cayrol, a camp

49 Humphrey Jennings, *Spare Time*, 1939

survivor, with the film posing the deeper question: 'how do we talk about this event?' Another, much later example, Agnes Varda's *Les glaneurs et la glaneuse* (*The Gleaners and I*, 2000), is a personal journey of discovery set amongst a different set of outsiders – in this case people dedicated to making sure nothing goes to waste, herself included. Camcorder in hand, she gathers people who collect 'leftovers' of every sort, in agriculture, in the city, in society, and records their observations and discoveries.

Essay films can give voice to protest, as in *Nightcleaners* (1972–75) by The Berwick Street Collective (Mark Karlin, Mary Kelly, James Scott and Humphry Trevelyan), and *Handsworth Songs* (1986) by the Black Audio Film Collective (John Akomfrah, Reece Auguiste, Edward George, Lina Gopaul, Avril Johnson, David Lawson and Trevor Mathison), the former film perhaps a model for the latter. *Nightcleaners* is a set of portraits of exploited night workers; simultaneously a record of their struggle for better pay and working conditions, the failure of the unions to embrace their cause, and, echoing Vertov, a meditation on the status of the filmed image. This latter aspect of the film evolved during

50 ABOVE AND OPPOSITE John Akomfrah, *Handsworth Songs*, 1986

its making, the members of the Collective rebelling against any drift toward narrative smoothness. The women's portraits are slowed down and peered at (re-filmed microscopically), as if to give space for thought and as if this intense scrutiny could help our understanding.

Handsworth Songs was the first film by Black Audio, and was made in response to civil unrest in Birmingham and London in October 1985 – and particularly to the media's demonization of the protestors. The opening images – a Black security guard standing next to a working Victorian machine in an industrial museum, a flock of birds taking off, an amusement arcade automaton-clown silently laughing, mute statues of civic dignitaries Neville Chamberlain and J. B. Priestley, a Black man describing an incident in rich West Indian *patois* – give a sense of the mix that is to follow: a meditation on 'how we got here'. The brave innovation in this film, which is both a protest and a wake-up call, was to cast it in the language of 'song', a music created by the rhythmic intercutting of different

recorded visual strands, and 'lyrics' gathered from voices caught in newsreel footage, together with an occasional poetic commentary in a woman's voice.

51
Equally political are William Raban's series of essays on the landscape of London. The writer Al Rees gives this lucid account of *Island Race* (1995), one of a trilogy of films set in London's East End, where Raban lived for many years, observing the changing scene:

[The film] was partly made on the Isle of Dogs during an election campaign featuring a leading British National Party [extreme right-wing] candidate. Traces of class and racial conflict are sprayed on walls and posters, edited between shots of traffic, busy streets and the London Marathon. Scenes of daily life in East and South London are punctuated by crowd-gathering rituals – rapt flag-waving families greeting a navy flotilla, the anxious solemnity of the Kray funeral, a street party and VE Day celebrations. The eye scans and questions those images, which connect and contrast

51 ABOVE AND OPPOSITE William Raban, *Island Race*, 1995

in form, scale and angle. Blurs of passing traffic seem to flatten
the screen, Tower Bridge and Docklands bathe in different lights,
close-up participatory shots are cut against cooler static images.
Live sound (with no voice-over commentary) is expanded by radio
clips and by David Cunningham's music for the framing metaphor
which opens and closes the film – a high-speed car ride out of and
back into the Channel Tunnel.[10]

Raban's early films were landscape, light and weather studies
like those of Chris Welsby – indeed they made the film *River*
Yar (1972) together early in their careers – and one can still
enjoy Raban's later films in this way; his camerawork, with its
frequent use of time-lapse, is alert to every ephemeral change
in the view. Yet his true subject is the impact of social and
political change, as reflected in the urban scene.
 Raban is committed to making single-screen films for the
cinema, but the essay form is equally at home in the gallery.

Elizabeth Price describes her films as moving 'from something that looks like a PowerPoint lecture, to something that looks like an infomercial to something that feels like a cinematic melodrama';[11] accordingly, she mixes filmed and computer-generated imagery with written and spoken texts and music. Her montages may be displayed over a number of screens (sometimes a horizontal next to a vertical), but are is as tightly choreographed as any single-screen work might be. *At the House of Mr X* (2007) is a study of the abandoned home of an unnamed art collector – a perfectly preserved if airless time-capsule of 1960s works of art and modish design. Price takes us on a tour of the shrouded space, focusing on objects then passing on, interweaving the whole with bursts of text, vocal music and (in text) the brash slogans associated with the cosmetic brands from which the owner made his fortune. Wry social commentary and the exploration of archival and neglected collections are something of a speciality in her work.

52 ABOVE AND OPPOSITE Cecil Hepworth, *Burnham Beeches*, 1909

Landscape Studies

Like painters and poets before them, filmmaking artists have
been keen to set down their response to particular landscapes
and environments. There are rare examples of such films
among those made by the camera operators of the Lumière
period, such as Cecil Hepworth's *Burnham Beeches* (1909) – a
series of long tracking shots through an ancient forest at the
edge of London, in which the camera's exclusive focus on the
majestic trees as it moves among them suggests a determined
attempt to capture the 'spirit of place'. A century later, David
Hockney's *The Four Seasons, Woldgate Woods* (2010–11) shows
that this simplest of approaches is still valid. Hockney takes
the viewer down a modest wooded lane in Yorkshire, repeating
this slow journey in each of the four seasons, savouring their
differences across four adjacent screens. Each of his four large
images comprises a grid of nine horizontal plasma screens and
was shot by a battery of nine cameras, the slight unsteadiness
between the images and their overlapping perspectives adding

52

53

subtle complexities to the scene. Yet the subject, a trip down a country lane, remains simple.

Apart from the 'actualities' of cinema's first decade, it is rare to find the rural landscape presented as the sole subject of an artists' film until the 1960s. Just occasionally, one finds a film in which a human figure is included within a landscape study as a surrogate for filmmaker and viewer, as in Kenneth Anger's *Eaux d'artifice* (1953), his evocation of night-time in the Villa d'Este gardens at Tivoli. Here, we follow a tiny baroque-costumed figure running endlessly between the fountains, her diminutive scale enhancing the fountains' grandeur.

54

There are echoes of this fifty years later in *Xilitla* (2010) by Melanie Smith and Rafael Ortega, a portrait of the Surrealist Edward James's 'garden' set deep in the rainforest at Las Pozas, Mexico. Two forlorn figures struggle with a large mirror as they explore this mix of poured-concrete Modernism and Watts Towers naivete, now overtaken by lush jungle growth, the lofty forest setting emphasized by the artists' adoption of a vertical format for both filming and projection.

53 David Hockney, *The Four Seasons, Woldgate Woods* (Spring 2011, Summer 2010, Autumn 2010, Winter 2010), 2010–11

54 Melanie Smith in collaboration with Rafael Ortega, *Xilitla*, 2010

When dealing with landscape as sole subject, artists are most directly challenged by the film camera's limitations. No wide-angle lens can simultaneously process the peripheral and central areas of vision as the human eye and brain can, working together. Onscreen, synthesis of the peripheral and central depends upon montage and the interplay of time and movement. While discussing film's contribution to the history of landscape representation in art, the Canadian artist Mark Lewis has spoken of the challenge of framing:

To me the question of composition, or rather, de-composition [within the film-frame] is crucial. Film, which has its genesis in the idea of the 'moving picture', is always and immediately a-composition-in-decomposition.... And it's the 'promise' of a composition, a promise that is continually broken and then renewed, that keeps me watching.[12]

Hence his own love of formal camera movements based on tracking shots and drone-borne cameras. Lewis's *Smithfield* (2000), for example, tracks around the perimeter of a nineteenth-century market building in central London, its consistent head-on focus on the façade and occasional views though the building complicating our reading of its unusual triangular form, offering a spatial puzzle to be unravelled. In *Forte!* (2010), his camera glides towards, and then over, a snowy Italian mountain range, to discover the bizarre Napoleonic-era Forte di Barda, concealed in the Aosta Valley below. In *Beirut* (2012), in another unbroken shot, the camera tracks along a nondescript shopping street, ascends a dingy hotel-façade and floats over the building's roof, descends into a narrow street beyond, then climbs again to finally discover a figure swimming in a tiny rooftop pool. Here the camera seems to have assumed the role of a restless voyeur, curious on our

55

55 Mark Lewis, *Beirut*, 2012

behalf, able to go where impulse takes it, and at last almost accidentally discovering a scene that seems a metaphor for inner peace in turbulent times.

Returning to the fixed frame and unbroken take associated with the Lumière brothers offered one extreme solution to the challenge, and many artists have adopted this simple format, asking the viewer simply to *look*. Hilary Lloyd's *One minute of Water* (1999) is simply a one-minute fixed-frame take of hypnotic light patterns on a rippling surface, shown looped on a television monitor. Similarly, Peter Hutton's series of *New York Portraits* (1979–90) might be seen as updates of *Manhatta* – again, silent, superbly composed, fixed-frame long-held shots that distantly observe the interaction of humans, the weather and the built environment of the city. Hutton clearly sought to recover the sense of a primal visual experience that must have accompanied a Lumière screening, in his words 'a *moment of seeing*, a very removed, private glimpse of things that we are totally familiar with.... It's about taking the time to just sit down and look at things'.[13] His visual sensibility often includes imagery that is quietly surreal: an advertising airship nudging its way between distant skyscrapers; a whirlpool appearing in a flooded street seen from far above; wind-blown sheets of newspaper dancing in an empty street; words left floating in the sky by a team of sky-writing planes....

56 Peter Hutton, *New York Portrait: Part I*, 1978–79

Closest to a conventional documentary are portraits of places composed of many shots – though still without any commentary. *Water/Ganga* (1985), by the Paris-based Indian painter and filmmaker Viswanadhan, follows the Ganges from Gangasagar Island in the delta to its source over 1,500 miles away in the Himalayas, where 'a canyon, worn water-smooth by the rapid current, narrows and leads into a treeless mountainscape of mystery and silence. The stream contracts into a brook and disappears into a subterranean passage leading to an ice cave....' Filmed over two months and distilled through a number of years of editing, it observes the river, its moods, the different people who live along its banks and the ways in which they work with it and worship it, and develops these images into a symbolic language of endurance and renewal. 'I learned – that which flows fast is 'Ganga' – a synonym for water throughout Indian civilization. Like the sequence of an old woman in the water who lifts a small pot, pours out water, over and over again for three minutes; that gave us a whole definition of life'.[14]

Years earlier, Margaret Tait had made a similar river portrait of a tiny, seemingly insignificant stream. Her *Orquil Burn* (1955) follows the Orcadian stream's course from the sea to its source in a marshy landscape, in hand-held but essentially static shots. As her camera moves into the landscape, the viewer quickly learns that the present image contains clues as to the location of the next, and so on. She accompanies each shot with a voiceover observation; not a commentary, just a naming of what's seen.

Her *Land Makar* (1981) is a double portrait of an Orcadian landscape of windswept grassland, sheep, growing potatoes and sheltering stone walls, and of Mary Graham Sinclair, the solitary woman who tends it. Again, there is no commentary, just the woman's lilting voice with its strong dialect; a natural music which is often barely audible and even less understandable, yet a vital part of the image. This is not ethnography (though no doubt it will be of eventual interest to future ethnographers), but an expression of how complete the interdependence of humans and landscape can be.

Formal shooting patterns offer a means of dealing systematically with the vastness of landscape, breaking it down into manageable pieces that will cumulatively represent the whole and take account of changes in light and weather. Hence, many landscape films have been labelled 'structural', helpfully or otherwise. British-born Canadian artist Chris Welsby has spent a lifetime documenting the relationship between weather and landscape, nature and technology. His enthusiasm for system-based shooting patterns is tempered by

57 Margaret Tait, *Land Makar*, 1981

58 Chris Welsby, *Seven Days*, 1974

his desire to oppose 'what is structured, measured, systematic and predictable, [with] what in nature is quite the opposite.'[15] Systems offer a way of capturing the fluctuating patterns of movement and light resulting from the Earth's rotation and the tidal pull of the moon, and the equivalents caused by human traffic. Sometimes the system itself is dependent upon random external factors: the passing of pedestrians in *Parkfilm* (1973); the strength and direction of the wind in *Wind Vane* (1972); the movements of a moored boat in response to wind and tide in *Estuary* (1980). In *Seven Days* (1974), it is the pattern of cloud cover and the sun's position, an interaction of order and chaos that Welsby describes as

a balance between a mechanistic structure – the sun rises and sets, the time-based interval [of shooting] – and the vagaries of the Welsh landscape – when it was sunny and when it wasn't – which you couldn't predict. The film attempts a symbiotic relationship between camera/structure, filmmaker and the landscape.[16]

Making the film, Welsby and his then-partner, the photographer and filmmaker Jenny Okun, camped on the side of Mount Carningli and gathered seven days' worth of weather, systematically sweeping the landscape with their camera from one horizon to the other, from east to west. They manually exposed one frame of film every ten seconds from sunrise to sunset, the camera tracking the sun's position in the sky or, when the sun was shining, its own shadow on the ground; sound was sampled every two hours. As with the walks undertaken by the sculptor Richard Long, the filmmaking was in effect a performance, even an endurance test, with the completed film its record. Later, in works such as *Trees in Winter* (2006), digital technology allowed Welsby to reflect the daily interplay of landscape and weather, using a bank of pre-recorded images that are continuously re-sequenced in response to live inputs from an adjacent weather station.

Most of the landscape studies by the Peru-born Anglo-French artist Rose Lowder are similarly systems-based, and require the design of a shooting scheme using squared paper, on which each square represents a frame. An electronic computer-controlled drive attached to her Bolex camera allows her to programme exposures – 'one frame in three' and so on – and to drive the motor backwards and forwards to fill in frames previously left blank. In *Tournesols* (*Sunflowers*, 1982) she combines different patterns of single-frame shooting from a fixed camera, but changes the focus between each exposure, resulting in a vibrating rhythm that seems to tug and shake the image. More radically, *Voiliers et Coquelicots* (*Poppies and Sailboats*, 2001) interweaves images of a field of poppies and fishing boats returning to the harbour at Sète in alternate frames; since the blue of the sea is recessive, the boats appear to float on a shimmering sea of red. *Bouquets 1-10* (1994–95) consists of a number of one-minute flower films:

Composed frame by frame in camera during filming... [which weave together] frames gathered in one area at different times.... Each bouquet of flowers becomes also a bouquet of frames, mingling the plants to be found in a given space with the activities that happened to be there at the time.[17]

These are more calculatedly pretty than her earlier studies, but their rapid rhythms are still visually aggressive enough to deter the faint-hearted. Echoing Welsby, Lowder says of her shooting systems, 'I *guess* at what [the effects of my shooting plan] might look like; I'm concerned to take the subject further; it's not about reproducing what's there'. For her, ' it's

59 Rose Lowder, *Voiliers et coquelicots* (*Poppies and Sailboats*), 2001

60 Michael Snow, *La Région centrale*, 1971

about achieving a balance between technology [the camera's possibilities] and nature'.[18] Lowder's work reflects strong ecological beliefs; often her films contain a built-in critique of consumption and of issues such as the French state's espousal of nuclear energy, which she contrasts with the brave endeavours of independent organic market-gardeners.

60 One of the most ambitious of all landscape studies is *La Région centrale* (1971) by Michael Snow, in which the camera, isolated on a mountain-top in Quebec, undertakes a seemingly solo three-and-a-half-hour exploration of the scene. The landscape itself is extreme – a wilderness of rocks, snow and minimal vegetation extending as far as the eye can see – and extreme, too, is the artist's exhaustive exploration of the camera's abilities. Snow was building on his earlier study of extreme camera choreography, *Wavelength* (1967). 'After finishing *Wavelength*, which is in its entirety a single camera movement (a zoom), I realized that the movement of the camera as a separate expressive entity in film is completely unexplored....' *La Région centrale* was, therefore, planned as a 'film "orchestrating" all the possibilities of camera movement and the various relationships between it and what is being

photographed'.[19] The camera is controlled remotely but still manually, via switches and dials:

[It] moves around an invisible point completely in 360 degrees, not only horizontally but in every direction and on every plane of a sphere. Not only does it move in pre-directed orbits and spirals but it, itself also turns, rolls and spins. So that there are circles within circles and cycles within cycles. Eventually, there's no gravity.[20]

As he set his custom-designed motorized camera mount in motion, Snow must have had huge expectations of what the camera's solo journey might record, but no certainty; in this sense his film was truly experimental. Snow conceived his task as constructing an equivalence between the behaviour of the camera and the vastness of the rugged landscape:

I wanted to make a film in which what the camera-eye did in the space would be completely appropriate to what it saw, but at the same time, equal to it. Certain landscape paintings have achieved a unity of method and subject. Cézanne for instance produced an... incredibly balanced relationship between what he did *and what he (apparently) saw.*[21]

No less heroic in scale was the series of five films made under the collective title *Lieder der Erde (Songs of the Earth*, 1979–2010) by Klaus Wyborny – one of many cycles of films that Wyborny made in a lifetime of landscape exploration. Again, the artist's challenge was to find an equivalent to human responses to the vastness and complexity of natural and man-made environments. Wyborny grew up amid the devastation of post-war Germany, his parents moving frequently until they finally settled in Hamburg. This made him a restless explorer, drawn to the landscape of decay. Wyborny avoids the long stare; instead he gathers fragments and brief shots, often filmed at oblique angles, sometimes through a coloured gel, sometimes superimposed, trusting that an accumulation of glimpses will live up to his initial response. His films are rigorously structured, often in counterpoint with sound or (in his later works) music. The *Songs of the Earth* cycle was shot on Super8 and largely edited in-camera, which brought its own challenges. Like Lowder, he devised 'time-structures'(scores) that he followed when editing in-camera:

so that I had to use whatever I shot, even if I had [bad luck] in choosing the moment or the location when taking a picture. Sometimes I was aware of the poor quality of a series of shots;

then I had to react to that in the next sequence, thus making the 'mistake' a challenge to the following series of images.... I like [these] extremely carefully structured modules followed by rough intrusions.... I like the mixture. The rough stuff protects against the tendency to produce kitsch by being too 'masterly'.[22]

Wyborny adds an interesting point about our yearning for the spectacular in depictions of landscape, and the impact of the endless flow of well-intentioned television nature documentaries made in response to this hunger:

For a long time I managed to see the world as if I was looking at it as a child. Now this has become difficult. The world has changed a lot and become very uniform. You find California everywhere. Documentary films of 'everything that is strange' have killed the unknown.... So the age of the great explorers...seems to have come to an end. [23]

Chapter 4
The Pleasures of Editing

London, October 1940.... Coming across Leicester Square just after the sirens, there are two French soldiers talking. The three-quarter moon-face very bright with a few streaks of cloud. A group of white faces outside Lyons looking up watching a great [barrage] balloon sailing into the sky. Then – in the shadow – a man with a street-piano fingering a prelude. The officers cross over. The guns begin to thud. The balloon rises fast across the luminous clouds. The moon is bright enough to cast long shadows. The piano begins to play 'Land of Hope and glory / Mother of the Free'. [1]

<div align="right">Humphrey Jennings</div>

This diary entry by the painter, poet and filmmaker Humphrey Jennings, made while working on his great series of wartime documentaries, is already a form of montage, a chain of images and sounds that have come together magically; a cinematic experience encountered amid the fleeting and chaotic impressions of daily life. In its form it anticipates the intuitive sequencing of images that would later become the norm for many artist filmmakers. Here, for example, is a planned montage by the Scottish artist Margaret Tait, distilled from the daily life that surrounded her on her native island of Orkney. In it, she builds a chain of poetic image-clusters that reflect the balance between transience and endurance in island life; she related its circular structure to the endless patterns of Celtic art and to the Greek Ouroboros – the snake that devours its own tail.

- *A child reading – a simple image, contemplating the intent way in which a young child reads or looks at a book, meeting the world of storybook or picture book. Hold it – hold it simple – hold it direct.*

- *The Edge of the Sea – literally the very edge where shore meets water – life on both sides.*
- *Birds in wilderness – ('here we sit like birds in the wilderness') Real birds – real wilderness ('In and out the dusty bluebells') (melancholic bird-calls) (bees)*
- *Stock [farm animals] on the Road – touch of incongruity, touch of 'what are they doing there?' whiff of ineffable sadness (if not tragedy) in the fate of all creatures – insistence through several instances of stock-moving, stock straying or finding its way out – or being driven along, willy-nilly*
- *Rust everywhere – plenty of instances of this. Rather inanimate, rather static, but nevertheless implied in the crumbling machinery / the dwindling fencing and gateposts – is that nothing stays the same*
- *Heavy Traffic – oh yes! Far from rusted yet. The maintained, the oiled, the useful, the busy*
- *Flight to and from – (comes out of [the previous shot]) – articulated lorries entering the ferry, heavy car doors, the leaving and arriving – aircraft, different sizes, up and away, down and in – sailboats and other boats – a busy scene – where do they all come from? Where are they going? The birds too, they flock and wheel and prepare to leave. Flights of individual birds.*
- *Crash of a wave – a direct statement – an irrefutable image*
- *Turning a page – the quiet page-turning by the grown person – with echoes perhaps of a device in many film-titles.*[2]

Before they achieved such simplicity, artists had first to explore what the collision of different types of filmed images might produce.

Montage

As early as 1916, it occurred to artists that films were not obliged to observe the established sequential logic and conventions of narrative editing. A group of leading Italian Futurists gathered around Arnaldo Ginna to make the absurdist quasi-manifesto film *Vita Futurista* (*Futurist Life*, 1916), which consisted of a sequence of novelties and provocations, edited together to light-heartedly illustrate their chosen artistic lifestyle. The film no longer exists, but apparently contained 'a Futurist lunch' in which the artists abuse an old man for his old-fashioned non-Futurist way of eating; a Futurist allows himself to become 'overwhelmed by sentimentality' (to absurd effect one assumes); a split-screen section reveals Futurist and non-Futurist ways of sleeping; a caricature of Hamlet is offered as a 'symbol of

61 Germaine Dulac, *La Souriante Madame Beudet* (*The Smiling Madame Beudet*), 1922–23

pessimistic traditionalism'; the artist Giacomo Balla falls in love with and marries a chair – 'a footstool is born'; there's 'a dance of geometric splendour' and other such scenes.[3] In the footstool sequence Ginna used distorting mirrors, and while editing the film he also hand-coloured some white, accidental imperfections in the film print in order to enhance the representation of a character's 'state of mind'. This was evidently a film of provocations and tricks, but more importantly, a demonstration that a film might productively consist of little more than a collision of diverse ideas and images. It took some time before other artists capitalized on this discovery.

The 1920s was a decade of editing experimentation. The director Lev Kuleshov recounts how even in the late 1910s, while working on the re-editing of films – 'making new films out of old ones' – he was able to indulge in 'pure research and experimentation, an excellent opportunity to learn the fundamentals of montage'. In one experiment that has become famous as 'the Kuleshov effect' he demonstrated an extreme

example of how one image can influence another when juxtaposed:

I alternated the same shot, a close-up of the actor Mozhukhin, with different other shots (a plate of soup, a girl, a child's coffin, etc). When juxtaposed by montage, the shots acquired different meanings. The emotions of the man on the screen became different. Two shots gave rise to a new notion, a new image that neither of them contained; a different third. I was stunned.[4]

This bold editing lesson would be taken to heart by many, not least by Sergei Eisenstein.

 Writing in the early sound period, Eisenstein looked to Modernist literature, sure that the stream-of-consciousness recently celebrated by Joyce in *Ulysses* (1922) was if anything better suited to cinema than to the novel:

> *Inner monologue.*
> *Why not??!*
> *Joyce in literature,*
> *O'Neill in drama,*
> *We in cinema!*
> *In literature – good*
> *In drama – bad,*
> *In cinema – best.*[5]

In France, the leading theorists and filmmakers Germaine Dulac and Jean Epstein were among those similarly exploring ways in which the editing of silent narrative feature films could evoke patterns of thought through visual metaphor and the stark juxtaposition of images. In a lecture on her film *La souriante Madame Beudet* (*The Smiling Madame Beudet*, 1922–23), a portrait of a woman stifled by marriage, Dulac described the film's opening sequence of shots and indicated how she expected these images to be read:

In the beginning: long shots.
Indications of sadness in the empty streets, the small quaint figures. 'The Provinces...'
Then a unifying shot: two hands playing a piano and two hands weighing a handful of money.
Two characters. Opposite ideals.... Different dreams. We already know this, and all without any actors.
Now we see the actors...a piano...behind it the head of a woman... a scrap of music. A vague reverie. The sun playing off the water among the reeds.

61

A shop. Cloth is measured. An account book. A man gives orders.
Up till now, everything is distant. People have only moved among
things. We see them move around and position themselves....
Movement. One senses that poetry and reality will clash.
In a very bourgeois room, a woman reads. Very worthy, a book...
Intellectualism. A man enters: M. Beudet...He is conceited. He
holds a book of fabric samples...Materialism.
Shot: Mme. Beudet doesn't even raise her head.
Shot: M. Beudet seats himself at a desk without speaking.
Shot: M. Beudet's hands count the threads of a fabric sample.
The characters are posed in shots that contrast with each other
and that isolate different gestures, thereby making them stand out
in relief.
All of a sudden, a long shot reunites these two people. Suddenly,
all the jarring incongruities of a marriage appear. It is a coup de
théâtre.[6]

Here, Dulac is pursuing a sophisticated narrative form that
expects the viewer to make the connections between images,
but elsewhere she additionally makes use of what she refers to
in her lecture as 'our rich palette' of effects – an array of fades,
dissolves, superimpositions, distortions and soft focus – the
very techniques Brunius so unkindly complained of. These
are additional ways of colouring our reading of the image and
suggesting her characters' interior lives; they are tools too
useful to be abandoned, and indeed continue in use to this day.

Even more boldly, Epstein shaped his entire film *La glace à
trois faces* (*The Three-faced Mirror*, 1927) around the interplay of
patterns of thought and 'live' experience. There is essentially
only one action that is seen in real time and logical sequence.
A fashionable young man takes his car out of a multi-storey
garage, drives out into the country and there meets his death
in a crash when his windscreen is shattered by a bird. But
this linear action is interwoven with his thoughts about the
three women who love him – each apparently awaiting his
arrival – and *their* thoughts and recollections about him. So
ambitious is the intercutting between 'the present' – the man's
journey – and these other levels of thought and memory, that
the viewer is hard-pressed to keep track, and finally must
submit to simply absorbing what's onscreen and hoping that
all will become clear eventually. Already, Epstein is making
new demands of the viewer. He was ambivalent, to say the least,
about 'stories' as such; they had no place in cinema: 'Cinema
is true; a story is false. ...There are no stories, there never have
been stories. There are only situations, having neither head nor

62

tail; without beginning, middle or end.... I want films in which not so much nothing as nothing very much happens'.[7]

'Nothing very much' in practice meant using only imagery that could *not* be put into words and was therefore unique to cinema – a quality he referred to as 'photogénie'. Through images alone, one should be able to convey all one needed to know about human 'situations'. *La glace à trois faces* is full of such uniquely cinematic metaphors. The young man exits the Modernist car park via a spiral ramp that plunges him repeatedly from dark into light and into dark again, then finally emerges into blazing daylight; the spiralling motion and the play of light and shadow echo his present indecision about, and prefigure his eventual escape from, the waiting women. Few of Epstein's other films are as complex in structure, but he remained true to his passion for the uniquely cinematic, largely rejecting studio sets in favour of an almost documentary dedication to real locations, and to visual metaphor as the main conveyer of meaning. Such editing complexities and liberal use of metaphor became the norm forty years later in the work of a different generation of artists, beginning with Maya Deren, Kenneth Anger and Gregory Markopoulos.

An example of how effectively the lessons of Dulac and Epstein were spread abroad in the 1920s is provided by *Limite*

62 Jean Epstein, *La glace à trois faces* (*The Three-faced Mirror*), 1927

63 Mário Peixoto, *Limite* (*Limit* or *Border*), 1930–31

(*'Limit'* or *'Border'*, 1930–31), the only film made by the Brazilian novelist Mário Peixoto, who as a young man in 1929 travelled to Paris and London specifically to study the latest developments in avant-garde film. Nearly two hours long, silent, and with almost no inter-titles, his film describes the states of mind of three figures – two women and a man – adrift in a seemingly limitless sea in a boat with neither sail nor oars. As in Epstein's *La glace à trois faces*, a series of extended, overlapping flashbacks suggest that their current predicament is related to their interconnected past experiences, and that unresolved pressures from the past have somehow brought them to this purgatory-like state. Their stranded state may be real or metaphorical. The storytelling is exclusively visual, which must have been an extraordinary challenge to a natural wordsmith, but he had learned his lessons well. The camera movements, alternating points of view (sometimes subjective first-person views, sometimes objective third-person), the pursuit of detail and the formal editing patterns cumulatively suggest that the camera has a mind of its own, and can travel through time and space at

will in its pursuit of visual equivalents for the emotions, fears and recollections of these three lost souls. The film opens and closes with an image borrowed from a photograph by André Kertesz, which Peixoto had admired while in Paris, of a woman's face framed by male wrists bound by handcuffs, suggestive of entrapment and suffocation; the author apparently described his whole work as a 'desperate scream'.

Nearly 100 years later, there are still echoes of Epstein's love of 'situations' and visual metaphor, coupled perhaps with Marcel L'Herbier's obsession with style and fashion, in the work of the Chinese artist Yang Fudong. His six-screen installation *East of Que Village* (2007) explores China's abandoned rural past, rather as Epstein's *Mor Vran* (1931) had explored an abandoned Breton island community left behind by modern France. Similarly, Fudong's single-screen multi-part *Seven Intellectuals in a Bamboo Forest* (2003–7) employs a series of non-narrative *tableaux-vivant* to evoke the dilemmas of a young Chinese generation lost between respect for tradition and the shallow allure of its high-rise urban present.

In Warsaw, still in the 1930s, working on a different scale and already anticipating the low-budget methods of most post-war artists, Stefan and Franciszka Themerson produced a short film which similarly works through visual metaphor – *Przygoda czlowieka poczciwego (The Adventure of a Good Citizen*, 1937). They made this parable of the artist's role in society while Stefan was writing the first draft of his book *The Urge to Create Visions*, and it depicts the public's hostile response to the Good Citizen who decides to act differently, responding to his visionary 'urge'. He overhears a carpenter saying to two men who are carrying a wardrobe 'the skies won't fall in if you walk backwards!' and is inspired to take this advice literally, so starts to walk backwards. People protest at this imaginative behaviour and produce banners insisting 'Forward-march, everybody! Down with walking backwards!' Finally, the Good Citizen addresses the film's viewers directly and says: 'You must understand the metaphor, Ladies and Gentlemen!' The Nazi burning of books and denunciation of 'degenerate art' just across the border with Germany must surely have been in mind, yet the tone manages to be playful. Stefan incidentally pointed out with satisfaction that one feature of the film was that 'it makes sense also when you view it backwards, from the end to the beginning, both the picture and sound; those who walked backwards – walk forward, and those who walked forward – walk backwards'.[8]

Another editing innovation of the French silent era is the rapid montage associated with the filmmakers Abel Gance and Dimitri Kirsanov. The context, again, is filmed melodrama.

Gance's *La Roue* (1920–24), like his later *Napoleon* (1926), is a work of extraordinary ambition – in this case over four hours long, shot using many different kinds of camera and camera-mount to afford unique perspectives, and telling a complex story involving a train driver, his adopted daughter, various rivals in love and a heady mix of potential incest, blackmail and unhealthy obsession. Gance marks the story's climactic moments with crescendos of rapidly intercut shots, some as short as a few frames (a fraction of a second), marking moments when dramatic action and emotional crisis come together. In one memorable sequence, the train driver Sisif, overwhelmed by his conflicting emotions, suicidally accelerates his engine towards a dead end. His crazed actions are intercut with images of his anxious adopted daughter trapped in a carriage behind, and close-ups of wheels, pistons, the steam-pressure gauge, belching smoke, speeding rails and more – all relating to different aspects of the mounting crisis. The camera is now the omniscient narrator, the accelerating editing pace suggestive of mounting hysteria. The film was a popular success, and most viewers were astonished by these montage sequences, but a few were also bothered by the film's old-fashioned plot. René Clair – still a journalist at the time, but soon to become a filmmaker – complained 'Oh, if only [Gance] were willing to give up literature and place his trust in the cinema'.[9] Léger admired the fact that Gance had, in effect, made a machine 'the leading character, the leading actor',[10] but perhaps more fully revealed his feelings through the making of his own *Ballet mécanique*, a ballet that involved actor-objects and little else.

Kirsanov's *Ménilmontant* (1924), named after the Paris district, traces the life of two young girls who are emotionally damaged by witnessing the murder of their parents. The film opens with this traumatic scene, shown in a blizzard of brief, erratically framed shots, often with moving camera, sometimes out of focus, sometimes showing isolated details, sometimes suggesting action happening off-screen, with the pace of editing increasing towards the climax to evoke the frenzy of the attack. The sequence is impressionistic and fragmentary – as in the children's nightmarish memory. Through these and other films of the period, rapid editing that mimicked the chaotic thought-patterns of an emotional crisis entered the filmmaker's lexicon, with echoes down the decades – memorably in Hitchcock's shower sequence in *Psycho* (1960) and the orgasmic fountain of gold bursting from the ground in Nicolas Roeg's *Eureka* (1983).

Such virtuoso displays of the power of editing were much discussed in cinema magazines and by film club members,

64 Stefan and Franciszka Themerson, *Przygoda czlowieka poczciwego*
(*The Adventure of a Good Citizen*), 1937

and French examples would certainly have been familiar to
Eisenstein and Vertov, though each made a very different use
of the technique. The accelerating montage in Vertov's *Man
with a Movie Camera* perhaps represents his critique of French
examples; the evocation of subjective experience was the very
opposite of his intention. Eisenstein, who made his first major
film *Statchka* (*Strike*) in 1924, also had a radically different
conception of what should be included in the montage mix.
For him, it was the *collision* of images that was the key to
creating uniquely cinematic meanings. An edited sequence
could contain images wholly unrelated to the present action
that would productively influence its reading: 'In every such
juxtaposition, the result is qualitatively distinguishable

65 Sergei Eisenstein, *Bronesosets Potyomkin* (*Battleship Potemkin*), 1925

from each component element viewed separately'.[11] Such juxtapositions engender 'a third something'. These separate components in the montage should have their own quality of 'attraction'. Eisenstein developed the term 'the montage of attractions' when working as a director of Revolutionary-period theatre, but applied it to his filmmaking. For him, it evoked acts in the circus and music hall that offer the spectator immediate 'sensual or psychological impact'. Thus, in the closing scene of *Strike*, he intercuts the shooting of the unarmed, rebellious workers with detailed scenes of the workings of a slaughterhouse.

65 The famous Odessa steps sequence in his *Bronesosets Potyomkin* (*Battleship Potemkin*, 1925) – another massacre – confines its montage to things that might have been seen by an omniscient eye present at the event. The complexity of his interweaving of expressive detail makes the sequence exhilarating. The camera tracks up and down – it leaps from place to place and moment to moment – completely disregarding

conventions of continuity of action or direction of movement, instead offering a blaze of extraordinary images – of fear, horror, power, vulnerability – one after another. Individual images stand out – the shattered, bloodstained glasses of the nurse (the image that so haunted the painter Francis Bacon); the unattended pram that begins its headlong descent of the stairs; the unwavering line of soldiers continuing their bloody onslaught. Importantly for artists that followed, Eisenstein's 'collisions' suggested that the potential to create new meanings was latent in *any* sequence of images, however contrasting or unrelated they might seem. It was an invitation to further experiment. This had repercussions far beyond those of the world of narrative film.

At the end of the 1920s, sound recording entered the editing mix. For most filmmakers, sound reinforced the narrative film's dependence upon dialogue and theatrical conventions, to the cost of meaning carried by the image. But again, the Russians were bold, and led discussions about how sound could be used more creatively, rightly fearing that its association with dialogue might stifle all experiment. The text 'A Statement [on Sound]', published collectively in 1928 by Eisenstein, Pudovkin and G.V. Alexandrov, was in effect simultaneously a warning to others and a challenge to themselves:

ONLY A CONTRAPUNCTUAL USE of sound in relation to the visual montage piece will afford a new potentiality of montage development and perfection. THE FIRST EXPERIMENTAL WORK WITH SOUND MUST BE DIRECTED ALONG THE LINE OF ITS DISTINCT NONSYNCHRONIZATION WITH THE VISUAL IMAGES. And only such an attack will...later lead to the creation of an ORCHESTRAL COUNTERPOINT of visual and aural images.[12]

Vertov's *Entuziazm* (*Enthusiasm*) provided a model of such counterpoint, and the lesson was not lost on a generation of post-war artists working in very different circumstances. The archivist, scholar and filmmaker Peter Kubelka consciously took this challenge to heart in his own small collection of films, openly acknowledging his teachers: 'Vertov and Buñuel had worked already with the same postulate, namely that natural synchronism is *not* the ideal.' He notes how, in *Enthusiasm*, 'in the scene at the beginning of the film, [Vertov] juxtaposes people who pretty-much drink themselves to death with those who refuse to live because they are too religious. He puts the sound of the drinkers with people who go up to the church, and the religious hymns with the drinkers...'.[13] The juxtaposition of image and sound in Kubelka's *Unsere Afrikareise* (*Our African*

Trip, 1966) is similarly but more subtly subversive of 'realist' expectations, in this case carefully undermining the film's apparent role as a holiday home-movie. *Unsere Afrikareise* had been commissioned by a group of Austrian businessmen who asked Kubelka to document their safari, which – typically of the period – was designed to allow them to kill magnificent animals and peer at 'natives'. The commissioners were horrified by the result; each image and sound in the film draws upon the viewer's expectations of 'natural' synchronization, then subverts it. 'In the scene where you see the elephant lying wounded, there are two hunters to the left side, still shooting at him. And I have synchronized, with those gunshots, this man who says, "elephant" and taps his fingers on the table. So you have an image which is very harmless, the fingers tapping, synchronized with the guns going off'.[14]

A very different but equally ambitious sound–image *montagiste* of the post-war generation was Gregory Markopoulos. Markopoulos's early films were psychological studies constructed through visual metaphor alone, as in the works of Epstein. In all his mature works he was as preoccupied as any of the silent-era filmmakers with the challenge of constructing a sophisticated narrative form, but with an added drive towards formal experiment for its own sake. Each of his longer films represents a variation upon the montage system of its predecessor. He commented to Jonas Mekas: 'I am trying [in my films] to speak an original language, to *create* an original language; I search for myself, for new means, for new techniques, for new visions, for new perspectives'.[15] Many of his films are silent or have minimal sound, but when he uses sound, it is never 'naturalistic'; rather, as in Kubelka's films, it always makes its own positive contribution to the montage. Characteristically, his editing involves a form of 'distance montage' – keeping many elements in play and allowing some narrative progression, but primarily serving to illuminate the theme or to evoke a state of consciousness. A shot of the main protagonist may be intercut with a blaze of images indicating his or her thoughts and perceptions; each seen for much less than a second, but sufficient to colour the reading of that first image, so when it returns, it appears altered and enriched. And the process continues with another blaze, further influencing our reading of the already-altered image, so the 'situation', to use Epstein's term, evolves cyclically, in tiny increments.

Markopoulos's most celebrated film, *Twice a Man* (1963), is a retelling of the myth of Hippolytus, in which 'a chaste youth rejects the advances of his step-mother Phaedre, and is saved from death by a caring physician'.[16] As in Epstein's *La glace à*

66

trois faces, Markopoulos establishes his cast of characters (some of them more symbolic or emblematic than individual) and through editing suggests the emotional forces at play among them. It is unlikely that much of the underlying myth would be recognized by an un-briefed viewer, yet the pattern of cross-cutting and superimpositions make clear the tensions and conflicts in the relationship between the two men, and between the younger man and the woman, his supposed stepmother, who is seen both in youth and old age. An awareness of these tensions, together with an appreciation of the visual complexity of the film, its immaculate photography, its rich colour, brief sections of music and fragmented words and phrases snatched from a translation of the myth, make the film quietly riveting. Markopoulos saw his film as demonstrating 'a new narrative form which is based on very brief film-phrases used in clusters to evoke thought through imagery'. He used these 'thought images' to 'build up the visual theme' with fragments of dialogue and music as 'heightening elements'.[17] His method was always labour-intensive but sparing of physical material. He rarely had a budget for filming and invented techniques that made the most of the small amount of film stock he had; many of his most startling effects were made in-camera, or as the result of elaborate editing plans.

Markopolous's *The Illiac Passion* (1967) is loosely based on Aeschylus' *Prometheus Bound*. We hear Markopoulos reading isolated words from Thoreau's translation, again fragmented to the point of offering little more than hints of meaning; hardly enough even to confirm that the film is myth-inspired. What appears onscreen is the naked Prometheus's vision of a series of gods sent by Zeus to torment him. But Mount Olympus has been transposed to Manhattan, with its art and experimental film-world gods standing in for their Greek antecedents, among them Andy Warhol as Poseidon (rather impotently peddling on an exercise-bike), Taylor Mead as the Demon and Jack Smith as Orpheus. Markopoulos establishes more than twenty such mythic characters, and through fifty minutes of intercutting and juxtaposition, explores their relationships and interplay.

Warren Sonbert, a young filmmaker in the circle of both Andy Warhol and Markopoulos, was also developing his own variant of distance montage in the mid-1960s, but under very different circumstances. His early works, such as *Where did our Love go?* (1966), are perfect mid-1960s time capsules, preoccupied with the new phenomenon of celebrity culture and stylishly done, but in editing terms still unremarkable. But with *The Tuxedo Theatre* (1968), Sonbert unveiled a form of distance montage in which he startlingly juxtaposed images

66 Gregory Markopoulos, *Twice a Man*, 1963

of white, cultured, urban Americans with people, cultures and landscapes from elsewhere in the world. He describes his mature films as 'accumulations of evidence'.[18] His ongoing subject becomes a reflection on the particularities and contrasts typical of the modern world – the differences and similarities between different races and cultures, familiar and alien gestures, contrasting attitudes to dwelling and landscape, artistic and social traditions. Spectacle is at the core of his work. His eye was attracted to any form of cultural display and to any choreographed behaviour, in the street (parades and protests), on the stage (music hall, ballet and opera), on the sports field, in markets and public parks, display among humans, even display among animals. His editing no longer offered a narrative or documentary argument. Rather, like Kubelka, he depended upon meaning emerging from shot-by-shot contrasts; the films are structured by visual rhymes – similarities between images – and the rhythm of his montage. He described one form of linkage:

In Rude Awakening *(1976) I [constructed] these series of what I call 'directional pulls' in which, let's say, a character reaches across the screen for a cup of coffee, and his hand goes in the direction of left to right, then the following image would be a plane taking off in that similar direction from left to right. One physical gesture will generate – in a widely differing time, space, focal length or exposure – something else. So there is that kind of continuum as well as contrast.*[19]

Markopoulos and Sonbert both associated their work with that of two of Hollywood's great narrative directors of the 1950s – Sonbert with Douglas Sirk, Markopoulos with Von Sternberg, from whom he learned by watching him at work in Hollywood. Sonbert's *Noblesse Oblige* (1981) was apparently structurally modelled on Sirk's *Tarnished Angels* (1957), and is the film in which the artist, who was to die of AIDs, comes closest to making a political statement, by filming the protests in San Francisco that followed the murders of Mayor George Moscone and the Councilman Harvey Milk, the first openly gay elected official in California.

 The Soviet-trained Armenian filmmaker Artavazd Peleshian developed yet another version of 'distance montage', consciously rejecting Eisenstein's theory of the creation of a 'third' meaning by the juxtaposition of two shots and instead exploiting the effect of key images repeated at a distance from one another, the shots sandwiched between them affecting our reading of the repeated ones. His films gain their rhythm from

the pattern of these repetitions, self-consciously mimicking musical form. His early, film-school-made *Mountain Vigil* (1964) was based entirely on archival footage, and celebrated the work of mountain people who risked their lives clearing falling rocks from a crucial railway, its non-linear structure suggesting an endless preoccupation; a heroic ongoing struggle rather than a particular achievement. *Skizbe* (*The Beginning*, 1967), again made at film school, evokes the Soviet 'beginning' – the events of the 1917 Revolution – using footage borrowed from Eisenstein, Vertov and others, ferociously edited to a mash-up of drumbeats and the sound of machine guns (mocking the rapid-fire montage of his elders). It then summarizes the subsequent challenges faced by the Soviet Union, including its struggles against the Nazis and the Cold War nuclear threat. A long, final shot of a child's face staring soulfully at the camera in close-up challenges us to keep up the struggle, to do better.

Peleshian's most abstract film, *Seasons* (1972), is ostensibly about the life of mountain sheep farmers, reflecting both how the annual seasons affect their work, and the 'seasons' in their lives – births, deaths and marriages. The imagery is extraordinary: haystacks being pulled down precipitous hillsides; men and sheep wrestling their way across furious rapids; the wedding of one of the men seen tumbling down the rapids; men careering down steep snow banks and scree while embracing struggling sheep. There is no logical narrative sequence, instead a cycle of life seen at its most visceral and extreme. Peleshian's later work seems a retreat from such bold abstraction, the heavy hand of state patronage perhaps compromising *Mer dare* (*Our Century,* 1982), his humorous/heroic montage on the theme of Man's venture into Space.

By the time Peleshian made *Our Century*, he had clearly seen the American artist Bruce Conner's inspired masterpiece *A MOVIE* (1958), and despite its honest borrowings, his film can hardly compete. Conner's astonishing film is a collection of found images extracted from newsreels and novelties, collaged into a sequence that starts with humour (early flying machines shaking themselves to pieces; people riding bizarrely shaped bicycles), progresses through things going seriously wrong (car crashes, the Tacoma Suspension Bridge oscillating itself to spectacular destruction), into natural disasters and war atrocities, and on to a final catastrophe – a torpedo launch and nuclear explosion – after which there is a hint of hope in an underwater shot of a platypus swimming upwards, towards the gleaming surface above. Conner would make many more such collages, often repeating and retiming his found imagery, forensically exploring aspects of American pop

67 Bruce Conner, *A MOVIE*, 1958

culture including the death of Kennedy, the fragile image of Marilyn Monroe, the testing of nuclear bombs and more. These remarkable films sit alongside his less well-known but equally original collage–sculptures.

Surrealism

Was the closing image of Eisenstein's *Strike* – a close-up of the eye of a slaughtered bull – in the minds of Luis Buñuel and Salvador Dalí when they planned the opening sequence of *Un Chien Andalou* (1929), the first great masterpiece of Surrealist cinema? This is the sequence as described in the original shooting script:

'Once upon a time'
A balcony. Night. A man [Buñuel himself] is sharpening a [cut-throat] razor by the balcony
The man looks through a window at the sky and sees...
A light cloud passing over the face of the full moon
The head of a young woman with wide-open eyes. The blade of the razor moves towards one of her eyes
The light cloud now moves across the face of the moon.
The razorblade slices the eyeball of the young woman, dividing it.
[title] 'eight years later'.[20]

This is an entirely different approach to editing. Where Eisenstein pursued his chilling metaphor logically through an evolving sequence of parallel horrors, Dalí and Buñuel present a reassuringly conventional image-sequence – 'once upon a time' / man / balcony / moon – only to round it off with a visual simile that delivers a deeply misanthropic shock, with no hope of easy assimilation, nor of any rational explanation. Buñuel himself described the whole film as 'a desperate appeal to murder'.

Surrealism provided the context in which artists were most able to radically challenge the audience's expectations of narrative continuity and development, essentially by appearing to obey the rules of narrative editing, then turning them against themselves. The aim was not a greater sophistication of meaning, as in the work of Dulac, Epstein and Eisenstein, but a fundamental disorientation in the viewer, thus to make room for the irrational and, uniquely, the subconscious. Indeed, Buñuel was keen to distance himself from the avant-garde: '[Our] film represents a violent reaction against what in those days was called "avant-garde", which was aimed exclusively at [an] artistic sensibility and the audience's reason.... [The] object

68 Luis Buñuel, *Un Chien Andalou* (*An Andalusian Dog*), 1929

is to provoke instinctive reactions of revulsion and attraction in the spectator'. [21] As early as 1923, the poet Robert Desnos had called for artists to explore the connection between cinema and dream, writing:

We go into the dark of the cinema to find artificial dreams and perhaps a stimulus capable of peopling our empty nights. I would like a filmmaker to fall in love with this idea. On the morning after a nightmare he would note down exactly everything that he remembers and reconstruct it in detail. It's not a question here of logic and classical construction but of things seen, of a superior realism, since this opens onto a new domain of poetry and dream. [22]

The irrational sequencing of images became a hallmark of Dada and the anti-film; what *Un Chien Andalou* added to this liberating approach was eroticism, as Desnos had requested. *L'amour fou*, 'mad love', was, and is, an enduring theme of

Surrealist cinema. (Particularly memorable is artist Jeff Keen's *Mad Love* (1978), his homage to Surrealist film made in the same vein: amateur, low-budget, episodic, reflecting its haphazard mode of shooting). It is possible to view *Un Chien Andalou* as a representation of frustrated male desire: the male protagonist is emasculated, ridiculously dressed and incompetent; his attempts to regain the woman of his dreams are endlessly frustrated; he is weighed down with life's absurd baggage (at one point he physically drags behind him a line bearing priests, bottle-corks, a piano and a dead donkey); he seems horrified by the woman's armpit hair, which through a dissolve transfers itself to his mouth, gagging him...and so on. Resisting interpretation, Buñuel wrote:

69 Germaine Dulac, *La coquille et le clergyman* (*The Seashell and the Clergyman*), 1927

In the working-out of the plot every idea of a rational, aesthetic or other preoccupation with technical matters was rejected as irrelevant...[The film] does not attempt to recount a dream, although it profits by a mechanism analogous to that of dreams.... NOTHING in the film SYMBOLIZES ANYTHING.[23]

L'Âge d'Or (1930), the other classic, equally disturbing Buñuel / Dalí collaboration, stirs blasphemy into the intoxicating mix, not least by depicting Christ as the leader of a group of exhausted libertines emerging from their orgies in the Marquis de Sade's Château de Silling.

The Surrealists did not have to be filmmakers in order to enjoy cinema. In later life, André Breton recalled his own means of achieving a Surreal cinematic montage:

When I was at 'the cinema age'...I [appreciated] nothing so much as dropping into a cinema when whatever was playing was playing, at any point in the show, and leaving at the first hint of boredom /of surfeit – to rush off to another cinema where we behave in the same way, and so on.... I have never known anything more magnetizing: it goes without saying that more often than not we left our seats without even knowing the title of the film which was in no way of importance to us anyway.... The important thing is that one came out 'charged' for a few days.[24]

Many artists' films have almost directly recreated this experience, among them the obsessive, nightmarish *La Verifica Incerta* (*The Uncertain Truth*, 1965) by Italian artists Gianfranco Barucello and Alberto Griffi, a film that clips together endless entrances and exits, comings and goings taken from otherwise forgettable westerns, thrillers and melodramas, resulting in mad leaps from space to space, from genre to genre, getting nowhere. Another is Joseph Cornell's *Rose Hobart* (1939), a collage of shots from the Hollywood B-movie *East of Borneo* (1931), from which he excised everything except shots featuring his idol, the now forgotten star who lends Cornell's film her name. With the plot dispensed with, what remains is an evocation of a cinema-goer's (perhaps ideal) state of consciousness, somewhere between sleep and waking. This allows a dreamlike focus on the heroine, now illuminated by moonlight (he gave his black-and-white film a blue cast), now threatened by sinister figures, now buffeted by gathering clouds. Nothing is explained; this is simply the heightened awareness that accompanies an obsession.

Themselves casual about appropriation, the Surrealists were mean-minded when it came to accepting the work of

fellow artists as truly 'Surrealist'. *Un Chien Andalou* and *L'Âge d'Or* were undisputed; Man Ray's *L'étoile de mer* (1928) and Germaine Dulac's *La coquille et le clergyman* (*The Seashell and the Clergyman*, 1927), both made earlier than *Un Chien*, were accepted by most, but the rest were contested and denounced. Man Ray was shocked to have his *Emak Bakia* (1926) rejected: 'I had complied with all the principles of Surrealism: irrationality, automatism, psychological and dramatic sequences without apparent logic and complete disregard for conventional storytelling'.[25] To some Surrealists it was too Dada-esque in its materialist references to camera and film-strip (it opens with a shot of Ray with his camera), and its rejection, rather than subversion, of storytelling. *L'étoile de mer* – based on a poem by Desnos – was better received. The poem attracted Ray because, as he said, it was already 'like a scenario for a film, consisting of fifteen or twenty lines, each line presenting a clear, detached image of a place or of a man or a woman. There was no dramatic action, yet all the elements for a possible action'.[26] Ray intercuts the poem's enigmatic lines – once again evoking unresolved sexual tensions – with his filmed images, which mix banal action with unexplained close-ups and image distortions.

Dulac's *La coquille et le clergyman* was initially denounced by the very writer of its scenario, Antonin Artaud. The plot, such as it is, follows the obsessive, erotic hallucinations of a priest who lusts after the wife of a general. Artaud had described *The Seashell* as not a story 'but...a succession of emotional states which are deduced from each other, as thought deduces thought, rather than thought reproducing the logical succession of events'.[27] Artaud objected to Dulac's introductory title, which described his deliberately incoherent scenario as 'a dream': 'Rêve de Antonin Artaud' runs the opening credit,[28] thus explaining its irrationality. This was not enough to reassure The British Board of Film Censors, who famously reported that the film was 'so cryptic as to be almost meaningless. If there is a meaning, it is doubtless objectionable'.[29]

Many later Surrealist films paradoxically take their lead from Jean Cocteau's *Le Sang d'un poète*, a work in which dream and myth have an equal part, and in which autobiography seems to play an essential, even dominant role. But where Buñuel insisted of *Un Chien* 'nothing in the film symbolizes anything', Cocteau might have said 'everything in my film symbolizes something'; classical allusions are evident in every frame. Cocteau was duly denounced by the Surrealists, but posterity would group his films with theirs, and reward

him with possibly a greater influence among film-making artists. *Le Sang d'un poète* documents 'the poet's quest', but can also be seen as a revisiting of the Pygmalion myth – the artist attempting to bring his artistic creation to life and suffering the consequences of his success. While it's a film of uncertain pace – there are sequences where the unclear action reveals Cocteau's inexperience as a filmmaker – his pictorial inventiveness more than compensates. In a talk given at its first screening at the Vieux–Colombier, Cocteau stressed the film's poetic mode rather than its Surrealism, though his simile is surreal:

In The Blood of a Poet *I have tried to film poetry the way that the Williamson brothers film the bottom of the sea. [A reference to the popular film-novelty* Expédition sous-marine des frères Williamson *(1912)]. It means letting-down the diver's bell deep inside me, like the diver's bell they let down deep into the sea. It means capturing the poetic state....*[30]

He then described some of the ways in which he achieved the effects that mark stages in his poet's search for his muse, and which make his film so memorable:

First you will see the poet go into *a mirror. Then he swims in a world neither you nor I know, but that I have imagined. This mirror leads him to a corridor, and he moves as though he's in a dream. It is neither swimming nor flying.... I nailed the sets [on their side] to the floor and filmed the scene from above. So the poet drags himself along instead of walking....*
In another scene, the poet has imagined his own creations so vividly that the mouth of one of them is imprinted on his hand like a wound; that he loves this mouth (that he loves himself in other words), that he wakes up in the morning with this mouth pressed-against him like a chance acquaintance. That he tries to get rid of it. That he rids himself of it onto a dead statue – that this statue comes to life – that it takes its revenge, that it sends him off into terrible adventures.[31]

These are adventures through which he explores his past, his quest for immortality and his death. The model of 'the poetic quest' pioneered here by Cocteau proved infinitely adaptable in the hands of the post-war generation of Californian artists who were among the first to adopt it. In the myth-based and symbol-laden films of Maya Deren, Kenneth Anger, Sydney Peterson, Gregory Markopoulos and the young Stan Brakhage, the quest of the 'poet' is now openly that of the artist-maker,

Jean Cocteau,
Le Sang d'un poète
(*Blood of a Poet*), 1930

either directly (the artist plays the leading role), or implicitly (the film-viewer directly shares the artist's journey, the camera's view is the artist's view).

Cubist Cinema

In 1924, Léger wrote of the origin of his film *Ballet mécanique*:

The war had thrust me, as a soldier, into the heart of a mechanical atmosphere. In this atmosphere I discovered the beauty of the fragment. I sensed a new reality in the detail of a machine, in the common object. I tried to find the plastic value of these fragments in our modern life. I rediscovered them in the Screen in the close-ups of objects... [Making the film] I worked as I had done before in painting. To create the rhythm of common objects in space and time, to present them in their plastic beauty; this seemed to me worthwhile.[32]

Cubist films – those that focus on 'the plastic value' of these fragments, or more simply those that 'bring different views of subjects together in the same frame, so appearing fragmented and abstracted'[33] – begin with Léger's 'ballet' and his close-ups of machines, which echo the imagery of his 'mechanical period' paintings of 1919–24. As Léger himself recognized, the 'rhythm of common objects' in his film is augmented by camera movement and editing, the latter based on the perceived spatial movement that occurs as the perspective in one shot gives way to that which follows. Léger was possibly the first artist to realize that one could make an engaging abstract film based solely on the choreography of space and movement in live-action footage, rather than the animated drawings of squares and circles (as in Richter et al.). He was equally alert to film's material qualities, and anticipated later artists' desire to make audiences aware of them too. This is clear from his own description of a famous sequence in his film, in which a shot of a woman ascending a staircase is repeated again and again: 'I wanted to amaze the audience first, then make them uneasy, then push the adventure to the point of exasperation...'.[34] Clearly, 'invisible' editing was dead. Léger's summary of the film's various sections suggests he was content for the work to be seen as a collection of discrete 'objects', united only by their rhythmic intercutting:

Charlot [his cubist Chaplin puppet] and title
Mechanical movement of objects in motion
Prismatic fracturing

71 Fernand Léger, *Ballet mécanique (Mechanical Ballet)*, 1924

Exercises in rhythm
External rhythms – humans and machinery
Titles and numerals
More exercises in rhythm;
a 'ballet mécanique' of common objects [pots and pans]
Charlot and woman in the garden [the woman filmed upside down,
and on a swing] [35]

Following in his wake, other contemporary artists declared
such essays in live-action abstraction to be a new form of
'pure cinema'. Henri Chomette's *Cinq minutes de cinéma pur*
(*Five Minutes of Pure Cinema*) and its companion piece *Jeux
de reflet et de la vitesse* (*Games of Reflection and Speed*, both
c. 1925) are even more loosely structured assemblages of shots
featuring chandelier fragments, grapes, glass rods and the
like – subjects clearly inspired by Léger's film – that spin
and rotate, and are intercut with landscape shots of winter
trees in brilliant sunlight and water reflections (examples

of *photogénie* perhaps?), all linked by in-camera dissolves and superimpositions. Richter's *Filmstudie* (1926) was also probably directly inspired by Léger's *Ballet*, though its visual rhyming and image similes recall the formal games of his only recently abandoned abstract animations. Closer to the original is Eugène Deslaw's *Marche des machines* (1928/9), a work completely dependent on the flow of rhythms between the images. Although mostly shot in one location, a steel-works with attached coal heaps, there is little reference to the purpose of the whirling machinery; dissolves and superimpositions further accent this abstraction. Deslaw had links with Futurist artists, and the Futurist composer Russolo accompanied some performances of his film using his noise-making *Rumorarmonio*, which must have added auditory strangeness to the whole.

More distantly related is the most convincing surviving Futurist film, *Velocità* (*Speed*, 1930), made collectively by the writers Tina Cordero and Guido Martina and the painter Pippo Oriani. This is known now only in a form edited by Deslaw in 1933 for a Spanish screening, and still has the charm of a very rough experiment. It is a loose assemblage of ideas rather than a grand composition, and one that admits its flaws – an evidently accidental lack of focus in some images sitting alongside sophisticated camera tricks and intentionally extreme focus-pulls elsewhere. Piled into the mix are pattern-making, references to the Futurist leitmotif of 'flight' (little model aeroplanes), slogans – 'Speed captures the dynamics of the city', handheld panning shots, whistling machines (Russolo's *Intonarumori*?), articulated lay figures and images of paintings inserted in homage to twentieth-century heroes such as Boccioni, Mondrian, Léger, and Kandinsky; all are rhythmically collaged together.

Often linked with Léger's film is Ralph Steiner's oddly un-balletic *Mechanical Principles* (1933), which, as its title suggests, can be seen as a didactic illustration of how energy is transferred and converted within engines by the action of gears, pistons, ratchets and so on, all shown in diagrammatic close-up and the kind of 'sliced-through' machinery that might be found in a science museum. Presented without commentary, the film offers little sense of how such transformed energy might be used, and so remains flat and pictorial, like an eccentric adjunct to the paintings of Steiner's friend Charles Sheeler. A more impressive American essay in Cubist form is Robert Florey's *Skyscraper Symphony* (1929), which intercuts shots of New York's towers, filmed in such a way as to reduce them to little more than geometric sculpture. Detached from

72

the ground – one never sees the streets on which they stand, and there's not a human figure in the entire film – camera movement and filming at odd angles reduces these giants to vast abstract blocks, which through editing become engaged in a slow-paced spatial performance.

Post-war Cubist films have most frequently been made in response to landscape, perhaps reflecting the difficulty of representing the human eye's capacity to scan and accumulate the distant view when limited by the narrow perspective of the film camera. Perhaps the most dedicated post-war Cubist filmmaker has been Ernie Gehr, who constructs compelling visual compositions from everyday street views, made fascinating by his editing, subtle superimpositions, repetitions and occasionally reversed – even upside-down – movement. His early *Still* (1969–70) shows New York streets at ground level, using long takes and little choreography other than that of human and vehicular traffic within the image. In its focus on the ordinary, it is indicative of things to come. What gives the film its interest is the occasional ghost imaging – the odd sense that people and objects are present but transparent – derived from superimpositions or reflections in the window between the camera and the view, adding a spatial ambiguity that is already Cubist. With *Shift* (1972–74), editing definitively adds to the choreography. Again a mundane street-view, it adds unexpected changes in the orientation of the image: some upside-down shots, some reversed left to right; some re-timing of shots, so that car movements are slowed or stop mid-track; and some changes in the direction of the daylight that alter the balance between foreground and background. These are all classic Cubist ploys. His masterpiece may be *Side/walk/shuttle*
73 (1991), with its shots taken from a glass external 'climbing' lift on the recently built Fairmont skyscraper hotel in San Francisco; this is architecture filmed as if it was an entirely abstract construction, as Florey had attempted in his earlier *Skyscraper Symphony*. Rectangular blocks (in this case adjacent apartment towers and offices), are filmed by an ever-travelling camera – sometimes climbing, sometimes descending exactly in parallel with the rectangle of the projected image, at other times with the camera tilting to hold one part constantly in view, producing radical changes in perspective. The shots frequently change their orientation – right way up, upside-down, sideways, forward, reverse-motion or seemingly slowed down – changes that enhance an abstract reading. As in *Ballet mécanique*, the pleasure is that of object-choreography, but here camera movement lends complexity to the interpretation of space. The whole has the feeling of a slow but vertiginous waltz.

72 Robert Florey, *Skyscraper Symphony*, 1929

The Pleasures of Editing

73 OPPOSITE Ernie Gehr, *Side/walk/shuttle*, 1991
74 RIGHT Hy Hirsh, *Autumn Spectrum*, 1957

Collage was an anti-illusionist technique widely employed by the Cubists. The USA has produced two artists, generations apart, who developed a variant of the Cubist film based on creating visual collages *within* the film frame – either through careful superimposition (Hy Hirsh) or by employing the optical printer used by Hollywood to create special effects (Pat O'Neill). Hirsh worked in California and Europe, O'Neill exclusively in Los Angeles. Inspired, like so many, by the example of Fischinger, Hirsh began making abstract animation films in 1951, while still producing documentary films for American television. He described his early live-action film *Autumn Spectrum* (1957), set to the Modern Jazz Quartet's *Autumn in New York*, as follows:

74

*A film-collage abstraction of images reflected on the water of
Amsterdam canals. Much importance is given the role of the
camera, for the entire conception, the composition, the 'montage',
the blending and superimposing of images are all accomplished
in the camera.... The whole film is in one 'scene' without a single
moment of darkness.*[36]

In further films, such as *La couleur de la forme* (1961), he
combined oddly assorted shapes in movement – flying birds,
fireworks, reflective surfaces, human silhouettes, vehicles – to
produce a seductive, fluid and rhythmic form of visual music.

 Hirsch's work, rarely seen outside California in the 1960s,
was a seminal influence on O'Neill. In an O'Neill film, collage
occurs within the frame as a result of matting-out sections of
the image and filling them in on a second pass through the
printer, often repeating the matting-out and filling-in many
times. In his episodic *Saugus Series* (1974), each of the seven
short films is 'an evolving still life' of 'meticulously assembled
but spatially contradictory elements'. In such an arrangement,
'the artist must always temper his repetition of movement of
forms with what might be called a certain amount of variety'.[37]
O'Neill achieves this variety and spatial complexity with a
decidedly West Coast delight in surreal juxtapositions. His
are the landscapes of an Ed Ruscha photograph or painting,
or a Hollywood backlot. The critic Jim Hoberman was an early
admirer, and memorably described a sequence in *Sidewinder's
Delta* (1976) 'when a giant trowel is plunged into the floor of
Monument Valley; it's as though John Ford had hired Claes
Oldenburg to dress his set'.[38] O'Neill recalled its making:

*The trowel scene was one of the first sections I got into a composite
state. I liked the way that the weather was revealing and obscuring
the horizon and its peaks. It kept repeating the 'tabula rasa' – the
blank whiteness of the screen... It was becoming a reflexive
situation, [as if] talking about the anxiety of image making. The
musical reverberation of the cement-finishing tool [trowel] had to
do with passivity, about waiting – waiting and playing with the
tools.*[39]

He identifies the sources of elements that he magically collaged
together in his optical printer to form another sequence: 'the
cactus is near Wickensburg, Arizona; the stone house in Indio,
California; the interior seen through the window is our kitchen,
and the light[bulb] and hand were shot in front of a blue-
screen'. Their combined effect is hypnotic; this is filmmaking
of ravishing visual inventiveness.

Chapter 5
The Conceptual Film and Other Phenomena

In Conceptual art, the presentation of the idea is enough; nothing else is needed. The Conceptual film and the closely related Structural film both emerged during the 1960s and 1970s, and their makers were united in their belief that films should present the artist's ideas just as they were, without elaboration or explanation; one thought, or the recorded trace of an event, or an observation, even one simple process carried through to its conclusion, should be enough. A shared characteristic of the work of this new generation was the rejection of narrative in any form. Out went montage and any interest in film's ability to mimic patterns of thought. A clear shape for the work was seen as important; this might be all that the viewer had to hold on to as the work unrolled. The pleasures offered by these idea-based films are often as much to be derived from *thinking* about the work after exposure to it, as from *looking* at it – though most works offer that pleasure too.

When making films, artists associated with Conceptualism have tended to express indifference to the technical processes involved. The artist and occasional filmmaker Marcel Broodthaers voiced an attitude that was typical of many:

I'm not a filmmaker. For me, film is simply an extension of language. I began with poetry, moved on to three-dimensional works, finally to film, which combines several artistic elements. That is, it is writing *(poetry),* object *(something three-dimensional) and* image *(film). The great difficulty lies, of course, in finding a harmony among these three elements.* [Later, he added, voicing the attitude of many Conceptual artists] *I don't believe in film, nor do I believe in any other art. I don't believe in the unique artist or the unique work of art. I believe in phenomena and in people who put ideas together.*[1]

While sharing this belief in the primacy of ideas, Structural filmmakers were by contrast notoriously serious about their medium. For them, the vitally important question was 'what is the essential nature of the moving image?' (whether film or video). Filmmaker and photographer Hollis Frampton commented on this fascination with film's materiality:

For the working artist, film is an object as well as an illusion. The ribbon of acetate is material in a way that is particularly susceptible of manipulations akin to those of sculpture. It may be cut and welded, and painted upon, and subjected to every kind of addition and attrition that doesn't too seriously impair its mechanical qualities.[2]

Some artists, as we shall see, have ignored even that last precaution. This focus on the physical medium was no guarantee that works would offer easy visual pleasures, though often they do. They also frequently demand sustained thought before their meanings become clear.

The Conceptual Film

The simplicity of the Conceptual film can be taken to extremes. The artist may not even need to lift a camera to make a 'film' – a filmic idea expressed on paper might suffice. Dieter Meier's *PAPERFILM – (idea by Dieter Meier, directed by you)* (1969) consists of a set of instructions: 'turn the sheet [this sheet of paper]; hold the sheet close to your eyes – so that you see nothing but white; open and close your eyes in a certain rhythm'. Typographically, he offers a series of patterns (a word 'open' or 'close' is ½ second):

open	*open*
open	*open*
open	*open*
close	*close* [3]

In its form – a child-like game – Meier's film reflects the wry humour of many Conceptual works, while more seriously echoing one of the dominant concerns of experimental filmmaking artists in the 1970s – the attention paid to film's basic materials, here light and its absence. Other 'paper' films show a critical relationship with cinema's mainstream, again a concern shared by many contemporary experimental filmmakers, and another example of the humour characteristic of the Conceptual film. In 1964, Yoko Ono published a number

75 Anthony McCall, *Long Film for Ambient Light*, 1975

of one-line *Film Scripts* in which she asked the audience, for example, 'not to look at Rock Hudson, but only Doris Day', or, using scissors, to 'cut the part of the image on the screen that they don't like'. [4]

Other 'filmless' Conceptual films replace humour with metaphysics, and at the same time manage to offer a tangible temporal-visual experience for those prepared to *look*. Such films were identified as 'paracinema' by Ken Jacobs, a term later expanded upon by film theorist Jonathan Walley.[5] Anthony McCall's *Long Film for Ambient Light* (1975) was a site-specific work that drew attention to the changing behaviour of the daylight penetrating the white-paper-covered

75

windows lining two sides of a New York loft over a fifty-day period, together with a statement pinned to the wall about the important dimension of time (or, in 1970s language, 'duration'). Annabel Nicolson's expanded cinema performance *Matches* (1975) quietly focused on light at its briefest and most elemental – the vulnerable yet hypnotic single flame of a match – which in a context of impenetrable darkness fleetingly allows a text on candle-power to be read alternatively by two performers, each striking her match in turn and reading until the flame extinguishes.

Perhaps reassuringly, most Conceptual films are firmly embedded in the material of celluloid film or videotape. Arguably the first artist to offer viewers a film-as-idea was Marcel Duchamp, the creator of 'readymade' works such as *Bottle Rack* (1914) and the celebrated urinal *Fountain* (1917) – creative acts that inaugurated the whole field of Conceptual art. Duchamp exhibited his enigmatic *Anémic Cinéma*, made with the assistance of Man Ray and cineaste Marc Allégret (and credited to his own alter-ego Rrose Sélavy) at the Studio des Ursulines in Paris in 1926. This was in part a close-up film record of his *Rotorelief Discs* (1923) – a set of spiral-shaped designs that, when spun, generate compelling illusions of depth – which he intercut with a series of absurdist palindromic puns such as BAINS DE GROS THÉ POUR GRAINS DE BEAUTÉ SANS TROP DE BENGUÉ (baths of fat tea for beauty-marks without too much Bengay [a muscle-relaxing cream]); and ESQUIVONS LES ECCHYMOSES DES ESQUIMAUX AUX MOTS EXQUIS (let us avoid the bruises of the Eskimos of exquisite words). Written in spiral form, these too spin before the camera. There are nine such enigmatic sayings, and the difficulty of deciphering, let alone comprehending, these spinning texts is of course deliberate, echoing the now-you-see-it, now-you-don't optical illusions of the discs. Academics have struggled over the film's possible coded meanings, but perhaps most importantly, and more simply, it provided a model for other visual artists who had ideas suited to dissemination through film. Many so-called Conceptual films from the 1960s and 1970s would be similarly associated with artworks in other media or performances, and many of these would be similarly teasing or obscure in their meaning. In Duchamp's case, the Studio des Ursulines audience was used to being outraged by artists' contributions, and there is no record of riots at the film's premiere; more likely, the audience expressed the kind of intrigued puzzlement that still frequently greets the film today.

Few of the Conceptual artists who have made films have done so exclusively. On the contrary, for the majority,

76 Marcel
Duchamp,
Anémic Cinéma,
1926

filmmaking was, or is, a secondary activity at best, the films
sitting alongside works in many other media. The Conceptual
pioneer Robert Morris uniquely managed to fuse a time-
based process with the body of a static object in his witty and
widely influential *Box with the Sound of its own Making* (1961),
a plain wooden box containing a tape recorder re-playing in
full the sounds of the sawing, hammering, and sanding that
had gone into its construction. Being time-based itself, film
offered a reliable means of recording ideas about process

77 Robert Morris,
Mirror, 1969

and performance, two closely related and widespread artistic concerns in the 1960s. For example, the Catalan avant-garde composer Carles Santos's film *La Cadira* (*The Chair*, 1967) offers the static image of a chair accompanied by an unexplained cacophony of chair-making, his version of Morris's *Box* challenging the spectator to deduce the connection between image and sound that Morris's title had made explicit.

When Morris himself turned to film, he showed a rare appreciation of what Epstein would have described as *photogénie* (the uniquely cinematic) in works such as *Mirror* (1969), a tightly choreographed and spatially intriguing interplay of large, hand-held mirror, film camera and snowy landscape, and *Slow Motion* (1969), a series of tight close-ups of a figure pressing forward against a glass revolving door, as if against the screen itself, all shot in slow motion. Morris apparently dictated instructions for the making of the latter film, in a supremely Conceptual gesture of artistic detachment.

Many films-as-ideas are designed to catch time-based visual phenomena, either fabricated by the artist or just 'found' in the environment and identified as worthy of recording. Among the most memorable of these, and certainly among the most widely seen at the time, were the series of short works commissioned and shot by German artist and gallerist Gerry Schum for his pioneering made-for-television series *Land Art* (1969). Here, the unexpected viewing context added to the 'puzzle' quality of the works. In Barry Flanagan's *Hole in the Sea*, for example, a continuous shot records waves breaking on a shoreline, mysteriously sweeping around some invisible barrier to reveal the eponymous 'hole' in the sea (in fact a glass cylinder embedded vertically in the sand, directly beneath the camera). In another, Jan Dibbets's *Twelve Hours Tide Object with Correction of Perspective*, a tractor ploughs a drawing into the surface of a sandy beach. Through its action, it manages to create a rectangular shape that exactly echoes the frame of the screen, in defiance of our expectations of the effects of distance and perspective, before the whole artefact succumbs to the incoming tide – an optical deception similarly explored by David Hall in his film *Vertical* (1970). Another notable film in Schum's series was Richard Long's *Walking a Straight 10 Mile Line Forward and Back Shooting Every Half Mile (Dartmoor England, January 1969)*, a succession of fixed-camera shots looking ahead, taken at within-sight intervals along one of Long's straight line walks.[6] An artist-cum-impresario, Schum was extraordinarily in touch with the artistic climate of his time. In *Identifications* (1970), a second series made for television, he assembled works by a further roster of soon-

78 Barry Flanagan, *Hole in the Sea*, 1969

to-be-famous names – Keith Sonnier, Peter Roehr, Mario
Merz, Josef Beuys, John Baldessari and the first of Gilbert and
George's film-performances, *A Portrait of the Artists as Young
Men* (1969/72), in which they stand, looking at each other, doing,
well, very little.

The context of broadcast television, exploited by Schum,
was dramatically unlike that of the art galleries in which most
Conceptual films and videos were shown. The British artist
David Hall was keenly aware of this, and his *TV Interruptions*,
aka *7 TV Pieces* (1971), made for Scottish Television, formed
part of his life-long assault on broadcast television's power

and its dominance in everyday life, and gave his particular idea-films a unique force and purpose. He asserted that the interruption of the expected flow of broadcast programmes by 'alien' and unexpected images momentarily transformed the television receiver into a sculpture:

Often I attempted to interface reality and image, apparatus and illusion – the spatio/temporal ambiguities of the medium. In one [of the TV Pieces] a water tap appears in the top corner of the blank screen. The tap is turned on and the cathode ray tube 'fills with water'. The tap is removed. The water is drained out, this time with the water line obliquely inclined to the expected horizontal. The screen is again blank – normal service is resumed, and the illusion restored.[7]

Attacks on broadcast television, and indeed cinema as an institution, would become a major theme in work by artists more generally associated with the 'anti-film', described later.

79 Gilbert and George, *A Portrait of the Artists as Young Men*, 1970

80 David Hall, *TV Interruptions* (*7 TV Pieces*), 1971 (installation version, 2006)

Fluxus and Other Phenomena

Artists associated with Fluxus, the international movement founded in the early 1960s by George Maciunas, made a speciality of the idea-film, and helped to popularize the form among their contemporaries. Fluxus was opposed to the precious art object and the whole apparatus of the art market; it focused instead on celebrating creative acts of discovery, particularly those located in the everyday. 'Promote living art, anti-art, promote NON-ART REALITY,' was one demand in Maciunas's *Manifesto* of 1963, though of course some Fluxus participants ended up fully embroiled in the gallery system. The diversity of the group made Fluxus the natural meeting-place of the anti-film, the Structural film and the Conceptual film. Within the group, artists were allowed to sign their film works individually, but were expected to submit them to an agreed numbering system (in practice at least until their individual careers took off). It was a movement prone to denunciations and dissent, but Macunias rightly complained when the critic P. Adams Sitney published his influential 'Structural Film' article in 1969, which identified the new formal tendency in the avant-garde but failed to properly acknowledge the formality of the already substantial body of Fluxus film work.[8] Because they are so simple, Fluxus films are almost invariably perfectly formed in Structuralist film terms.

First in sequence (at least numerically so) came Nam June Paik's *Fluxfilm no. 1, Zen for Film* (1962–64), a Conceptually pure work made for contemplation, consisting of a projected length of clear film in which visual and aural interest is almost incidentally provided by the slow accumulation of scratches and dust, by-products of its screenings. There are many such echoes of John Cage's 'sound' work *4'33"* (1952) in the realm of the idea-film. In the *Fluxfilm Anthology* we have eight minutes of clear film; in other iterations of *Zen for Film*, simply a loop. Numerically second came Dick Higgins's *Fluxfilm no. 2, Canyons and Boulders* (1966), a close up of the artist's open mouth chewing; a visual simile. Later works included Maciunas's *Fluxfilm no. 7, 10 Feet* (1966), in which the film strip serves as a measuring tape as it counts the feet between start and finish, and George Brecht's *Entrance to Exit (Fluxfilm no. 10)* (1966), which perhaps celebrates the darkened room of cinema; between the illuminated entrance sign at the beginning of the film and an exit sign at the end, we see nothing, but experience the passing of time. A comment on the emptiness of commercial cinema-going?

Maciunas's *Fluxfilm no. 20, Artype* (1966), and Paul Sharits's *Fluxfilm no. 29, Word Movie* (1966) are both animations of a sort,

81

the former made by applying various Letraset (Benday) dots and line-patterns to clear film, the latter by filming plain colours and fifty single words in one frame each, 'so that the individual words optically/Conceptually fuse into one 3½-minute-long word'.[9] Both films dissolve in projection into a blaze of flashing light, the latter seeming to contain an additional impossible-to-decipher written message. Yoko Ono's *Fluxfilm no. 9, Eyeblink*, was one of several works shot at ultra-high speed (at 200 frames-per-second, by photographer Peter Moore), as was Chieko Shiomi's *Fluxfilm no. 4, Disappearing Music for Face* (1966), in which Ono's smile fades from view (a focus pull?). That Ono felt free to revisit this concept in her portrait of John Lennon, *Film no. 5 (Smile)*, demonstrates the Fluxus belief that ideas are free and transferable; art is not a commodity.

In 1966, Maciunas gathered together a collection of 'Fluxfilms' and issued them on one reel via the Filmmakers Co-op in New York, but others continued to be added to the list, some made earlier and adopted by Fluxus. Among the latter were Wolf Vostell's collage film involving fleeting images snatched one frame at a time from television, *Fluxfilm no. 23, Sun in Your Head* (1963), and several by the Italian-born French artist Ben (Ben Vautier), including a self-portrait of the artist sitting on a bench in Nice, *Fluxfilm no. 41*, *Regardez-moi, cela suffit* (*Look at me, that's enough*), made as early as 1962. These are wonderfully simple in both form and content. In an alternative version, *Fluxfilm no. 38 (*1966), Ben stands, head wrapped in bandages, holding a sign saying '*Je ne vois rien, je n'entends rien, je ne dis rien*' (*I see nothing, I hear nothing, I say nothing*); perhaps an inspiration to Gilbert and George? Another early Ben 'film' in the same spirit was a poster displayed at the Cannes Film Festival in 1963, announcing:

Ben, créateur de l'art total; Cannes ville 1963; FilmVérité crée par l'intention d'une réalite totale; lieu de projection partout; écran vos yeux; réalisation (le tout) Ben; interprétation vous; musique (la vie) Ben; mise en scène Ben; durée illimitee; couleur naturelle.

In essence, he dismisses the labours of the film industry on display nearby and claims the viewer's moment of reading his text as an ongoing, jointly authored cinematic work of art. He boldly claims the creative *grand prix* for the film and even offers viewers a certificate of their participation: 'receive your certificate as participant in this total-art'.

82

81 OPPOSITE Paul Sharits, *Word Movie*, 1966

82 Ben Vautier, *Je ne vois rien, je n'entends rien, je ne dis rien* (*I see nothing, I hear nothing, I say nothing*); *Fluxfilm no. 38*, 1966

Ben saw himself as an inheritor of the Lettrist mantle, making this poster his supreme anti-film. More characteristically, in his *Traversée du port de Nice à la nage* (*Swimming Across the Port of Nice*, 1963), he jumps fully clothed into the sea, after which the camera zooms out and reveals the distance he has to swim. Now a tiny point in the distance, he swims towards the camera, the film running out as he reaches the shore; his arrival evokes relief, intentionally or otherwise. Among his *Actions de rues* (*Street Actions*, 1952–79), some live performances, some filmed (of which *Je ne vois rien...* is one), are films in which 'I sleep on the ground; I set up a table in the middle of the street and serve food as in a restaurant; I set myself up at the exit of a gallery and sign the works of other artists; I make the same gesture twenty times', and so on. Where much Conceptual art is dry and austere, Ben's work of the 1960s and 1970s is simultaneously formally rigorous, questioning, humorous, faintly absurd and, not least, a celebration of the pleasures of French life – the outdoor café, the Mediterranean, the French corner shop. In fact, the Pompidou Centre holds the contents of the tiny shop he created and ran as a 'total work of art' in Nice.

Another artist who enjoyed a semi-detached relationship with Fluxus was Robert Filliou. His works, like Ben's, are seriously playful and often seem determined to get art off its pedestal; to connect with more mundane activities. His *Do It Yourselves Erotic Film* (*Faites-le vous-mêmes*) (1972) offers viewers a series of projected handwritten instructions for achieving pleasure: 'clasp your neighbour by the neck', 'put your hand on his knee' (all fairly innocent stuff), while *Düsseldorf ist ein guter Platz su schlafen (Dusseldorf is a good place to sleep*, 1972), filmed by Tony Morgan, shows the artist's apparent satisfaction with the comforts of a cobbled street surface. Dusseldorf in the early 1970s was a hub of new-media activity and exhibitions, so was indeed 'a good place' to be an avant-garde artist. In his *Double Happening* (1970), also made with Morgan, he and the performance artist Emmett Williams are discovered sitting in adjacent toilet cubicles (apparently the women's bathroom in the Dusseldorf Art Academy), doors open; a third figure enters and passes in front of them, not initially noticing the seated men, then says something off camera to which the artists respond loudly, in unison: 'we happen to be making a film!' This is perhaps a satirical response to Warhol's earlier films of daily human activity – *Eat*, *Sleep*– or at the very least a demonstration of how an idea, however humble, can be transformed into a film. In an even earthier mode, Morgan, working this time with Daniel Spoerri, made *Résurrection* (aka

83 Bill Woodrow, *Floating Stick*, 1971

Beefsteak Resurrection, 1968), featuring another essential bodily function: we follow the cyclical path of the eponymous steak from human excrement to cow, visiting *en route* the toilet, plate, frying pan, slaughterhouse and field. Every action is seen in reverse motion; the 'resurrection' of the film title. Spoerri commented that the film was made in response to an argument between the artists about the different attitudes of the English and French to cleanliness and shit.[10]

Particularly poetic examples of 'fabricated' visual phenomena recorded as Conceptual films are works by the sculptor Bill Woodrow, and another Yoko Ono/John Lennon

collaboration. Woodrow's *Floating Stick* (1972) consists of two short reels of Super8 film, in which the camera follows the flight of a nondescript stick as it magically floats horizontally a few feet above the ground through fields beside a stream, before finally dropping into the water and drifting away. This is cheap magic, for one occasionally sees the string and rod from which the stick is hanging, but the flight is no less captivating for that. (The film was made at the same time as Woodrow's *Untitled E46* (1971), in which the same stick is the physical link between two photos of itself; one in the sky, one in water). More expensive magic – but still utterly engaging – is Ono and Lennon's *Apotheosis* (1970), made (unusually for the time) with a professional production team and with money no problem, in which the artists are seen climbing into the basket of a balloon in snow-bound Lavenham, Suffolk, before an apparently continuous ascent to the heavens, passing through heavy clouds and on into the clear blue above. The idea of filming an 'apotheosis', an act which implies a release from earthly life, was apparently Lennon's, and may reflect his desire to escape the trap of celebrity, or perhaps to anticipate a new phase of artistic and domestic life with Ono. There are many more such films based on single visual ideas or wry observations of daily activity. In contrast to some Conceptual artists of the 1990s, who seemed determined to make their fortune through art-making, the generation to which Ben, Filliou and Spoerri belonged seem to have been dedicated artisans, happy for their art to celebrate or question the ordinary and to freely share their gifts with all comers. Certainly, none made money from these films.

Performance

In the later 1960s and early 1970s, a number of artists began making studio-based performance works specifically for the camera. Perhaps they were inspired by the Fluxus films, or challenged to do better by the often inadequate documentation of contemporary live performance works, such as the dance-based collaborations of John Cage, Merce Cunningham and Robert Rauschenberg *et al.*, the 'happenings' of Claes Oldenburg and Alan Kaprow or the early dance works of Yvonne Rainer, Lucinda Childs and others. Among these new filmmakers were Bruce Nauman, Vito Acconci, Richard Serra, Rebecca Horn and Dennis Oppenheim, all of whom created works based on intimate, ritual-like acts of performance. What distinguishes these works is their formal simplicity and rigour; being designed for the screen, their 'choreography' is limited

to movement within the tight visual field of the usually static camera, so the framing is fixed, the visible space is limited and, to keep things simple, the length of the work is determined by the length of a film-roll or of a roll of videotape, frequently shot in a single take without later editing. The activity depicted is similarly limited – repeated gestures, variations on a theme, a 'game' or a set of 'tests'.

Characteristic of the genre, and one of the earliest examples, is Bruce Nauman's *Bouncing Two Balls between the Floor and the Ceiling with Changing Rhythms* (1967–68), in which the artist attempts to bounce balls in a specific pattern within a square marked by tape on the studio floor. It is a game of controlled performance and its failures. The challenge to the viewer in such works is to recognize the pattern underlying the depicted behaviour and to work out its rules. Nauman made several variants on the *Bouncing Balls* theme with different rules, and then, perhaps alert to echoes of the compulsive behaviour of teenage boys, mocked his own obsession by producing a final variant – simply *Bouncing Balls* (1969), a close-up of his testicles, bouncing in filmed slow motion. More cerebral are his *Dance or Exercise on the Perimeter of a Square* (1967–68), a courtly quadrille for a solo dancer, and, in another twist, *Pacing Upside Down* (1969), a long video in which he walks around the marked square, hands over head, in ever-increasing circles, often exiting the frame. The whole performance was shot by an upside-down camera, so he appears to be walking on the ceiling.

An iconic Conceptual film – and one of the first of its type to be bought by museums, thanks to its author's fame as a sculptor – is Richard Serra's *Hand Catching Lead* (1968), a series of close-ups of the artist's grubby hand and forearm repeatedly attempting to intercept, generally unsuccessfully, a small lead sheet dropped from above by an unseen participant (his reflection, perhaps, on the high failure rate of most artistic enterprises). Shot in black-and-white, with fixed camera and no sound, it reveals Serra's fascination with this heavy metal and sits alongside sculptural works in which he made lead perform in different ways – balanced, rolled up, propped and (in molten form) splashed into its final shape. Serra went on to make a magisterial record of a 'found' metal sculpture – his *Railroad Turnbridge* (1976). The camera observes the complex swing-bridge structure that spans the Willamette River in Oregon as it opens to let a boat pass beneath and closes again to let a train pass though, and so on. Most engagingly, in a film structured by editing, we also see *through* the length of the structure as it turns, and watch the distant landscape sliding mysteriously

84 Bruce Nauman,
*Bouncing Two Balls
between the Floor and
Ceiling with Changing
Rhythms*, 1967–68

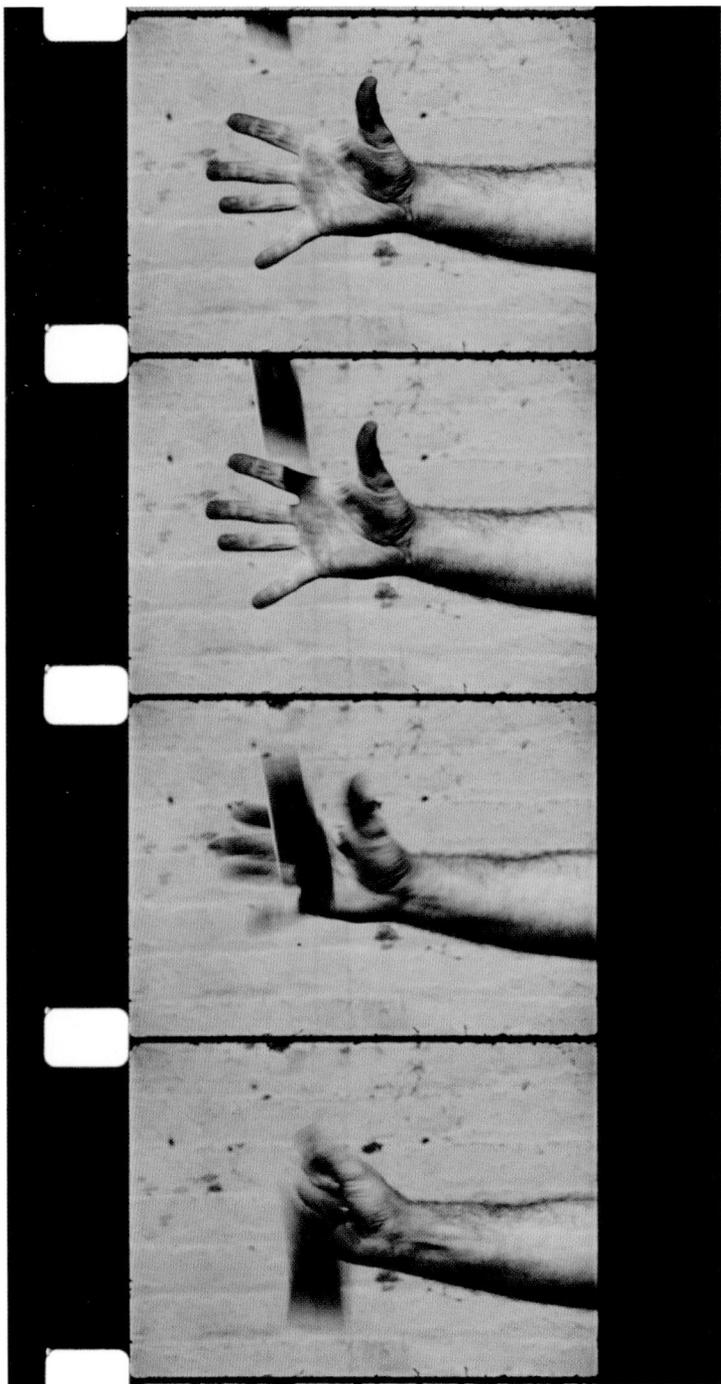

85 LEFT Richard Serra,
Hand Catching Lead, 1968
86 OPPOSITE Vito Acconci,
Pryings, 1971

past the aperture of the open bridge-end, echoing the 'window' of the film screen.

The early films of Vito Acconci, such as his *Three Attention Studies* (1969), are formally choreographed 'actions' that contain just a hint of dramatic development, the source of which is usually offscreen. His description:

In Looking Around Piece, *the performer stands before a fixed camera, which records his eye and head movements as he follows a moving object outside the frame. In* Starting Piece, *the performer starts too far away to be captured by the camera; as he walks down the hill, he gradually enters the frame. In* Catching Up, *the performer and cameraman walk side by side across a field. Sometimes the performer falls behind as the camera continues its pace; the performer must make an effort to catch up and return into the frame.*[11]

Later works include a series based on subjecting his body parts to extreme behaviour that in turn induce an almost visceral response in the viewer. In *Grass/Mouth*, the first of *Two Takes* (1970), he stuffs grass into his mouth till he chokes; in the second, *Hair/Mouth*, he similarly fills it with the hair of a seated woman. Our uncomfortable response to such actions could be cited as a textbook example of the viewer identifying with the performer onscreen, essential to mainstream cinema, but here given an intimacy and ambiguity unfamiliar to Hollywood.

His series of works based on live performances with Kathy Dillon are also deliberately, uncomfortably voyeuristic. In one,

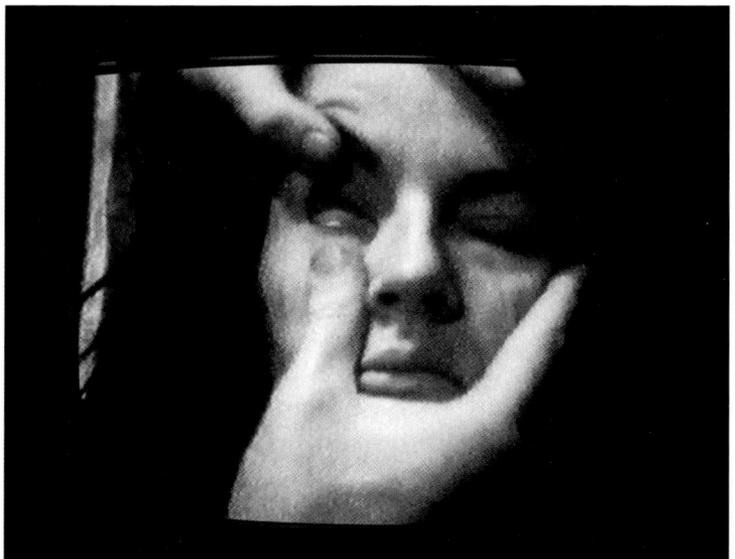

Pryings (1971), 'a study in control, violation and resistance', the camera focuses on Dillon's face as Acconci tries to prise open her closed eyes; her resistance is palpable as his attention to her oscillates between sadistic and caring. In another film, the two-screen *Remote Control* (1971), we see Acconci and Dillon crouched in wooden boxes in different rooms, each facing a static camera and video monitor, and watch his attempts to manipulate her actions as though by remote control. Communicating across the space between the screens, he instructs her to tie herself up with rope, and 'shows' her: 'I'm bringing the rope over your knees…I'm lifting your legs gently'. The erotic overtones in these exchanges rapidly become disturbing.

In films such as *Einhorn* (*Unicorn*, 1970) and *Pencil Mask* (1971), Rebecca Horn has recorded performances that seem the realization of a private, intimate reverie, involving the actor using strange prosthetic attachments to the upper body or face. Recalling the filming of *Einhorn*, Horn said:

> [I had a vision] of this woman, another student. She was very tall and had a beautiful way of walking. I saw her in my mind's eye walking with this tall, white stick on her head which accentuated her graceful walk…. [I measured her and built] this body-construction that she would have to wear naked…I invited some people and we went out to this forest at 4am. She walked all day and she was like an apparition.[12]

Pencil Mask seems a response to darker, more disturbing visions. Wearing the claustrophobic head-covering mask that bristles with outward facing pencils, the wearer frantically draws marks on an adjacent wall as if trying to communicate.

The short actions recorded in the films of Dennis Oppenheim are simpler speculations on the theme of human communication, and also implicitly explore the limited ability of the moving image to transmit physical feelings. In *Arm & Wire* (1969), he engages the viewer's empathy, showing 'my arm rolling across electrical cording; the impressions produced by the downward pressure are returned to their source and registered in the material that expends the energy'.[13] Similarly, in *Identity Transfer* (1970), we see in close-up Oppenheim pressing the nail of one index finger into the tip of the other, leaving a temporary indentation. In *Compression: Poison Oak* (1970) he painfully crushes and compresses a bunch of poison oak leaves with his right hand; in *Air Pressure (Hand)* and *Air Pressure (Face)* (both 1971), we see his hand/face distorted by a jet of air from a high-pressure air pump. In *Disappear* (1972), he

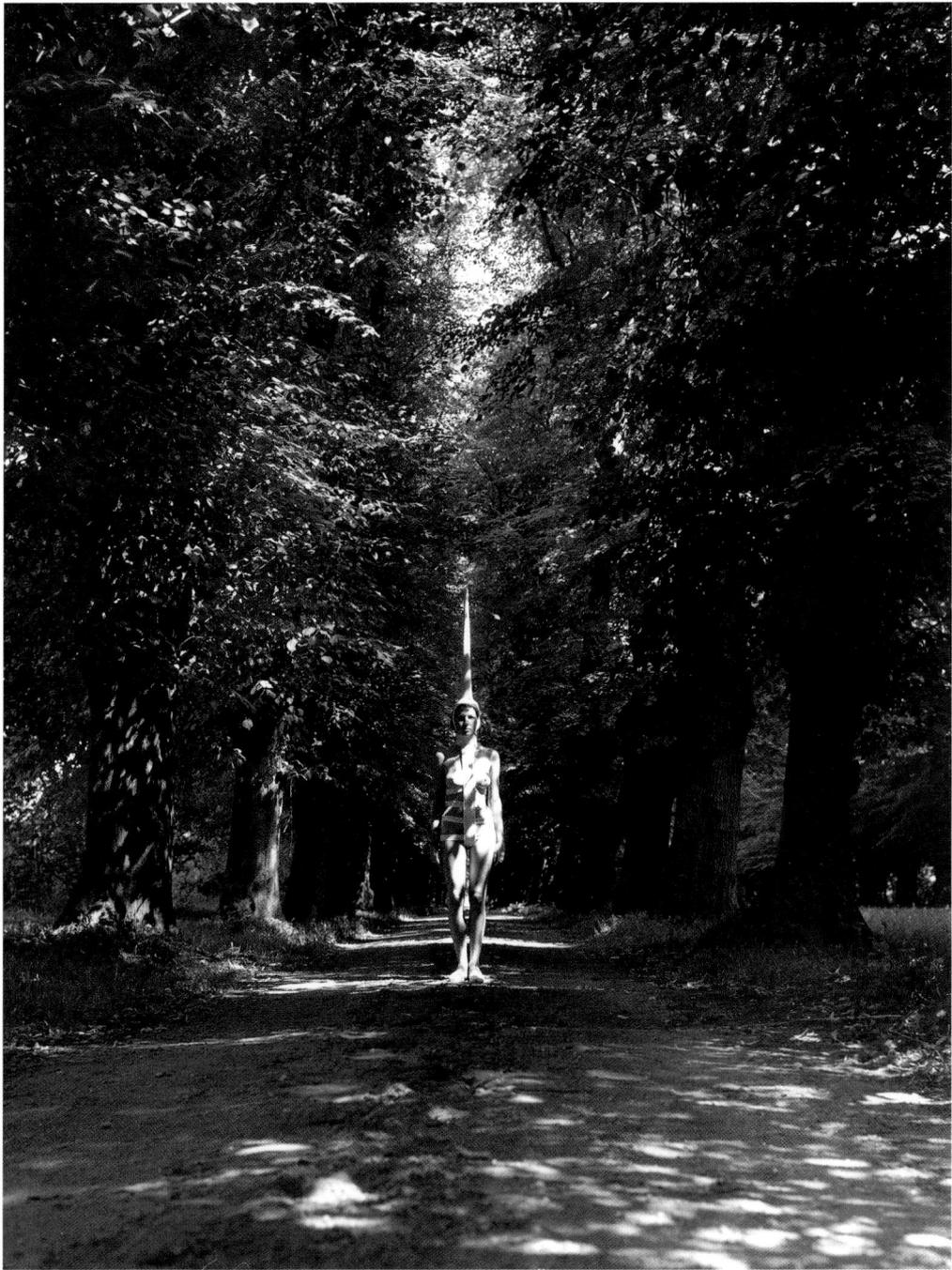

87 Rebecca Horn, *Einhorn* (*Unicorn*), 1970

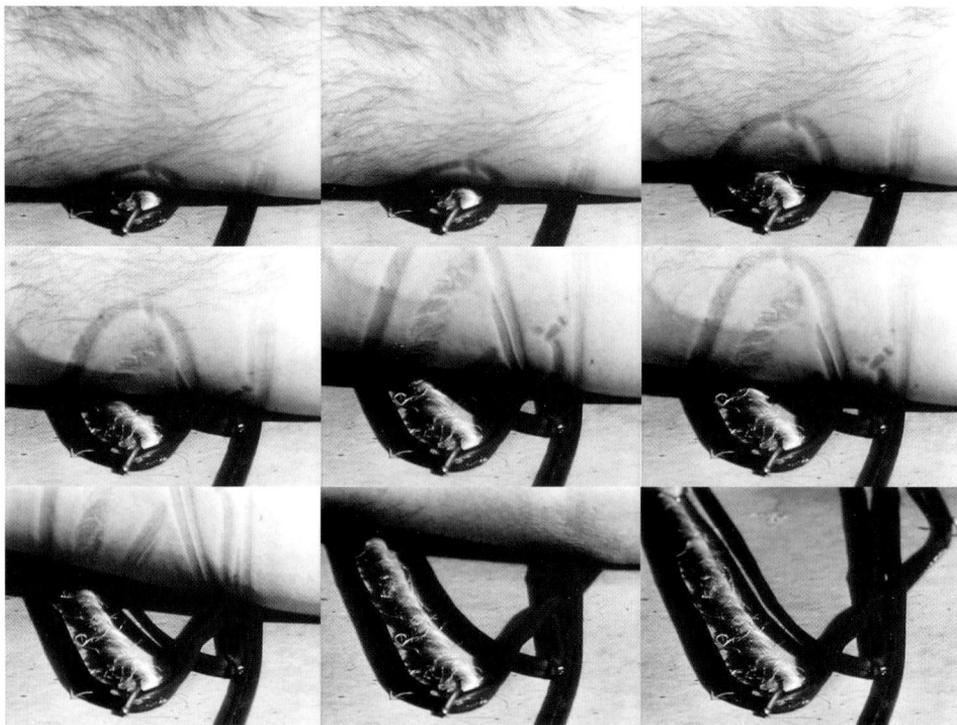

88 Dennis Oppenheim, *Arm & Wire*, 1969

attempts to will his hand to dematerialize, chanting his wish while moving his hand faster than the camera can process the image, turning it into a fuzzy blur; the viewer experiences a dematerialization that is invisible to him.

The outpouring of film and video works by artists in the 1970s was remarkable, and saw performance-based works made by artists as varied as Marina Abramović, Lynda Benglis, Joseph Beuys, Ian Bourn, Chris Burden, David Critchley, Dore O, VALIE EXPORT, Gary Hill, Nancy Holt, Joan Jonas, Ana Mendieta, Tony Oursler, Jayne Parker, Nam June Paik, Robert Smithson, William Wegman and Lawrence Weiner, among many others. Only a few stayed the course to become dedicated filmmakers. John Baldessari was so struck by this profusion that he dedicated some of his own contributions to lampooning the whole enterprise. In *I Am Making Art* (1971), his own slight, ineffectual body movements mock the whole notion of performance-based art, while in *I Will Not Make Any More Boring Art* (1971), he pointedly subverts his declared resolution by writing the film's title over and over again for the film's

89

89 John Baldessari, *I Will Not Make Any More Boring Art*, 1971

duration. Even more caustically, in *Baldessari Sings LeWitt* (1972), he undermines this apparent tribute to one of Conceptual art's key figures by setting thirty-five of Sol LeWitt's more serious pronouncements to the tunes of contemporary popular songs (and sings them very poorly....)

One turns to the films of Dutch artist Bas Jan Ader with relief. His work is Conceptualism at its most enigmatic yet poetic, and its most personal. Rarely more than a minute long, his films record actions that embody the feeling of risk universally experienced by artists as they launch into making a new work, and confront the likelihood of failure. Many depict acts of falling, seen distantly, as if to suggest their 'ordinariness' and even their inevitability. In *Fall 1* (1970), he is seen sitting on a chair at the apex of the roof of his Los Angeles home; he deliberately tips over, slides, and falls to the ground. In *Fall 2* (1972), he rides his bike off the quayside and into an Amsterdam canal. In *Broken Fall (Organic)* (1971), we see him high in a tree, hanging by his hands and edging out along a slim branch until his grip gives and he falls into the stream

90

90 Bas Jan Ader, *Fall 2, Amsterdam*, 1970

below. Hinting at personal tragedy, *I'm too sad to tell you* (1970) is a three-minute, silent, black-and-white close-up self-portrait of the artist crying. Concurrently with the making of this work, he sent postcards to friends with the film's handwritten title as its only message. He certainly embraced subjectivity in his work. Do we also need to know that when he was two years old, his father was shot by the Nazis for sheltering Jews? How much is our reading of these films also coloured by the knowledge that he died at sea while making *In Search of the Miraculous* (1975), a work that required him to sail alone from Cape Cod, Massachusetts to Falmouth in Cornwall?

The spectacularly sculptural films of Gordon Matta-Clark record his startling Conceptual interventions into nondescript buildings. In one, he saws down the middle of a wooden house in New Jersey to the point where the two sides sag apart (*Splitting*, 1974). In another, he removes large, perfect circles from the exterior walls, floors and ceilings of a Paris townhouse to create spatial cone-shaped voids (*Conical Intersect*, 1975). Matta-Clark explained that 'The conical shape, cutting like a periscope through the old Paris into the new, [the Pompidou was being built nearby] was inspired by Anthony McCall's film

Line Describing a Cone (1974)'; one Conceptual work inspiring another.[14] His films preserve both the extended surgical processes of transformation, some of which took days to accomplish, and the ephemeral, precarious, even dangerous final state of his labours. Like Rachel Whiteread's *House* (1993), her complete cast of the inside of a modest East London terraced home, none of these extraordinary sculptures survives.

Today, half a century later, almost every artists' film shelters under the banner of Conceptual art, and the term has lost much of its original meaning. One looks to an artist such as Francis Alÿs for a sense of the original spirit. Alÿs is very much the child of Ben – witty, but with an added twenty-first century awareness of the fragility of culture and strangeness of modern life. In *Paradox of Praxis pt 1 – Sometimes Making Something Leads to Nothing, Mexico City* (1997), he pushes a large rectangular block of ice around the streets of Mexico City, leaving a damp trail like that of a snail, until the block is no more. His *Zócalo May 20 1999* (1999) is a twelve-hour continuous shot of Mexico City's Plaza de la Constitución (known as the Zócalo), a place created in the nineteenth century for militaristic parades, where people now seek shelter from the blazing sun in the shade of its vast central flagpole, the Madre Patria. As the shadow moves imperceptibly, clock-like, around the square, the sheltering humans move too. In 1968, in the same square, civil servants were forced to congregate to welcome the new government, but instead began bleating like sheep; and so in *Patriotic Tales* (*Cuentos Patrioticós*, 1997), Alÿs has a shepherd leading sheep round the Madre Patria flagpole in an endless circle – a perfect loop-film. The digital replication of the sheep – one is added every circuit until the film's midpoint, from which point they decrease at the same rate – sustains this continuing, ironic carousel (the civil servant's daily grind?) In response to the Taliban's ransacking of the Kabul film archive and attempted incineration of its contents in 2001, Alÿs made *REEL–UNREEL* (2011), in which we see children play with hoops, running with them through the dusty streets, markets and urban fields of Kabul, dodging heavily laden lorries, cars, motorbikes, donkeys, flocks of sheep and goats, other excited children and passers-by. Early on, the hoops become 35mm film reels, and as one child unspools film onto the ground, another far behind is reeling it up again, mimicking the healthy life of a film. At the end of its twenty-minute journey through the city, the unspooling reel jumps a small fire, then to the children's consternation careers over a sheer drop (their cultural inheritance gone?) Visual metaphor,

91

91 Francis Alÿs (In collaboration with Julien Devaux and Ajmal Maiwandi), *REEL–UNREEL*, 2011, Kabul, Afghanistan

used so boldly by Dulac, the Themersons and Deren, remains a powerful driver in many Conceptual films.

The Lure of the Material

Throughout the decades associated with Conceptual and Structural film, artists showed a particular fascination with the material qualities of film and video. No aspect of the 'stuff' of the moving image went unexplored – neither the materials involved in its creation, nor the processes involved in its reception. It is no coincidence that this was the period in which artists began to organize their own production resources, filmmaking workshops and laboratories, editing facilities and exhibition spaces, all of which involved a new intimacy with the materials with which they worked. But that alone hardly explains the joy with which they undertook the task. The functions of the film camera, the projector, the screen, the projected cone of light, the film-strip, all became subjects for investigation; likewise, the limitations and imperfections of early video cameras and the bulb-like television screen set in its wooden or plastic box. Equally, the more Conceptual processes of editing, framing the image, lens function and even the relationship with the audience were legitimate subjects. Artists at last fell in love with their medium in all its messy materiality.

Nam June Paik perhaps kickstarted this celebration of the material with an installation version of his Fluxus *Zen for Film*. Its projector and hanging loop of film formed part of the work on show; it was an invitation to look more deeply at the relationship of film-strip, projector and screen image. His later *TV Buddha* (1974), a seated Buddha contemplating a video monitor on which his own 'live', motionless image is being shown (tirelessly recorded by an adjacent video camera), played a similar 'year zero' role in relation to the history of video materiality. Yet, remarkably, some of the earliest examples of artists celebrating film's material essence appeared not in New York, Paris, London, Dusseldorf or Cologne, but in the former Yugoslavia, in a series of works shown at Zagreb's Genre Film Festival in the early 1960s. *K3 ili Čisto nebo bez oblaka* (*K3 or Clear Sky without Clouds*, 1962) by Mihovil Pansini, shown at the 1963 festival, consisted of bits of clear but slightly tinted film, edited together. Until this moment the maker of Deren-like psychodramas, Pansini was offhand about the work, initially more concerned with its shock value than its materiality. He saw his work as a contribution to the anti-film, but revealed his fascination with the material as he defined it as '[a] precise

92

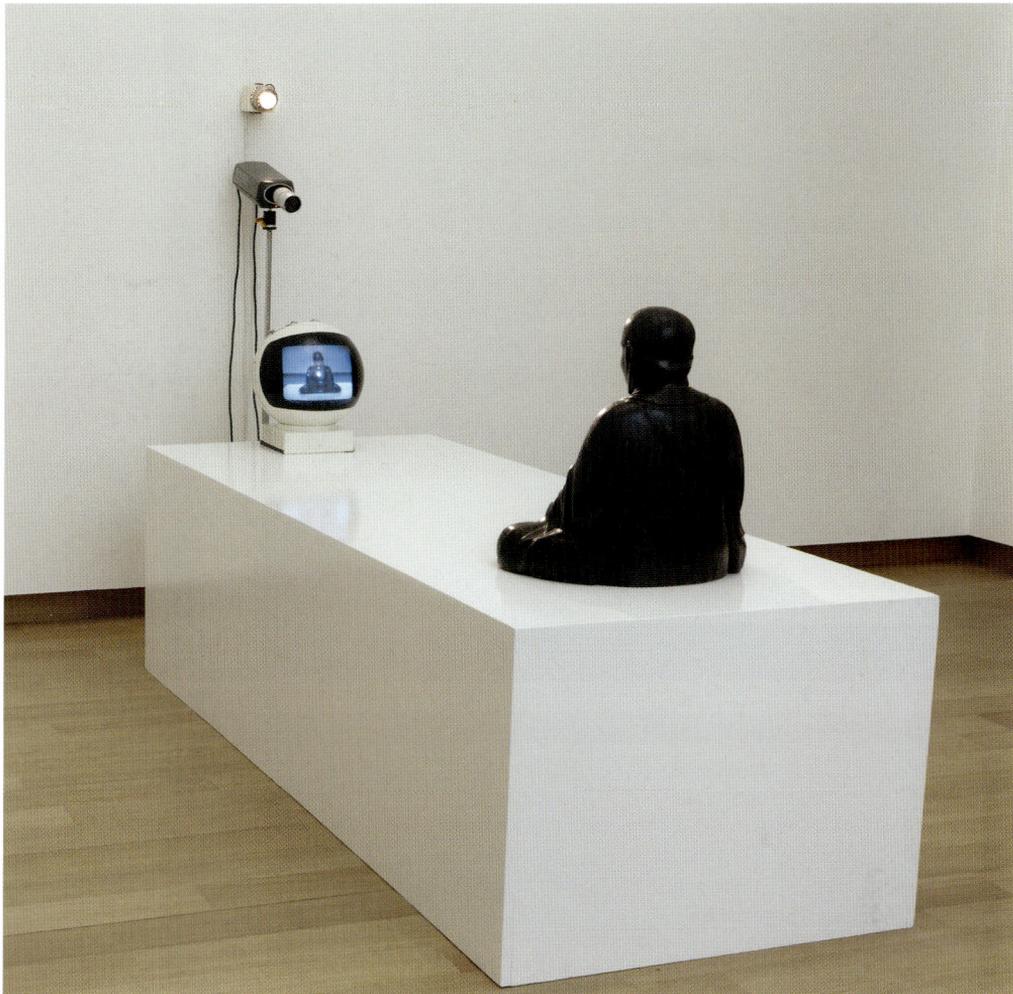

92 Nam June Paik, *TV Buddha*, 1974

execution, balance of idea, maximal simplification of the
work;...nothing but a pure visual-acoustic phenomenon.'[15]

 Intending to mock Pansini and his new focus on the film-
strip and projector, his colleague Milan Samec made *Termiti*
(*Termites*) (1963), a film of stains made by spilling developer onto
the unexposed film-strip, which when projected were animated
into life. This demonstrated materiality so successfully that it
was embraced as a perfect exemplar of the anti-film by Pansini
and his supporters and entered the canon. Following on from
that, Zlatko Hajdler's *Kariokineza* (*Kariokinesis*, 1965) was a

93

93 Milan Samec, *Termiti* (*Termites*), 1963

The Conceptual Film and Other Phenomena 183

performed work involving film-strip and projector, in which the film is manually arrested so that the projector's claw progressively shreds the static image, which then melts and burns in the heat of the projector lamp, projection making these savage attacks visible. Similar performances with the film-strip would soon be repeated across Europe and North America, though in ignorance of these Yugoslav precedents.

The 'film-strip-as-subject' film that became most widely known to contemporary audiences was George Landow's *Film in Which There Appear Sprocket Holes, Edge Lettering, Dirt Particles, etc...* (1966), an eleven-minute film of looped imagery featuring a blinking woman – the 'china girl' image originally used by the Kodak Company to test colour reproduction – but printed off-centre by Landow, to make visible the sides of the film-strip, now brought to the middle of the image. Once again, we are asked to focus on components not normally seen; the woman's blinking is almost subliminal, the eponymous 'sprocket holes, edge lettering, dirt particles, etc' being the true subject of the film. That Landow chose a 'found object' reflects his Fluxus heritage, while other artists made marks directly on the film-strip in order to achieve a comparable impact. Perhaps the most extreme example comes again from Tony Conrad, in another early instance of expanded cinema. His *4X Attack* (1973) is the brief record of – indeed simply the surviving remnants of – a strip of unexposed 16mm film (the Eastman 4X black-and-white film stock of the title) that has been violently battered with a hammer. Conrad gathered the bits together, flashed the film with a strobe (to expose it) 'to activate the stress record' and developed (chemically fixed) the collected bits in a cheese-cloth sack, then reassembled them into a projectable film. Here, the Dada anti-film directly meets 'film-as-material'.

In *7302 Creole* (1973) Conrad literally cooked film stock together with chicken and other classic Creole ingredients and fed the results into the projector (the number 7302 denoting a specific black-and-white film-stock used for making positive copies from negatives, apparently essential to the recipe). The critic Branden W. Joseph witnessed a recreation of this spectacle and gives a graphic description of the hapless projectionist's struggles with the greasy, chicken-covered film strip, which pleasingly caused 'Structural film' effects on-screen as it struggled to get through the projector-gate: 'the meat ran all over the projector and it was full of grease and chicken. It slipped in the gate [causing the effects] and stank

94 OPPOSITE George Landow, *Film in Which There Appear Sprocket Holes, Edge Lettering, Dirt Particles, etc...,*1966

The Conceptual Film and Other Phenomena

because the lamp heated it up, and it was really like an olfactory experience, and it tested the skill of the projectionist who was covered in slime!"[16]

95 The recipe for Wilhelm and Birgit Hein's *Rohfilm* (*Raw Film*, 1968), the first major film of German Structural cinema, was:

dirt, hair, ashes, tobacco, fragments of cinematic images, sprocket holes and perforated tape...glued onto clear film. This then projected and re-photographed from the screen, since the thick, glued strips technically allow only one projection. During this process, the original [film-strip] gets stuck now and then in the projector gate, so the same image appears again and again, or the frames melt under the excessive heat of the projector which is running at a very slow speed. The ensuing film is put through all kinds of reproductive processes, projected as video, displayed on an editing table and a viewing machine, and is filmed again in order to capture the specific changes engendered solely by the processes of reproduction.... 8mm film is run through the viewing machine without a shutter and re-photographed so that the frame borders and perforations – in other words the film strip as material – becomes visible.[17]

96 Annabel Nicolson's expanded cinema performance *Reel Time* (1973) allowed the audience to share the projectionist's private experience of the physicality of film passing through the projector, which is usually concealed within the exclusive space

95 OPPOSITE Wilhelm and Birgit Hein, *Rohfilm* (*Raw Film*), 1968
96 BELOW Annabel Nicolson, *Reel Time*, 1973

of the projection box. But the pun concealed in the work's title reflects that its true subject is located elsewhere, while remaining equally materials-based. Here, the whirr, clatter and spilling light of the projectors (there are two) is accompanied by the similar clatter of a manual Singer sewing machine that the artist is using to sew into the filmstrip. This strip then makes its way via a long hanging loop back into one of the projectors to reveal its evolving material development, while the other projector illuminates the scene and casts the artist's shadow onto a second screen. Two texts are haltingly read in sync, with pauses caused by the perforated film-strip inevitably breaking; one a manual on the projector's functions, 'how to thread it; how it works', the other on the sewing machine's functioning, again 'how to thread it, how it works'. The piece makes a point about 'labour' as well as function, and for Nicolson expressed 'the difficulties and frustrations I was having with the medium I was drawn to'.[18] Recent Feminist writers have seen a critique of traditional male and female realms of activity in this work; more simply, Jonas Mekas, who saw an early performance, delighted in how the struggling projector revealed 'the film slipping very beautifully'.[19]

Immersion in the processes of filmmaking, and particularly time spent at the editing table, where film can be viewed forwards and backwards and at any speed, has led some artists to forensically examine existing films and their embedded imagery. Through the camera lens, they peer at the film emulsion and investigate the shallow boundary between the still and the moving – the moment of transition from still to moving that so transfixed Maxim Gorky when he first encountered cinema. In *Tom Tom the Piper's Son* (1969), Ken Jacobs invites us to spend two hours chasing narrative details and ambiguities present in the film grain in a 1905 Biograph one-reel novelty shot by D. W. Griffith's great camera operator, 'Billy' Bitzer. With more political eyes, the artists Yervant Gianikian and Angela Ricci Lucchi revisited footage shot in the early twentieth century by the Italian documentary filmmaker Luca Comerio, who filmed remote people and locations in an unquestioning spirit of celebration. Borrowing the title of Comerio's most successful work, their film *From the Pole to the Equator* (1986) picked over, slowed down and examined his now decaying footage to reveal instead the predatory nature of man and the unthinking violence of the whole colonial enterprise.[20] More simply, and in an act of homage to a master of narrative film, Douglas Gordon took Alfred Hitchcock's classic *Psycho* (1960), a film famed for its qualities of suspense and horror, and drained it of both by projecting it at two frames

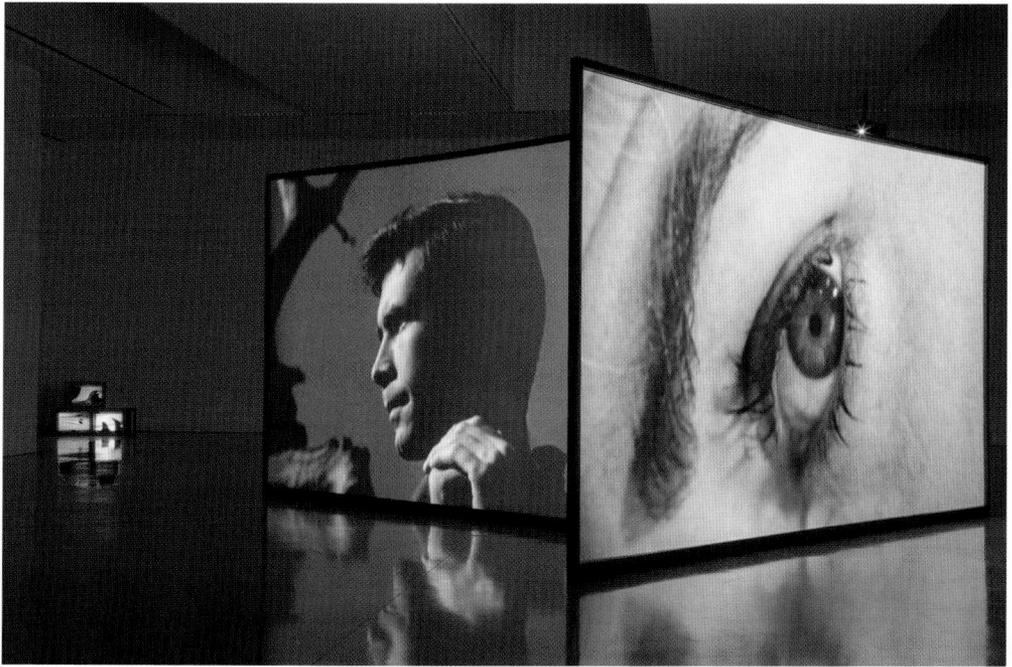

97 Douglas Gordon, *24 Hour Psycho Back and Forth and To and Fro*, 2008

97 a second rather than the customary 24, to create his *24 Hour Psycho* (1993). Thus transformed, we struggle to remember any narrative cause and effect, and see instead its formal beauty, its perfect composition in the frame, the stately progress of a zoom shot, a sudden change of viewpoint, images of extreme action rendered abstract. Fifteen years later, Gordon effected another transformation, now projecting the slowed-down film on two screens side-by-side, one version running forwards, one backwards. Twelve hours in, the screens momentarily show the same image: an additional game is played.

 The physicality of the cone of light emitted by projectors has also been celebrated by artists in many ways. In *Take*

98 *Measure* (1973), William Raban made tangible the cone's length; we watch as the filmmaker unrolls 16mm film between the projector and the screen, using his prepared film-strip as its measure: 'The projector starts, and the film snakes back through the audience, as it is consumed by the projector. The screen image is a film-footage-counter which [thus] measures the 'throw' of the cinema'.[21] Space is thus united with time through the projector's intervention. In Anthony McCall's *Line Describing a Cone* (1974), the beam of light is made visible by

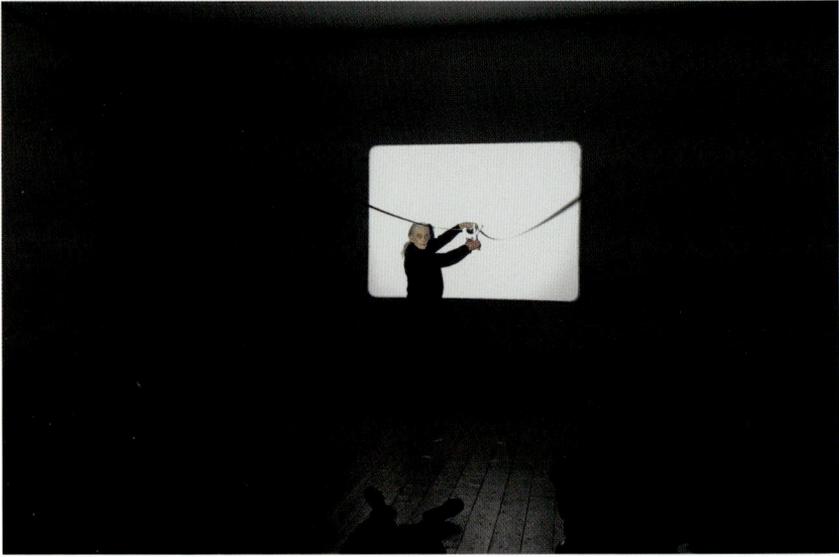

98 William Raban, *Take Measure*, 1973; performance view, 2017

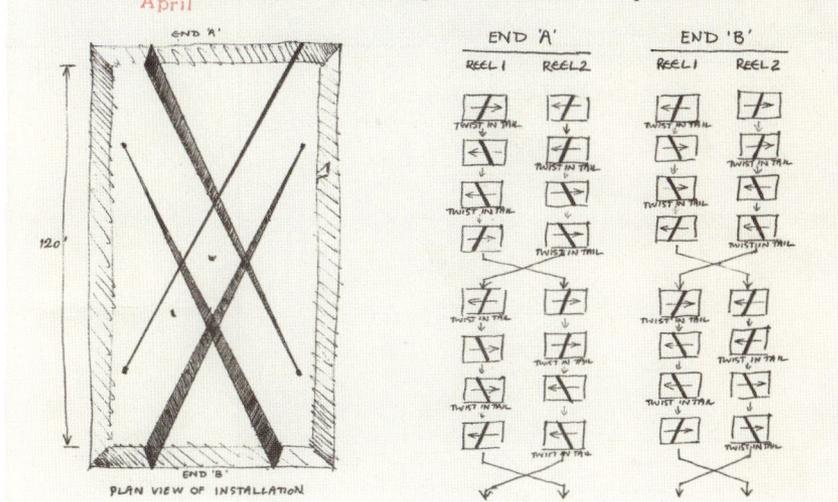

99 Anthony McCall, *Long Film for Four Projectors*, 1974

being projected into a haze of smoke or mist. A white dot grows
into a circular line and becomes a laser-like beam penetrating
the auditorium's darkness, so forming the eponymous cone
over the film's thirty-minute duration. *'Line Describing a Cone*
is what I call a solid-light film. It is dealing with the projected
light-beam itself, rather than treating the light-beam as a mere
carrier of coded information, which is decoded when it strikes
a flat surface (the screen)'.[22] Blaise Cendrars would have been
delighted; as early as 1919, he observed:

*Above the spectators' heads, the bright cone of light wriggles like
a dolphin. Characters stretch out from the screen to the projector
lens. They plunge, turn, pursue one another, criss-cross, with
a luminous, mathematical precision. Clustered beams. Rays.
Prodigious spirals into which everything is falling. Projection of
the sky falling. Life from the deep.*[23]

Apart from the growing circle, there are no images as such
in McCall's version, but comparable 'characters' are created
by swirls in the mist. McCall has produced many variants,
all elegant and absorbing. For example, in *Long Film for Four
Projectors* (1974), the projectors are set at either side and at a
distance from the ends of a long rectangular room, and make
symmetrical sweeping movements in the mist.

99

The Conceptual Film and Other Phenomena

Throw out of focus.

100 Morgan Fisher, *Projection Instructions*, 1976

The camera–filmmaker relationship has been repeatedly celebrated and explored. 'Self-shooting' (today's 'selfie') might be thought the sole subject of Lutz Momartz's *Selbstschusse* (1967), a film in which we see what the camera sees as the beaming artist repeatedly throws it into the air above him and catches it. But it is also, more enduringly, a visual cry of pleasure at the camera's workings, an affirmation of the essential connection between the 'camera-eye' and 'I' the filmmaker. The same joy of intimacy is present in Gill Eatherley's *Light Occupations* (1973), a series of short visual poems – almost haikus – that include *Lens and Mirror Film*, *Hand and Sea* and *Lens Hand Foot*. These record moments of seemingly spontaneous (but tightly planned) interplay between camera, artist and subject; her image in a mirror, her shadow on the ground, her hand and foot seen in and out of focus.

100 The role of the projectionist – a contributor to the cinematic experience usually unnoticed – is brought centre-stage in Morgan Fisher's *Projection Instructions* (1976). The audience and the projectionist both see a set of instructions onscreen, designed to explore the elements in a film's performance that the projectionist controls – not just focus, racking and sound volume, but also house lights and the movable masking of the screen surrounds. That risks are involved is demonstrated when the onscreen command 'throw the image out of focus' results

in the subsequent instruction being unreadable. Fisher has made a career of such skilful and witty deconstructions of the cinema experience. His *Production Stills* (1970) is one of many films or performances by artists that set out to document the process of their own making. In Fisher's example, he illustrates each stage in the act of filming the very film we are watching through the medium of Polaroid images placed sequentially before the camera, nothing else. Initially a blank rectangle, the images ripen into full clarity as we watch:

I gave the Polaroid camera to Thom [Andersen, a noted filmmaker himself] and the cinematographer turned the camera on and the film shows the pictures that Thom took, while on the soundtrack we hear the process of his taking them. The fact that what you see *in the Polaroids is something that already happened and that* what you hear *is something that you don't yet see [it will be the subject of the next image] is what the film gave me.*[24]

This disjunction between image and sound is what gives the film its fascination. Conventionally, 'production stills' are taken as an *aide-memoire* while a film is being shot; here, they constitute the film itself.

Some films that lay bare the filmmaking process also embrace the complex business of developing and printing the exposed film, a process usually carried on remotely in the film laboratory. Steve Farrer's *100 Foot Show (Audience Arriving at LFMC – Entering the Courtyard)* (1976) directly recalls the Lumières' *making-showing* practice. The audience attending the London Filmmakers Co-op's tenth birthday celebration was recorded on a 100-foot roll of film as they arrived for the show, and the film was immediately developed in the Co-op's lab and projected as part of the show they were attending. In its black-and-white, silent, slightly blotchy form, with its images of figures emerging from a gateway, it very consciously echoed *Workers Leaving the Lumière Factory* (1895), which one assumes must similarly have been initially shot for its subjects' pleasure and bemusement.

As film entered the gallery at the turn of the century, a new generation of artists rediscovered the attractions of film's materiality. Tacita Dean's well-known devotion to celluloid film, and her campaign to preserve its manufacture in the face of the digital takeover, is reflected in her insistence that the film projector should be a visible part of any installation of her work. In works by Rosa Barba, one often sees the projected film writhing within a transparent box attached to the projector – its convolutions occupying the time it spends between its being

101 Joan Jonas, *Vertical Roll*, 1972

spewed out at the rear of the projector and its inevitable fate of being swallowed up and projected again.

The materiality of video was and is both more elusive and more problematic. Immediate feedback – the possibility of reviewing and so accepting or rejecting the material just shot – proved a bonus to many, the potential 'liveness' of the image inspiring new forms of pleasure. Video also offered limitless possibilities for direct audience participation. In an early example, Bruce Nauman's *Going Around the Corner Piece* (1970), closed-circuit video cameras and artfully placed screens allowed viewers to chase their own image, always seen mysteriously 'ahead', at a distance, from the rear and tantalizingly disappearing 'around the corner'. David Hall's *Progressive Recession* (1974) played the same game, but deliberately more confusingly; as the viewer moves through the installation, the layout of cameras and images 'progressively separates and distances the viewer's image from its origin'.[25]

Hall's *This is a Video Monitor* (1974) and *This is a Television Receiver* (1976) used the language of Structural film (repetition and re-filming from the screen) to insist on the materiality of

102 Stephen Partridge, *Monitor*, 1974

the wooden box and glass screen of the television set, as did his witty, more Conceptual *7 TV Pieces*, discussed earlier. His *Videcon Inscriptions* (1974) capitalized on the susceptibility of the videcon tube – a component of early video cameras – to 'burning' by intense hotspots of light, leaving snail-trail-like after-images that echo the camera's earlier movements. Joan Jonas's *Vertical Roll* (1972) rejoiced in the very instability of early video – the tendency of the image to 'slip' rhythmically and blur as a result – creating a classic Structural work with an engaging Minimalist percussive soundtrack. Stephen Partridge's *Monitor* (1974) celebrated another attractive vulnerability of video, the effect of 'feedback' – the screen-within-a-screen that appears when a camera sees its own live image on a video monitor. Rotating the monitor onto its side resulted in a chain reaction of further turns of the monitors visible onscreen, each multiplying the effect of the last, so plunging into an endless, twisting perspective.

Since video was a new medium and subject to a relentless drive for visual novelty, there were snares for artists in the form of off-the-peg visual effects that could be added when editing.

The Conceptual Film and Other Phenomena 195

Artist and Happenings-creator Allan Kaprow warned against these and other visual clichés, many associated with Structural cinema, not least among them the video artists' 'relentless fondness for time-lag devices'. Here he might be criticizing Nauman's *Going Around the Corner*, or Dan Graham's much-celebrated installation *Time Delay Room* (1974), in which the spectators moved between two mirror-image rooms containing built-in monitors showing the people in the 'other' room, one monitor 'live' and the other with an eight-second delay, offering them 'inconsistent impressions' and leaving them 'trapped in a state of observation...caught in a feedback loop', as Graham suggested. Kaprow saw such video environments as resembling 'World's Fair "futurama" displays with their familiar push-button optimism and didacticism. They are part fun-house, part psychology lab....' He concludes that 'Until video is used as indifferently as the telephone, it will remain a pretentious curiosity'.[26] There are echoes here of Brunius's rant against technique for technique's sake, but Kaprow's final observation is prescient; no one in the early 1970s would have conceived that a mobile phone (itself a device of the future) would become the most commonly used apparatus for video recording. And today, with video indeed being used 'as indifferently as the telephone', the artist's moving image has fully entered the age in which 'the individual voice' has become dominant.

Chapter 6
The Anti-Film and the Formal Film

The anti-film and the formal film are probably artists' film at its most challenging. Close siblings, one savagely rejects all existing cinematic rules, while the other obsessively imposes new ones. The anti-film has its roots in Dada, and assaults the viewer by upsetting all the conventions of narrative cinema. The formal film fiercely asserts its own structure – sometimes resorting to mathematical systems (the Metrical film), sometimes painstakingly deconstructing the language of narrative cinema (the Structural film), often with an assertiveness equal to that of the anti-film. Both can be understood as artists' responses to the 'drugged and enchained' state of mainstream cinema, as Buñuel saw it.

The makers of the formal film, like the makers of the Conceptual film, saw their works as 'objects' that were complete in themselves. They were not 'about' anything else; the material onscreen, be it film or video, was subject enough in itself. Harking back to the debates of the 1920s, they asked, 'what is the essence of the moving image? what makes it unique?', and, going further, 'what processes are involved in our 'reading' of film, and can these be made transparent to the viewer?' The new approaches to 'process' and 'making' associated with Conceptual Art offered these artists one set of models to draw upon; the arrival of Film Studies as a new academic discipline suggested others. Paradoxically, but perhaps inevitably, what eventually compromised both the anti-film and formal film was precisely their inbuilt desire to renew cinema and reinvigorate the moving image.

Anti-Film and Anti-Television

The first warriors associated with the anti-film's assaults were filmmakers involved in the final fling of Dada in the 1920s; artists for whom any form of logic was the enemy. Later anti-film combatants reappeared in the form of Lettrist artists, the Yugoslav anti-film movement and even Fluxus's more anarchic wing. Their final assault in the 1970s was upon television, the new opium of the masses.

The first undisputed masterpieces of the anti-film were both almost incidental in their origin, being commissioned by Dada's artist–impresarios Tristan Tzara and Francis Picabia as time-fillers that might add the novelty of film to planned theatrical outrage-performances. Man Ray's brief (three-minute) *Le retour à la raison* (*The Return to Reason*) was requested by Tzara for a mixed programme entitled *La Soirée du Coeur à Barbe* (*The Evening of the Bearded Heart*) at the Théâtre Michel, Paris, in July 1923. René Clair's *Entr'acte* (*Intermission*) was commissioned by Picabia as part of his anarchic ballet programme *Relâche (Performance Cancelled)* in 1924. Man Ray claimed that he was asked to provide his film with only a few hours' notice, so he adapted his cameraless still image 'Rayograph' technique to the film strip, scattering carpenter's nails, drawing pins and even salt and pepper onto a roll of unexposed cine-film and fixing their white shadows in his darkroom, before randomly intercutting the results with some experimental film footage shot earlier – night-scenes of lights at a fairground, a hanging spiral of paper with its shadow, and positive and negative shots of the naked torso of his muse, Kiki de Montparnasse. 'Reason' is hardly in evidence; the film is joyously beyond understanding and contributed to the violent outrage that greeted the whole event – largely provoked by the sectarian attacks of Surrealism's self-appointed guardian André Breton.

René Clair's *Entr'acte* was less spontaneous in its making, but no less outrageous in intent. Deliberately anti-logic, it managed to include bad taste as well. Picabia apparently offered Clair a page of ideas for this proposed 'intermission' to his ballet, while Erik Satie, who was writing the ballet's score, promised some music; but in practice Clair could do as he pleased. The film opens with a slow-motion shot showing Satie (in bowler hat and pince-nez) with Picabia, firing a cannon directly at the audience from a Paris rooftop; in a later shot Duchamp and Man Ray play chess on another rooftop until they are washed away by a fire-hose. The main section of the film consists of a slow-motion funeral procession through a fairground, led by a camel-drawn hearse. En route, the corpse jumps out of the coffin, long-skirted mourners are assaulted

103 Man Ray, *Le retour à la raison*
(*The Return to Reason*), 1923

104 René
Clair, *Entr'acte*
(*Intermission*),
1924

by air-jets concealed beneath the pavement, rational space dissolves in cubist-style superimpositions and an upside-down rollercoaster ride, and, in a tribute to the ballet context, the camera looks up the skirt of a bearded, tutu-clad dancer. Even the 'end' title-card is a joke: a man bursts through it, seemingly emerging through the screen and into the space of the auditorium. Clair wrote of his pleasure in being able to 'do without rules and logic in the world of images'.[1]

Hans Richter, having abandoned the abstract imagery of his *Rhythmus* series, made several short live-action films consistent with his new role as a maker of Dada collages. *Filmstudie* (1926) is an assemblage of shots – a Dada collage in time – made by an artist who was still more interested in experimenting with the moving image by, for example, exploring visual analogy (flapping birds' wings echoed by flapping abstract shapes), than in making a committed anti-film gesture. But it fitted the Dada bill, and was first shown with Ray's *Emak Bakia* (1926) at Studio des Ursulines. His *Vormittagspuk* (*Ghosts Before Noon*, 1928) lightheartedly picks up the Dada spirit of *Entr'acte*; Richter described it as:

Four bowler hats, some coffee cups and neckties 'have had enough' [are fed up] and revolt from 11.50 till 12.00 a.m. Then they take up their routine again. Darius Milhaud and [Paul] Hindemith are actors in the film.... The chase of the rebellious 'Untertanen' ('objects' are also people) threads the story. It is interrupted by strange interludes of pursuit which exploit the ability of the camera to overcome gravity, to use space and time completely freed from natural laws.[2]

The same anarchic spirit characterizes his *Alles drecht sich, alles bewegt sich* (*Everything Moves, Everything Revolves*,1929), an experiment made to test the new Tobis sound system, and *Zweigroschenzauber* (*Twopenny Magic*, 1930).

'Lighthearted' is a not an epithet that could ever be attached to the anti-film films made in the 1950s and 1960s by the Lettrists, the group founded by Romanian poet Isidore Isou together with Maurice Lemaître and Gil Wolman, or the 'Situationist' splinter-group led by Guy Debord. For all of them, making films was part of a necessary assault on the medium, based on their conviction that all forms of art inevitably contributed to capitalism's enslavement of society. Therefore, the fruits of capitalism must be turned against themselves; film should attack cinema. *Détournement* would become the maxim of the Situationists. More positively, Lettrists also believed in a poetry based on language reduced to its base units – the

phoneme and the syllable, even the solitary letter (again an echo of Dada poetry). The painter Edgar Pillet's sole Lettrist film *Genèse* (*Genesis* 1950) is a work of pure typography. Isou's only film work, *Traité de bave et d'éternité* (*Venom and Eternity*), was intended as Lettrism's manifesto, and was launched at the Cannes film Festival in 1951 with the support of many of the leaders of contemporary French culture – Cocteau, Blaise Cendrars, the actors Jean-Louis Barrault, Danielle Delorme and others, who also make their appearance in the random footage that constitutes the visual track of the film. The film opens with chanted Lettrist poetry (a tiny repeated loop; almost *musique concrète*), then written texts and manifestos appear demanding that cinema, the 'fat pig', must be subjected to fresh atrocities, and so on. Unexpectedly, the aggressive, hectoring voice-over includes praise for the films of D.W. Griffith, Gance, Chaplin, Clair, Eisenstein, Von Stroheim, Flaherty, Buñuel and Cocteau – a surprisingly conservative canon for an iconoclast. The anti-film spirit is seen most clearly in the total disassociation of image and sound (no hint of synchronization or creative counterpoint exists between them) and in the physical scratches and drawn marks made on the film's surface. When Stan Brakhage saw *Venom and Eternity* at a rare American screening, he was delighted, and the scratched-out faces in its found footage inspired him to scratch out the protagonist's eyes in his *Reflections on Black* (1955).

Gil Wolman's *L'anticoncept* (1951/52) consisted of a recorded verbal assault accompanying the projection of imageless light onto an inflated weather balloon. It was shown to an elite audience at the Ciné-Club d'Avant-Garde at the Musée de l'Homme in Paris; its oppositional stance was enough to deny it a licence from the film censors, so it missed out on a 'popular' audience at the 1952 Cannes Film Festival, but its text was later printed in the Lettrist magazine *Ion*, perhaps its most effective form of distribution. *Ion* also included the text of Guy Debord's film *Hurlements en faveur de Sade* (*Howls for Sade*, 1952). Here, again, eighty minutes of alternating periods of white (imageless) screen and darkness was accompanied by a part-lecturing, part-nonsense recitation by the artist. Debord's best-known work, *Society of the Spectacle* (1973), is based on his 1967 book of the same name, which, he liked to believe, enjoyed a role in provoking the uprisings of May '68. Here, the visual track is outrageous 'hot' imagery – the towering edifices of urban capitalism, 1960s 'dolly birds', starlets frolicking in the sea at Cannes, American rocket attacks in Vietnam, Castro delivering speeches, the shooting of Lee Harvey Oswald. Against this visual onslaught Debord intones 'Spectacle is the bad dream of

[an] enchained modern society, which ultimately only expresses its desire to sleep. Spectacle is the guardian of this sleep' and more, distantly echoing Buñuel's original complaint.

Lemaître proved the most prolific and consistent Lettrist, his sheer productivity – over 100 films made by the mid-1990s, alongside paintings and prolific writings – suggesting that his project was less to do with obliterating cinema than altering the popular film-goer's response to the medium. His first work, *Le film est déjà commencé? (Has the Film Started?*, 1951), echoes those of his peers in its form: a lecture set against unrelated images (he had collaborated with Isou). Again, anticipating the Structural film, Lemaître claimed an empowering motive behind his attacks: 'In a *supertemporal* film [his own designation of one branch of his *oeuvre*] the spectator becomes a film director in his own right, or a film star, or a noted critic.... No longer is there an unbridgeable gap between the screen and the public'[3] (though this might not be an audience's most immediate response to his attacks).

Many formal filmmakers of the succeeding generation would also acknowledge an anti-film impulse in their work, but they deliberately took the dialogue between destruction and creation into new territory by insisting that what replaced the old should assume a wholly new, purposeful form. The Yugoslav filmmaker Mihovil Pansini was one of the first artists to describe his works as 'anti-films', though, as discussed earlier, they were also steps in a formal 'material' direction. The early collage films made by the Structural filmmakers Birgit and Wilhelm Hein and Malcolm Le Grice were in part anti-films, but this impulse in their work quickly gave way to an interest in foregrounding the processes of perception and establishing a radically new form of film/audience relationship. Le Grice spoke of this transition, as seen in his own early films *Yes, No Maybe Maybe No, Talla* and *Blind White Duration* (all 1969–70): 'there was an element of audience attack in those films; a Dadaistic thing. Later I wanted to reject [this]...I got around to feeling that I wanted to make a cinema that attempted to be totally positive, rather than iconoclastic'.[4]

Similarly, many of the first generation of video-artists intended their works to upset the comfortable yet authoritarian role of broadcast television, while establishing different ways of relating to the electronic image. Working within the already anti-art context of Fluxus, the twin fathers of video art, Wolf Vostell and Nam June Paik, began their overlapping careers by attacking the live broadcast image (this before home-video recording was introduced in the mid 1970s) while at the same time stressing the mundane objecthood of the domestic

105 ABOVE Maurice Lemaître, *Le film est déjà commencé?* (*Has the Film Started?*), 1951
106 OPPOSITE Wolf Vostell, *TV Dé-coll/age*, 1963

television set, firmly contextualizing it. As early as 1959, Vostell had included a television set in his angst-filled installation *Black Room*, a reflection on the state of post-war Germany; but in his 1960s series of film and television *dé-coll/ages* – collage works in which the stress is firmly placed upon the act of taking imagery *apart*, rather than re-assembling it – he more seriously addressed the power and status of the moving image. Of course, what results from this process of 'decollage', is, inevitably, an assemblage. His first major show, '6 TV Dé-coll/age' (1963), at the Smolin Gallery in New York, took the form of an installation of television sets with their scrambled imagery mixed with added ingredients that invited spectator participation (of a sort). These were his production notes:

Environment: 6 TV sets with different programmes running. / The picture is de-collaged. / & meltings – Pots with plastic toy airplanes melting due to heat. 6 grilled chickens on a canvas. / Audience has to eat them off the picture. 6 chicken incubators / on canvas / the chickens to hatch on day of exhibition. / Everyone receives an ampoule with liquid they can use to smear the magazines. Everything happens at once. In addition, one pack of groceries is glued to each TV set.[5]

Television is put in its place, firmly set amid the messiness of life. When making *dé-coll/ages* intended to be shown on their own, outside the installation context, Vostell happily re-filmed his imagery from broadcast television before scrambling it,

106

107 Peter Weibel, *TV News/TV Death*, 1970/72

the mismatch between film and video technologies itself causing break-up and visible scan-lines; in other words, valued evidence of video-materiality to add to his cut-ups. Through these distortions one might just glimpse a pretty television announcer, an American Air Force pilot in his cockpit; once again, hot imagery is negated. His *Electronic Dé-coll/age, Happening Room*, made for the Venice Biennale of 1968, featured six television sets with their distorted imagery in the midst of a glass-strewn floor, with motors moving them and other objects – skis, a coal shovel, a fish-tank, a honey-pot – around the set, their choreography controlled by a primitive computer in response to the movements of viewers.

Nam June Paik's early 'sculptures' used magnets set on top of television sets to destroy transmitted images, distorting them into abstract patterns. For his first major show, 'Exposition of Music – Electronic Television' (1963), at the Parnass Gallery in Wuppertal – just before Vostell's New York show, and possibly an inspiration for it – he scattered variously adapted televisions throughout the space. More constructively, he learned from television engineers Hideo Uchida and Shuya Abe how to generate hypnotic patterns using the flow of electrons in domestic television sets, turning them into performing instruments. The Abe-Paik video synthesizer would become a creative tool responsible for the 'look' of much of Paik's future work, which was to involve television programmes, his signature 'robots' (made of assemblages of television sets), and live performances.

The programme content of broadcast television increasingly became the focus of such anti-television interventions. David Hall's *101 TV Sets* (1972–75, made with Tony Sinden) arranged a host of domestic television sets in three ranks, one row above another, tuned to different channels or simply mis-tuned, all strenuously competing for attention while impotently submerged in an overwhelming audiovisual clamour. Like all of Hall's works, this display both denied the broadcast message and asserted the television set or video monitor as a sculptural object, a transmitter of light and later, a medium capable of more.

News broadcasts, perhaps predictably, were often singled out for attack. In a darkly humorous metaphor, Peter Weibel's *TV News/TV Death* (1970/72) has a newsreader reading old news while strenuously smoking a cigar, seated in the contained space of an empty television set. His puffing fills the television with smoke to the point at which he becomes invisible – no doubt aided by offscreen smokers. In Communist states, such attacks took on a particular political significance.

107

Sanjha Iveković's *Slatko Nasilje* (*Sweet Violence*, 1974), crudely superimposes black bars over Zagreb television's state-approved economic and social propaganda, her simple act of defacement alerting viewers to the 'sweet violence' emanating from the falsely reassuring set in the living room corner. Sadly, her work was seen only by tiny numbers in unofficial galleries, unlike some similar attacks by her contemporaries in the West, which were actually transmitted by the medium they were attacking. Hall, for example, was able to make and broadcast *This is a Television Receiver* (1976), in which a well-known BBC newsreader reads the artist's text about the materiality of the television set – already a startling message to receive from an authority figure – before, even more disturbingly, the sequence is serially repeated, with each repetition becoming more distorted and abstracted by re-filming until little remains but pure light and noise.

Possibly the most powerful, and certainly the most direct anti-television work was made by Richard Serra, who purchased time on a cable network to transmit *Television Delivers People* (1973). In this piece, fifty-five written statements scroll down an otherwise blank television screen, telling the poor 'enchained' viewers precisely what is happening to them, the whole seven minutes accompanied by appropriately emollient muzak. These are a few of the statements:

The product of television, commercial television, is the audience
Television delivers people to an advertiser
It is the consumer who is sold
You are the product of TV
You are delivered to the advertiser, who is the customer
He consumes you
You are the product of television
Television delivers people.[6]

The Metrical Film

The formal, mathematically edited film – the film in which 'structure' becomes dominant – can trace its history back to the silent film *Impatience* (1928) by the Belgian artist and documentary filmmaker Charles Dekeukelaire, which was shown to the international avant-garde community at a 1929 gathering at La Sarraz. A title at the beginning of the film states that 'it consists of four elements – the motorbike, the woman, the mountain and abstract blocks; the rhythm is given by a mathematical fragmentation of the film's running time, divided up into temporal segments where the four repertories

108 Charles Dekeukelaire, *Impatience*,1928

of images succeed each other in every possible combination, with no respect for either melodic line or dramatic tension'. The film is thirty-six minutes long, so in naming it 'Impatience' Dekeukelaire was probably anticipating the response of an unprepared audience. The four groups of images might suggest a Futurist film – an unsentimental ode to speed and the machine – were it not for the film's length and its ferocious commitment to mathematical editing. Instead, its aggressive relationship with the viewer links it to Dada and makes it another forerunner of the post-war anti-film. With no known connection to Dada, one wonders how Dekeukelaire arrived at this radical construction. He almost certainly would have seen Léger's *Ballet mécanique*, with its short, looped sequence of the woman climbing the stair, which was similarly calculated to frustrate; but if that was his inspiration, he far exceeded the outrage of his source. No doubt as a consequence, his film was rarely screened after its first performance, so its influence both at the time and in later years was minimal. It remained in the Belgian archives awaiting discovery and appreciation by Structural filmmakers half a century later.

The idea that a predetermined editing pattern might give shape to an entire film next emerged in Vienna in the mid-1950s. The works of Peter Kubelka and Kurt Kren were followed by many others across Europe, Japan and North America. Kubelka's first film, *Mosaik im Vertrauen* (*Mosaic in Confidence*, made with Ferry Radax, 1954–55), is an experiment in image/sound editing in which he intercuts shots of a race-car crash at Le Mans, a man and woman talking, and other footage in 'wrong' combinations, frustrating any narrative reading. Instead, he creates new, non-naturalistic 'sync events' (his term, echoing Vertov): odd but irresistible fusions of image and sound. It was a technique he used again, this time in a narrative context, to create the non-naturalistic visual metaphors in *Unsere Afrikareise. Adebar* (1957) was Kubelka's first fully 'metrical' film (the term is his), its formulaic editing unconsciously echoing that of *Impatience.* At just one minute long, *Adebar* is less of a provocation; indeed, it is tantalizingly short, and benefits from the artist's usual practice of showing it several times in succession. Six different high-contrast shots of silhouetted dancing couples are permutated until every variation has been exhausted. The shots, which are either thirteen, twenty-six or fifty-two frames long, alternate with each edit between positive and negative printings, and each shot starts and ends 'frozen' before releasing into movement. In the same year, Kubelka was hired to make a short commercial for a local beer company; the film he finally submitted was just

109

109 Peter Kubelka,
Adebar, 1957

ninety seconds long and bears the beer's name, *Schwechater*.
It features extremely rapid metric cutting based on a pattern
of one, two, four, eight and sixteen frames, intercut with
identical lengths of black leader. The imagery of drinkers
and beer-glasses was tinted red, 'washed-out' and sometimes
shown in negative; it frustrated the simplistic desires of its
commissioners, but is a work of intense, hypnotic impact.

Arnulf Rainer (1960) followed, the first film to consist of only
pure black-and-white frames. 'I built a structure of the four
BASIC ELEMENTS of cinema: light, darkness, sound, silence.
They were materialized by four strips of 35mm film: blank
film, black film, sound film and silent film. The indivisible
atom of cinema is one frame which equals one twenty-fourth
of a second'.7 *Arnulf Rainer* is an austere work, the reduction
of cinema to its absolute minimum; a conscious attempt to
give the art form (or certainly his fellow artists) an irreducible
baseline comparable to that offered to fellow painters by
Kasimir Malevich's *Black Square* paintings of 1915 onwards.
Logically, having been reduced to its 'individual atoms', surely
cinema should have come to an end? What after all, was left
to be done? But in fact, much remained – as even Kubelka was
aware. He returned to exploring visual metaphor in *Unsere
Afrikareise*, and even to the emotional language of human
performance in *Pause* (1977), leaving all further exploration of
'individual atoms' to others.

Kurt Kren's first film, *1/57: Versuch mit synthethetischen Ton
(Test)* (*Experiment with Synthetic Sound* (*Test*), 1957) is startlingly
like *Impatience* in its crude pattern of mechanical cutting
between unrelated objects – a cactus, a brick wall, the tiny
image of a revolver pointing directly at the audience – presented
in shots of equal length and edited in parallel with samples of
rasping noise, created by scratches drawn in the soundtrack
area. It established his anti-Illusionist approach to editing
with a brutal directness. His first mathematically composed
film was *2/60: 48 Kopfe aus dem Szondi-Test* (*48 Heads from the
Szondi-Test*, 1960), a permutation of images whose length is
determined by the Fibonacci sequence; one, two, three, five,
eight, thirteen, twenty-one and then thirty-four frames, before
reversing. The crude, newsprint photographs of the eponymous
heads apparently formed part of an early twentieth-century
psychological test, but the film's unusual editing causes
different heads to come to prominence at random, subverting
any significance they might have had in the original test.
Kren is perhaps joyfully cocking a snoot at a dubious branch
of Viennese head-medicine. *3/60: Bäume im Herbst* (*Trees in
Autumn*,1960) similarly permutates the order of clusters of

frames of different lengths, resulting in a shimmering, unstable but hypnotic record of tree-shapes and leaves, made more graphic by being limited to black-and-white. As he recalled, 'I wandered around Vienna with the camera. I had a little piece of paper with me with the number of frames, telling me how I should shoot the single frames'.[8] This was, again, calculated using the Fibonacci sequence.

With *15/67: TV* (1967), he offers an editing masterclass, using just the rhythms discovered within the filmed image. In barely four minutes of film, he created a perfect little dance made up of five basic steps combined in different orders. His account of its origins is deceptively simple:

I was in Venice, waiting for friends at a café. They were late and I started to get bored. I happened to have my camera with me, so I took a few shots from where I was sitting, views of the sea through the window. In Vienna I got the idea of having twenty-one copies made of those five shots. These twenty-one-times-five shots I put together in a certain order, resembling in a way a children's rhyme, a counting-out rhyme.[9]

In these shots one sees incidental happenings: a floating crane passing in the distance from right to left; a woman idly kicking a bollard; the same woman standing and twisting her body; a man and child passing in the middle ground; a woman and child passing in the other direction, quickly obscured by a person leaning forward in the foreground. Kren permutates these unassuming yet complex movements in what appears to be an unpredictable order, though it is in fact fully mapped out in order to create a deeply absorbing piece of visual choreography. It is as hypnotic as watching television – hence, perhaps, its title – but more fascinating.

With *6/64: Mama und Papa (Materialaktion Otto Mühl)*, Kren began a series of films based on performances by friends who were the founder members of Viennese Actionism – Gunter Brüs, Otto Muehl and Herman Nitsch. For these, he adapted his mathematical schema to fit the process of recording, or – perhaps more accurately – responding to, their taboo-breaking 'actions'. As viewers, we are confronted by flashes of extreme imagery – naked bodies engaged in obscure, often violent and sexual actions, the performers often drenched in coloured pigment, blood, feathers, raw eggs, semen and even faeces. Paradoxically, while disrupting the linear flow of events, Kren's ferociously fast editing pattern makes it impossible to distance ourselves from what we see; we can't get 'used to' the image as we might in a conventional documentary record. Kren keeps

The Anti-Film and the Formal Film

213

us in a state of continuous first impression, uncomfortably confronted by visceral sensation alone.

Structural Film

The films of Kren and Kubelka are often seen as precursors to the mid-1960s mode of filmmaking that was controversially given the label 'Structural film' by the critic P. Adams Sitney. The term seemed to imply a relationship with contemporary linguistic theory, but in fact, writing in the context of a survey of current work, Sitney was more simply drawing attention to a shift away from poetic forms or psychological studies, and towards a concern with shape and process. The characteristics that Sitney identified included a fondness for 'fixed camera-position (or fixed-*frame* as experienced by the viewer), the flicker effect and loop printing (the immediate repetition of shots, exactly and without variation)', 're-photography off the screen' and, perhaps most provocatively, an 'elongation' of form, 'so that time will enter as an aggressive participant in the viewing experience.' He summarized: 'the Structural film insists on its

112 LEFT Tony Conrad, *The Flicker*, 1966
113 OPPOSITE Michael Snow, *Wavelength*, 1967

shape, and what content it has is minimal and subsidiary to the outline'.[10]

As with the Conceptual film, a remarkable feature of the Structural film was its rapid international spread. Whatever the term meant, artists around the world seemed willing and even keen to be associated with it. The Structural film's characteristics were easily grasped through description, even before any direct experience, although Sitney's tour of Europe in 1967–68 with a collection of The New American Cinema provided at least some opportunities for the work to be seen. In particular, the reputation of films such as Tony Conrad's *The Flicker* (1966), a film of strobing black-and-white frames, and Michael Snow's *Wavelength* (1967), which can be summarized as a forty-five-minute continuous zoom shot – films seen by a few at the Knokke EXPRMNTL Festival of 1967–68 and widely reported and described thereafter – proved a catalyst. Developments in North America, Britain and Germany had their echoes in France, Poland, Yugoslavia, Hungary, Holland and Japan. That said, many Europeans were already making formal films before they saw any North American models. Kren, Le Grice and Birgit and Wilhelm Hein found another source of inspiration for their work in the abstract films of the 1920s and 1930s by Richter, Ruttman and Lye, before they saw and discovered any kinship with the work of Conrad or Snow.

111 Paul Sharits,
N:O:T:H:I:N:G, 1968

In the face of criticism, Sitney later qualified his definition of the movement: 'It is unfortunate that the films I'm discussing have been confused with "simple" forms or "concept art". It is precisely when the material becomes multifaceted and complex, without distracting from the clarity of the overall shape, that these films become interesting'.[11] Content still mattered. An early star of Structural filmmaking, Paul Sharits, echoed this when he wrote:

One could claim that much of the critical writing about [these films] – in establishing the importance of the qualities of "wholeness"...underemphasized the specific articulations of their internal parts, implying, perhaps unintentionally, that the filmmakers were constructing strictly from the outside inwards.[12]

Instead, Sharits was keen to emphasize what he saw as musical 'overtones', even elements of autobiography, in his own colour-flicker films such as *N:O:T:H:I:N:G* and *T,O,U,C,H,I,N,G* (both 1968). He was also aware that the detailed patterns of his films' formal composition, being so close to unreadable in projection, merited exhibition in the form of what he called *Frozen Film-Frames* (1966–77), the completed films taken apart into strips and re-presented, sandwiched between sheets of Perspex (Plexiglass), like finely detailed stained-glass windows. In that form, structure – patterning – is undeniably the dominant visual experience. These 'solid light' works also offered a sellable object; the gallerist Leo Castelli had Sharits on his books for a while in the mid 1970s.

Conrad, who had been a part of La Monte Young's circle of performer/composers, was unapologetic about the fact that his work was indeed 'constructed from the outside inwards'. He both enjoyed and was surprised by the notoriety of his film. 'When I made *The Flicker*, people were astonished that there could be a film with no images. That just doesn't seem like a big deal to me at the time, when the visual arts had already been immersed in reductive activity. I had considerable experience through music in addressing audiences with what I call reductive materials, or with a "boring" cultural product'. Each of *The Flicker*'s five sections has its own pattern of repeating frames, and Conrad suggested to Mekas that, like Dieter Meier's *Paper Film*, it was a film to be seen 'with the eyes closed'[13]. He goes on to describe 'a sort-of contestation between the viewer's experience and the experience of the maker of the film.... That was, and remains, what I consider to be the optimum cultural outcome for the work'.[14] Shades of the anti-film.

111
112

Snow, like Sharits, was insistent that *Wavelength* was no empty formalist exercise. Indeed, he saw it as a form of deconstructed story film – even if its four narrative incidents last only a couple of minutes each and are framed in what appears to be a single, forward camera movement of forty-five minutes' duration. For him, the subject of the film is 'filming reality', making the process visible to the viewer. 'That it's light, and it's on a flat surface, and it's also images…. I was trying to do something very pure…about the kinds of realities that are involved'.[15] Filmic illusion is contrasted with evidence of the materiality of image and sound. The 'continuous' zoom movement was shot over a week and included night filming, the use of filters, different film stocks spliced together and sometimes negative film, so the colour varies wildly. It also required several camera positions, at first taking in the full width and depth of the loft but ending in a tight close-up of a small black-and-white photo of waves – thus the title 'wavelength'. 'Naturalistic' sound accompanying the narrative incidents is contrasted with 'pure sound', an ascending sine-wave drone that starts low but over the length of the film slowly rises to an inaudible pitch. The material is indeed 'multifaceted and complex'; yet, what gives the film its power is the Conceptual simplicity of its formal structure.

Constructed from the outside or from within, there are hints of the obsessive in the composition of many Structural films. The repetitions, rapid editing, single-frame techniques, re-filming from the screen and extended duration are factors that, individually or combined, have the potential to make the Structural film both difficult to watch and difficult to decipher. Nonetheless, there are pleasures to be found. There is the satisfaction of finally identifying exactly *what* is being filmed; in unpacking its possible relation to the film's enigmatic title; in deducing the principles or set of rules that have shaped the film. The latter is comparable to recognizing the pattern in a canon or fugue by Bach, or perhaps even more appropriately, one of the contemporary *Studies* for piano by Conlon Nancarrow, made between the late 1940s and the 1980s. Nancarrow, like a number of structural filmmakers, conceived his scores initially as mathematical constructions – in his case to be punched out on a pianola roll, concentrating on the clarity and uniqueness of their visual shape before submitting the roll to the pianola player, then rejoicing in (and presumably sometimes rejecting) what was revealed. That sense of the work only fully revealing itself to the artist on completion of the making process, and to the viewer only as the film projection ends, makes it possible to see many structural films as truly experimental. Peter

Kubelka has described how he spent three years composing and re-composing the score of *Arnulf Rainer*, his film of black-and-white frames.[16] With no camera available, he typed and re-typed its structure on paper as a pattern of 'x's and blanks, and only when he was at last able to shoot the film and convert his 'x's into film-frames, and then project it, was its power revealed to him. The diagrams, structure charts and other forms of score associated with the formal film can be fascinating artworks in themselves. There are notable graphic scores by Sharits, Kren, Heinz Emigolz, Peter Tscherkassky and many others.

The Japanese artist Takahiko Iimura might have been in P. Adams Sitney's mind when he identified 'time...as an aggressive participant in the viewing experience' of the Structural film. Iimura argued that 'temporality [in film] has been neglected. It's always been treated as a kind of supporting factor to the visuals.... My concern is not with rhythm but with intervals of time, with concrete duration as material'.[17] This interest led to him make works of unusual purity, which in their minimalism risk being unwatchable, a condition he comes close to embracing. He describes *Models (Part B) Counting 1 to 100* (1972):

It has four sections. The first is Counting 1 to 100 or 10 Xs. An X replaces each tenth number. The second section doubles the number of Xs, although the replacements are not so regular. Then in the third and fourth sections, I double the number of Xs, first to 40, then in the fourth section to 80. The more Xs, the more difficulty you (the viewer) have in counting. Two systems are involved – counting 1 to 100 and counting the x's. In most cases it's impossible to count both at the same time.[18]

Time is experienced (eleven minutes of it). The viewer has become 'an active participant', an important goal for many Structural filmmakers; but at this extreme, perhaps the pleasures run thin.

Using repetition as a means of drawing attention to 'duration', and thus to one of the realities of the viewing experience, was also important to Le Grice and Peter Gidal. In Le Grice's films, the pattern of repetition is often subtle and the range of material repeated varied; in Gidal's, the repeated sequences are often so long that recognizing the point at which the repetition begins becomes hard, adding an element of puzzle to the experience. As the two most influential British artists associated with Structural film, Le Grice and Gidal regularly published theoretical articles about the essential relationship between film and its viewer, which was for them the most important issue to address through filmmaking,

elegant structure being of little interest in itself. Discussing his first important film, *Castle One* (1967), a film composed of loops of found footage, Le Grice explained:

I wanted to bring the film as close as possible to the current reality of the spectator in the projection situation…. There's a lightbulb that hangs in front of the [cinema] screen which flashes on and off during the presentation. It just lights up the auditorium and bleaches out the screen so the image of the film disappears altogether. The auditorium is suddenly very real in a way that you 'don't want it to be' in a film.[19]

So, the materiality of the screening event itself was as important as the materiality of the film medium; audiences should be as fully aware of the act of *watching* as the maker had been of the act of *making*. But content – the choice of subject matter onscreen – still mattered.

Still working with repetition, Le Grice's *Berlin Horse* (1970) mixes footage from two sources; archival imagery of horses escaping a burning stable and home movie footage of a horse exercising on a long lead. It is a film of circular movements, rendered unexpectedly lyrical by the rhythm of its repetitions, its lush added colour and its melodic looped soundtrack by Brian Eno. Thereafter, Le Grice did his best to achieve a balance between formal rigour, 'materiality' and rewarding spectacle in his work. One of his most engaging films from this period, the wholly abstract installation *Gross Fog* (1973), consists of nothing more than loops of richly coloured edge-fogged film, simultaneously projected to overlap on a wide screen, their fluctuating colours and tones combining rhythmically.

Le Grice said of his figurative twin-screen (sometimes multi-screen) works that they were 'not about overload. It was about comparing *this* with *that*.'[20] This act of laying out for inspection the materials and processes of filmmaking is celebrated in the four-screen *After Manet* (1975), a re-enactment of an iconic scene from art history – Manet's *Le Déjeuner sur l'herbe* (1863). Like its source, it also provides an opportunity to celebrate a circle of close friends. A rural picnic with food, wine, books and a gramophone is staged with four filmmaker friends, each of whom is given responsibility for one camera (one screen as seen by the viewer). Following a programme established by Le Grice, they record the scene, employing the camera in different ways – fixed-tripod and mobile, panning and zooming – and the images we see on the four screens additionally catalogue the different 'states' of film: negative and positive, black-and-white and colour, silent and sound. (The un-programmed

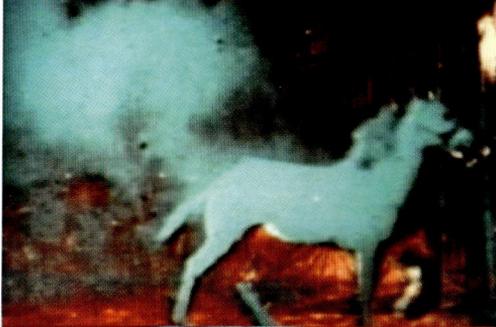

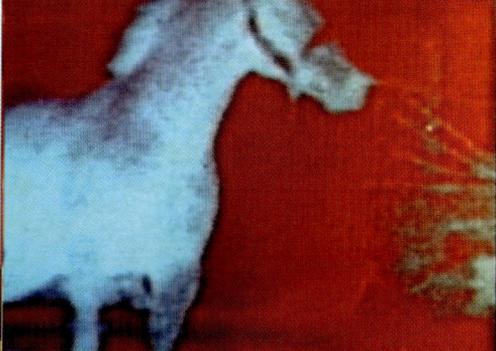
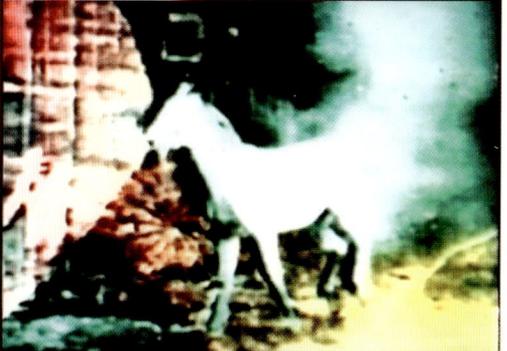

114 Malcolm Le Grice, *Berlin Horse*, 1970

afternoon heat and the amount of alcohol consumed added its own material effects to the performance).

The process of deconstruction continues in Le Grice's feature-length works, with the 'comparisons' now presented sequentially on one screen. They additionally unpick the techniques of narrative film construction. In *Blackbird Descending: Tense Alignment* (1977), we watch artist Lis Rhodes, clearly standing in for Le Grice, as she in turn watches (Le Grice's) domestic life roll on around her, implicitly providing the subject for the film. Four events are seen from four viewpoints: Rhodes sits at a window and writes at her typewriter; through a window a man is seen pruning a tree; a woman hangs out coloured sheets on a washing line; in the house, another woman answers a phone. These apparently simultaneous events are seen again and again, to explore all possible variations of the spectator's viewpoint, none privileged, as if seeking an egalitarian overview through which the artifice of filmmaking will be revealed. Finally, Le Grice shows us the camera filming the very scenes we have witnessed. This work and his subsequent *Finnegan's Chin, Temporal Economy* (1981) are Structural cinema at its most didactic, and for Le Grice himself represented an extreme beyond which he no longer needed to travel. But other artists unexpectedly took up the challenge. More than a decade later and in the very different context of the gallery installation, one finds an equally exhaustive and extreme form of narrative deconstruction in works by Bruce Nauman and Stan Douglas. For Nauman's *Violent Incident* (1986), the filmmaker employed actors in an empty studio to enact a brief, endlessly repeated scripted scene, their clichéd behaviour replacing Le Grice's daily routine. 'Two people come to a table that's set for dinner with plates, cocktails, flowers. The man holds the woman's chair for her as she sits down. But as she sits down, he pulls the chair out from under and she falls on the floor. He turns around to pick up the chair, and as he bends over, she's standing up, and she gooses him. He turns around and yells at her – calls her names [and so on...]'.[21] We are offered this bizarre episode of escalating tension in various versions: the couple exchange roles; it is played by two men; it is played by two women; the editing is performed differently, with all the alternative versions running simultaneously and unendingly across twelve monitors.

Similarly, Stan Douglas's two-screen installation *Win, Place or Show* (1998) stages a six-minute set of angry exchanges between two men, their rambling argument involving the

115

115 OPPOSITE Stan Douglas, *Win, Place or Show*, 1998

The Anti-Film and the Formal Film

news, radio, conspiracy theories and horse racing, at times degenerating into a physical fight. The action is shown simultaneously from two angles, as two images side by side on adjacent screens, with the complexity of the editing appearing to be linked to the growing rage of the participants. The novelty here is that the editing is in fact being carried out live by a computer, Douglas having created enough footage to ensure that the same combination of shots is highly unlikely to be created. This is deconstruction *in extremis*. Like Le Grice, Douglas is exhaustively unpicking the rules of conventional narrative editing, but in so endlessly permutating all possible variations, he overwhelms us.

Later works by Le Grice become less schematic and more meditative. His discovery of the then-new medium of Video8 led to filmmaking based on diaristic shooting and intuitive, rather than entirely pre-planned, structuring. When editing *Chronos Fragmented* (1995), he catalogued his shots in a database and then asked the computer to offer this material back to him in random order or in response to word-search, prompting 'a number of connections I would not have arrived at otherwise'.[22] Thus Le Grice ends up with his own version of the autobiographical essay–film, and now openly embraces the power of visual metaphor.

For Gidal, the avant-garde's struggles against 'dominant' cinema assumed political importance, though not the politics of a commitment to filmmaking that might improve the lot of the working man and woman, as espoused by some contemporaries on the political left. Instead, his view was that the seductive and enslaving power of Hollywood must be resisted, image by image and frame by frame. With a nod to Marx, he dubbed his own branch of the Structural film as 'structural materialist'; engendering films that are 'at once object and procedure.' And again, his most quoted maxim: 'Each film is a record (not a representation, not a reproduction) of its own making'.[23] Gidal's camera scans the scene, often a domestic interior, following no recognizable pattern of camera movement (his script-substitute scribble drawings are an encouragement to himself to avoid any hint of the predictable in its choreography). It fleetingly focuses on obscure objects – an edge, a highlight, a shadow – resisting any temptation to allow things to become fully recognizable. This is an aesthetic of obscurity, a love of the out-of-focus and the blurred. The camera's progress is relentless, seemingly unending. Given the length of some of his repetitions, the

116 OPPOSITE Peter Gidal, *Roomfilm*, 1973

117 Ryszard Wasko, *A-B-C-D-E-F = 1–36*, 1974

realization that a shot has been seen before may elude the viewer. In the early, ten-minute *Room Double Take* (1968), the second half of the film exactly reprints the first (the film's title contains an ambiguous warning of this). In the fifty-minute *Roomfilm 1973* (1973), every six-second shot is immediately repeated, making the pattern obvious but no less challenging; duration now seriously enters the game. To maintain interest, one searches through the blur for recognizable landmarks in the room, perhaps hoping to construct a composite image of the space and its contents.

116

Gidal has spoken of his attempts to resist social and cultural pressures: 'One is not separate from one's culture. One is imbricated in the cultural narrative structures that exist because that is the culture that one is bought up in. But one resists it all the time'.[24] After making his early portrait films, anxiety about cinema's 'male gaze' led to his rejection of any representation of human figures – especially women – in his subsequent films. But he also stressed that his method valued the unanticipated: 'The hand, the eye, the mind and the mechanical apparatus in relation to one another have a force, their own productive one, separate from any intentionality

or consciousness.'[25] He sees such conflicts as productive; the artist's sense of struggle during the process of making is already a good sign, and evidence of the struggle surviving within the work itself is even better.

There are echoes of Gidal's intellectual struggles in the work of the Polish artists associated with the Łódź Workshop of the Film Form in the early 1970s, made evident in an early Workshop manifesto. The same anxiety about 'imbrication' in a romantic mainstream and the role of subjectivity is found in the very different context of pre-Solidarity Poland. They rejected both 'politically engaged' or 'emotional' tendencies in film, and also 'the literary cinema':

We reject all other utilitarian functions deriving from outside the essence of cinema, that is Politicizing / Moralizing / Aestheticizing / And Amusing the spectator.... We seek out what is to be constructed through the phenomenon of film technique; we seek its unique spheres and boundaries that lie beyond the possibilities of verbal expression.[26]

The films of Ryszard Wasko show the Workshop project at its most rigorous, resulting in works almost as austere as those of Iimura. *A-B-C-D-E-F = 1–36* (1974) is an investigation in its most schematic form, undertaken in laboratory-like conditions. Wasko's camera performs thirty-six different programmed moves in front of a huge squared board with letters of the alphabet spaced on alternate lines, vertically and horizontally. He admitted that 'This attempt to catalogue all possible camera movements and to exhaust all their combinations... soon proved a utopian endeavour'.[27] But failure is not a problem; the attempt is the thing. He set out his statement of intent and followed it to the letter in a transparent process, showing a clear willingness to go where others hadn't gone before. His *30 sytuacji dźwiękowych* (*30 Sound Situations*, 1975) is an analysis of the responsiveness of film technology to different sound environments – a classroom, a stairwell, a park and so on – in a cool exploration of film's ability to deliver an 'uncompromised' representation of reality.

Wasko's colleagues Jósef Robakowski and Wojceich Bruszewski allowed their subject matter to range further, Formalism here engaging with performance and documentary impulses. Robakowski's *A Test* (1971) was made by punching variously sized holes in black film, drawing attention to the material presence of projected light and the projector's actions. Dieter Roth, Giovanni Martedi, Takahiko Iimura and Malcolm Le Grice would all independently make variations on this

117

theme at some stage in their careers, responding to the seductive materiality of the film-strip. More engaging is *Idę* (*I am Going*, 1973), a 'durational / bi-mechanical performance', as he described it. In a continuous take, the artist climbs the two hundred steps of a metal lookout tower, holding the camera in front of him and counting out aloud as he ascends, his voice and slowing footsteps revealing his growing exhaustion. Similarly, Robakowski's *Ćwiczenia na dwie ręce* (*Exercise For Two Hands*,1976), shown on two screens, displays the artist's ambidextrous skills – the product of filming with a camera held in each hand. The viewer mentally conjures an image of the role of the performer; or perhaps discovers the still photo of the artist making the work often displayed nearby, which gives the game away without undermining the impact of the performance.

Workshop member Wojceich Bruszewski's *YYAA* (1973) and *Matchbox* (1975) are editing studies as compelling as Kren's. In *YYAA*, Bruszewski cut together different takes of a full-force yell directed at the camera – 'Yaaa!' – edited so that they merge into one impossibly continuous scream, with no apparent pause for breath, becoming hoarser until the filmmaker almost collapses at the end. Deliberate changes in lighting within the close-up image and abrupt shifts in the pitch of his voice affirm the role of editing in the piece. In *Matchbox*, a brief close-up shot of the eponymous box striking the table top is repeated in a loop. The visual track is slightly shorter than the soundtrack, so the two drift apart; but as the loop continues they finally come together again, highlighting the artificiality of the 'sync' image in film.

Some of the most original Structural films were made in Yugoslavia, well before Sitney's visit in 1968. The small number of films made by the performance artist Tomislav Gotovac blend an ambivalent response to American popular culture with a defiant Formalism, both in stark contrast to the 'poetic short films' being made for the international market by many of his contemporaries. *Prije Podne Jednog Fauna* (*L'Après-midi d'un faune*, 1963) intercuts three unrelated scenes without explanation: a distant view of people on a hospital terrace accompanied by Glenn Miller music, a close-up of a flaky plaster wall and cars parked under trees with people occasionally passing. The camera zooms in and out seemingly without purpose, while an American television melodrama contributes much of the soundtrack of sirens and a man shouting, which continues over an empty black screen. The elegance of Debussy and Mallarmé is utterly absent; instead there is emptiness, distance, inactivity, nothingness.

118 Wojceich Bruszewski, *Matchbox*, 1975

119 Gotovac's *Pravac* (*Stevens-Duke*) (*Straight Line* (*Stevens-Duke*), 1964) is dedicated to Duke Ellington and the director George Stevens – conservative choices in the West, but perhaps still controversial in a Communist state – and offers a continuous, unbroken fixed-camera view taken from the front of a tram (oddly anticipating Gehr's *Eureka*). *Plavi jahač* (*Blue Ride*r), or *Godard-art* (1964), is strangest of all; a home movie-style film of café society peopled by artist friends that notably also portrays the women working behind the serving hatch, who are the most relaxed and 'natural' of the café's occupants. The film is again set against 'found' American soundtrack recordings – Glenn Miller, racy dialogue and the theme tune of the television Western *Bonanza* – and there are references to Irish and Chinese workers in the US, the latter perhaps suggesting the disjuncture between artists and wider Croatian society at that time. His 'actions' as a performance artist – such as lying naked

119 Tomislav Gotovac,
Pravac (Stevens-Duke)
(*Straight Line (Stevens-Duke)*), 1964

in the street – similarly set out to shock spectators out of their complacent acceptance of 'things as they are'.

A fascination with symmetry characterizes the structural work of Croatian artist and activist Ivan Ladislav Galeta. Galeta's *Two Times in One Space* (1976–84) takes a 'found' film – *In the Kitchen* (1968) by Nikola Stojanovic – and superimposes it onto itself (initially by projection; later by optical printing) with a 216-frame (nine-second) delay. This superimposition utterly transforms the slight comic satire on middle-class urban life, claustrophobically set in the tiny kitchen-space: a family at supper distractedly eating and arguing, the child being sent to bed, the father helping to prepare more food then preparing the marital bed in the kitchen, the mother drying dishes, a canary singing, the radio on, and, when a blind on the door to the balcony is lifted, another minor drama taking place on a balcony opposite. When superimposed, the figures become mysteriously both more solid and insubstantial; the overlapping music and the incidental spoken words and birdsong combine delightfully. One enjoys the game of watching out for events to repeat while at other times being caught unawares when they do so, having been distracted by some little drama as it unfolds. *Water Pulu 1869–1896 (Water Polo 1869–1896*, 1987/8) is built around the central image of a circle, the ball involved in a lively water polo match, which becomes the natural focus of attention. Galeta optically re-frames the filmed record of this match so that the ball now miraculously appears in the exact centre of the screen at all times, hanging apparently motionless. As a consequence, the world appears to spin obsessively around this fixed point, the whole bizarre performance accompanied by Debussy's *La Mer*.

Taking his obsession with symmetry even further, *Wal(l)zen* (1989) takes the form of a temporal as well as visual palindrome. Galeta found a pianist able to play Chopin's *Waltz Op 64, no.2* both backwards and forwards, and recorded his hands at the keyboard as he performed this trick. In an early version, Galeta simply showed the film forwards, then in reverse, so the forwards performance becomes backwards, and vice-versa. But in a later reworking made at the Béla Balázs Studio, he intercuts and sometimes superimposes different sections of the original to create a more complex mirroring, all the time maintaining the shape of Chopin's composition. The familiarity of its tune makes it easy to follow, despite wide variations in the 'colour' of the notes we are hearing. For Galeta, it was important that his work was underpinned by an abstract philosophy, developed from the work of an artist he admired, Waclaw Szpakowski (1883–1973), whose continuous line drawings of variations on

120 Ladislav Galeta, *Two Times in One Space*, 1976–84

the Greek key pattern prefigure his work in their absolute symmetry: 'the way in – is the way out'.

Sometimes, artists have found an analytical, almost archaeological, purpose to the pattern of repetitions – pleasure in the pattern becoming subservient to a new 'truth' revealed. Martin Arnold, a Viennese pupil of Kubelka, has made a speciality of loop-printing short sequences from Hollywood films in order to reveal psychological meanings apparently hidden within; meanings that are certainly at odds with the original film's intended narrative, and surely unrecognized by its maker. They are almost an unconscious stratum, waiting to be uncovered. In *Pièce touchée* (1989), Arnold progressively works his way through a nondescript eighteen-second shot from Joseph M. Newman's crime thriller *The Human Jungle* (1954), in which a woman sits reading in a chair, a man enters the room, they kiss and the man leaves; nothing more. There is no movement at first (once again, this is like the frozen frame engineered by Lumière's projectionist), then the woman's hand begins to move imperceptibly, almost to vibrate, and increasingly oscillates, her expression beginning to alter and show an awareness of some distraction. The film runs forwards in tiny steps, but also backwards again, as if it is twitching. As the movement escalates, the repeats lengthen and the woman's attention drifts towards the door, the door handle begins to move.... The scene is riveting; every shade of movement seems both 'normal' and potentially dreadful. Time unpicked in this way seems to reveal both 'actual' emotional drama in the detail (as predicted by Epstein in his riff on a close-up of the mouth) and to suggest other dramas of our imagining. In *Alone, Life Wastes Andy Hardy* (1998), derived from one of the series of Andy Hardy movies starring Judy Garland and Mickey Rooney, 'Andy' embraces his aged mother, but the repetition of his hugging motion makes it appear that he is attempting rape; in the meantime, with arms outstretched, Judy is singing in another room, and stutters and stammers though her song 'There must be someone waiting, waiting, waiting....' Again, forwards and backwards motion and repetition introduce false emotions, yet there seems to be a hint that these are truths latent in the saccharine original; there may be something rotten in the American nuclear family (certainly as depicted by Hollywood).

Though a short-lived and, as we have seen, widely interpreted phenomenon, the Structural film challenged all subsequent filmmaking artists to rethink their assumptions about the basic reproduction of time and space in film, and, like the Conceptual film, helped to establish the notion of 'film as an object', complete in itself.

Chapter 7
The Everyday

The Film Diary

Among the first films made by the Lumière brothers in the 1890s, listed in their catalogue of films available for early screenings alongside the more familiar novelty items such as *Arrival of a Train at La Ciotat* and *The Gardener Takes a Shower*, are some that are undeniably glimpses of 'lost Edens' – for example, *The Cat's Lunch, Children With Toys, A Game of Cards, Children Out Shrimping* and *Baby's First Steps*.[1] These must have been treasured by their makers, yet it seems that very few such intimate home movies or diary-films have survived from the next few decades of cinema, owing, no doubt, to restricted access to film cameras (today, we casually store them on our phones). Home movies and artists' film-diaries are often close in spirit; indeed, the latter could be seen as little more than a home movie with grander aspirations. The question remains: when did the first such film appear that can claim our interest as a work of art?

One candidate might be a film diary made by the animator Oskar Fischinger in 1927, *München-Berlin Wanderung* (*Walking from Munich to Berlin*), though Fischinger never showed it publicly in his lifetime. The film gains its interest equally from its maker's experimental frame of mind and the unusual way he chose to spend some weeks that summer. Still very early in his career, having made some animation tests but yet to release a proper film, Fischinger set off from Munich, heading for Berlin, 360 miles away, where he anticipated that more interesting film work might be available. Extraordinarily, he decided to walk there by country roads and through little towns, and to record his walk on film. He took with him just a backpack, tripod and film camera, and shot clusters of single frames and occasional

121 Oskar Fischinger, *München-Berlin Wanderung* (*Walking from Munich to Berlin*), 1927

short bursts of live-action, recording scenes and events along the road: a river crossing made by rowing boat, views of picturesque villages dominated by rural Baroque church towers, hop-pickers working their way across a field, orderly vineyards, peasants in their working costumes smiling quizzically at the camera, itinerant shepherds with flocks of sheep and geese, curious children, storm-clouds gathering, welcoming hosts at inns. He used film sparingly, as he only had one roll (four minutes) in his camera. Perhaps he imagined that he might one day make enlargements of some single frames for a photo album? (It seems he didn't). It's a film of jittery motion and flashing images, broad daylight and gathering gloom, but, as with the best diaries, the result is a vivid account of a personal journey, and at the same time, a record of a vanishing rural way of life and its landscape.

One of cinema's great film-diarists, Jonas Mekas, made a crucial observation about how film-diaries inevitably differ from written ones. 'When one *writes* diaries, it's a retrospective

process, you sit down, look back at your day and you write it all down. To keep a *film* (camera) diary is to react (with your camera) immediately, now, this instant. Either you get it now, or you don't get it at all'.[2] 'Reacting instantly' is the essence of the film diary. Good ones, those worthy of reaching a public, connect with universal experiences and at the same time reflect the filmmaker's own encounter with interesting times and interesting lives, so gaining an exceptional point of view. Mekas's diaries reflect not only his own extraordinary life's journey from Lithuania to the US, but also the emergence of artists' film in America in the 1950s and 1960s, a movement in which he himself played a pivotal role. Almost immediately on his arrival in New York in 1949, although penniless, Mekas bought a camera and started shooting footage of his daily activities – his first ventures into the city's streets and parks, meetings with other Lithuanian exiles, filmmaking ideas shared with his brother and fellow filmmaker Adolfas, and later the founding meetings of the New York Filmmakers Cooperative and the *Film Culture* magazine editorial group. Only in the 1960s did he begin to realize that the film diary was a form that he might develop for its own sake. Earlier, in Lithuania, he had written *Idylls of Semeniskiu* (1948), a cycle of poems about the rural life of his birthplace, and this poetic mix of observation and commentary on daily events carries over into his films.

Mekas has described his method:

On some days I shoot ten frames, on others ten seconds, still on others ten minutes. Or I shoot nothing.... The camera has to register the reality to which I react and also it has to register my state of feeling (and all the memories) as I react. Which also means that I have to do all the structuring (editing) right there, during the shooting, in the camera.[3]

Spontaneity – immediate response – is everything. *Walden: Diaries, Notes and Sketches* (1969) was the first of his diaries released, and established his style. In the context of the ambitiously conceived filmmaking of the artists he championed, the title's reference to Thoreau may be seen as a declaration that this was a return to basics; simple ideas and simple means. Mekas allows his subjects to interact with him: they smile at the camera, inter-titles give cues to scenes that follow and from time to time he includes meditative comments in a slow-paced, poetic voiceover. Sound is more continuous than picture, so his words, or a Chopin waltz, or his own halting accordion-playing may overlap several scenes. The action is frequently condensed and sped up by rapid single

122

framing (as in Fischinger's *Walk*), though shots may be held longer to emphasize an action, a gesture or a descriptive camera movement.

Reminiscences of a Journey to Lithuania (1972) records Mekas's first trip back to the village of Semeniskiai to see his mother and other surviving family members after an absence of almost twenty-five years. Scenes of awkward but happy reunions and shared memories are bracketed between sequences from his 'lost' early days in New York, then a filmed visit to the Elmshorn suburb of Hamburg where he was held in a forced labour camp during the war (a suburb he finds to be in denial of its past), and a concluding celebration of his new 'family' of New York avant-garde film luminaries, the critics Annette Michelson, P. Adams Sitney and filmmakers Ken Jacobs and Peter Kubelka, meeting together at Kubelka's home in Vienna. *Lost Lost Lost* (1976) may be his masterpiece. It takes its title from a planned documentary film on the displaced Europeans living in America that he and his brother had hoped to make in the 1950s, but the present work consists simply of diary footage from 1949 to 1963. It poignantly chronicles his impoverished life in the early years, then his discovery of a context and a sense of purpose though his involvement in New York's literary and emerging film avant-gardes, and in 1960s protest movements. In other words, it records his maturation as an artist. His later diaries become both more personal and more public, on the one hand recording his marriage and arrival at late fatherhood and his move from Soho to Brooklyn, on the other reflecting his contact with celebrities like the Kennedy family, John Lennon and Yoko Ono, Alan Ginsberg and Andy Warhol, the public status of these friends inevitably contrasting with the intimacy of his filming style. His *Birth of a Nation* (1997), a feature-length collection of portrait shots of major and minor figures in the international film avant-garde, is fascinating to those who can recognize the bright young things of the 1970s but indigestible to the uninitiated. Both films are the product of Mekas's compulsion to record and then to share. But, as he says on the soundtrack of *Outtakes from the Life of a Happy Man* (2012), there is no ulterior motivation, 'no purpose; just images; [it's] just images, for myself...and for a few friends; just images'.

Mekas's film diaries were – and remain – an inspiration to many later filmmakers, but they were first screened at a moment when several of his close associates were already showing film-diaries of their own, and it was perhaps their example that encouraged Mekas to complete and show his.

122 OPPOSITE Jonas Mekas, *Walden: Diaries, Notes and Sketches*, 1969

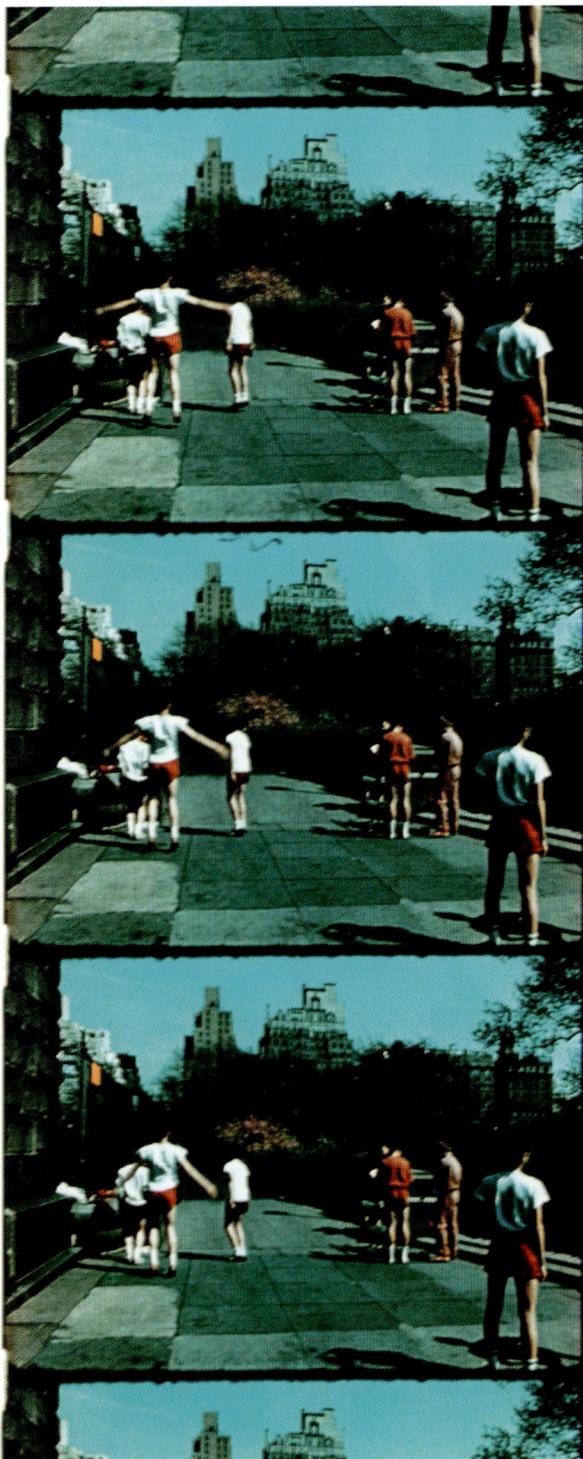

KODAK 3393 73. 2004

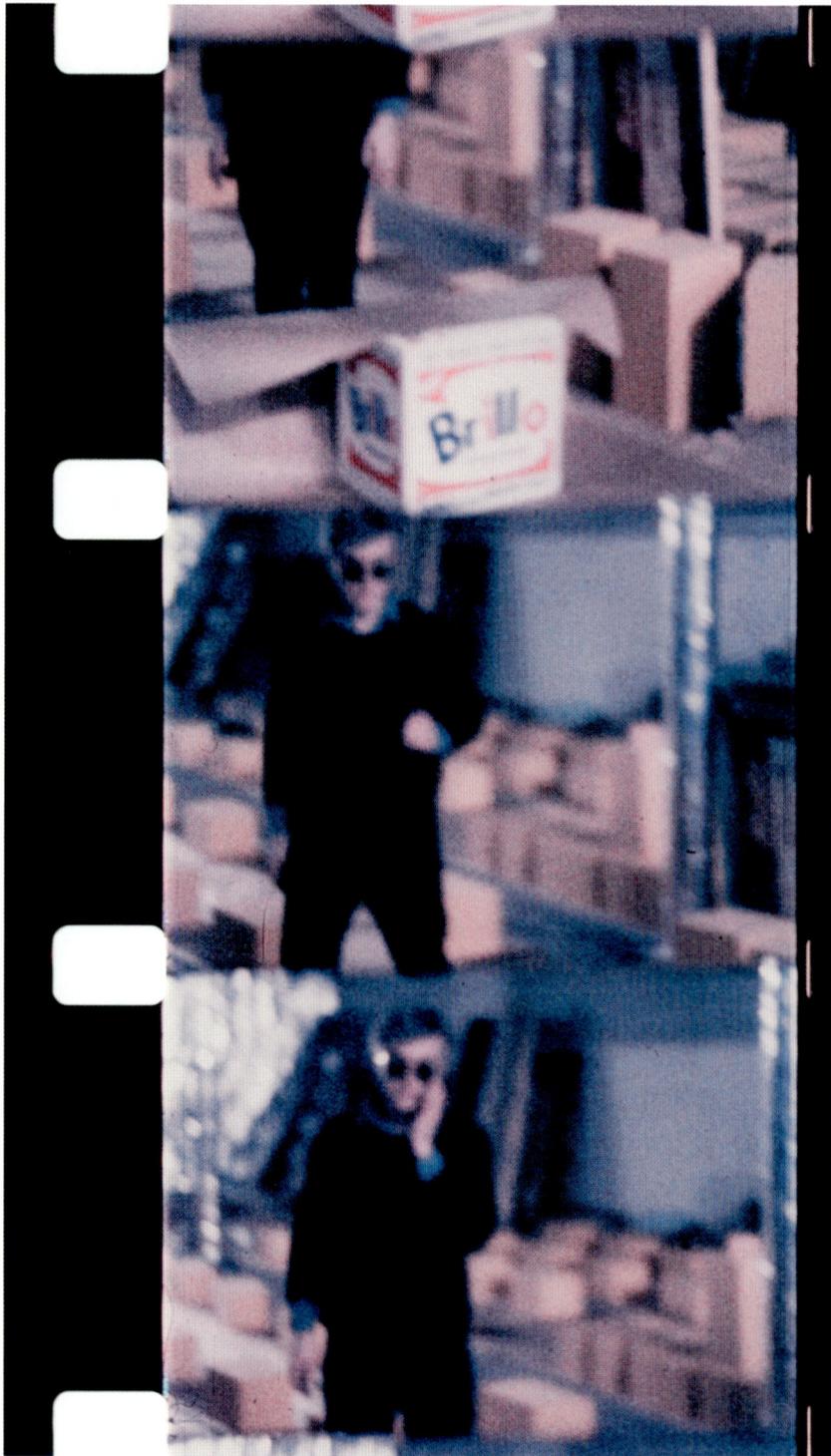

One such contemporary, Marie Menken, had been making diary-like studies since the late 1950s. Her *Glimpse of the Garden* (1957) consists of shots of plants, paths and water, some filmed through a magnifying lens, isolating fragments of the view and informally set to a recording of birdsong, while the silent *Andy Warhol* (1965) observes Warhol's partly delegated creative process. Using a hand-held camera, Menken snatches glimpses of Warhol and his assistants, the poet Gerard Malanga and others, as they work at his studio – 'the Factory'. The result is an intimate portrait of the artist before celebrity took over, still personally involved in creating the *Flowers* and *Jackie* silkscreens, some of his most famous works, and in wrapping up the *Brillo Boxes*. She notes the untidiness of the space, the silver-lined loo, friends and associates coming and going.

 Other contemporaries who made the diary form their own included Taylor Mead, Gerard Malanga and Michel Auder, all associated with Andy Warhol and witness to Warhol's own diaristic obsessions, notably sound recording. Warhol never listened to some of his sound tapes; one series found immortality of a sort in the form of his 'novel' *A* (1968), which transcribes twenty-four hours of almost continuous drug-fuelled chatter by his friend Ondine. Michel Auder's video diaries are as prolific and indiscriminate as Warhol's; minimally edited chunks of his life reveal his marriage to and stormy relationship with the Warhol star Viva, his interaction with other former Warhol stars, his struggles with drugs and his travels. One ninety-minute section is his *Portrait of Alice Neel* (1976–82), which includes footage shot as the artist worked on a portrait of the pregnant Margaret Evans. It seems that Auder, as much as Neel, is the film's subject; it is her response to Auder, his entourage and the ever-present camera that dominate the film. Warhol's other disciples were more likely to follow the late-Mekas route of recording the highlights of their travels and celebrity encounters; both Gerard Malanga and Taylor Mead made film journals of their travels in Europe, mostly predictable records of Grand Tour sightseeing and meetings with famous friends abroad (the railway heir Jerome Hill, patron of Anthology Film Archives, resident of Cassis and a film diarist himself, among them).

 The real joy of the film diary is often found in its humbler manifestations, those made purely for the pleasure of recording. One of the most lyrical of these is an early work by film–landscapist Peter Hutton. Its prosaic title, *July 71 in San Francisco, Living at Beach Street, Working at Canyon Cinema,*

123

123 OPPOSITE Marie Menken, *Andy Warhol*, 1965

Swimming in the Valley of the Moon (1971), gives fair warning that its scope is modest, but does little to prepare the viewer for the compensating sumptuousness of his black-and-white imagery. Equally in his diaries and his landscape studies, Hutton endows his everyday subjects with a grandeur that comes from careful composition within the frame and long takes that allow events, such as they are, to unfold in their own time.

Derek Jarman's Super-8 diaries, which began with *Studio Bankside* (1970) and *Journey to Avebury* (1971), were also down-to-earth in intention, made as mementoes of time spent with loved people and in cared-for places, initially to be shared only with his immediate circle. Admiration for their mix of spontaneity and calculation, intimacy and abstraction eventually persuaded him to share these small-scale works with a wider public and drew him more fully into working with cinema. Jarman never fell completely under the spell of the great machine of mainstream cinema, retaining his love of Super-8 to the end. He sometimes shot his feature films on this amateur gauge, only later blowing up the footage to 35mm for cinema release. Both *The Angelic Conversation* (1985) and *The Last of England* (1987) were made this way, and in their structure they retain the informality of the amateur gauge, offering more of a collection of visual ideas than a sustained narrative.

Quite another kind of film diary was created by Dieter Roth in the shape of his multi-screen work *Solo Scenes* (1997–98). Unwittingly, he found an entirely positive way to respond to Léger's challenge to make a twenty-four-hour film 'in which ordinary people with ordinary jobs are investigated with a sharp but concealed eye for all those hours', though the life – his own – that he chose to investigate was far from 'ordinary'. He put his 'work, silence; banal everyday intimacy and love' onscreen. While Mekas pursued the 'key moment' and the 'spontaneous reaction', Roth was determined to record only the everyday and mundane, and planned a method that was likely to exclude anything picturesque or colourful. *Solo Scenes* was born of Roth's conviction, evident in all his artworks, that everything has equal value. In his artwork *Flacher Abfall (Flat Waste)* (1975–92) he collected the detritus of daily life – sweet wrappers, packaging, bus tickets (or more often airline tickets, since he had home studios in Iceland, Germany and Switzerland), indeed anything that was less than 5 mm thick, and stored it neatly in clear plastic envelopes in lever-arch files, forming static diaries of a sort. Made in the last year of his life, *Solo Scenes* comprises 131 video-monitors showing

124 OPPOSITE Dieter Roth, *Solo Scenes*, 1997/1998; installation view 48th Venice Biennale, 1999

unedited, continuous fixed-camera views (though sometimes he moves the camera from one fixed site to another) as he works, eats, sleeps, goes to the loo or otherwise rests or occupies himself creatively in another part of his environment. The very absence of reality television histrionics, the sense instead of quiet purposefulness, together with the multiple views and timeframes that give the viewer work to do in reconstructing time and space, makes the work compelling viewing.

Combining portraiture with study of place, Agnès Varda's *Daguerréotypes* (1975) documents the daily life surrounding the celebrated cineaste's Paris flat in the Rue Daguerre:

Cinema shot in my courtyard, in my road, among those who leave their doors open, the traders. It's neither an enquiry nor a systematic study of the local people.... It's just that for personal reasons I wanted to stay close to home, and so set up my camera at the end of a cable plugged into my power socket.... It's a modest local document about a few small traders, an attentive look at the silent majority; a district album...[a document for] the archives of the social anthropologist of 2975....[4]

These intimate portraits are brought together and given a 'big cinema' context through Varda's voice-over narration and a staged performance by an accordion player and a magician that (artfully) bring the community together. She referred to this film as a work of 'local cinema'.

Sometimes, footage shot according to the principles of the diary-film is transformed by the artist into something else; something altogether more ambitious. Nearly all of the many films shot by Stan Brakhage were initially made in response to daily life; but the footage was altered either by extreme actions taken while shooting, such as rapid, expressive camera movements, focus-pulls, superimpositions, or later by hand-painting or bleaching the film-strip, creating a simulation (or 'record', he would claim) of his emotional response. His method was initially inspired, he admitted, by what he saw in Marie Menken's films – a release from obligation to 'relate to ordinary visual perception' and a licence to attempt an 'authentic documentation of [the] inner spirit'.[5] For Brakhage, the methods and even the aspirations of the 'amateur' filmmaker were as important to the development of his art as were the masterpieces of classic cinema. 'I have a growing conviction that something crucial to the development of the art of film will come from amateur home-movie making, as well as from the study of the classics: Eisenstein, Griffiths, Méliès and so forth'. He sang the praises of the 'amateur's' 8mm camera:

'It is so small and lightweight – I stick it in my pocket and carry it everywhere – and so cheap....' He rejoiced in the resulting film's transformation in projection: '8mm film is given such a blow-up on the screen that you can see the grain of the film stock much more clearly than in 16mm high-speed film. The crystals that make blue look quite different from those making red and green.'[6]

The degree of abstraction in the material that Brakhage moulds into his films – its very obscurity (just what are we looking at?) and extreme subjectivity – is conveyed by his friend Dan Clark's transcription of part of the twenty-six-minute *Prelude* to Brakhage's magnum opus *Dog Star Man* (1961–64). The film's grand theme is that of the artist's struggles and daily preoccupations in his remote mountain cabin in Colorado, featuring Brakhage himself, his dog and the snowy mountain landscape. But 'meaning' is entirely carried by little more than hints of the recognizable, set within a near-abstract play of light and movement. Clark's layout on the page gives a sense of how these glimpses, movements and suggestions cluster together into 'phrases', although another viewer might have punctuated this transcription differently and conveyed a very different response to the rhythm of the image-flow. This is the opening:

> *dark green for a long time*
> *flashes slowly appear, faint, blurred, becoming more distinct*
> *bluish foam, cars at night*
> *red blurs, orange, bluish foam, orange body blurred*
> *red DSM face [Dog Star Man/Brakhage's own], blue, green DSM*
> *face, bluish foam green, red, blue, red, green*
> *yellow fire, dog's head*
> *green, blue, white*
> *fire over rotating distorting-lens shot of foam – appears stretched,*
> *twisted, as if being wrung out*
> *greenish dog; red, green, orange*
> *yellow flames on green, red fire on black*
> *cars at night, red fire, blue, car lights, blue, red fire, green-orange*
> *globules, orange, white*
> *black-painted film superimposed with a masked round white*
> *shape, painted film, dog fur*
> *flames with rotating distorted foam, turns pink, turns blue*
> *white vertical scratches on black-green, yellow fire, scratches...*[7]

Brakhage's images don't strictly record the events unfolding around him; rather, they follow his intuitions about the uniqueness and expressiveness of what he is seeing through his viewfinder. This is vision and emotional response in one.

125 Stan Brakhage,
Dog Star Man, 1961

Experience sometimes tells him that what he has just shot needs another layer, so he rewinds the film within the camera and shoots again, or else at the time of printing the film adds another layer (or layers). He edits in response to the flow of what he has gathered. *Dog Star Man* contains his first extended use of hand-painting over filmed imagery – a technique he believed simulated hypnogogic vision (the patterns visible when eyes are closed) – revealing a determination to unlearn 'adult' vision. In the later series *Scenes from Under Childhood* (1967), he set himself the challenge of matching the 'untutored vision' of infancy. In the opening paragraphs of his extended essay 'Metaphors on Vision', he wrote:

Imagine an eye un-ruled by man-made laws of perspective, an eye unprejudiced by compositional logic, an eye which does not respond to the name of everything, but which must know each object encountered in life through the adventure of perception. How many colours are there in a field of grass to a crawling baby unaware of 'green'?[8]

In *Dog Star Man*, the visual flow contains hints of adult sexual preoccupations and anxieties, themselves an echo of the uncensored sexual awareness of infancy. Such filmmaking has to be absorbed at the level of the *gestalt*, as in music or in abstract painting, or, in the spirit of Hirschfeld-Mack's encounter with the moving image in 1912, as a response to the 'the power of the alternating, abrupt and long drawn out movements of light-masses'.[9]

The filmmaker, painter and performance artist Carolee Schneemann was a close friend of Brakhage, and her films can be seen as being made in a dialogue with his, offering a critique of his vision (though she admired the originality and audacity of his achievement). Most radically, her film *Fuses* (1965) presents a woman's view of the pleasures of sex; she films her partner James Tenney and herself as they make love, and, by controlling the camera actions herself, directly challenges what filmmaker and writer Laura Mulvey would later identify as 'the male gaze' implicit in so much film-making, whether that of artists like Brakhage or commercial film directors. The sex act, commonly the subject of pornography, is visualized in an assertively positive expression of a woman's awareness. Like Brakhage, Schneemann used paint, rapid cutting and collage on the filmstrip to give expression to her imagery. Other films by Schneemann responded to the appalling imagery flooding television and newspapers during the Vietnam War (*Vietflakes*, 1966) and documented her performance art (*Meatjoy*, 1964

126

126 Carolee Schneemann, *Fuses*, 1965

onwards); but her most ambitious, and also most critical of Brakhage, *Kitch's Last Meal* (1974–78) is once again a form of film diary, and consists of five hours of Super8 footage. It is usually projected onto two screens one above the other, but has been shown in various forms during its five years of making.

Kitch was Schneemann's cat and companion, the film less a daily record than a recollection of everyday events in which the cat's presence was a constant factor. As Schneemann explained:

The film is not an attempt "to see" what is, [or] to understand the self, [or] presume the vision of the cat, but through the mediation of the cat and our intimate shared life, to see lived patterns in a framed passage, subject to recurrence, repetition – as are the details of ordinary life which form these patterns.[10]

She considered the cat as a far from disinterested observer:

Normally a feminist (to my sense of it), Kitch gave intense concentration and attention to the details of life which traditional male culture isolates, denigrates, or despises. The full and entire spectrum of human physical functions and activities were always a source of interest and delight.[11]

The film's form reflects the complexity of thought – both human thought and the artist's speculation about cat-thought.

The entire film forms a fabric, a permeable membrane of remembrance…. It was my analysis of the cat's awareness by which the parameters of shooting were determined…. The implicit 'drama' of the film was my premise to film what I observed Kitch observing so long as she lived. Since I began this diary-work when the cat was already sixteen years old, her death was inevitable if not imminent.[12]

This text was written before the film's completion and Schneemann later acknowledged that the film was also a diary of her relationship with her then-partner Anthony McCall and its eventual break-up, echoed in the death of Kitch.

Bill Viola, one of the most widely exhibited video artists of the twenty-first century, was initially inspired by Brakhage, and particularly by his determination to find images equal to the depiction of life's great sacraments – birth, sexual union and death. His early single-screen film *The Passing* (1991) depicted his mother's last breaths and his infant son's first, intercut with an extended shot of his own body floating, submerged in water as if in purgatory, and travelling shots of a glowing nocturnal desert landscape, scattered with debris, perhaps representing the chaos and mystery of daily life itself. In his later installations Viola has largely abandoned montage and presented his elemental images individually, sometimes on different screens, often mimicking the format of religious iconography and thus giving his work the solemn appearance of museum exhibits (which many have become). Near-static groups of figures confront the mysteries of human experience in symbolic form, all depicted in Viola's signature extreme slow

motion. Viola has described his *Martyrs (Earth, Air, Fire, Water)* (2014), made for St Paul's Cathedral in London, and its later companion piece *Mary* (2016) as 'practical objects of traditional contemplation and devotion',[13] deliberately connecting with earlier pictorial and spiritual traditions.

'The Cinema of Looking'

Related to the film diary, but less concerned with the filmmaker's personal experiences and reactions, are films that set out to document beauty uncovered in 'the everyday'. Both making these films and viewing them requires what might be considered a suspension of the normal expectations of spectatorship, and any desire for a quick visual hit. Required instead is a willingness to slow down and to 'look'. The first masterpiece in the genre must be *In the Street* (1948) by the American photographer Helen Levitt, made collaboratively with the painter Janice Loeb and the writer James Agee. The film has no purpose other than to record the pleasure found in the act of watching. The subject is children playing in a New York street, their games and interactions with passers-by. There is no message or ulterior motive; the camera's framing is informal and the editing little more than functional punctuation; this is filmmaking as straightforward and direct as it can be.

The films of another photographer, the Swiss-born American Rudy Burckhardt, were initially perhaps no more than home movies:

At first, my movies were a lot like my still photographs, except [they] had the extra thrill that you can kind of guess what's going to happen.... When you take a still photograph, you try to wait for the right moment, everything seems just right, and then you click the shutter and the picture is finished. Now if you have a movie camera, and things are moving in your scene, then you try to let things happen, [you hope that] that somebody will cross from one corner to another, and then somebody else will come from another corner, and maybe they collide.[14]

He recalled: 'a friend of mine was going to call it the cinema of contemplation, so I said, why don't you just call it the cinema of looking, which is even simpler'.[15]

But while 'looking', he was also alert to the unexpected; the bizarre glimpsed in the everyday. His early *Montgomery Alabama* (1941) looks at buildings, traffic, the landscape and

127 OPPOSITE Joseph Cornell, *Aviary*, 1955

people going about their business, but includes unexpected imagery that almost anticipates Pop Art in its focus – a bottle standing in the street that is revealed to be enormous when a person walks in front of it; billboards seen atop buildings, tangles of telegraph wires. Sometimes his films seem like an elegy for a past age. *Under Brooklyn Bridge* (1953) records the demolition of early nineteenth-century neoclassical warehouses – redundant stone temples – that once crowded the waterfront beneath the famous bridge, and offers portraits of the dust-covered demolition workers as they take their lunch in taverns.

127 Burchardt was one of several artist–filmmakers chosen by his friend Joseph Cornell to make films of the everyday poetry to be found in the New York streetscape, such as *Aviary* (1955), showing winter sunlight, birds, humans and statues in New York's Union Square, and *What Mozart saw on Mulberry Street* (1956), which records dusty junk-shop windows, one with a bust of the composer; each film is a simple act of observation. Cornell's *Wonder Ring* (1955), a portrait of the soon-to-be-demolished Third Avenue Elevated Railway, was shot by Brakhage, others by collage filmmaker Larry Jordan.

Sometimes observational films have the quality of visual epiphanies, in which the artist's perception and the camera's recording mechanism magically come together. Guy Sherwin's *Short Film Series* (1976–2014) is a collection of such moments; each draws on his deep knowledge of his camera's ability to perform an act of space-time-light transformation within the chosen scene. Some are uncomplicated one-reel (three-minute) 128 film records: '*Cycle* – With camera fastened to the bicycle-seat, looking down at the back wheel, I cycle in circles through puddles, leaving a succession of trails to dry in the sun. My shadow revolves through the frame like a wheel'. Others involve the magic of one subtle edit: '*Tree Reflection* – A tree changes place with its reflection in the canal. Towards the end of this palindrome, a coot returns backwards.'[16] (In the second half the film runs upside-down, so in reverse).

Closer in spirit to that of Marie Menken, the films of the German artist Helga Fanderl are shot on the amateur (silent) gauge of Super 8 and directly edited in camera. 'My films record encounters with events and images in the real world that attract me…. There is no post-production in my work. Every single film preserves and reflects the traces of its creation, the sensations and emotions I felt in the moment of filming'.[17] Some seem like a visual metaphor (cranes restlessly flying from branch to

128 OPPOSITE Guy Sherwin, *Cycle*. From *Short Film Series*, 1974–2004

branch in a large aviary); some note a haptic coincidence (a Ferris wheel and roundabout, the artist's viewpoint making their spinning movements seem enmeshed, like gearwheels), some just one striking visual phenomenon (crab apples bouncing to the ground, as a hidden hand shakes them from the tree). In hundreds of little films recorded over more than thirty years, Fanderl has sought out and documented such magical moments.

The Film Portrait

Preserving the 'likeness' of loved ones is the impulse behind much home movie-making, yet only rarely seems to result in a work of art. The Lumières' family studies tended to focus on shared activity rather than direct portraiture; but there was greater artistic potential in another early film by Fischinger, ever the innovator, who shot portraits of his 'team' – himself, his brother Hans and cousin-wife Elfriede – in his Berlin studio in 1931, at a time when his *Studies* series was in full flow and he was enjoying some success. Harshly lit from a single slight source, Oskar is the central figure, Hans mostly behind the camera until he manages to arrange a cable release so is able to include himself in some final shots, Elfriede characteristically unable to stop talking and laughing. (Her indomitable spirit would sustain Oskar materially and emotionally during his bleak Hollywood years). But this is a modest film of single frames and short bursts, and was never intended for public release.

Relationships prompt the most intimate of portraits. An unnamed individual is the subject of Tom Chomont's *Oblivion* (1969), which shows a body, a profile (not perfect – we are dealing with a real person, presumably the filmmaker's partner of the moment, and this is no Warholian fantasy of bodily perfection), fragmented by rapid cutting, alternations between positive and negative imagery, solarization and a painting of flowers (by the subject? suggestive of warmth?), then final shots of cold winter (the relationship ended?). Another film by Chomont, *The Cat Lady* (1969), is a portrait of his close friend Carla Liss, a Fluxus artist and, like Mekas and Schneemann, a renowned cat-lover. Seen seated and in profile, the only movement is her outstretched hand stroking a largely offscreen cat; but there are explosive interruptions of imagery from *The Creature From the Black Lagoon* (1954), perhaps an acknowledgement of Liss's volatile temperament and the cat's calming influence. Equally direct and simple is Chick Strand's *Anselmo* (1967) a three-minute portrait of her

129

129 LEFT Tom Chomont,
Oblivion, 1969
130 ABOVE Gunvor
Nelson, *My Name is
Oona*, 1969

friend Anselmo Aguascaliente, a Guanajato street musician, which also commemorates his spontaneous reaction to a gift. The filmmaker brings him a tuba, which she knew he had long wished for, and in the Mexican desert they greet and circle around each other in joy.

Gunvor Nelson's *My Name is Oona* (1969) is made from within the family circle; it shows her daughter, still a child but on the cusp of emerging into the adult world. A collection of loving images of the daughter smiling at her mother behind the camera is intercut with superimposed negative and positive images of trees, alternately sparkling with light and darkly menacing, evoking the artist's mixed hopes and fears for her daughter's future.

In the 1950s and 1960s a form appeared that has proven enduringly popular with artists: the mini-essay film portrait, in which footage of the subject is surrounded by images reflecting their environment and achievements. An early example is a portrait of the artist and occultist [Marjorie] Cameron in Curtis Harrington's *The Wormwood Star* (1955). The young avant-garde, soon-to-be-Hollywood director surrounds Cameron's already striking appearance with close-ups of her symbolic drawings, accompanied by recordings of her reading from her writings and the rhythms of ceremonial drumming. Similarly striking is

131 BELOW John Akomfrah, *The Unfinished Conversation*, 2012
132 OPPOSITE Andy Warhol, *Jonas Mekas (Screen Test)*, 1966

Margaret Tait's *Hugh MacDiarmid – A Portrait* (1964), images of the poet at home and in the streets of Edinburgh accompanied by his unique voice reading verses from his poems, written in a rich (near-lost) dialect: 'I lo'e the stishie / O' earth in space / Breenging by / At a haliket pace'.[18] Nam June Paik's *A Tribute to John Cage* (1973–76), a cut-up of records of performances by Cage and himself, and John Akomfrah's three-screen tribute to the cultural theorist Stuart Hall, *The Unfinished Conversation* (2012), largely assembled from archive footage, are more recent notable examples.

131

Another form, closest in technique to the studio portrait of old, became suddenly popular as a direct result of Andy Warhol's obsession with recording the famous and the beautiful in different media. In the early 1960s Warhol invited members of New York's *beau-monde* to sit for what he called his *Screen Tests* – a series of one-reel (four-minute), black-and-white, tightly framed head-and-shoulder shots, silent and unedited. He issued an extraordinary challenge to his over 400 sitters, among them 'Baby' Jane Holzer, Barbara Rubin, Ethel Scull, Gerard Malanga, Allen Ginsberg, Roy Lichtenstein, Jonas Mekas and Harry Fainlight. Warhol would place them in front of the camera and ask them to look directly into its lens, not to smile, even sometimes not to blink (as if taking a still photo); he would then turn on the camera and leave it running, often wandering away to leave his subject alone to confront the camera's gaze. Some saw this as an invitation to perform indifference; others

132

openly revealed their discomfort; few, it seems, had the courage to avoid the staring lens and to walk away. Their responses disclose much about their personalities. The *Screen Tests* were shot at twenty-four frames-per-second, then projected at sixteen frames-per-second. Slowed down, the landscape of the face becomes even more exposed, and the films unexpectedly and disturbingly confront the viewer with the sitter's unrelieved stare, reversing the traditional spectator–subject relationship. They are arguably Warhol's most enduring achievement, and many artists were directly inspired to follow his example. Peter Gidal, who knew Warhol while in New York, marked his arrival in England by making *Heads* (1969), a series of portraits of notable London art-world and music personalities including Steven Dwoskin, Pete Townshend, David Hockney, Marianne Faithfull, Richard Hamilton, Anita Pallenberg, Francis Bacon and Carolee Schneemann that closely follows the format of the *Screen Tests*, except in his tighter and more austere framing of the image.

Also prompted by Warhol, but very different in their ambition, are the series of one-reel/100-foot portraits that form *Galaxie* (1966) by Gregory Markopoulos. Like his friend Curtis Harrington, Markopoulos felt it important to include references to the sitter's achievements and living or working environment, and used his technique of image clusters and superimpositions to achieve this. He described the making of the first portrait in the series, of the poet and critic Parker Tyler:

In selecting a background for Mr Tyler's portrait, I decided upon the lamp and desk where he is most constantly at work.... With Parker Tyler's suggestions in mind I decided on the movement of the first composition and began filming immediately. The first take lasted fifteen feet. The subject did not move, he had been forewarned of the problem of winding the camera. I wound the camera. Parker Tyler again began the limited action. This continued from the first take to the last take up to ninety-five feet. Often I would fade out, then fade in.... And so, having reached ninety-five feet...I covered the lens and re-wound towards the beginning of the film roll. Once again, with a second composition, the same process was repeated. Then a fourth, fifth and sixth time.[19]

So, these are films in which the subject is surrounded by oscillating light, significant objects, complex pictorial space and overlapping time.

Warhol's direct influence can be seen again in Sam Taylor-Johnson's *David* (2002), her hour-long, silent, looped film portrait of David Beckham sleeping after football training in

133 Tacita Dean, *Michael Hamburger*, 2007

Madrid, shot in a single take. Here she reflects her admiration for *Sleep*, Warhol's six-hour epic from 1963 in which he filmed the sleeping poet John Giorno, his lover of the time, creating a film-object of almost private devotion. In contrast to Warhol's then little-known subject, and perhaps with a twenty-first century sense of irony, Taylor-Johnson takes as her subject one of the most intensively photographed global celebrities of the time, and places him in an unexpectedly intimate, almost vulnerable setting.

Among her many forms of art-making, Tacita Dean has shown a particular dedication to the film portrait. Some of these are studies of artists at work – Merce Cunningham seen distantly in a wheelchair in his last years, rehearsing dancers (*Craneway Event*, 2009) or David Hockney smoking and contemplating his own portrait series *82 Portraits and 1 Still Life* (*Portraits*, 2016). Others observe the artist in repose – Cy Twombly lunching and reading a newspaper (*Edwin Parker*, Twombly's given name, 2011), Claes Oldenburg looking at a collection of discarded ephemera stacked on shelves (*Manhattan Mouse Museum*, 2011). Dean has also sometimes adopted the essay form. In *Michael Hamburger* (2007), the subject seems keen to divert attention elsewhere; he reads a poem by Ted Hughes and holds forth on the subject of the reclassification of apples, of which he was a connoisseur. Again, this document was shot near the end of the poet and translator's life. *Mario Merz* (2002) shows Merz in Tuscany, sitting at a table, with friends unseen. Dean apparently stalked Merz over several visits to art events in Europe, and finally

133

secured his agreement to sit for a portrait on the condition that she didn't record his voice:

So that afternoon in the garden with the table under the trees, we made a film. Mario picked up a large pinecone and cupped it in his lap. The sun went in and out with the impromptu speed of an ungainly fade. Funeral bells began tolling in the main square; cicadas stopped and started under their own command and crows flew to and from the roof, while Mario chatted away. He sat on various chairs in different places in the garden, and I took four reels of film before the sun gave in to the rain clouds and a thunderstorm began.[20]

134

A contribution by the 1990s generation of artist–filmmakers has been what might be described as the subversive film portrait – films that employ some form of subterfuge in order to prompt revelations of character from the sitter. Gillian Wearing's *2 into 1* (1997) is a triple portrait in which she explores the emotional relationship between a mother and her twin sons. But the sons lip-sync the descriptions of their characters originally spoken by their mother, and she lip-syncs their descriptions of her – thus uncovering the complex pushes and pulls in the mother-son relationship. At the same time, body language reveals much about each participant's sense of self.

The self-portrait introduces the larger field of artists' films concerned with their maker's identity. An unusually celebratory example, Yoko Ono and John Lennon's *Two Virgins* (1968), was made to announce the new couple's artistic partnership (and in defiance of the hostility of some Lennon fans). At first, and in extreme slow-motion, the couple's faces merge into one, sometimes with pastoral images superimposed; then we see them looking at each other and finally kissing. Their joint album of the same title provides the soundtrack. More modest, but similarly defiant in spirit, the Austrian painter Maria Lassnig's *Self Portrait* (1971) is a short animation in which we see her head, drawn economically in coloured lines, as it mutates through a range of self-images, some drawn from fantasy, some from 'reality', while on the soundtrack she sing-chants in heavily accented English about her life and her frustrated dreams. It's a modest addition to her powerful body of painted self-portraits, made over several decades.

A minimal but poignant self-portrait is offered by Colombian artist Oscar Muñoz in *Línea del destino* (*Line of Destiny* 2006), its title a reference perhaps to the lines interpreted in palmistry.

134 OPPOSITE Gillian Wearing, *2 into 1*, 1997

135 Henwar Rodakiewicz, *Portrait of a Young Man*, 1925–31

In its two minutes, we see the image of his face reflected in water cupped in his hands, which disappears as the water leaks away; surely a 'vanitas', a reminder of the transience of all life, and perhaps an allusion to the transitory fidelity of all portrait images.

135 One of the earliest of all filmed self-portraits was made by Henwar Rodakiewicz – a silent, fifty-minute piece titled *Portrait of a Young Man* (1925–31), first shown by Alfred Stieglitz at his An American Place Gallery in New York. But Rodakiewicz himself does not appear in any of the film's three movements. Instead, his young self is described solely through the mood of the onscreen images and the rhythms of his editing. An opening title card suggests:

As our understanding and sympathy for the things about us must reveal our character, so this is an endeavour to portray a certain young man in terms of the things he likes and his manner of liking

them: the sea, leaves, clouds, smoke, machinery, sunlight,
the interplay of forms and rhythms, but above all...the sea.

This abstract study of movement and rhythm is another variant of *Ballet mécanique* and *Film Studie*; but the implication of Rodakiewicz's title is a wider one, that all artists' films are unavoidably a form of self-portrait through the choice of images that they include. Chantal Akerman directly recognized this in her own self-portrait film *Chantal Akerman par Chantal Akerman* (1996), largely an anthology of clips from her earlier work.

The belief that even abstract images might describe an individual continues to reverberate, as the Californian artist Nathaniel Dorsky, describing his own work, insists:

There are two ways of including human beings [in film]. One is depicting human beings. Another is to create a film-form which, in itself, has all the qualities of being human: tenderness, observation, fear, relaxation, the sense of stepping into the world and pulling back, expansion, contraction, changing, softening, tenderness of heart. The first is a form of theatre and the latter is a form of poetry.[21]

Rodakiewicz might have agreed; in the event, he never made another abstract work, but instead went on to collaborate with some of the great documentary makers active in the USA in the 1930s and 1940s – Paul Strand, Ralph Steiner and Willard Van Dyke.

Chapter 8
The Individual Voice

Identity

In an article about the functions of poetry, Seamus Heaney wrote of many poems being 'stepping stones in one's own sense of oneself. Every now and again you write a poem that gives you self-respect, steadies your going a little farther out into the stream.'[1] While the intimate production methods of the amateur and a focus on the subjective are characteristic of many forms of artists' film, a willingness to address difficulty, to reveal intimacies or to 'go a little farther out into the stream' and assert values at odds with the moral mainstream, is at its strongest in the many artists' films that directly address 'one's own sense of oneself'. In the last quarter of the twentieth century, the rise of second wave feminism, the impact of forced migrations and the struggles for gay liberation and racial equality have been echoed in an outpouring of films and videos made by artists in response to the question, 'Who am I?', 'What is my experience?, and – having discovered an answer (however partial) – now insisting 'This is who I am'. Many films that explore personal experience and identity have their roots in the work of Maya Deren, who pioneered the field in the 1940s and memorably theorized the way in which 'experience' might be inscribed in the moving image (in the process offering another sharp definition of poetry):

*Now poetry, to my mind, consists not of assonance, or rhythm, or rhyme, or any of these other qualities we associate as being characteristic of poetry. Poetry, to my mind, is an approach to experience...it is a 'vertical' investigation of a situation, one that probes the ramifications of the moment, and is concerned with its qualities and its depth.... Poetry [is] concerned...*not *with what is occurring but with what it* feels like *or what it* means.[2]

136 Maya Deren,
At Land, 1944

She contrasts this with the 'horizontal' investigation of drama. The idea of basing a film on the artist's personal search may come from Cocteau, and the tactic of alternating between a first-person and third-person camera-eye may come from Deren's partner Sasha Hammid (maker of *An Aimless Walk*, under his former name Alexander Hackenschmied); but it was Deren who first unambiguously placed the artist in front of the camera, charged with the task of representing the emotional path from 'feeling to feeling'. Deren's films *Meshes of the Afternoon* (1943) and *At Land* (1944) can be seen as autobiographical in their expression of the artist's inner life and its frustrations – they are full of echoes of Dulac's *Mme Beudet* – and in their rejection of any framing narrative, they usher in the modern artists' film, which uses metaphor alone to present real psychological problems and social predicaments in visual form.

136

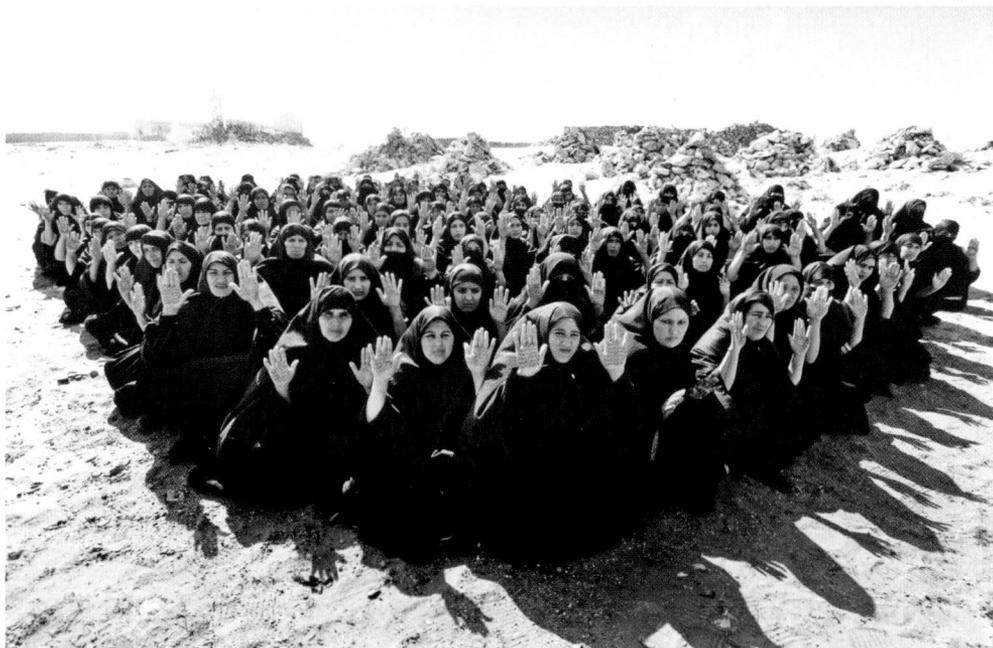

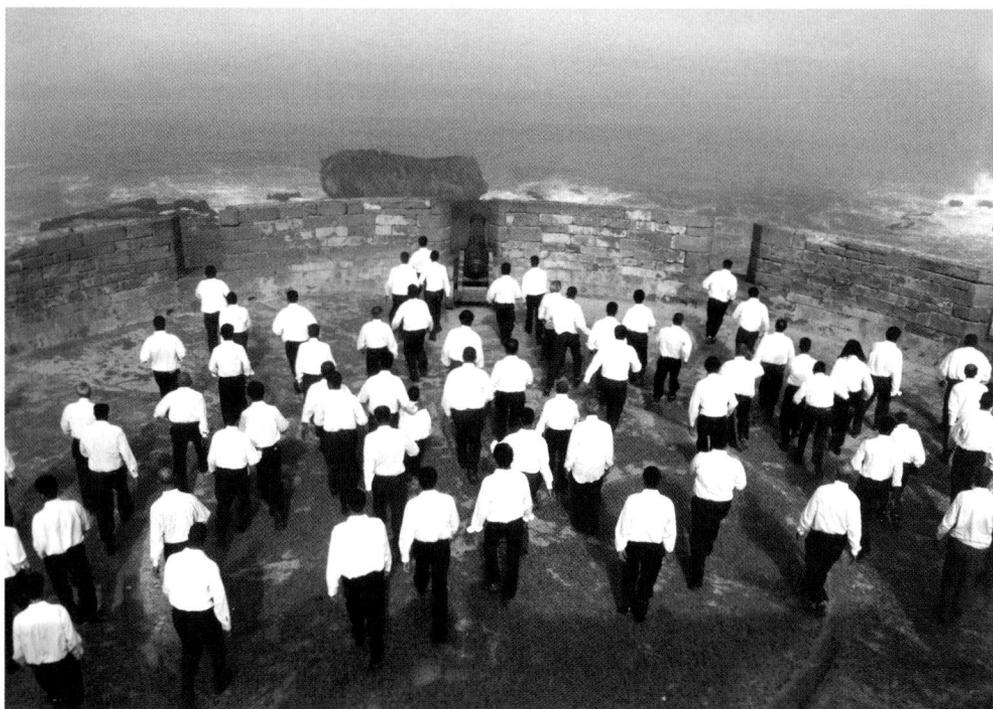

At Land opens with a dreamlike sequence of images: a woman (Deren herself) emerges from backwards-moving waves and crawls up a beach; she hauls herself onto a fallen tree; drags herself along the middle of a table surrounded by people seated for dinner who studiously ignore her; she interrupts a chess-game and snatches a pawn; it tumbles down a waterfall and floats away; she chases it and encounters a man who in successive shots changes identity; and so on. It ends with her running down the beach and encountering versions of herself from earlier, apparently watching her. Finally, she leaves a trail of footprints in the sand. One can read the film as an evocation of birth, growth, thwarted attempts to assert identity, the search for sympathetic partners, assertions of self and awakening self-awareness, and in its final shot, the vulnerability of any trace of one's achievement. Deren herself denied any autobiographical significance, and emphasized instead its representation of the universal artist's need 'not so much to act upon such an [alienating] universe as re-act to its hostile variety.... To preserve, in the midst of such relentless metamorphosis, a constancy of personal identity.'[3]

137 There are close echoes of Deren's work in the Iranian-born artist Shirin Neshat's two-screen installation *Rapture* (1999), in which Neshat reflects on gender divisions and culture in Islamic society though a succession of dreamlike black-and-white images and highly stylized performance. A large group of men occupies one screen, a similar-sized group of women the other, each group engaging in its own set of actions but choreographed in parallel, forging the link between their worlds. The men are identically dressed in Western clothes and are linked with the defensiveness of an ancient fortress; they enter it en masse, and seem content to perform regimented, even absurd roles and activities within its walls. The women, uniformly dressed in the all-covering chador, are more unexpectedly associated with the desert, 'thrown into nature, where one doesn't expect to see them' as the artist says.[4] While we see them devoutly chant and pray, they make their way across the desert in unregimented ways, a brave few finally climbing into a rowing boat and launching themselves into the unknown vastness of the sea. *Rapture* is an exile's meditation on the culture she has left behind, and particularly on the often misread extent of restrictions and freedoms enjoyed by women.

138 *I Dish* (1982), an early film by Jayne Parker, also employs Deren-like performance and visual metaphor, essentially to

137 OPPOSITE Shirin Neshat, *Rapture*, 1999

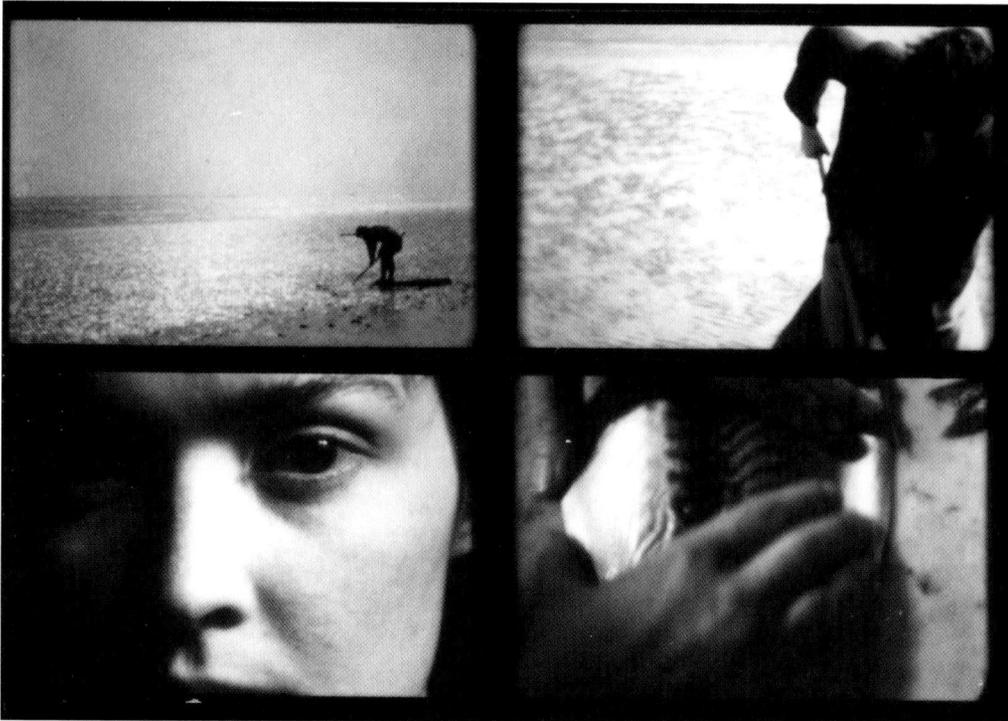

138 Jayne Parker, *I Dish*, 1982

explore the psychological state of a single woman. In a poetic text written about the making of the film, Parker described how it was important to her that the woman's relationship with the technology of filmmaking should be free from any implicit male gaze. (This aspiration in itself might be one definition of Feminist filmmaking):

I watched her from a distance, respecting her, her space, her privacy.... I didn't observe her in close-up. The close-up shots are from her point of view.... She is never vulnerable in the open landscape, not even when she is naked in the pond – which is a metaphor for the inner / third landscape which is inside her.[5]

The male figure in the film, also naked, is seen only indoors and obsessively washing himself, and never makes it into the outside world.

The issue of how women should be represented in film is often a fraught one, but in the 1970s and 1980s, many women found new ways in which they might positively represent

themselves. In *Light Reading* (1978), a film essentially about 'language' and how it is used, Lis Rhodes employed images and particularly the voice-over text of her film to describe the transition from 'someone being watched' to someone now in control of her own image'. :

> *She watched herself being looked at.*
> *she looked at herself being watched.*
> *but she could not perceive herself*
> *as the subject of the sentence*
> *as it was written*
> *as it was read*
> *the context defined her as the object of the explanation.*

Another strategy adopted by women artists has been to put things onscreen that were formerly unseen or at best grossly misrepresented; to bring them into the light or to restore to them some sense of their proper meaning. Gunvor Nelson's film *Kirsa Nicholina* (1969) records the birth of a friend's daughter, an event already remarkable in its time because it occurs at

139 Lis Rhodes,
Light Reading, 1978

home, filmed utterly un-clinically, in a celebratory and loving environment. A midwife is present, the father assists, and at the moment of birth, the mother reaches down and grasps the hand of the emerging child and guides it out of her body and into her arms. Closely related in subject, Catherine Elwes's *Myth / There is a Myth* (1984) might be said to recover the breast, so frequently the subject of the male gaze in both the history of painting and cinema's mainstream. 'The body of the mother, so often reduced to an image of sentimental and selfless bounty in the canon of Western art, is reclaimed as a source of desire and fear.... Its ability to withhold as well as satisfy creates in the male imagination a fear that, one day, woman will take revenge for her subjugation'.[6]

More bluntly, VALIE EXPORT commented on the male obsession with the breast in her expanded cinema performance *Tapp und Tastkino* (1968) in which she walked the streets with a 'mini-cinema' box strapped to her naked chest with curtains across its front, and invited passers-by to put their hands in and satisfy their fantasies. A year later, for her performance *Action Pants: Genital Panic* (1969), she walked through an art-film cinema wearing a pair of cut-away pants that framed her crotch, challenging the audience to engage with a 'real', offscreen woman and at the same time cleverly reversing the objective

140

141

140 Catherine Elwes, *Myth / There is a Myth*, 1984

141 VALIE EXPORT, *Tapp und Tastkino* (*Tap and Touch Cinema*), 1968

of revealing costumes such as bikinis. In her short film *Mann & Frau & Animal* (1970–73) she asserts women's right to their own sexual gratification; she is seen in a bath pleasuring herself with a jet of water from the shower hose, its head removed, and we hear her moans of pleasure; after climaxing, in a final twist, the image of her vagina becomes 'a photo', now smeared with white stuff, and we hear a man's gasping sound. This transformation suggests the inevitable patriarchal appropriation of images of, for and by women.

Anne Severson's *Near the Big Chakra* (1972) grapples with pornography:

I realized I had never seen any woman's vagina except in crotch shots in pornographic magazines or close-ups in birth films... 'Chakra' is Sanskrit for wheels and centres of radiating life force.... Near the Big Chakra *assumes that it's a good idea to take a look at things even if they're forbidden, or taboo, or frightening, or exciting, or mysterious, or dangerous. I guess that's one of my basic assumptions about what's interesting to do in the world, and also what's interesting to do in art.*[7]

In the film we see the vaginas of thirty-eight women, aged three months to sixty-three years.

142 Martha Rosler,
*Semiotics of the
Kitchen*, 1975

143 Birgit Hein, *Kali Film*, 1988

Parody has long been a potent form of fight-back, and
Martha Rosler's *Semiotics of the Kitchen* (1975) satirizes a
stereotypical representation of woman through the form of a
mock television cookery show, offering a primer which 'replaces
the domesticated "meaning" of tools with a lexicon of rage and
frustration.'[8] In a single fixed-camera take, Rosler constructs
an alphabetical catalogue of kitchen utensils and accessories,
'apron, bowl, chopper, dish...', exaggeratedly performing their
functions, her mime suggesting her own violent rejection of the
product in each action. Her protest at society's banishment of
women to the kitchen also humorously mocks the patronizing
tone of much 'women's television'.

Birgit Hein's *Kali Film* (1988), meanwhile, takes images of
violent women from horror and crime films – genres prone to
exploitation – and by stripping them of their narrative context
and collaging them together, reveals their latent sexual power.
Hein wrote:

*We have to ask ourselves how these images of women arise, and
what they mean to men and women.... The* Kali Film *shows
fantasies of sexuality and violence that are taboo in official
culture.... We find pictures of our own base instincts. Kali is the*

The Individual Voice

275

mother goddess in Indian Hindu mythology. She is the child-bearing and at the same time the killing and castrating woman. Men have been fearing her might since primitive times.[9]

It has been equally important for artists to affirm the Black body image in film. *Bear* (1993) was Steve McQueen's first major film. In claustrophobic close-up, we see two naked men, one of them McQueen himself, wrestling and provoking each other, sometimes gently, sometimes fiercely, exchanging glances, stares, smiles, the camera dancing around them, the relationship between the men remaining ambiguous (is it one of trust or hostility?). McQueen fastidiously designs the spaces in which his works are shown, and with *Bear* he uses enforced proximity with the projected image – the larger-than-life size of the figures and their silence – to heighten the confrontation with them. He explains:

You are very much involved in what's going on. You are a participant not a passive viewer. The whole idea of making it a silent piece is so that when people walk into the space they become very much aware of themselves, of their own breathing...I want to put people into a situation where they're sensitive to themselves watching the piece[10]

While watching the piece, audiences are also inevitably sensitive to Black maleness. McQueen has continued to make single-screen films and installations, while developing a uniquely successful career as a feature film maker, notably his Oscar-winning *Twelve Years a Slave* (2013). The Black experience is ever-prominent in his work.

In the post-war USA, Deren's films – and before them, Cocteau's – provided a model for a generation of gay filmmakers, including Harrington, Markopoulos, Kenneth Anger and poet–filmmaker James Broughton, all at least initially based on the West Coast (some with connections to Hollywood) and all determined to make works that gave some form of expression to their sexuality. Two films made at the end of the 1940s, one by a twenty-year-old living in Hollywood, the other by a forty-year-old *enfant terrible* of literature in France, introduced a personal cinema based on affirmation of gay sexual desire and candid self-exposure. Each made a powerful film-poem that openly expressed his own 'forbidden' sexuality; Kenneth Anger with *Fireworks* (1947) and Jean Genet with *Un chant d'amour* (1950). Anger was living in France when Genet made his film, suggesting that Genet may indeed have seen *Fireworks*.

144 Steve McQueen, *Bear*, 1993

In Anger's film 'A dissatisfied dreamer awakes, goes out in the night seeking "a light" and is drawn through the needle's eye. A dream of a dream, he returns to bed less empty than before.'[11] The firework of the title is a phallic roman candle, and the dreamer is Anger himself, who goes into the night searching a pick-up, is beaten up by sailors, but returns to bed with a dream lover and the fulfilment of the orgasmic firework. Made clandestinely at home while his parents were away, this brave and witty coming-out film was made in distant response to Cocteau's *Le Sang d'un poète*, and to Anger's delight, was immediately recognized by Cocteau as the work of a fellow poet.[12]

Genet's film is stylistically closer to the conventions of French classic cinema. It is his subject matter, gay love, and his particular use of framing and close-up, that gives his film its power. Silent despite its date, it employs dream imagery and visual metaphor to show the fulfilling love exchanged between two male prisoners held in separate cells, and the contrasting sexual frustration of the voyeuristic warder who sadistically rules over them. Genet was a connoisseur of erotic detail. 'In a certain situation, a clenched fist can move us enormously if the eye registers the texture of the skin, a black nail here, a wart, and the furtive caress of a finger on the palm that we wouldn't have seen in the theatre – and perhaps which the characters ignore.'

145 Jean Genet, *Un chant d'amour* (*A Song of Love*), 1950

146 Sadie Benning, *It Wasn't Love*, 1992

And again: 'The enlarged appearance of a bubble of saliva on the corner of a mouth can – as the scene unfolds – arouse an emotion in the viewer which would give a weight, a new depth to this drama'.[13] Where Epstein's description of the expressiveness of the mouth in close-up (see p. 21) was emotionally neutral, Genet sees instead cinema's disturbing potential. The scenes of cigarette smoke passed between the lovers through a straw poked through the wall that divides them, an erotic exchange given and received with ecstatic pleasure, is particularly memorable. Genet was unapologetically making a film that some would find pornographic, but he had intended it for an underground gay audience. He might now be surprised at how much more widely it is appreciated.

The coming-out film is the quintessential film about identity, and the relative cheapness and free availability of video recording devices hastened its mass arrival in the 1970s and 1980s. For her bold pop-exploration of her own sexuality, *It Wasn't Love* (1992), made while still in her teens, Sadie Benning chose to shoot using a child's toy, the Fisher Price 'Pixel-Vision' video camera, and rejoiced in its pixelated, 'bitmapped' almost chequerboard image. The film concludes with a triumphant and affirmative lesbian embrace. Later in life, she recalled

146

147 Isaac Julien, *Looking for Langston*, 1989

the importance of this unthreatening camera to her as she struggled to give expression to her emotions:

it didn't really feel like it was an art medium. It was more like a best friend or something that would sit there, and listen to me, and kind of help me organize my thoughts. Now it's still the same, but I've developed not only as a person but as an artist – technically learning how to do things and visually learning how to put images together.... I also like to use my handwriting [on screen] just because I feel like the videos are like a visual diary in a way.[14]

A gay embrace is also central to Isaac Julien's breakthrough film *Territories* (1984), made while he was still a student at Central St Martins School of Art. Essentially a documentary, *Territories* presents the annual celebration of London's Notting Hill Carnival as a symbolic act of cultural resistance, but a complex one. We see the spectacle of the Carnival in all its splendour alongside news reports and footage of violence, images of police surveillance and, more unexpectedly, a complex interweaving of different forms of 'gaze' – between police and reveller, woman and man, man and man – reflecting hostility, alienation and, more remarkably, sexual desire. Julien sees this early work as an attempt to redress the media's neutralization of the liberatory power of carnival, and, since

147 he is one of the figures in the filmed embrace, an assertion of his own identity. His later film *Looking for Langston* (1989) is a reflection on the life of the African American writer Langston Hughes, which allowed Julien to explore the themes of homophobia, interracial love and repressed Black male desire. Julien is among the most internationally successful makers of multi-screen gallery installations in the late twentieth and twenty-first centuries.

148 Stuart Marshall's five-television-screen and text installation *Journal of the Plague Year* (1984) borrows its title from Daniel Defoe's account of the Great Plague of 1665, and with it warns that it is a response to the AIDS epidemic, at its most devastating in the UK in the 1980s and 1990s, and with little chance of survival. Marshall would himself die of the illness, and the focus of his installation is the homophobic response of the British Government and particularly the tabloid press. A tranquil sleeping figure resembling Marshall occupies one screen, while around him are hostile newspaper headlines, images of the Flossenbürg concentration camp, where the Nazis imprisoned and murdered homosexuals and political prisoners, and images of burning books and papers recalling the Nazis' attack on academic research into sexuality, which Marshall sees echoed in the Thatcher Government's attack in 1988 on

148 Stuart Marshall, *Journal of the Plague Year*, 1984

London 1984

the proper discussion of gender and sexuality in schools, in the form of Section 28 of the Local Government Act.

Most of Marshall's subsequent work would be made for television, benefitting from the arrival in the UK of Channel 4, which for a while dedicated regular programming strands to supporting diverse and minority voices. In works such as *Desire* (1989), *Comrades in Arms* (1990*), Over Our Dead Bodies* (1991) and *Blue Boys* (1992), he explored the cultural representation of gay people in different social and historical situations, looking to uncover a positive narrative and, not least, pleasure in the image. He spoke of his and colleagues' television work:

One of the reasons why our work has been at the cutting edge is because that whole project of deconstructive practice which bloomed in the late seventies and early eighties collapsed when the problem of pleasure came up. There was so much suspicion of cinematic pleasure.... Now that's the point where we – lesbian and gay filmmakers – took off, because our pleasures had never been spoken about. We wanted to speak about our pleasures in a way which was very difficult for heterosexual Feminist filmmakers.[15]

Earlier, among the first to respond to this still-unspoken challenge were the young gay filmmakers in the circle of Derek Jarman, an artist always determined to put pleasure onscreen. Cerith Wyn Evans and John Maybury made Super-8 films full of homoerotic visual pleasure, such as Maybury's *Sunbathing for Idols* (1978), *A Fall of Angels* (1981) and *Tortures that Laugh* (1983) and Wyn Evans's *Action Sentimentale* (1980), *Have you seen Orpheé Recently?* (1981) and *He Who Falls* (1981). The individual voice can be heard at its most poignant in Jarman's *Blue* (1993), his last film, made when he was almost blind and approaching his own death from AIDS. The film is imageless but for a radiant screen of 'International Klein Blue'. An hour-long prose work for three voices, colour and music, it was broadcast simultaneously by Channel 4 television and BBC Radio 3 in a unique collaboration:

Blue is the universal love in which man bathes – it is the terrestrial paradise.
I'm walking along the beach in a howling gale – Another year is passing
In the roaring waters
I hear the voices of dead friends
Love is life that lasts forever.
My heart's memory turns to you
David. Howard. Graham. Terry. Paul....

A Note on The Taboo

In making films that dealt openly with gender and sexuality, artists frequently found themselves at odds with prevailing cinema censorship rules, and consequently accused of peddling pornography. The trials that followed the seizure of prints of Jack Smith's *Flaming Creatures* played their part in ending film censorship in the USA, and, paradoxically, in the growth of a market in hardcore pornography. But the desire to make honest films with no subject forbidden has led some artists to directly engage with the 'un-showable'. A dispassionate account of sexual activity was one obvious candidate, and the eighteen-year-old Barbara Rubin's multi-screen (one image within another) *Christmas on Earth* (1963–65) was among the first to depict of an array of sexual couplings in a disengaged, egalitarian view. It was closely followed by Warhol's *Couc*h (1964), with an all-star cast – Gerard Malanga, Piero Heliczer, Naomi Levine, Gregory Corso, Allen Ginsberg, 'Baby' Jane Holzer, Amy Taubin, Ondine, Jack Kerouac, Taylor Mead, Rufus Collins, Billy Name and others – seen in static long-shot, coupling variously and with different degrees of enthusiasm.

Warhol's later *Blue Movie* (1969) involved Viva and Louis Waldron performing alone, and was preceded by a hint of courtship (an unscripted chat about the nature of pornography, the Vietnam War and housekeeping). It was made, according to some sources, at Viva's insistence, and in the hope that Warhol should see for himself the beauty of the heterosexual sex act. More typical of Warhol's own prurient interest in sex was *Blow Job* (1964), which is taboo-breaking in subject alone. The thirty-six-minute film shows a young man apparently receiving oral sex, though the viewer only sees his head and shoulders, leaving the person performing the act to the viewer's imagination – another filmic study of the 'orography of the face' that might have surprised and delighted Jean Epstein.

Taboos surrounding certain bodily functions are directly confronted in one of Kurt Kren's collaborations with Günter Brus, his enigmatically titled *16/67: September 20* (1967). It takes the English subtitle to reveal its actual subject – *'The Eating Drinking Pissing Shitting Film'*. In typical Kren fashion, these actions are seen in tight close-up, filmed at odd angles, and in long takes that are fragmented and intercut repeatedly into short bursts. As often in Kren's work, the ferocious editing pattern makes it impossible to distance ourselves from what we see, the physical connection between taking in and giving out becoming inescapable.

149 Stan Brakhage, *The Act of Seeing with One's Own Eyes*, 1971

Stan Brakhage, like Gunvor Nelson, made films of the births of his children, following his wish to document life's great sacraments. In *Window Water Baby Moving* (1959), the first of several, he films his wife Jane at a window, in a bath, then giving birth, before passing the camera to her so she can film his joyful face, momentarily replacing but also affirming the film's otherwise implicit male gaze. More controversially, he also set out to confront the strong taboos surrounding death and the dead body. In *The Act of Seeing With One's Own Eyes* (1971), he filmed an autopsy at the Pittsburgh Morgue. The combination of vision and emotional response in his film-language helpfully removes the process from the purely objective and clinical, though for as long as one is able to recognize anything, the process still makes uncomfortable viewing:

Like the people who gave the process its beautiful name – 'autopsies' literally means 'the act of seeing with one's own eyes' – I needed *to see these things, to see something of what it was to be just turned into furniture meat. After experiencing several days of photographing autopsies, I felt suicide would be very difficult, if not impossible. There's something sadly ridiculous about the dead, and why would you turn this complexity of a wondrous human possibility into a hulk of decaying matter?*

He concludes, 'I love that you have the sense at the end of *The Act of Seeing* that it's landscape. There are wondrous landscapes inside this body, and it's a terrain that, yes, we need to see'.[16]

'New Movies and Happiness'

A laid-back approach to narrative, at least to the unfolding of events, however minimal the action, can be seen as emerging from the fusion of the 'cinema of looking' and the cinema of 'identity'. Jonas Mekas, who was the first to draw attention to this strand of filmmaking in his *Village Voice* column in 1964, 'Some Notes on Some New Movies and Happiness', characterized it as, above all else, 'not serious at all'.[17] These narratives are about living in the moment, acceptance of things as they are and enjoying the spectacle; self-evidently, there is little need for moral judgment of any sort, though film censors have sometimes thought otherwise. The examples Mekas gives include Ken Jacobs's *Little Stabs at Happiness* (1959–63), Marie Menken's *Glimpse of the Garden* (1957), Warhol's *Eat* (1963), Ron Rice's *Senseless* (1962), Dick Higgins's *Invocation of Canyons and Boulders*, Robert Breer's *Pat's Birthday* (a record of a Claes

149

150

Oldenburg Happening, 1962), Barbara Rubin's *Christmas on Earth* and the gallery installation *Shower*, by Robert Whitman (1964). He summarizes:

These movies are like games, not 'serious' at all. They do not even look like cinema. They are happy to call themselves 'home movies'. Useless, 'thoughtless', 'childish' games, with no great intellect, with 'nothing' to say, a few people sitting, walking, jumping, sleeping, or laughing, doing useless, unimportant things, with no 'drama', no 'intentions', no messages – they seem to be there just for their own sake. How Irresponsible![18]

One can see precedents for such happy 'irresponsibility' in the work of the great American comics of the silent era – Chaplin, Keaton, Langdon and even Laurel and Hardy – but the modern iteration surely begins with the stream-of-consciousness monologue by Jack Kerouac and the total absence of meaningful action in Robert Frank and Alfred Leslie's *Pull My Daisy* (1959), which featured Allen Ginsberg, Gregory Corso, Peter Orlovsky, Larry Rivers, Alice Neel and – in her first role before the camera – Delphine Seyrig. The third act of Kerouac's play *The Beat Generation* formed the initial shooting script, but was soon abandoned. Frank, the cameraman, describes the film's evolution: 'You're in a room where people are sitting around. You see something and you swing the camera…then Alfred did the directing in his editing. Because after two days of rushes we sort of gave up on the story. It is in *this* way that it is to my mind a pure film, rather than an acting film'.[19]

It was shot silent, presumably leaving open the possibility of recording any dialogue later, synchronizing it with the filmed image in the Italian fashion; but instead Frank and Leslie opted for Kerouac's voiceover monologue, a decision that transformed the film:

Jack had seen the picture, twice, silent. He thought he was ready to supply something…and we tried it at his house. No good. So we brought him down to the studio and put the picture on. He was wearing earphones, feeling great, listening to unrelated jazz. We went through it in three sections, reel by reel at one sitting (the film is roughly three twelve-minute reels long).

Kerouac partly describes what we are seeing, partly comments and partly riffs on a theme, often revealing the latent sexism of Beat culture; poor Carolyn, the painter (Seyrig), is little more than a domestic servant in this non-drama. He begins:

150 Ken Jacobs, *Little Stabs at Happiness*, 1959–63

Early one morning in the universe. The wife is getting up, opening up the windows, in this loft that's in The Bowery on the Lower East Side, New York. She's a painter, and her husband's a railroad brakeman and he's coming home in a couple of hours, about five hours, from the local. Course the room's in a mess. There's her husband's coat on a chair – been there for three days – neckties and his tortured socks.[20]

We are offered the simple pleasure of watching; of 'enjoying the spectacle'.

Mekas gives this description of one sequence from the several unrelated episodes that constitute Ken Jacobs's 'unserious' film *Little Stabs at Happiness* (1959–63):

A woman sitting in a chair. She sits there and she swings, back and forth, back and forth, without anything else happening. She doesn't even move or look around much, it is a beautiful summer day, somewhere downtown; it could be Orchard Street, or Avenue B. The time goes by, and she swings and nothing else really happens.... We are not used to such inner peace, to such stillness, to doing 'nothing'. Yes, this is one of the most tranquil scenes in all cinema, and most simple – an image that I have been carrying in my

memory from childhood, something that I have never seen since, until I saw it in Little Stabs *again.*[21]

Much of the 'action' in the film could be described as goofing around on the streets, adults and kids doing little, aside from a moment of uncharacteristic purposefulness when Jacobs himself is seen drawing on the pavement for the children's amusement. The final section features Jack Smith alone, in a dress, on a rooftop, occasionally chewing on a pink balloon, appropriately prefaced by the title (in exquisitely eccentric script) 'The Spirit of Listlessness', which might equally describe the whole film. Jacobs describes the informality of its making:

Material was cut [together] as it came out of the camera, embarrassing moments intact. 100 foot rolls [of film] time well with music on old 78s. I was interested in immediacy, a sense of ease, and of an art where suffering was acknowledged but not trivialized with dramatics. Whimsy was our achievement, as well as breaking out of step.[22] *[Out of step with mainstream cinema, one assumes.]*

151 Jack Smith, *Flaming Creatures*, 1962–63

Another of Mekas's cited films, Ron Rice's *Senseless* (1962), consists of a series of picaresque episodes shot while on the way to Mexico, where Rice had hoped to make an altogether different film. These scenes are held together solely by the persona and childlike antics of Taylor Mead. Rice's approach to 'acting' and 'action' consciously recalled the anarchic narrative structures and unworldly personae of the silent-era comics. But the incidents depicted in Rice's films are not the elaborately staged set-pieces of Laurel and Hardy, but a humbler chain of unrelated actions performed by a Laurel-like innocent.

Jack Smith's own contributions to the unserious 'happiness' genre add a deliberate but still casual strand of decadence to the mix. His earliest appearances in *Blond Cobra* (1959–63) and *Little Stabs* had already set the tone. Credited to Jacobs, but based on footage shot by Bob Fleischner, *Blond Cobra* catches Smith in a mood of confession and despair, underlined by Jacobs's choice of camp 1930s tunes and references to Hollywood melodramas. In women's clothes, Smith poses and mugs for the camera, and, in his voiceover, extemporizes a fantasy about the antics of a lesbian Mother Superior (personified strikingly onscreen by Francis Francine) followed by the story of 'a lonely little seven-year-old boy' lost in a large house, who burns the penis of another child with a match. This latter sounds remarkably like a true personal confession, and Warhol would learn from watching such episodes that the confessional mode could be exploited to give his later sound (but still actionless) films such as *Chelsea Girls* (1966) some level of dramatic interest.

Smith's *Flaming Creatures* (1963) was the subject of an obscenity trial, and landed Mekas in prison for his role in its promotion.[23] Many years later, it is hard to understand what the fuss was about; it, too, is a vision of happiness of a sort. One sees bare breasts (sometimes shaken) and flaccid penises (one with lipstick being applied), but nothing typically pornographic. Instead we are offered an extended Arab harem scene, as might have been painted in the nineteenth century by Delacroix, but here gloriously free of sexual hierarchy and with an added sense of humour. The opening title sequence is accompanied by the soundtrack of the 1944 Hollywood film *Ali Baba and the Forty Thieves*, with its gongs, drums and whispered call 'today...Ali Baba comes today'. In a succession of tableaux we see sexually ambiguous creatures, many of whom perform in drag, all of whom seem to have been discovered in a world outside recognizable time and place, there free to indulge whatever impulse occurs to them. The costumes are extraordinary; said Smith, 'the costumes *are* the characters'.[24]

There are sedate dances; a parody of a lipstick advertisement in which men demonstrate its uses; a 'rape' scene accompanied by the sound of pigs squealing, which appears to become an orgy and climaxes in an earthquake (the camera shakes, a lantern swings and dust descends over the scene). Essentially this is a film of beautiful images and a humorously egalitarian camera, as happy to focus on a foot being licked as the elegant image of a statuesque woman in a hat with a flower. Smith claimed that his film was 'as complete as possible a collection of the funniest and hopefully hilarious things I knew at the time....'[25] It is also loving, melancholy and bold.

Flaming Creatures was much imitated. Mekas toured it around Europe in 1964, and its later trials made it widely discussed. It is probable that Jeff Keen saw it in London that year, drawing on Smith's film along with imported Beat literature when making his decidedly heterosexual, Hollywood-nostalgic no-budget films *Marvo Movie* (1967), *White Dust* (1972) and others. Here, again, are costume, spectacle, characters appropriated from popular cinema, minimal action and pop-culture versions of classic myths, but with the added ingredients of drawn imagery and graphic slogans that are very much Keen's own. Similarly, Tonino De Bernardi's two-screen Super8 *Il Mostro Verde* (1967) was made after encountering Smith, Rice and other contemporaries. De Bernardi throws Adam and Eve into the mix, a half-hearted pursuit of the Green Monster across the two screens, a sea of shiny black plastic, pansexual, mostly naked creatures, some with mad wigs, some fanged vampires, one staked in Hammer Horror fashion, and scenes at a garbage dump with figures in Arabian-style costume and a policeman in pursuit – a reference to the *Flaming Creatures* trials? Essential to these films is their liberated vision; priority is given to the imagination and the pursuit of happiness connected to an assertion of identity (however unconventional). These are films made with friends, for friends, in an environment of friendship.

Steven Dwoskin's *Central Bazaar* (1976) is another near-remake of Smith's film, but is utterly different in tone; certainly not a happy film. Dwoskin knew both Smith and Warhol in New York, but made *Central Bazaar* in his adopted home of London, with its own distinctive subcultures. It, too, consists of a succession of non-narrative shots of a group assembled in a colourful, fabric-lined set and isolated from the outside world, some of the men in drag, all elaborately made up, some masked. But Dwoskin (through his camera) is determined to interrogate human relationships wherever they occur; he peers at couples when they form, and when some participants show

152 Kenneth Anger, *The Inauguration of the Pleasure Dome*, 1954

signs that they are uncomfortable in their roles, he relentlessly
pursues them. Examples of British reserve and discomfort are
very much on display, some outbursts of anger, much tentative
petting. His creatures are rarely as relaxed and uninhibited as
Smith's crew appeared to be. Dwoskin's camera dramatizes
our role as voyeuristic spectators; it prowls, probes for
vulnerabilities and stares for longer than is comfortable, again
in contrast to Smith's camera's amiable neutrality.

Kenneth Anger could be said to have anticipated these
visions of timeless indulgence with his *The Inauguration of the
Pleasure Dome*, first made as a three-screen film in 1954, later
revised into a single-screen version and now set to Janáček's
Glagolitic Mass. The film invokes the stately pleasure dome of
Samuel Taylor Coleridge's *Kubla Khan*, but, more prosaically,
it was also inspired by the rituals of Aleister Crowley and by
a Hollywood 'Come as your Madness' Halloween costume
party attended by his friends Cameron, Curtis Harrington,
Samson De Brier, Anaïs Nin and others, some of whom
shared his fascination with Crowley's *magick.* This, again,
is a film of superimpositions, costumes, rich colour and
minimal performance, but here with a programme based on
a Eucharist – a ritual of consumption performed by mythical
beings based on his friends' chosen Halloween identities. As

152

host, De Brier is Shiva, and he takes other forms according to whom he is greeting – Osiris, Nero, Alessandro Cagliostro and Crowley himself (The Great Beast 666); Cameron is both The Scarlet Woman and Kali; Nin is Astarte; Harrington is Cesare the sleepwalker from *The Cabinet of Dr Caligari*; Anger himself is Hecate; Paul Mathison is Pan; others play Ganymede, Aphrodite, Isis and Lilith. The ceremony involves the consumption of wine, jewels, opium and hash, aids to achieving a state of enlightenment, its purpose possibly being to achieve oneness with one's chosen deity. This sense of purpose perhaps undermines its status as a pure expression of 'happiness', but what is certain is that it is primarily a film of extraordinary visual splendour.

David Larcher's six-hour *Monkey's Birthday* (1975) is another vision of happiness of a sort, in which the artist fuses his discovery of a new approach to filmmaking with the exploration of places such as Turkey, Iran and Afghanistan, and of alternative models of living. His family and friends travelled with him and became part of the evolving work. In his earlier *Mare's Tail* (1969), he had already shown his fascination with the filmed image and with what could be done to the film-strip – re-filming it during projection, chemically treating the surface, superimposing images and so on; interrogating 'the material'. *Monkey's Birthday* carried these experiments further, even as Larcher travelled with his entourage and documented daily events and extraordinary sights, trying different lenses and effects, processing some film-reels in the back of the furniture van in which the family lived. In this diary-cum-meditation, the synthetic exoticism of the setting of *Creatures* is replaced by real cultural treasures encountered on the road. The film openly embodies the male gaze; included are self-filmed scenes of lovemaking, his family at play, camping in the desert, his partner washing herself. It must have been nightmarish to be in his entourage, yet the imagery is magnificent. Larcher had an ability to conjure up visual effects from the simplest of materials, his method often benefitting from accidents encountered and exploited en route. Later, with the arrival of video technology, he became one of the very few artists who managed to make works of real visual brilliance and invention using video's magic box of effects, deploying them in ways never dreamed of by others. *VideOvoid* (1993–95) is perhaps his masterpiece, yet Larcher's work remains hardly known, a consequence of his stubborn independence – a stubbornness still typical of the artist–filmmaker.

153

153 OPPOSITE David Larcher, *Mare's Tail*, 1969

Chapter 9
Sustenance

On Making a Living

Is it possible that lack of money can prevent somebody from making art? Who came first, the poet or the publisher?

Stefan Themerson

One stubbornly fixed characteristic of artists' film across the decades has been its inability to provide a living wage for its makers; rarely does income from the exhibition of a film cover even the cost of its production. It is true that most painters and poets similarly make little money from their work, certainly within their lifetime, but until recently the filmmaking artist uniquely faced production costs based entirely upon an alien, commercial economy. In the age of film, the cost of production equipment and film processing was geared solely towards the needs of the entertainment industry. Now, the advent of digital technology has made 'film' almost as cheap and flexible as pencil and paper, levelling the playing field, at least in terms of production. But an adequate return from exhibition remains rare. Even in the early days, probably the most celebrated and successful artists' film, Buñuel and Dalí's Surrealist *Un Chien Andalou*, earned its makers little more than '7–8,000 francs' during its initial eight-month run in Paris, far from covering the cost of its making. In fact, these costs had already been paid for by Buñuel's mother.[1] And few artists' films enjoy such a long run; many are screened just a few times.

The private financing of large-scale projects, and the freedom from commercial concerns it offers, is rare. Jean Cocteau recalled 'I've been completely free only once, with *Le sang d'un poète*, because it was privately commissioned (by

the Vicomte de Noailles, just as was Buñuel's *L'Âge d'or*)'.[2] The scandal surrounding the release of *L'Âge d'or* – its deliberate blasphemy – brought de Noailles's sponsorship of films to an end, and delayed the release of *Le sang d'un poète* by nearly two years.[3] Hans Richter and Viking Eggeling's first efforts were supported by a friendly banker, but that support soon dried up. Such experiences propelled the search for self-sufficiency and cheaper methods of production. Many artists resorted to working exclusively in the amateur realm of 16mm and 8mm film, and later video, when these 'non-standard' formats became available.

When working in the amateur realm, finding appropriate exhibition spaces remained the challenge. Without widespread exhibition and distribution, recovering any production costs was impossible. More recently, the arrival of cheap video reproduction, DVDs and the internet has encouraged various forms of self-publishing and DVD small-press equivalents such as LUX (UK), Re-Voir (France), EAI and Anthology Film Archives (USA), Index (Austria) and others. A few artists have also benefited from the belated intervention of the art market in the 1990s, which at last saw the potential in artists' moving images thanks to these new exhibition technologies. Until then, and for the majority even now, filmmaking artists have most frequently financed their work themselves. As in the past, they survive either by selling works made in other more established media, or by teaching or pursuing paid work within the commercial cinema that takes advantage of their specialist skills.

In the 1930s, advertisers were occasionally sympathetic, if infrequent, commercial sponsors of artists – for example, Stefan and Franciszca Themerson produced a now-lost advert for a jewellery shop, *Musical Moment* (*Drobiazg Melodyjny* 1933), Hans Richter made *Europa Radio* for Philips in 1931, Oskar Fischinger made the cigarette advertisements *Muratti Privat* and *Muratti Greift Ein* (1935) and Len Lye's *Colour Flight* (1938) was created for Imperial Airways. A very few artists – Jerome Hill, Ian Hugo and Joseph Cornell among them – had private means; a few, such as Norman McLaren in Canada and Artavazd Peleshian in the USSR, benefited from consistent state patronage in various forms; and as public funding of the arts increased in some countries in the post-war years, a few artists were able to win grants for filmmaking and exhibition. But even now, wherever they live and work, the majority have to accept that their chosen profession offers little hope of any real financial return. Writing in the 1930s, Stefan Themerson showed scant patience with fellow filmmakers if they complained about their circumstances: 'Is it possible that lack

of money can prevent somebody from making art? Who came first, the poet or the publisher?[4]

More compassionately, in 1937 Themerson also helped to organize the short-lived Cooperative of Film Authors in Warsaw (Spoldzielna Autorow Filmowych), one of the first of a growing number of self-supporting filmmaking and screening groups that emerged around the world, and wrote and published a magazine dedicated to film arts, *fa – f(ilm) a(rtistique)* – with his partner Franciszka as artistic editor.[5] Mutual support was the message. Dedicated film groups like the Themersons', together with occasional international gatherings and a proliferation of short-lived specialist magazines, written by makers and their critic friends, provided a lifeline for artists in the pre-war period. These were joined after 1945 by the novelty of artist-led film distribution organizations, and even collectively owned and run production and exhibition facilities.

On Mutual Support

As early as the 1920s, Parisian film clubs such as the Studio des Ursulines, Studio 28 and Jean Tédesco's Le Vieux Colombier had attempted to run a dedicated cinema programme on a semi-commercial basis, and were seen by artists as sympathetic places in which to share work with other makers; the Vieux Colombier even occasionally offered itself as a studio space for production. In London, The Film Society (1925–39) brought foreign uncensored art cinema and artists' films to a public of middle-class intellectuals on a once-monthly basis. In Los Angeles, the Filmarte organization screened such films from 1928 and was joined later by the American Contemporary Gallery. In Holland, the Filmliga (1927–31) was closely associated with local filmmakers Mannus Franken, Joris Ivens and others; in Belgium, Le Séminaire des Arts was founded by the filmmaker Count Henri d'Ursel, who established the Prix de l'image in 1937, forerunner of the Knokke EXPRMNTL festivals.[6] In Germany, Die Camera in Berlin (1929), and the association of film clubs, the Volksfilmverband fűr Filmkunst, were concerned primarily with exhibition, while the Deutsche Liga fűr den unabhängigen Film (German League for Independent Film) founded by Hans Richter with fellow filmmakers Lotte Reiniger, Walter Ruttmann and others, was concerned with production. In Spain, Buñuel helped set up the first film club at the Residencia de Estudiantes (1920–23), an immediate precursor to the Cine-Club Espaǧnol (1928–31), and he remained in charge of its screening programme even while living in Paris.

These organizations, small and amateur though many of them were, knew of each other's existence and exchanged programmes of work and information. The father of the British documentary movement, John Grierson, gave prints of Post Office films by Len Lye and others to the Themersons to show in Poland; Eisenstein, Man Ray and Hans Richter all personally introduced their work at the Film Society in London; Germaine Dulac visited the Cine-Club Espagñol at Buñuel's suggestion – and so on. Hoping to build on these exchanges, more than twenty filmmaking artists from all over Europe, among them Ivor Montagu from the Film Society in London, Ruttmann and Richter from Germany, Eisenstein, mid-tour from Russia, Franken, from the Film Liga in Holland, Alberto Cavalcanti from France, Ernesto Giménez Caballero, filmmaker and founder of the magazine *Gaceta Literaria* from Spain, Enrico Prampolini from Italy, artists Hijo and Moitiro Tsutya from Japan and Montgomery Evans, a New York literary figure who invested in theatre and film, from the US, gathered at the Congrès de La Sarraz in Switzerland in 1929, where they proposed setting up an international association of film societies and cine-clubs. In 1930, artists from seven nations did indeed sign up to the 'International League for the Independent Cinema'; the clubs' common distrust of the influence of the commercial industry being reflected in their resolution that 'no commercial or semi-commercial association could affiliate as a voting member'.

After the Second World War, it took time for such international networks to re-establish, but they became increasingly widespread and developed different models of engagement and support. The post-war political settlement added its own complications, not least the dispersal and even obliteration of earlier filmmaking communities. Most immediately, there were local attempts to revive filmmaking activity and to reawaken the international spirit that had earlier characterized the art form. Two major exhibition initiatives, one in California and the other in Belgium, attempted to summarize pre-war achievements with a comprehensive international review of landmark films, hoping also to herald a new beginning. In San Francisco, Richard Forster and filmmaker Frank Stauffacher organized the 'Art in Cinema' series (1947–) at the San Francisco Museum of Art, aided by Hans Richter, whose new film *Dreams that Money Can Buy* (1947) was premiered alongside first screenings of new work by Maya Deren, Sydney Peterson, the Whitney brothers and others. Two years later, Jacques Ledoux, a young curator at the Royal Belgium Film Archive, began its long-running series of

occasional EXPRMNTL festivals, later held at Knokke Le Zoute, in the bizarre surroundings of a seaside casino decorated by René Magritte. There were screenings of work by many of the young filmmakers from the USA mentioned above, plus a few new voices from Europe, among them Luigi Veronesi, who showed *Studi sul colore* and Eli Lotar, who showed *Aubervilliers*, both of them prize-winners. Later Knokke festivals in 1958, 1963, 1967 and 1974 would be similarly extraordinary meeting places for new voices from Europe and North America. In London, Olwen Vaughan, who had been involved in both The Film Society and the early days of the British Film Institute, attempted to establish a New Film Society with a similar retrospective of pre-war work, which failed in its primary objective but played a role in encouraging Free Cinema, England's documentary and feature-film 'New Wave' of the 1950s and 1960s. Of these initiatives, only the Californian series could claim to have kickstarted a substantial filmmaking movement among local filmmaking artists, but even so, it was clear that festivals dedicated to artists' films would become an important part of the post-war ecology, as they remain today.

As in the pre-war years, however, it was regular screenings organized by local enthusiasts that kept the art form alive among local groups of artists during the latter half of the century. A pioneer of this practice was Maya Deren, who in the mid-1940s began screening her own works at the Provincetown Playhouse in New York's Greenwich Village, and toured and lectured extensively throughout the 1950s. Her example inspired Amos Vogel to set up his New York-based Cinema 16 screenings and distribution organization, which operated between 1947 and 1963. His efforts were in turn eclipsed by those of Jonas Mekas, with the founding of the New York Filmmakers' Cooperative (1962) and associated screening space the Filmmakers' Cinematheque, and later Anthology Film Archives.

Mekas's conception of an artist-run distribution cooperative was in part a direct response to the selection policy of Cinema 16, which distributed only those films Vogel had successfully exhibited, notoriously to the exclusion of several works by Stan Brakhage. Mekas's egalitarian commitment that *all* films offered to the Filmmakers Cooperative would be promoted and distributed on an equal basis seemed to promise artists both an unprecedented degree of visibility and a sense of identity as part of a like-minded group. Mekas described their objectives thus: 'it is a cooperative film distribution service owned and governed by filmmakers themselves. The "membership card" to the cooperative is your film. No filmmaker is rejected. Seven

filmmakers are elected each year to guide the policies of the cooperative. They meet every two weeks at the Co-op to argue'.[7]

New York's cooperative model was replicated in London (London Filmmakers' Cooperative, 1966), San Francisco (Canyon Cinema Cooperative, 1966), Rome (Cooperative of Italian Independent Cinema, 1968), Australia (Sydney Filmmakers Cooperative, *c.* 1970), Paris (various cooperatives from 1974) and elsewhere around the world, with video organizations quickly following suit – for example New York's Electronic Arts Intermix and The Kitchen (both 1971) and London's London Video Arts (1976). These organizations almost invariably organized screenings as well as distribution, and some, like the London Cooperative, Millennium (New York), LVA and The Kitchen, also developed production workshops.

The economic reality facing these artist-run organizations – that money was hard to make – engendered in some an atmosphere of heroic defiance, a sense of necessary self-sufficiency and rejection of the values of a world that rejected them, eloquently reflected in an article written in the 1970s by New York filmmaker and Fluxus artist Dick Higgins:

Our strategy must be such that we gain from every act of art which we commit [act of film-making, act of screening] some tactical advantage, even if it is only among ourselves (which gives us freedom to breathe). When we make our own organizations – magazines, or publishing for instance – we must not over-expand beyond our actual audiences, or beyond our ability to reach these audiences. This is an age when the dinosaurs are dying, and the future belongs to the warm-blooded little mammals. Most of our work, for now, should be designed so that, even if it were not paid for, we should not be financially ruined. Survival is among our moral obligations, so long as it is distinguished from cowardice.[8]

Fifty years on, despite Higgins, the dinosaurs – Hollywood's blockbuster films – are doing fine, and one might add that a number of gallery-backed filmmaking artists such as Bill Viola and Matthew Barney are doing fine too – but now at least *some* warm-blooded little mammals are also making a little money, if only thanks to a trickle of DVD sales and occasional purchases by museums. The editioning of films and videos – restricting to a handful the number of copies made, the art world's method of ensuring scarcity and thus maintaining value – was, and is, resisted by many artists, who welcome the potentially infinite reproducibility of the moving image. But a compromise that enables works to be both placed in distribution and at the

same time editioned has helped some artists find a degree of financial independence without being wholly 'owned' by the art market.

The artist Ben Rivers has expressed the modern dilemma:

I don't think [editioning] *is necessarily the best way to distribute work. I think it's a good way for me to make some money, which enables me to make the work that I want to make. You can't rely on arts funding to make film, so you need to find ways of sustaining yourself as an artist.* [Editioning] *has worked for me, but I was clear with the gallery right from the start that the films would also be available for distribution, like from LUX.*[9]

The relationship between the art market and artist-led distribution services continues to evolve. But an attitude of defiant self-help, even self-sufficiency, remains typical. Cocteau, incidentally, went so far as to define artists' films by their very *inability* to make money, calling them 'cinematograph' rather than 'cinema', cinema for him being that which is dependent upon 'instant financial return'.[10]

Today, in a final paradox, the pioneer artist-led cooperative organizations have been partially eclipsed by the very growth of the art form that they so carefully nurtured. The potential demand by today's tens of thousands of filmmaking artists has forced them to adopt a different role in the internet age. All have had to abandon their founding 'take all comers' principles and accept instead the selection of those who they wish to support. But in the age of the 'death' of celluloid film as a material base for the moving image, the original spirit lives on in the few cooperative organizations that have sprung up dedicated to keeping low-cost 16mm film printing and processing facilities alive, No.w.here (London) and L'Abominable (near Paris) being prominent among them.

On the Role of Writing

While artists were establishing ways of handling film that were different from those of Hollywood, it was often through the medium of specialist magazines that they first shared their achievements with their peers. It was in the form of reviews, letters and articles, manifestos and notes on their craft that many artists' ideas spread. Arguably, the widespread adoption of many of the most radical ideas about film form – the 'no-editing-at-all' stance of Warhol's early filmmaking or the glissando form of Michael Snow's *Wavelength* – derives more from written accounts than from actual viewings. Those

responsible for the running of artists' film clubs were aware of the importance of the support of print media; they encouraged and sometimes directly produced magazines associated with their activities. *Close-Up, Film Art* and *Cinema* shared the interests of London's Film Society; the Dutch Filmliga published a monthly journal; in France, *Cinéa – Ciné pour tous* was associated with Le Vieux Colombier.

In the post-war period, the London Filmmakers Cooperative spawned *Cinim* and *Undercut*; the French artists' distributor Light Cone was associated with *Scratch*; New York's long-running *Film Culture* magazine was associated with Mekas, the Filmmakers Cooperative and Anthology Film Archives; the *Millennium Film Journal* with the screenings of New York's Millennium Film Workshop. Given these affiliations, it was rare for any of these magazines to follow the work of those moving image artists who chose primarily to show in galleries; 'gallery artists', therefore, looked instead to *Artforum*, *Studio International* and later *Frieze* for comparable attention.

The specialist magazines of the 1920s and 1930s championed 'film art' – a term that included both ambitious feature films and what we would now recognize as artist's works. Out of these early magazines came the first crop of books to seriously discuss film as an art form, among them Jean Epstein's visionary *Bonjour Cinéma* (1921), a collection of his essays (including 'Grossissement') and Eisenstein's *The Film Sense* (1942), a round-up of his own evolving theories of film construction. These, too, saw experimental and innovative film as integral to the broader art of cinema – the contribution of artists as one part of a whole. More clearly focused on cinema's emerging avant-garde was Hans Richter's *Film Opponents Today – Film Friends Tomorrow* (*Filmgegner Von Heute – Filmfreunde Von Morgen*), published in 1929 to coincide with the *Fi-Fo – Film und Foto-exhibition* – in Stuttgart, which he had helped to organize. The cameraman Guido Seeber produced a tiny, brilliant Cubist film, *Kipho*, to promote the exhibition. Illustrated with striking images from films by Marcel Duchamp, Joris Ivens, Man Ray, René Clair, et al., the book contains the first of many accounts that he would publish of the rise of an international film avant-garde.

Two books written before the Second World War, both by artists, adopted an entirely different approach, and are still inspiring to read today; neither is exclusively about film, but both gather together ideas and speculations about the still-latent potential in what we might now call lens-based and time-based media. In the introduction to his *Painting, Photography, Film* (*Malerei Fotografie Film*, 1926), Laszlo Moholy-

Nagy speculates about the still camera's use, based on his own experimental practice at the Bauhaus:

The camera has offered us amazing possibilities which we are only just beginning to exploit. The visual image has been expanded and even the modern lens is no longer tied to the narrow limits of our eye; no manual means of representation (pencil, brush etc.) is capable of arresting fragments of the world like this; it is equally impossible for manual means of creation to fix the quintessence of a movement; nor should we regard the ability of the lens to distort – the view from below, from above, the oblique view – as in any sense merely negative, for it provides an impartial approach, such as our eyes, tied as they are to the laws of association, do not give.

He provides the reader a first taste of the open-minded, 'nothing should be taken for granted, nothing excluded' frame of mind that would become common among filmmaking artists in the decades to come.

Similarly, in his *The Urge to Create Visions*,[11] Stefan Themerson spiritedly testifies to the power of 'the urge' experienced by all artists in whatever medium:

It would be absurd to say that Gutenberg built the foundations of poetry. It would be equally wrong to think that the art of the cinema was born with Edison or Lumière. Poetry, long before we found a way of preserving it in written or printed characters, was recorded in human memory. Visions, long before we found a way of developing them on cinema film, were recorded in poetry.[12]

Poetry, clearly, should be the aspiration of filmmaking artists.

The first publication in English to devote itself exclusively to artists' film as we now know it was the catalogue *Art in Cinema*, which accompanied Foster and Stauffacher's 1947 San Francisco screenings. The book's canary-yellow cover, with its Miro-like abstract design by Bezalel Schatz, was itself a bold declaration of film's affiliation with the modern visual arts. Alongside notes on the films and statements by many of the contributing artists, it contains Richter's 'A History of the Avant-garde' (his first in English) and a chronology of key works and key events, many echoed in these pages, brought up to date by the inclusion of more recent (late-1940s) North American artists such as Maya Deren and Sydney Peterson.

The 1960s saw a flood of books proclaiming the arrival of a new wave of activity across the globe. Sheldon Renan's *An Introduction to the American Underground Film* (1967) offered

a useful series of profiles of leading American figures and their work; Parker Tyler's *Underground Film: A Critical History* (1969) was more analytical and indeed judgemental, as its title suggests; my own *Experimental Cinema* (1971) added some of the key European figures of the period, as did Birgit Hein's more polemical *Film im Underground: Von seinen Anfangen bis zum unabhängigen Kino (Underground Film – From its beginnings to the independent cinema* (1971). P. Adams Sitney's *Visionary Film – The American Avant-garde* (1974) illuminatingly linked strands of American work with the Romantic poets and visionary literature of the nineteenth and early twentieth centuries, especially Pound and Stein, and did much to establish the canon of North American artists' films just as museum curators began to take an interest in the moving image.

A less lofty, more international view was offered by Cinema 16 organizer Amos Vogel in his *Film as a Subversive Art* (1974), in which artists' work was included primarily according to its taboo-breaking content. Steven Dwoskin's *Film Is – the International Free Cinema* (1975) and Malcolm Le Grice's *Abstract Film and Beyond* (1977) soon followed. All of these, apart from Tyler's *Underground Film*, have the simultaneous strength and weakness of being written by makers or activists closely involved in the movement. By the end of the 1980s, academia and the art market had joined the debate and largely taken over the field, the former subsidizing more narrowly focused doctoral studies, the latter issuing weighty monographs on individual artists. Academic scholarship is seen at its best in the writings of David James, who has cast an unprejudiced eye on independent cinema in *Allegories of Cinema: American Film in the Sixties* (1989) and other volumes; in A. L. Rees's *A History of Experimental Film and Video* (1999)*;* and in the dedicated research by Scott MacDonald into artists' organizations such as Cinema 16 and the Canyon Cinema Cooperative[13] and his penetrating interviews with key, mostly American artists in the series *A Critical Cinema* (1988–). Malte Hagener's *Moving Forward, Looking Back* (2007) is a scholarly study of the European avant-garde of the period 1919–1939.

Often the most illuminating sources are the artists' own writings. Deren pioneered this field with her pamphlet *An Anagram of Ideas on Art, Form and Film* (1946)*.* In it, she echoes Cocteau's encouragement to artists to experiment, writing: 'The task of cinema or any other art form is *not* to translate hidden messages of the unconscious soul into art but to experiment with the effects [that] contemporary technical devices have on nerves, minds, or souls.' She repeated the message in her

occasional articles for amateur filmmaker magazines such as *Movie Makers*, urging amateurs to take advantage of their freedom from the industrial machine:

above all, the amateur filmmaker, with his small lightweight equipment, has an inconspicuousness (for candid shooting) which is the envy of most professionals, burdened as they are by their many-ton monsters, cables and crews. Don't forget that no tripod has yet been built that is as miraculously versatile in movement as the complex system of supports, joints, muscles and nerves which is the human body, which, with a bit of practice, makes possible the enormous variety of camera angles and visual action. You have all this, and a brain too, in one neat, compact, mobile package.[14]

The film-diarist and activist Jonas Mekas became a trusted messenger to the emerging film avant-garde through his weekly 'Movie Journal' column in New York's *Village Voice*, and later *Soho Weekly News.* Starting in 1958 and continuing for over five decades, he reviewed works by fellow artists as they appeared, denounced 'bad' commercial cinema (but welcomed 'good'), interviewed visitors from abroad and generally flew the flag for small-scale filmmaking. Addressed to fellow artists (notionally to Gregory Markopoulos and others with whom he was in correspondence), Stan Brakhage's *A Moving Picture Giving and Taking Book* (1971) was a 'how-to' guide that identifies the basic materials of film and outlines the simple mechanics of handling a camera and film-editing, while at the same time illuminating his own often non-standard approach. 'Shoot on double-perforated film stock [he advises], so a shot can be spliced into the edited sequence *upside-down* as well as left-to-right reversed', and so on. Some fellow artists have indeed followed his suggestions, and many more have been inspired by his historically informed but irreverent approach to the medium.

The late twentieth and early twenty-first century have added the internet as a source of knowledge, guidance and debate; artist's own websites, as well as those of Ubuweb, LUX, EAI, Light Cone and others can not only *show* artist's works, but provide information through attached interviews, texts and chatrooms.

On the Ideal Viewing Space[15]
As a space in which to view the moving image, the cinema has its limitations. Here is the artist Robert Smithson's riposte to Elizabeth Bowen in 1971:

Going to the cinema results in an immobilization of the body. Not much gets in the way of one's perception. All that one can do is look and listen. One forgets where one is sitting. The luminous screen spreads a murky light throughout the darkness. Making a film is one thing, viewing a film another. Impassive, mute, still the viewer sits. The outside world fades as the eyes probe the screen. Does it matter what film one is watching? Perhaps. One thing all films have in common is the power to take perception elsewhere. As I write this I am trying to remember a film I liked, or even one I didn't like. My memory becomes a wilderness of elsewheres. How, in such a condition, can I write about film? I don't know.[16]

Besides the wonderful 'wilderness of elsewheres', Smithson's text expresses a dissatisfaction widespread among filmmaking artists with the 'impassive, mute' role forced on the viewer by the mainstream cinematic experience. His distaste perhaps also explains his own, brief filmography. Mercifully, other artists have battled on to reverse the power balance between maker and viewer, not least by reshaping the viewing context.

In the first years of film, before purpose-built cinemas as such existed, all filmmakers – Georges Méliès, the Lumière cameramen and their contemporaries – had to make positive choices about how and where to screen their silent films. They found space in music halls, circus booths and hired halls, none perfect, but none bringing unwanted expectations of 'film' itself. Maxim Gorky's lyrical account of his first brush with the moving image 'Last night I was in the Kingdom of Shadows...' was set in Aumont's, a restaurant with a 'dark room' requisitioned for the performance; one can imagine the background noise of clattering dishes. But by the time artists first became seriously interested in film in the 1920s, the situation was very different; cinema had become institutionalized. The rise of the narrative film and the building of cinemas to house it made inevitable the marginalization of artists' film that lasted for the next sixty years. Only if artists found a niche within the mainstream industry were big cinema screenings possible, either as programme-filling 'shorts' (as in the GPO-sponsored animations of Len Lye), or as what we would now know as 'art-house' features (the privately financed films of Jean Cocteau).

For the rest, it has always been self-evident that there was little possibility of attracting an audience to a cinema when all one had to offer was a four-minute abstract or poetic film, however gem-like that film might be. Portable 35mm projectors did exist, but there is little evidence that they were widely used by artists beyond such rare novelties as a screening within

a live theatre performance (René Clair's *Entr'acte* within Picabia's ballet *Relâche*). The most popular solution became the still familiar film club screening, where artists could show work to each other and to a small but knowledgeable audience. Increasingly, specialist film festivals and other international forums became crucial to the form's circulation and dissemination. As amateur 8mm and 16mm technology became available, home or the studio became potential screening venues available to artists – and for many it is still their preferred space. As we have seen, none of this activity was likely to generate a proper financial return or with it a workable economic system for artists, and none of it represents the work reaching the full extent of its potential audience.

It was only in the 1970s that artists began to enjoy a real choice of context in which to see their work publicly performed. The expansion of ideas about what art-making might involve, together with the development of new moving image exhibition technologies – video recorders, video projection and film-loop projectors – made filmmaking artists think, perhaps seriously for the first time, about the different kinds of environment that might best suit their works.

Still in the 1930s, László Moholy-Nagy was brave enough to dream of an ideal space, suited to artists of his experimental persuasion:

A cinema should be built equipped for different experimental purposes in regard to apparatus and projection screen. One can for example visualize the normal projection place being divided by a simple adapter into different obliquely positioned planes and cambers, like a landscape of mountains and valleys; it would be based upon the simplest possible principle of division so that the distorted effect of the projection could be controlled. Another suggestion for changing projection screens might be: one in the shape of a segment of a sphere instead of the present rectangular one. This projection screen should have a very large radius and therefore very little depth and should be placed at an angle of sight of about 45 degrees for the viewer.

Here, he is anticipating IMAX and other 'surround' projection systems, but he continues more radically:

More than one film (perhaps two or three in the first trials) would be played on this projection screen; and they would not, indeed, be projected onto a fixed spot but would range continually from left to right or from the right to left, up and down, down and up, etc. This process will enable us to present two or more events which start

independently of one another but will later by calculation combine and present parallel and coinciding episodes.[17]

Here, he anticipates the 'Movie-Drome', a domed multi-projector environment built in the 1960s by artist Stan VanDerBeek.

Wildly impractical though these ideas sound, Léger's friend, the architect, theoretician and De Stijl member Frederick Kiesler, did get to design and build such a structure (if on a more modest scale) in 1929, in the form of New York's Film Guild cinema at 52–4 West Eighth Street. This had a comparable arrangement of angled screens and ambient 'sympathetic' lighting, but its use was hardly compatible with regular screenings in conventional formats, upon which any commercial cinema depended, and the arrangement was short-lived.[18] Such innovative screen formats came into their own in the context of 1950s 'World's Fair' multi-screen extravaganzas, 1960s and 1970s expanded cinema and later gallery installations and one-off live performances.

As early as 1958, Stan Brakhage helped Kenneth Anger mount a three-screen projection of his film *The Inauguration of the Pleasure Dome* at the Brussels Experimental Film Competition, and experienced the technical challenges involved:

I worked constantly with Kenneth for a couple of days.... attempting to bring this triptych off. All the projectors came out of sync during the rehearsals and the pubic screening. Finally three out of the seven judges agreed to give up their lunch-hour one day for a final try...which succeeded.... The experience was so incredibly beautiful that I would never for a moment consider the single track [version] as more than a taster for the total experience.[19]

At the adjacent Brussels World's Fair, the two artists witnessed a seven-screen synchronized projection – the *Laterna Magika* – shown in the Czech pavilion by Alfréd Radok (film director) and Josef Svoboda (stage designer), and found it 'banal in subject matter' but 'technically fascinating'.[20]

One – perhaps final – attempt to create an 'ideal' fixed-seat cinema for artists' screenings was undertaken by Jonas Mekas's Anthology Film Archives in 1970, in the form of the 'Invisible Cinema' designed by Peter Kubelka, drawing no doubt on Wagner's 'invisible' theatre concept with its 'invisible orchestra' (sunk below the stage). In Kubelka's version, it is the audience that is discretely concealed from view, each individual sitting in his or her own semi-hooded coffin. 'I saw cinema as a machine, like a camera. My cinema is like the interior of a camera. The

idea is that you sit in blackness and the only thing you see is the screen.'[21] More pragmatically, most artist-run screening spaces have opted for movable seating (individual chairs), and the ability to install projectors and screens at will.

Apart from Moholy-Nagy's inspired speculations, one doesn't know how frustrated pre-war artists were by their day-to-day lack of choice; there's not much by way of a written record of their vexations. Would Léger have liked to show his *Ballet mécanique* in a gallery alongside his contemporary painting, as now happens? Would the makers of abstract 'visual music' such as Ruttmann and Fischinger have liked to see their films shown as part of an orchestral concert, as now occasionally happens? That many artists were dissatisfied with the options available to them is beautifully illustrated in a lecture by Maya Deren, who in 1961 described her own films as 'chamber cinema' rather than experimental or avant-garde film, making a crucial point about scale and appropriate context. Implicitly, she saw artists' films as small in scale, and therefore – like chamber music – ideally to be performed to an attentive audience in an intimate space. Chamber films were 'poetic, lyric-form, abstract, eloquent', requiring small groups of 'virtuoso performers, with every note heard individually', not submerged in a larger orchestration. Films should explore 'every expressive possibility of the instrument', echoing Cocteau. As a form of visual poetry, artists' film had the potential to speak to (at least a small part of) everyone.[22] This suggests that she would have considered neither the conventional cinema space of a National Film Theatre nor the busy walk-through of a gallery at Tate Modern to be appropriate or satisfying. Perhaps the modern habit of watching works at home on a television set from a DVD, or streamed directly to an iPad, might be closer to her ideal? Artists today can certainly specify the way in which they want us to view their works. Many do – and many are quite exacting in their demands. (Deren's lecture was delivered at her alma mater, Smith College, a women's college, and in it she stresses the potential of film as a woman's medium; how pleased she would be to see women's pre-eminence in the field in the 21st century.)

Brakhage was clear about the benefits of seeing work in the home context:

I have said for years that showing a film that is a work of art once, in an auditorium, is like a single flashing of an Ezra Pound poem around the old New York Times *building's electronic news-sign.… If this sort of presentation were true of poetry, poetry couldn't exist. In the language that poetry requires,* study *and*

involvement *and* an ability to manipulate language back and forth *are necessary. If film got into homes it would suddenly open up all these possibilities. A man could not only have the film and look at it as many times as he wanted to, which is important, but also – perhaps more important – exactly* when *he wanted to. Maybe at home he could even stop the film and look at an individual frame, or run it at any conceivable speed and move it backwards and forwards to study it.*[23]

Not all artists were initially of the same mind. When in the 1960s, *Aspen* magazine included a print of Hans Richter's *Rhythmus 21* together with films by VanDerBeek, Moholy-Nagy and Robert Rauschenberg in an 8mm 'film kit' issued with the magazine, Richter was outraged. Mekas urged him to see it differently: 'Ten thousand copied of *Rhythmus 21* went to American homes. That's fantastic. "They didn't pay me a penny" says Richter, "Should I sue them?" "No" I said, "I think it's fantastic that 10,000 copies are available in American homes."'[24]

The simultaneous arrival of video and 'expanded cinema' (performed film and multi-screen film) in the late 1960s and early 1970s opened gallery spaces to moving image artists in new ways, even before film-loop projectors and digital video projection made continuous exhibition possible. Early videos by artists could only be shown on domestic-size video monitors, so were more at home in the space of a small gallery than in a fixed-seat cinema. Artists were happy to assume a one-to-one relationship between viewer and tape, and it became customary to find a video player, a television or monitor with a seat before it and an implicit invitation: 'press *play* to see the work'. Many early tapes have an intimate, confessional tone which capitalizes on this format.

Appropriately, what was arguably the first ever exhibition of video art – Nam June Paik's 'Exposition of Music – Electronic Television' (1963) took place at the Parnass Gallery in Wuppertal, which was in fact the home of the architect Rolf Jährling and his wife, avant-garde enthusiasts who regularly made space for artists to show their work. Paik was in residence there during 1963, and in March filled the house with strange objects – among them domestic televisions tuned to display interference and scanning distortions caused by added exterior magnets.[25]

Vito Acconci – an artist who quickly tuned in to video's potential and loved its intimacy – vividly described the compromises that came with the public exhibition of this domestic-scale medium:

The problem is that videotape is 'thrown into' a gallery. The room is usually darkened, probably with fixed seating – the tape, then, becomes a spectacle and loses its quality of 'home companion'; there's a crowd of people in front of the monitor – too many faces to come face to face with; there might be more than one monitor showing the same tape – so I can't have a definite point to stand in.

He continues – jokingly one hopes – by proposing a gallery viewing setup in which the viewer discovers two walls built three feet apart, each with a monitor set into it at eye-level; a configuration of extreme architectural control designed to force the viewer to 'actively meet the image'.[26]

Following Acconci, a few artists have indeed designed very specific environments in which particular works should be seen. Bruce Nauman's *Live-Taped Video Corridor* (1970) placed two monitors showing apparently 'live' images within a V-shaped, narrowing 'corridor' construction. The presence of a camera and the monitors showing the same space tempted the viewer to enter. One monitor showed a live image in which the viewer appeared; the other, disorientatingly, a previously taped continuous view of the space still empty. In works such as this, video becomes participant in an architectural game.

In the last decades of the twentieth century, as museum curators began to wrestle with the problem of exhibiting moving-image work alongside paintings and sculptures, the notion of the video-installation-as-sculpture became popular. Paik's video-robots – humanoid figures made up of collections of televisions – at last found a home, David Hall began making his monumental piles of inward-facing monitors, such as *A Situation Envisaged: The Rite* (1980), a work equally about visual overload and the difficulty of establishing an individual voice, Tony Oursler started his tiny, confessional talking heads projected onto balloons, and so on.

An assemblage that seemed to set a new standard for imaginative gallery installation was Gary Hill's *Inasmuch As It Is Always Already Taking Place* (1990), a corpse-like collection of large and tiny television screens. The image-bearing glass bulbs are stripped of their surrounding cabinets, linked by entrail-like wires and installed in an illuminated slot in the wall, almost a coffin. Elaborating on this metaphor, Hill describes this arrangement as:

one of accumulation – a pile-up. [The images] appear as a kind of debris – bulbs that have washed up from the sea. Each one is a witness to a fragment of a body – perhaps a reclining figure, a man reading, a corpse etc – forever rendering [the body] actual size, ad

infinitum; (i.e. a 1-inch tube displays a portion of a palm of a hand, or perhaps an unrecognizable terrain of skin; a 4-inch tube displays part of a shoulder or an ear; a 10-inch tube emits the stomach and so on).[27]

With its tight framing and enforced intimacy, there are visual echoes of Holbein's painting *The Body of the Dead Christ in the Tomb* (1521).

In the twenty-first century, many filmmakers who might formerly have held religiously to the cinema space were tempted into the gallery, pleased to find the art world willing to give them sympathetic curatorial attention. Chantal Akerman, Chris Marker and Jean-Luc Godard were among many who revised existing longer works for the gallery context. Often they fragmented them into short sequences displayed on separate monitors or screens, expecting viewers to make connections as they moved between them, creating their own montage. A problem clearly exists if such works contain any degree of linear narrative: how does one prevent viewers from walking in halfway through? Ben Rivers – who has made feature-length works for the gallery – identifies the key challenge as being 'to find different ways of creating that privileged screening experience.... There are ways of encouraging the audience to watch from the beginning to end, like having them press a button to start the film [or having] timed screenings'.[28] This is clearly a halfway-house compromise; but it has been adopted not only by him but by many others.

The opposite view – that one must conceive the work in a form less dependent on a beginning, middle and end – is put forward by Mark Lewis, who places the question in its historical context:

It is true that I try to find ways to display my films so that they can feel 'comfortable' in gallery spaces next to other works such as photographs, paintings and so on.... It is also true that I think the museum is the best place for the quiet and deliberate contemplation of artwork. Therefore, not only have I rejected the cinema as a place to show my films, I have also tried to 'strip the films down' – no sound, not too long, the reduction of temporality and so on.[29]

This debate between artists continues.

From the viewer's perspective, new technologies – videotapes, DVDs, the internet – have brought one huge benefit above all others: the ability to see the artist's moving image on demand, as we have long expected of literature and

music, and as only dreamed of by Brakhage. Gábor Bódy's *Infermental* (1980–91) and other artist-curated video-magazines were one early attempt to create a more intimate and time-flexible viewing context, as were the on-demand videotheques of the 1980s (the London Institute of Contemporary Art; ZKM Karlsruhe, the Pompidou Centre). Today it is possible to find many classic artists' films on the internet, via dedicated sites such as Ubuweb, Vimeo or more generally on YouTube, where they sit alongside artist's individual websites and those of galleries and distributors. No less important is the range of writing about artists' films posted online by serious scholars and enthusiasts alike. The ecology is changing, and will continue to change. But artists' film is no longer a hidden art form, a secret joy known only to a few; it surrounds us, for all to see.

Notes

Chapter 1

1 Elizabeth Bowen, 'Why I go to the cinema', *Footnotes to the Film*, ed. Charles Davy (London, 1937)
2 Fernand Léger, *Fonctions de la peinture* (Paris, 1965), pp. 138–39, 165
3 Ludwig Hirschfeld-Mack in László Moholy-Nagy, *Painting, Photography, Film* (Berlin, 1926)
4 The Lumière programme, as seen by Gorky at the Nizhny Novgorod Fair, *Nizhegorodski listok*, 4 July 1896; translation in *Readings 3* (London, 1973)
5 'Cocteau on Film', *Film: An Anthology*, ed. Daniel Talbot (Berkeley, 1966), p. 218 [author's italics]
6 Epstein, quoted in a memorial tribute by Henri Langois, *Cahiers du Cinema* 24, June 1953
7 Robert Beavers, 'La Terra Nuova', *The Searching Measure* (Berkeley, 2004) [author's italics]
8 'impossible stories', *The Logic of Images* (London, 1991), p. 51–52
9 Fernand Léger, in *Arte Cinema* (Milan, 1977)
10 'Nothing to Love – Andy Warhol interviewed by Gretchen Berg', *Cahiers du Cinema in English* 10, 1967, p. 40
11 Nicky Hamlyn, by email, March 2020
12 'Les Vues Cinematographique', *Annuaire general et international de la photographie* (Paris, 1907), in Richard Abel, trans. Stuart Lieberman, *French Film Theory and Criticism 1907–1939*, vol. I (Princeton, NJ, 1993), p. 44
13 Jean Cocteau, 'Carte Blanche', *Paris-Midi*, 29 April 1919, in Abel, vol. I (1993), p. 173
14 Jacques Brunius, *En marge du cinema Francaise* (Paris, 1954)
15 'Grossissement', *Bonjour Cinema* (Paris, 1921), in Abel, vol. I (1993), p. 238
16 'The Premature Old-Age of Cinema', *Les Cahiers Jaunes* 4, 1933, in Abel, vol. II (1993)
17 'Synchronisation of the senses', *The Film Sense* (London, 1943)
18 '8mm vision', *The Brakhage Scrapbook, Collected Writings* (Kingston, NY, 1982)
19 Tacita Dean, 'Save This Language', BBC Radio 4, 17 April 2014
20 '*La Roue*, Its Plastic Quality', *Comoedia*, 16 December 1922, in *Functions of Painting*, ed. Edward F. Fry (London, 1973)
21 'On the Cabinet of Dr Caligari', *Cinéa* 56, July 1922, in Abel, vol. I (1993) p. 271
22 See Michael Kirby, *Futurist Performance* (Boston, MA, 1971)

Chapter 2

1 Ludwig Hirschfeld-Mack in Moholy-Nagy, *Painting, Photography, Film* (Berlin, 1926), p. 80
2 'Abstract Cinema – Chromatic Music 1912', quoted in Mario Verdone, 'Ginna, Corra, and the Italian Futurist film', *Bianco et Nero* 10–12, 1967
3 'Le Rhythme coloré', *Les Soirées de Paris* 26-27, July–August 1914, in Richard Abel, trans. Stuart Lieberman, *French Film Theory and Criticism 1907–1939*, vol. I (Princeton, NJ, 1993), p. 90
4 Blaise Cendrars, *Aujourd'hui 1917-1929 suivi de Essais et reflexions 1910-1916* (Paris: Denoel, 1987), pp. 73-74
5 Niemeyer (later Ré Soupault) left a detailed account of the process in 'Viking Eggeling', *Film as Film* (London, 1979), pp. 75-77
6 'The major part of *Rhythmus* was made in 1922...the two concluding movements pressing towards the centre of the film are a recent addition'. Richter's note for the Film Society screening of 16 October 1927
7 'Germaine Dulac', *L'Art du Movement* (Paris, 1999)
8 *Ibid.*
9 Oskar Fischinger, quoted in *Articulated Light* (Cambridge, MA, 1997)
10 Norman McLaren, Center for Visual Music <http://www.centerforvisualmusic.org/Fischinger/CVMFilmNotes2.htm>
11 Robert Breer, 'Statement', *Film Culture* 29, 1963
12 #3 by Joost Rekveld, *Light Cone* <https://lightcone.org/en/film-1214-3>
13 For the best account of Lye's evolving theory of human wellbeing, see Roger Horrocks, *Len Lye, a Biography* (Auckland, 2001)
14 'Photography without camera – the photogram', in Moholy-Nagy, *Painting, Photography, Film* (Berlin, 1926)
15 Moholy-Nagy, 'Light Architecture', *Industrial*

Arts, 1/1, London, 1936
16 Hirschfeld-Mack in *Painting, Photography, Film*, p. 80

Chapter 3

1 Robert Flaherty, BBC talk, 1949, quoted in *Robert Flaherty Photographer/Filmmaker: the Inuit 1910–1922* (Vancouver, 1979)
2 John Grierson, review of *Moana*, *New York Sun*, 8 February 1926
3 Luke Fowler, filmed interview supporting his Turner Prize show, 2012 [author's verbatim notes] The film itself is a reworking of his earlier *What you See is Where You're At* (2001)
4 Erika Balsom, '"There is No Such Thing as Documentary", an interview with Trinh T. Minh-ha', *frieze* 199, November–December 2018
5 Quoted in the booklet of the Munich Filmmuseum DVD *Berlin, die Sinfonie der Grosstadt* & *Melodie der Welt* (Munich, 2009)
6 Notably, Jean-Luc Godard with his 'Dziga Vertov group'.
7 *Dziga Vertov Revisited*, ed. Simon Field (New York, NY, 1984)
8 Ado Kyrou, *Luis Buñuel* (New York, NY, 1963)
9 'Der Filmessay; eine neue form des dokumentarfilms', in *Schreiben Bilder Sprechen: Texte zum essayistischen Film*, ed. Christa Blümlinger and Constantin Wulff (Vienna, 1940)
10 A. L. Rees, *Tate Magazine*, Summer 1996
11 Turner Prize exhibition guide, 2012
12 'Mark Lewis in conversation with Klaus Biesenbach', *Cold Morning* (Vancouver, 2009)
13 Scott Macdonald, 'Peter Hutton', *A Critical Cinema* 3 (Berkeley, CA, 1998) p. 242
14 Pompidou leaflet, *c*. 1980s
15 Michael O'Pray and William Raban, 'Interview with Chris Welsby', *Undercut Reader – Critical Writings on Artists' Film and Video*, ed. Nina Danino and Michael Mazière (New York, NY, 2002)
16 'Interview with Chris Welsby', *ibid*.
17 Rose Lowder introducing her work at Tate Modern, 17 January 2014 [author's verbatim notes]
18 *Ibid*.
19 Excerpted from a proposal by Michael Snow to the Canadian Film Development Corporation in March 1969, in Michael Snow and Louise Dompierre, *The Collected Writings of Michael Snow* (Waterloo, ON, 1994)
20 Michael Snow to Charlotte Townsend, *Arts Canada* 152–3, March 1971
21 Michael Snow, *Film Culture* 52, Spring 1971, p. 58

22 'Interview with Klaus Wyborny', Federico Rossin, May 11–13, 2012 <https://expcinema.org/site/en/rhythmic-writings-and-atmospheric-impressions-interview-klaus-wyborny>
23 *Ibid*.

Chapter 4

1 'Chronology and Documents', in Mary-Lou Jennings, *Humphrey Jennings: Filmmaker, Painter, Poet* (London, 1982)
2 Margaret Tait, 'Video Poems for the 90s (working title)', *Subjects and Sequences, A Margaret Tait Reader* (London, 2004). This particular script was written in response to a request from Scottish Television for a twelve-minute film, never realized.
3 Michael Kirby, *Futurist Performance* (Boston, MA, 1971), pp. 122–42
4 Lev Kuleshov, 'The Art of the Cinema (My Experience)', 1929, in *50 Years in Films* (Moscow, 1987); the 'archive' footage available on YouTube makes Kuleshov's claims seem rather far-fetched!
5 Sergei Eisenstein, notebook entry, 26 September 1930, in Jay Leyda and Zina Voynow, *Eisenstein at Work* (New York, NY, 1982)
6 Germaine Dulac, 'The Expressive Techniques of the Cinema', *Ciné-magazine* 4, July 1924, in Abel, vol. I (Princeton, NJ, 1993), p. 309
7 Jean Epstein, 'The Senses' ('Le Sens I bis'), *Bonjour Cinema* (1921), trans. Tom Milne, in Abel, vol. I (1993), p. 242
8 Stefan Themerson, *The Urge to Create Visions* (London, 1983), p. 82
9 Fernand Léger, 'La Roue, Its Plastic Quality', *Comoedia illustré*, March 1923, in Abel, vol. I (1993), p. 272
10 *Ibid*.
11 Sergei Eisenstein, 'Word and Image', *The Film Sense* (London, 1943)
12 Eisenstein, Pudovkin and G. V. Alexandrov, 'A Statement', 1928, in *The Film Factory: Russian and Soviet Cinema in Documents, 1896–1939*, ed. Richard Taylor and Ian Christie (Cambridge, MA, 1988)
13 Andre Habib, Frederick Pelletier, Vincent Bouchard and Simon Galiero, 'An Interview with Peter Kubelka', *Cinema, Off Screen*, 9/11, November 2005
14 *Ibid*.
15 Jonas Mekas, 'An Interview with Gregory Markopoulos', *Village Voice*, 10 October 1963, in *Movie Journal* (New York, NY, 1972), p. 101
16 Gregory Markopoulos, *Twice a Man* <https://markwebber.org.uk/archive/tag/gregory-markopoulos/>

17 Gregory Markopoulos, 'Towards a New
Narrative Film Form', 1963, in *Film as Film: The
Collected Writings of Gregory Markopoulos*, ed.
Mark Webber (London, 2014)
18 Warren Sonbert, 'Artists statement', Tenth *New
American Filmmakers Series* (New York, NY, 1985)
19 Warren Sonbert, 'Conversation with David
Simpson at the School of the Art Institute of
Chicago's Film Centre', 1985
20 Shooting script, reproduced in Phillip
Drummond, *Un Chien Andalou* (London, 1994)
21 Luis Buñuel, quoted in Paul Hammond's
programme notes for London Filmmakers
Cooperative, 15 September 1976
22 Robert Desnos, 'Le Rêve et le cinema', *Paris-Journal*, 27 April 1923. A close member of Breton's
Surrealist group, Desnos died of typhus in the
Buchenwald concentration camp.
23 Luis Buñuel, 'Notes on the Making of
Un Chien Andalou', *Art in Cinema*, ed. Frank
Stauffacher (San Francisco, 1947)
24 Paul Hammond, *The Shadow and its Shadow*
(London, 1978)
25 Rudolf Kuenzli, *Dada and Surrealist Film*
(Boston, MA, 1987)
26 Man Ray, *Self Portrait* (Boston, MA, 1963)
27 Antonin Artaud, quoted in 'La Coquille et
le clergyman', *L'art du mouvement – collection
cinématographique du musée national d'art
moderne* (Paris, 1996) [author's translation]
28 Paul Hammond, LFM Cooperative
programme note, September 1976
29 James C. Robertson, *The Hidden Cinema:
British Film Censorship in Action, 1913–1975*
(London, 1993)
30 Jean Cocteau, 30 January 1932, reprinted as
an introduction to the film's screenplay, *Two
Screenplays* (New York, NY, 1968)
31 *Ibid.*
32 Léger, quoted in *Art In Cinema* (San Francisco,
1947)
33 The Tate Gallery's definition of Cubist
painting <https://www.tate.org.uk/art/art-terms/c/
cubism>
34 Léger, quoted in Kuenzli, *Dada and Surrealist
Film* (Cambridge, MA, 1987)
35 *Ibid.*
36 Hy Hirsh, '*Autumn Spectrum*' in EXPRMNTL
Festival catalogue (Knokke, 1958)
37 Pat O'Neill, Filmforum programme notes,
28 January 1977
38 Jim Hoberman, 'Flash in the Panorama',
Village Voice, 19 June 1978
39 Pat O'Neill, Filmforum programme notes,
28 January 1977

Chapter 5

1 Marcel Broodthaers, interview with *Trepied,
October,* vol. 42, in *Marcel Broodthaers: Writings,
Interviews, Photographs* (Autumn, 1987), pp. 36–38
2 Hollis Frampton, *On the Camera Arts and
Consecutive Matters: The Writings of Hollis
Frampton*, ed. Bruce Jenkins (Cambridge, MA,
2009)
3 Dieter Meier, issued at the ICA, London,
September 1969. He showed other versions in
Germany in 1969.
4 Yoko Ono, *Six Film Scripts by Yoko Ono* (Tokyo,
1964)
5 See Jonathan Walley, *Paracinema: Challenging
Medium-specificity and Re-defining Cinema in
Avant-garde Film* (Madison, WI, 2005)
6 Schum's series *Land Art* also included works
by Michael Heizer, Walter de Maria, Dennis
Oppenheim and Robert Smithson; *Identifications*
also included works by Kieth Sonnier, Gino de
Dominicis and Gilbert Zorio.
7 David Hall <http://www.davidhallart.com/>
8 P. Adams Sitney, 'Structural Film', *Film Culture*,
47, 1969
9 Paul Sharits, note in *Filmmakers Cooperative
Catalogue* (New York, NY, 1972)
10 Tony Morgan, *Resurrection (Beefsteak)*, 1968
<www.richardsaltoun.com/content/feature/230/
artworks-14466-tony-morgan-resurrection-
beefsteak-1968>
11 Vito Acconci, *Three Attention Studies*, 1969
<www.eai.org/titles/three-attention-studies>
12 'Rebecca Horn in conversation with Germano
Celant', *Rebecca Horn* (New York, NY, 1993)
13 Dennis Oppenheim, note in *Video Katalog*
(Köln, 1975)
14 Gordon Matta-Clark, *Conical Intersect*, 1975
<www.eai.org/titles/conical-intersect>
15 Mikhovil Pansini quoted in Pavle Levi,
Cinema by Other Means (Oxford, 2012)
16 Branden W. Joseph, *Beyond the Dream
Syndicate: Tony Conrad and the Arts after Cage*
(Princeton, NJ, 2011)
17 Birgit Hein, *Film im Underground: Von seinen
Anfängen bis zum Unabhägigen Kino* (Frankfurt
am Main, 1971)
18 Letter, 3 August 2020
19 Jonas Mekas, 'Movie Journal' *Village Voice*,
18 October 1973
20 Luca Comerio, *Dal polo all'equatore* (1925)
21 William Raban, *Take Measure*, 1973 <lux.org.
uk/work/take-measure>
22 Anthony McCall, 'Statement', EXPRMNTL
festival catalogue (Knokke, 1973–4)
23 Blaise Cendrars, 'The Modern: A New Art, the

Cinema', *La Rose Rouge*, 7, 12 June 1919, in Abel, vol. I (1993), p. 183
24 'Interview with Morgan Fisher', *Millenium Film Journal*, 60, 2014
25 David Hall
26 Allan Kaprow, 'Video Art, Old Wine, New Bottles', *Artforum*, June 1974

Chapter 6
1 René Clair, 'RHYTHMUS', *G*, 5–6 [edited by Richter], 1926
2 Hans Richter, 'Dada and Film', in *Dada, Monograph of a Movement*, ed. Willy Verkauf (New York, NY, 1975)
3 Lemaître, from the soundtrack of *Toujour a L'avant-garde jusqu'au paradis et au delà / Ever the avant-garde till heaven and after* (1972)
4 Malcolm Le Grice, 'Interview with Albert Kilchesty & MM Serra at Film Forum', 30 August 1984 (unpublished, University of the Arts London)
5 Wolf Vostell, *Television Dé-collage*, 1963 <www.medienkunstnetz.de/works/television-decollage/>
6 Richard Serra, 'Text of *Television Delivers People*', *Art Rite Video*, 7, Autumn 1974
7 Peter Kubelka, in Tacita Dean, *Film* (London, 2012)
8 *Index* 2, *Kurt Kren Structural Films*, 2004
9 *Ibid.*
10 Sitney, 'Structural Film', 1969
11 *Ibid.*
12 Paul Sharits, 'Hearing / Seeing', in *The Avant-garde Film Reader, A Reader of Theory and Criticism*, ed. P. Adams Sitney (New York, NY, 1978)
13 'Movie Journal', *Village Voice*, 24 March 1966
14 Tony Conrad to Mark Webber, in *Tony Conrad Tate Modern*, June 2008
15 Jonas Mekas and P. Adams Sitney, `Conversation with Michael Snow', *Film Culture*, 41, Autumn 1967
16 *Fragments of Kubelka* (DVD; Vienna, 2014)
17 Scott MacDonald, 'Taka Iimura', *Critical Cinema*, 1 (Berkeley, 1988), p. 128
18 *Ibid.*
19 Le Grice, 'Interview with Albert Kilchesty & MM Serra at Film Forum', 1984
20 *Ibid.*
21 Bruce Nauman quoted in Joan Simon, 'Breaking the Silence: an interview with Bruce Nauman', *Art in America*, September 1988
22 Malcolm Le Grice, 'The Chronos Project', *Vertigo*, 5, Autumn/Winter 1995, p. 21. The film was commissioned by Channel 4 but its imagery has been much mined for inclusion in later installations.
23 Peter Gidal, *Structural Film Anthology* (London, 1978)
24 'Action at a Distance' (Interview by Mike O'Pray), *Monthly Film Bulletin*, BFI, March 1986
25 *Ibid.*
26 Booklet accompanying *The Workshop of the Film Form* (1970–1977), Electronic Arts Intermix [undated]
27 *Ibid.*

Chapter 7
1 Early titles listed in *Auguste and Louis Lumière Letters*, ed. Jacques Rittaud-Hutinet (London, 1995)
2 Jonas Mekas, programme note for MOMA NY screening, 23 June 1970
3 *Ibid.*
4 Agnès Varda, 19th London Film Festival programme notes (1975)
5 Stan Brakhage on Marie Menken, *Film Culture*, 78, pp. 1–10
6 'Eight Questions' [1968], *Brakhage Scrapbook*, ed. Robert Haller, (New Paltz, NY, 1982)
7 Dan Clark, *Brakhage, Filmmakers Cinematheque Monograph n2*, (New York, NY, 1966)
8 'Metaphors on vision / by Brakhage', *Film Culture*, 30, Autumn 1963
9 Hirschfeld-Mack, in Laszlo Moholy-Nagy, *Painting, Photography, Film*
10 Carolee Schneeman, *Ideolects* 9–10, Winter 1980–81
11 *Ibid.*
12 *Ibid.*
13 'Bill Viola's major new work for St Paul's Cathedral', 26 July 2016 <www.stpauls.co.uk/news-press/latest-news/bill-violas-major-new-work-for-st-pauls-cathedral-2>
14 Joe Giordano, 'The Cinema of Looking; Rudy Burckhardt and Edwin Denby in conversation with Joe Giordano', *Jacket 21*, February 2003
15 *Ibid.*
16 Guy Sherwin, *Short Film Series: Cycle*, 1974–2004 <lux.org.uk/work/short-film-series-cycle>
17 Helga Fanderl <helgafanderl.com/about/>
18 'Somersault', from *Pennywheep*, Edinburgh, 1926
19 Lecture delivered at the Greg Sharits and John Hicks Experimental Cinema Forum, University of Boulder, Colorado, 25 April 1966
20 Text associated with the film's showing as part of the 'Still Life' exhibition at Fondazione Nicola Trussardi, Milan, 2009; based on films made in Morandi's studio.
21 Nathaniel Dorsky <nathanieldorsky.net>

Chapter 8

1 Seamus Heaney, 'On Poetry', *The Guardian Review*, 28 December 2014
2 Maya Deren, 'Symposium Poetry and the Film', *Cinema 16*, 28 October 1953. Other participants were Dylan Thomas, Arthur Miller and Parker Tyler [author's italics].
3 Maya Deren, 'Chamber Films', *Filmwise*, 2, 1961
4 Shirin Neshat, 'Images and history', lecture in the Humanities Division, University of Oxford, 17 May 2012
5 Jayne Parker, 'Landscape in *I Dish*', *Undercut*, 7–8, London Filmmakers Cooperative, 1983
6 Catherine Elwes, *Video Art: a Guided Tour* (London, 2004)
7 Scott Macdonald, 'Anne Severson', *A Critical Cinema*, 2 (Berkeley, CA, 1992), p. 326
8 Martha Rosler, *Semiotics of the Kitchen*, 1975 <www.eai.org/titles/semiotics-of-the-kitchen>
9 Wilhelm and Birgit Hein, *Kali-Filme*, 1987–88 <lux.org.uk/work/kali-filme>
10 Steve McQueen, *Bear*, 1993 <www.tate.org.uk/art/artworks/mcqueen-bear-t07073>
11 Kenneth Anger, quoted in P. Adams Sitney, *Visionary Film – The American Avant-garde* (Oxford, 1974)
12 Cocteau was instrumental in its being awarded poetic film prize at the 1949 Biarritz Festival du Films Maudit ('Damned Films' – films banned by censorship).
13 Jean Genet, 'Notes on filming *Le Bagne* (*The Penal Colony*)', in *The Cinema of Jean Genet*, ed. Jane Giles (London, 1991). *Le Bagne* was a proposed follow-up to *Un chant d'amour* and a development of its theme.
14 Bruce Jenkins, 'In the Bedroom / On the Road – a conversation with Sadie Benning and James Benning', *Millennium Film Journal*, 58, 2014
15 Stuart Marshall, in 'Filling the lack in everybody is quite hard work, really: A roundtable discussion with Joy Chamberlain, Isaac Julien, Stuart Marshall and Pratibha Parmar', in *Queer Looks: Perspectives on Lesbian and Gay Film and Video* (Oxford, 1993). Marshall's television work was commissioned by Channel 4's pioneering gay and lesbian strand 'Out'.
16 'Stan Brakhage', in Scott MacDonald, *A Critical Cinema* 4 (Berkeley, 2005), p. 93
17 Jonas Mekas, 'Movie Journal', *Village Voice*, August 1964
18 *Ibid.*
19 Robert Frank, quoted in Jerry Tallmer, 'Introduction', *Pull My Daisy, text for the film by Robert Frank & Alfred Leslie* (New York, NY, 1961)

20 Jack Kerouac, *Pull My Daisy* (1961)
21 Jonas Mekas, 'Movie Journal', *Village Voice*, August 1964
22 Ken Jacobs, *Little Stabs at Happiness*, 1960 <www.eai.org/titles/little-stabs-at-happiness>
23 It was put on trial with *Scorpio Rising* and Genet's *Un Chant d'amour*; see J. Hoberman, *On Jack Smith's Flaming Creatures* (New York, NY, 2001)
24 *Wait for Me at the Bottom of the Pool: The Writings of Jack Smith*, ed. J. Hoberman and E. Leffingwell (London, 1997)
25 *Ibid.*

Chapter 9

1 Philip Drummond, *Un Chien Andalou* (London, 1994)
2 'Cocteau on Film', *Film: An Anthology*, ed. Daniel Talbot (Berkeley, CA, 1966)
3 Robert Short, *The Age of Gold: Surrealist Cinema* (Chicago, IL, 2008)
4 S. Themerson, 'Dialog tendencyjny', *Wiadomości Literackie*, 17, 1933
5 *fa*, 1, February 1937, on French experimental cinema; *fa*, 2, March-April 1937, contains the first text of Themerson's treatise *The Urge to Create Visions* (*O potrzebie tworzenia widzeń*).
6 'Avant-Garde 1927–1937' DVD filmarchief de la Cinémathèque [Royal Belgian Film Archive], 2009
7 Jonas Mekas, 'Movie Journal', *Village Voice*, 23 November 1967. The seven directors for 1967 were Stan VanDerBeek, Ed Emshwiller, Shirley Clarke, Peter Kubelka, Ken Jacobs and Robert Breer.
8 Dick Higgins, *An Exemplativist Manifesto* (New York, NY, 1976). Quoted in Beverley O'Neill, 'Ways and Means', *LAICA Journal*, April–May 1977
9 'Ben Rivers by Erika Balsom', *Speaking Directly: Oral histories of the Moving Image* (San Francisco, CA, 2013). The subject of artists' film distribution is fully explored in Balsom's *After Uniqueness: A History of Film and Video Art in Circulation* (New York, NY, 2017).
10 'Cocteau on Film', *Film: An Anthology*, ed. Daniel Talbot (Berkeley, CA, 1966)
11 Stefan Themerson, *The Urge to Create Visions* (Amsterdam, 1983); initially published in *fa* in 1937 and later extended to book length.
12 *Ibid.*
13 *Cinema 16* (Philadelphia, PA, 2002); *Canyon Cinema — Life and Times of an Independent Film* (Berkeley, CA, 2008)
14 Maya Deren, 'Amateur Versus Professional', *Movie Makers Annual*, 1959
15 An earlier version of 'The Ideal Viewing Space' was published in *Millennium Film Journal*, 58, Fall 2013

16 Robert Smithson, 'A Cinematic Atopia',
Artforum, September 1971

17 Moholy-Nagy, *Painting, Photography, Film*
(1926)

18 Stripped of Kiesler's innovations, it became
the Eighth Street Playhouse. In Film Guild
programme notes it was referred to as 'The House
of Shadow Silence'.

19 Stan Brakhage, 'Letter to Gregory
Markopoulos', in *Giving and Taking Book* (1971)

20 *Ibid.*

21 Georgia Korossi, 'The Materiality of Film:
Peter Kubelka' <www2.bfi.org.uk/news/
materiality-film-peter-kubelka>

22 Maya Deren, Lecture, 11 April 1961

23 '8mm vision', *The Brakhage Scrapbook*
(Kingston, NY, 1982)

24 Jonas Mekas, 'Movie Journal', *Village Voice*,
10 October 1968

25 Also shown at Parnass that year was Wolf
Vostell's *Dé-coll/age 1963* – his collage of
television imagery shot from the screen in
extreme close-up.

26 Vito Acconci, 'Some Notes on My Use of
Video', *Art-Rite*, 1/7, 1974

27 Gary Hill, quoted in 'Time in the Body',
Corrine Diserens, *Gary Hill – In The Light of the
Other* (Oxford, 1993)

28 'Ben Rivers by Erika Balsom', *Speaking
Directly: Oral histories of the Moving Image* (San
Francisco, 2013)

29 'Mark Lewis in conversation with Klaus
Biesenbach', *Cold Morning* catalogue, 2009

Further Reading

Abel, Richard, *French Film Theory and Criticism 1907–1939*, vols I and II (Princeton, NJ, 1993)

Comer, Stuart (ed.), *Film and Video Art* (London, 2008)

Curtis, David, *Experimental Cinema* (New York, NY, 1971)

—— *A History of Artists' Film and Video in Britain* (London, 2007)

Dean, Tacita, *Film* (London, 2012)

Drummond, Phillip (ed.), *Film as Film* (London, 1979)

Dwoskin, Steven, *Film Is – The International Free Cinema* (London, 1975)

Elwes, Catherine, *Video Art a Guided Tour* (London, 2004)

—— *Installation and the Moving Image* (London, 2015)

Haller, Robert A., *Brakhage Scrapbook: Collected Writings 1964–1980* (New Paltz, NY, 1982)

Hamlyn, Nicky, *Film Art Phenomena* (London, 2003)

James, David E., *Allegories of Cinema: American Film in the Sixties* (Princeton, NJ, 1989)

Kuenzli, Rudolf, *Dada and Surrealist Film* (Boston, 1987)

Le Grice, Malcolm, *Abstract Film and Beyond* (London, 1999)

London, Barbara, *Video Art – The First Fifty Years* (New York, NY, 2020)

MacDonald, Scott, *A Critical Cinema – Interviews with Independent Filmmakers* (series; Los Angeles, 1988–2021)

Meigh-Andrews, Chris, *A History of Video Art: The Development of Form and Function* (London, 2006)

Mekas, Jonas, *Movie Journal – The Rise of the New American Cinema, 1959–1971* (New York, NY, 2016)

O'Pray, Michael, *Avant-garde Film: Forms, Themes and Passions* (London, 2003)

Rees, A. L., *A History of Experimental Film and Video* (London, 2006)

—— *Fields of View: Film, Art and Spectatorship* (London, 2020)

Rush, Michael, *Video Art* (London, 2003)

Sitney, P. Adams, *Visionary Film – The American Avant-Garde* (New York, NY, 1974)

—— (ed.) *The Avant-Garde Film, A Reader of Theory and Criticism* (New York, NY, 1978)

Vogel, Amos, *Film as a Subversive Art* (London, 1974)

Wheeler-Dixon, Winston, and Gwendolyn Audrey Foster (eds), *Experimental Cinema – The Film Reader* (London, 2002)

Young, Paul, and Paul Duncan (eds.), *Art Cinema* (Köln, 2009)

List of illustrations

Includes work duration, medium and artist's nationality or place of practice.

29 Stefan and Franciszka Themerson, *The Eye and the Ear*, 1944–45. 11 mins, UK. © Themerson Estate

30 Francis Bruguière, *Light Rhythms*, 1930. 5 mins, UK. Collection David Curtis

31 Mary Ellen Bute, *Abstronic*, 1954. 6 mins, USA. © 2021 Center for Visual Music

32 Robert Smithson, *Spiral Jetty*, 1970. 35 mins, still from the film, USA. Courtesy the Holt/Smithson Foundation and Electronic Arts Intermix (EAI), New York. © Holt-Smithson Foundation/VAGA at ARS, NY and DACS, London 2021

33 Jeremy Deller, *The Battle of Orgreave*, 2001. 62 mins, UK. Courtesy the artist. Photo Parisah Taghizadeh

34 Ann-Sofi Sidén, *Warte Mal!* (*Hey Wait!*), 1999. 13 channel DVD with 5 projections and 8 video booths. Edition of 3 with 1 A.P. Variable duration, Swedish/Germany/Czech Republic. Courtesy the artist and Galerie Barbara Thumm, Berlin

35 Charles Sheeler and Paul Strand, *Manhatta*, 1921. 10 mins, USA. Courtesy the BFI National Archive

36 Robert Flaherty, *Man of Aran*, 1934. 77 mins, UK/Ireland. ITV/Shutterstock

37 Trinh T Minh-ha, *Surname Viet Given Name Nam*, 1989. 108 mins, USA. Courtesy Trinh T Minh-ha

38 Walter Ruttmann, *Berlin, die Sinfonie der Grosstadt* (*Berlin, Symphony of a Great City*), 1927. *c.* 65 mins, Germany. Fox Europa/Kobal/Shutterstock

39 László Moholy-Nagy, *Impressionen vom alten Marseiller Hafen* (*Impressions of the Old Port of Marseilles*), 1929. 11 mins, Germany. Centre Pompidou, MNAM-CCI, Dist. RMN-Grand Palais

40 Dziga Vertov, *Tchelovek s kinoapparatom* (*Man with a Movie Camera*), 1929. 68 mins, USSR. Vufku/Kobal/Shutterstock

41 Dziga Vertov, *Entuziazm* (*Enthusiasm or Symphony of the Don Basin*), 1931. 65 mins, USSR. Courtesy the BFI National Archive

42 Deimantas Narkevičius, *Energy Lithuania*, 2000. Super 8 mm film transferred onto DVD, 17 mins, Lithuania. © Deimantas Narkevičius, courtesy Maureen Paley, London

43 Henri Stork, *Images d'Ostende* (*Images of Ostend*), 1929. 11 mins, Belgium. Courtesy the BFI National Archive

44 Patrick Keiller, *London*, 1994. 100 mins, UK. © British Film Institute

45 Kahlil Joseph, *m.A.A.d.*, 2014. Two-channel video installation, 35mm film transferred to HD video and VHS home footage, 15 mins 26 secs, USA. Courtesy the artist

46 Georges Franju, *Le Sang des Bêtes* (*Blood of the Beasts*), 1949. 22 mins, France. Forces Et Voix De La France/Kobal/Shutterstock

47 Alberto Cavalcanti et al., *Coalface*, 1935. 12 mins, UK. © GPO

48 Steve McQueen, *Caribs' Leap/Western Deep*, 2002. Super 8mm and 35mm colour film transferred to video, sound. *Western Deep* 24 mins 12 secs, *Caribs' Leap* 28 mins 53 secs, UK. Courtesy the artist, Thomas Dane Gallery and Marian Goodman Gallery. © Steve McQueen

49 Humphrey Jennings, *Spare Time*, 1939. 14 mins, UK. © GPO

50 John Akomfrah, *Handsworth Songs*, 1986. 16mm colour film transferred to video, sound, 58 mins 33 secs, UK. © Smoking Dogs Films, courtesy Lisson Gallery

51 William Raban, *Island Race*, 1996. 28 mins, UK. Courtesy William Raban

52 Cecil Hepworth, *Burnham Beeches*, 1909. 3 mins, UK. Courtesy the BFI National Archive

53 David Hockney, *The Four Seasons, Woldgate Woods (Spring 2011, Summer 2010, Autumn 2010, Winter 2010)*, 2010–11. 36 digital videos synchronized and presented on 36 monitors to comprise a single artwork, 4 mins 21 secs, UK. Edition of 10 with 2 A.P.s. © David Hockney

54 Melanie Smith in collaboration with Rafael Ortega, *Xilitla*, 2010. Single channel video, 16:9 projection upright, colour, 25 mins, Mexico. Courtesy the artist and Galerie Peter Kilchmann, Zurich

55 Mark Lewis, *Beirut*, 2012. 8 mins 10 secs, UK/Canada. Courtesy the artist and Daniel Faria Gallery, Toronto

56 Peter Hutton, *New York Portrait: Part 1,* 1978–79. 16 mins, USA. Centre Pompidou, MNAM-CCI, Dist. RMN-Grand Palais

57 Margaret Tait, *Land Makar*, 1981. 32 mins, UK. Courtesy Estate of Margaret Tait and LUX, London

58 Chris Welsby, *Seven Days*, 1974. 20 mins, UK. © 2005 Chris Welsby

59 Rose Lowder, *Voiliers et Coquelicots* (*Poppies and Sailboats*), 2001. 2 mins at 18 fps, France. Courtesy Light Cone

60 Michael Snow, *La Région Centrale*, 1971. 180 mins, Canada. Courtesy Michael Snow and LUX, London

61 Germaine Dulac, *La Souriante Madame Beudet, (The Smiling Madame Beudet)*, 1922–23. 38 mins, France. Courtesy BAFV Study Collection,

Central St Martins, University of the Arts, London. Collection David Curtis

62 Jean Epstein, *La glace à trois faces* (*The Three-faced Mirror*), 1927. *c.* 40 mins, France

63 Mário Peixoto, *Limite* (*Limit* or *Border*), 1930–31. *c.* 115 mins, Brazil. AF archive/Alamy Stock Photo

64 Stefan and Franciszka Themerson, *Przygoda czlowieka poczciwego* (*The Adventure of a Good Citizen*), 1937. 8 mins, Poland. © Themerson Estate

65 Sergei Eisenstein, *Bronesosets Potyomkin (Battleship Potemkin)*, 1925. *c.* 75 mins, USSR. Goskino/Kobal/Shutterstock

66 Gregory Markopoulos, *Twice a Man*, 1963. 49 mins, USA. © Estate of Gregory J. Markopoulos. Courtesy Temenos Archive

67 Bruce Conner, *A MOVIE*, 1958. 16mm to 35mm blow-up, black & white, sound, digitally restored, 2016. 12 mins, USA. Music: "The Pines of the Villa Borghese", "Pines Near a Catacomb", and "The Pines of the Appian Way", movements from *Pines of Rome* (1923–24), composed by Ottorino Respighi, performed by the NBC Symphony, conducted by Arturo Toscanni, courtesy Sony Masterworks/RCA Records. Courtesy The Conner Family Trust, Kohn Gallery, Los Angeles and Thomas Dane Gallery. © The Estate of Bruce Conner

68 Luis Buñuel, *Un Chien Andalou* (*An Andalusian Dog*), 1929. *c.* 20 mins, France. Moviestore/Shutterstock

69 Germaine Dulac, *La coquille et le clergyman* (*The Seashell and the Clergyman*), 1927. *c.* 40 mins, France. The Picture Art Collection/Alamy Stock Photo

70 Jean Cocteau, *Le Sang d'un poète* (*Blood of a Poet*), 1930. 55 mins, France. Collection David Curtis

71 Fernand Léger, *Ballet mécanique* (*Mechanical Ballet*), 1924. 12 mins, France. Kobal/Shutterstock. © ADAGP, Paris and DACS, London 2021

72 Robert Florey, *Skyscraper Symphony*, 1929. 9 mins, USA

73 Ernie Gehr, *Side/walk/shuttle*, 1991. 41 mins, USA. Courtesy Ernie Gehr

74 Hy Hirsh, *Autumn Spectrum*, 1957. 7 mins, Holland/France. Centre Pompidou, MNAM-CCI, Dist. RMN-Grand Palais

75 Anthony McCall, *Long Film for Ambient Light*. Installation view, 2pm, June 18, 1975, and 3am, June 19, 1975 at the Idea Warehouse, New York. © Anthony McCall, 1975

76 Marcel Duchamp, *Anémic Cinéma*, 1926. 7 mins at 22 fps, France. Centre Pompidou, MNAM-CCI, Dist. RMN-Grand Palais. Photo Hervé Véronèse. © Association Marcel Duchamp/ADAGP, Paris and DACS, London 2021

77 Robert Morris, *Mirror*, 1969. 9 mins, USA. © The Estate of Robert Morris/Artists Rights Society (ARS), New York/DACS, London 2021

78 Barry Flanagan, *Hole in the Sea*, 1969. 3 mins 44 secs, UK. Courtesy Waddington Custot and Plu Bronze

79 Gilbert and George, *A Portrait of the Artists as Young Men*, 1970. Video, 7 mins, UK. Arts Council Collection, Southbank Centre, London. © The Artists 2021, courtesy Jay Jopling/White Cube London

80 David Hall, *TV Interruptions*, (7 TV Pieces), 1971. 7 channel video installation, sound, black & white, 16mm to video, 22 mins, UK. Courtesy Richard Saltoun Gallery. © The estate of the artist

81 Paul Sharits, *Word Movie*, 1966. 4 mins, USA. Centre Pompidou, MNAM-CCI, Dist. RMN-Grand Palais. Permission from Christopher and Cheri Sharits

82 Ben Vautier, *Je ne vois rien, Je n'entends rien, Je ne dis rien (Fluxfilm no. 38)*, (*I see nothing, I hear nothing, I say nothing (Fluxfilm no. 38)*), 1966. 7 mins, France. Centre Pompidou, MNAM-CCI, Dist. RMN-Grand Palais. © ADAGP, Paris and DACS, London 2021

83 Bill Woodrow, *Floating Stick*, 1971. 5 mins 20 secs, UK. © Bill Woodrow

84 Bruce Nauman, *Bouncing Two Balls between the Floor and Ceiling with Changing Rhythms*, 1967–68. 10 mins, USA. Centre Pompidou, MNAM-CCI, Dist. RMN-Grand Palais. © Bruce Nauman/Artists Rights Society (ARS), New York and DACS, London 2021

85 Richard Serra, *Hand Catching Lead*, 1968. 3 mins, USA. Centre Pompidou, MNAM-CCI, Dist. RMN-Grand Palais/image Centre Pompidou, MNAM-CCI. © ARS, NY and DACS, London 2021

86 Vito Acconci, *Pryings*, 1971. 17 mins, USA. Centre Pompidou, MNAM-CCI, Dist. RMN-Grand Palais. © ARS, NY and DACS, London 2021

87 Rebecca Horn, *Einhorn*, 1970. Super 8mm to DVD, 12 mins, Germany. Photo Achim Thode. Courtesy Sean Kelly, New York. © 2021 Rebecca Horn/VG Bild Kunst, Bonn

88 Dennis Oppenheim with Bob Fiore, *Arm & Wire*, 1969. 16mm film, black & white, 8 mins, USA. Courtesy the Estate of Dennis Oppenheim

89 John Baldessari, *I Will Not Make Any More Boring Art*, 1971. Black & white, sound, 31 mins 17 secs, USA. Courtesy the Estate of John Baldessari

90 Bas Jan Ader, *Fall 2*, Amsterdam, 1970. 16mm film, black & white, 19 secs, Netherlands. Colour production print. Courtesy Meliksetian/Briggs, Los Angeles. © The Estate of Bas Jan Ader/Mary Sue Ader Andersen, 2021/The Artist Rights Society, New York/DACS, London

91 Francis Alÿs (in collaboration with Julien Devaux and Ajmal Maiwandi), *REEL-UNREEL*, 2011. Video installation, colour, sound, 19 mins 32 secs, Mexico (b. Belgium). Courtesy the artist and David Zwirner. © Francis Alÿs

92 Nam June Paik, *TV Buddha*, 1974. Collection Stedelijk Museum Amsterdam. © Nam June Paik Estate

93 Milan Samec, *Termiti* (*Termites*), 1963. 1 min 40 secs, Croatia. Courtesy Hrvatski filmski savez/Croatian Film Association

94 George Landow (Owen Land), *Film in Which There Appear Sprocket Holes, Edge Lettering, Dirt Particles, etc...*, 1966. 4 mins, USA. Centre Pompidou, MNAM-CCI, Dist. RMN-Grand Palais. Photo Hervé Véronèse. Courtesy Estate of Owen Land and Office Baroque

95 Wilhelm and Birgit Hein, *Rohfilm* (*Raw Film*), 1968. 20 mins, Germany. Courtesy Birgit Hein

96 Annabel Nicolson, *Reel Time*, 1973. Expanded cinema performance, variable durations, UK. Photo Ian Kerr. Courtesy Annabel Nicolson and LUX, London

97 Douglas Gordon, *24 Hour Psycho Back and Forth and To and Fro*, 2008. Exhibited at Gagosian, New York, November 14, 2017–February 3, 2018, 24 hours, UK. *Psycho*, 1960, USA, directed and produced by Alfred Hitchcock, distributed by Paramount Pictures © Universal City Studios. Photo Rob McKeever. Courtesy Gagosian. © Studio lost but found/DACS 2021

98 William Raban, *Take Measure*, 1973. Variable duration, UK. March 2017 performance, photographed by Mark Blower. Courtesy William Raban

99 Anthony McCall, *Long Film for Four Projectors*, 1974. USA. London Filmmakers Co-op Cinema announcement card, 1975. Courtesy BAFV Study Collection, Central St Martins, University of the Arts, London

100 Morgan Fisher, *Projection Instructions*, 1976. 16mm, black & white, optical sound, 4 min, USA. Edition of 10 with 1 A.P. USA. Courtesy the artist and Bortolami Gallery, New York

101 Joan Jonas, *Vertical Roll*, 1972. 19 mins 38 secs, USA. Courtesy Electronic Arts Intermix (EAI), New York. © ARS, NY and DACS, London 2021

102 Stephen Partridge, *Monitor*, 1974. 6 mins, UK. Courtesy Stephen Partridge

103 Man Ray, *Le retour à la raison* (*The Return to Reason*), 1923. 3 mins, France. © Man Ray 2015 Trust/DACS, London 2021

104 René Clair, *Entr'acte* (*Between the Acts*), 1924. 22 mins, France. Centre Pompidou, MNAM-CCI, Dist. RMN-Grand Palais

105 Maurice Lemaître, *Le film est déjà commencé?* (*Has the Film Started?*), 1951. 62 mins, France. Photo Centre Pompidou, MNAM-CCI, Dist. RMN-Grand Palais. © ADAGP, Paris and DACS, London 2021

106 Wolf Vostell, *TV Dé-coll/age*, 1963. 47 mins, Germany. Centre Pompidou, MNAM-CCI, Dist. RMN-Grand Palais. © DACS 2021

107 Peter Weibel, *TV News/TV Death*, 1970–72. 5 mins 47 secs, Austria/Germany. © Archive Peter Weibel

108 Charles Dekeukelaire, *Impatience*, 1928. 36 mins, Belgium. Centre Pompidou, MNAM-CCI, Dist. RMN-Grand Palais

109 Peter Kubelka, *Adebar*, 1957. 1 min 30 secs, Austria. Courtesy Peter Kubelka and LUX, London

110 Kurt Kren, *15/67 TV*, 1967. 4 mins, Austria. Centre Pompidou, MNAM-CCI, Dist. RMN-Grand Palais. Photo Hervé Véronèse. © DACS 2021

111 Paul Sharits, *N:O:T:H:I:N:G*, 1968. 35 mins, USA. Permission from Christopher and Cheri Sharits

112 Tony Conrad, *The Flicker*, 1966. 30 mins, USA. Courtesy Estate of Tony Conrad and LUX, London

113 Michael Snow, *Wavelength*, 1967. 45 mins, Canada. Courtesy Michael Snow and LUX, London

114 Malcolm Le Grice, *Berlin Horse*, 1970. 9 mins, UK. Courtesy Malcolm Le Grice

115 Stan Douglas, *Win, Place or Show*, 1998. Two-channel video projection, 4 channel soundtrack, 204,023 variations, dimensions variable, average duration of 6 mins each, Canada. Courtesy the artist, Victoria Miro, and David Zwirner. © Stan Douglas

116 Peter Gidal, *Roomfilm*, 1973. 55 mins, UK. Courtesy Peter Gidal and LUX, London

117 Ryszard Wasko, *A-B-C-D-E-F=1-36*, 1974. 8 mins, Poland. Courtesy Ryszard Wasko and LUX, London

118 Wojceich Bruszewski, *Matchbox*, 1975. 3 mins 27 secs, Poland. Courtesy the estate of the artist

119 Tomislav Gotovac, *Pravac (Stevens-Duke)* (*Straight Line (Stevens-Duke)*), 1964. 6 mins 5 secs, Yugoslavia. Courtesy Hrvatski filmski savez/Croatian Film Association

120 Ladislav Galeta, *Two Times in One Space*, 1976–84. 12 mins, Yugoslavia. Courtesy Hrvatski filmski savez/Croatian Film Association

121 Oskar Fischinger, *München-Berlin Wanderung* (*Walking from Munich to Berlin*), 1927. 4 mins, Germany. © 2021 Center for Visual Music

122 Jonas Mekas, *Walden: Diaries, Notes and Sketches*, 1969. 180 mins, USA. Centre Pompidou, MNAM-CCI, Dist. RMN-Grand Palais. Photo Hervé Véronèse

123 Marie Menken, *Andy Warhol*, 1965. Silent, 22 mins, USA. Centre Pompidou, MNAM-CCI, Dist. RMN-Grand Palais. Photo Hervé Véronèse

124 Dieter Roth, *Solo Scenes*, 1997–98. 121 channels. Variable lengths, Switzerland/Iceland. Installation view at 48th Venice Biennale, 1999. Photo Heini Schneebeli. Courtesy Hauser & Wirth. © Dieter Roth Estate

125 Stan Brakhage, *Dog Star Man*, 1961. 78 mins (*Prelude* 25 mins), USA. Courtesy the Estate of Stan Brakhage and Fred Camper (www.fredcamper.com)

126 Carolee Schneemann, *Fuses*, 1965. 18 mins, USA. Centre Pompidou, MNAM-CCI, Dist. RMN-Grand Palais/Service audiovisuel du Centre Pompidou. © ARS, NY and DACS, London 2021

127 Joseph Cornell, *Aviary*, 1955. 14 mins, USA. Centre Pompidou, MNAM-CCI, Dist. RMN-Grand Palais. Photo Hervé Véronèse. © The Joseph and Robert Cornell Memorial Foundation/VAGA at ARS, NY and DACS, London 2021

128 Guy Sherwin, *Cycle*, 1978. 3 mins, UK. Courtesy Guy Sherwin

129 Tom Chomont, *Oblivion*, 1969. 6 mins, USA. Courtesy the Canadian Filmmakers Distribution Centre

130 Gunvor Nelson, *My Name is Oona*, 1969. 10 mins, USA. Courtesy Filmform

131 John Akomfrah, *The Unfinished Conversation*, 2012. 45 mins 48 secs, UK. Courtesy Lisson Gallery. © Smoking Dogs Films

132 Andy Warhol, *Jonas Mekas,* 1966. 16mm film, black-&-white, silent, 4 mins 30 secs at 16 fps, USA. © 2021 The Andy Warhol Museum, Pittsburgh, PA, a museum of Carnegie Institute. All rights reserved. Film still courtesy The Andy Warhol Museum

133 Tacita Dean, *Michael Hamburger*, 2007. 16mm colour anamorphic film, optical sound, 28 mins. UK. Courtesy the artist, Frith Street Gallery, London and Marian Goodman Gallery, New York and Paris

134 Gillian Wearing, *2 into 1*, 1997. Colour video for monitor with sound, 4 mins 30 secs, UK. Courtesy Maureen Paley, London, Tanya Bonakdar. © Gillian Wearing

135 Henwar Rodakiewicz, *Portrait of a Young Man*, 1925–31. 55 mins 41 secs, USA. Courtesy Light Cone

136 Maya Deren, *At Land*, 1944. 15 mins, USA. Centre Pompidou, MNAM-CCI, Dist. RMN-Grand Palais

137 Shirin Neshat, *Rapture*, 1999. 13 mins, USA. Photo by Larry Barns. Courtesy the artist and Gladstone Gallery, New York and Brussels. © Shirin Neshat

138 Jayne Parker, *I Dish*, 1982. 15 mins, UK. Courtesy Jayne Parker

139 Lis Rhodes, *Light Reading*, 1978. 20 mins, UK. Courtesy Lis Rhodes and LUX, London

140 Catherine Elwes, *Myth / There is a Myth*, 1984. 9 mins, UK. Courtesy Catherine Elwes

141 VALIE EXPORT, *Tapp und Tastkino* (*Tap and Touch Cinema*), 1968. Austria. Courtesy VALIE EXPORT. *© DACS 2021*

142 Martha Rosler, *Semiotics of the Kitchen*, 1975. 6 mins 9 secs, USA. Courtesy Martha Rosler

143 Birgit Hein, *Kali Film*, 1988. 12 mins, Germany. Courtesy Birgit Hein

144 Steve McQueen, *Bear*, 1993. 16mm black & white film transferred to video, continuous projection, 10 mins 35 secs, UK. Courtesy the artist, Thomas Dane Gallery and Marian Goodman Gallery. © Steve McQueen

145 Jean Genet, *Un chant d'amour* (*A Song of Love*), 1950. 26 mins, France. Courtesy the BFI National Archive

146 Sadie Benning, *It wasn't Love*, 1992. 20 mins, USA. Courtesy Video Data Bank, School of the Art Institute of Chicago, www.vdb.org. © Sadie Benning

147 Isaac Julien, *Looking for Langston*, 1989. 45 mins, UK. Courtesy the BFI National Archive

148 Stuart Marshall, *Journal of the Plague Year*, 1984. Five monitors with text, (single screen version 40 mins), UK. Courtesy Estate of Stuart Marshall and LUX, London

149 Stan Brakhage, *The Act of Seeing with One's Own Eyes*, 1971. 32 mins, USA. Courtesy the Estate of Stan Brakhage and Fred Camper (www.fredcamper.com)

Index

'The single most influential series of art books ever published' *Apollo*

'Outstanding ... exceptionally authoritative and well-illustrated' *Sunday Times*

'World of Art delivers real knowledge with crisp, useful clarity' *Guardian*

Comprehensive in coverage and accessible to all, the World of Art series explores both the newest and the perennial in all the arts, covering themes, artists and movements that straddle the centuries and the gamut of visual culture around the globe.

You may also like:

History of Film
David Parkinson

Performance Art
RoseLee Goldberg

Movements in Art Since 1945
Edward Lucie-Smith

The Photograph as Contemporary Art
Charlotte Cotton

World of Art

Be the first to know about our new releases, exclusive events and special offers by signing up to our newsletter at **www.thamesandhudson.com**